JOSEF KOUDELKA **NEXT**

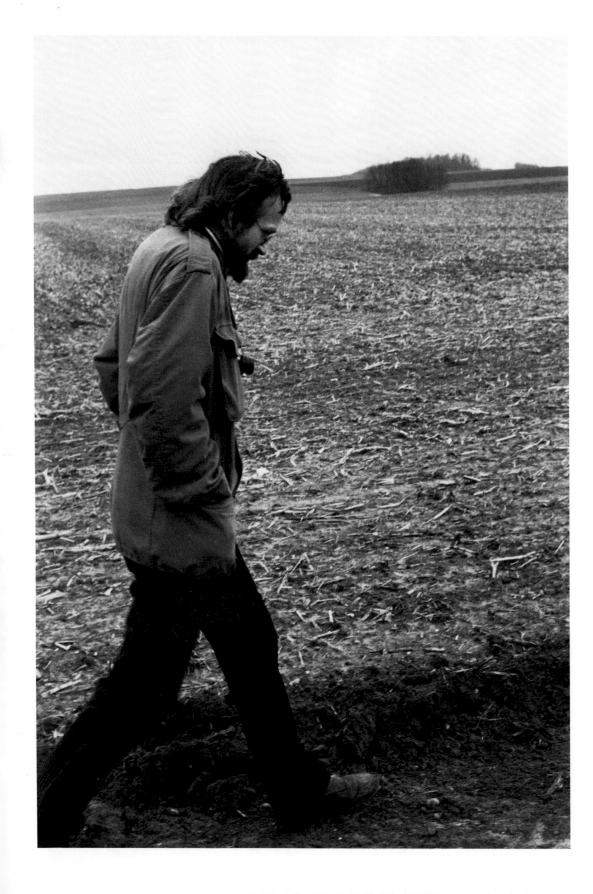

JOSEF KOUDELKA **NEXT**

A Visual Biography by Melissa Harris

aperture

The Magnum Foundation's Legacy Program preserves and makes accessible materials related to Magnum Photos and the larger history of photography to which it has uniquely contributed. This series explores the creative process of Magnum photographers, from the agency's founders to its contemporary members, through a mix of biographical text, archival materials, and iconic imagery.

Managing Editor: Andrew E. Lewin
Series Editor: Carole Naggar

All photographs in *Next* are by Josef Koudelka, unless otherwise indicated.

Frontispiece: *Josef Koudelka*, France, 1972. Photograph by Henri Cartier-Bresson

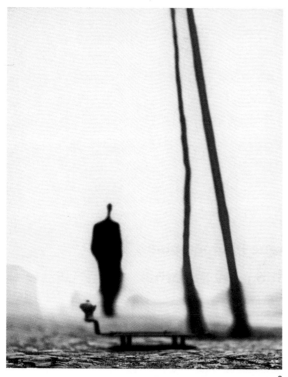

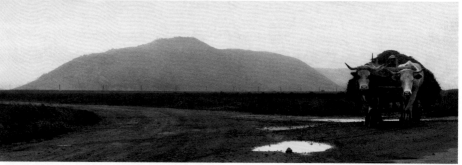

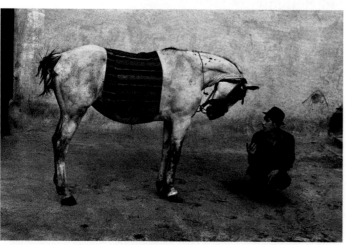

1 Jan Tříska and Marie
 Tomášová in Josef Topol's
 Hodina lásky (Hour of
 Love), directed by Otomar
 Krejča, Divadlo za branou,
 Prague, 1968

2 Prague, 1960

3 Slovakia, 1958

4 Romania, 1968

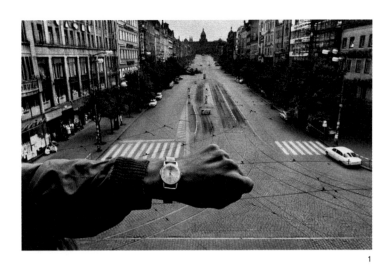

1

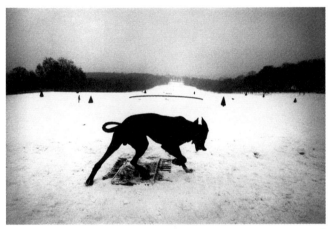

2

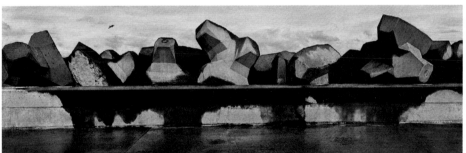

3

1 Hand and wristwatch,
 Prague, August 1968

2 France, 1987

3 France (Nord-Pas-de-
 Calais), 1989

7

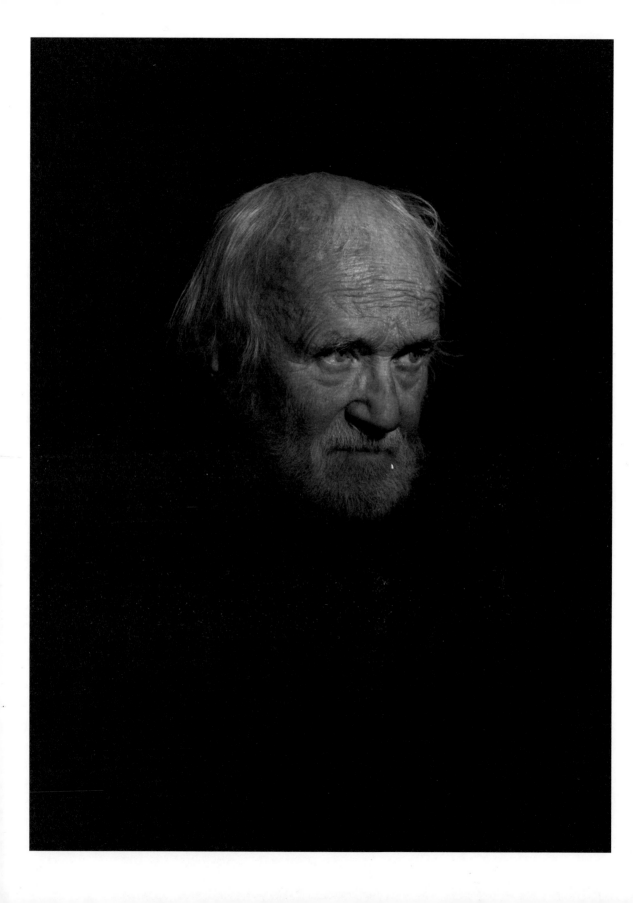

Prologue

Josef Koudelka is resolutely hopeful. He searches for the positive in any situation and lives fervently and willfully. Nevertheless, for decades the photographer has laughingly, and with reason, referred to himself as "Mr. No." He regularly says no to interviews, teaching, panel talks, and speeches; with one exception, he has never, since going into exile from his native Czechoslovakia in 1970, accepted a commercial or editorial assignment. And so in 2012, when Magnum Foundation[1] approached me, and then Koudelka, about my writing his biography — as part of a series the foundation had initiated at the time — the immediacy of his "yes" was surprising: Koudelka is profoundly private, occasionally shy, and he guards his time ferociously. He thinks projects. He thinks long term. He thinks

JK's Ivry studio, France, 2010

books and exhibitions. He thinks only and always about the work. He is never sidetracked. This biography, however, was to be about the life — inseparable though it might be from the work.

As much as Koudelka does not enjoy, might even dread, speaking about his photography publicly — the few times he has agreed to do so have always been connected to a publication or show — he has become more practiced at it

Opposite: *Josef Koudelka*, 2015. Photograph by Antoine d'Agata

in recent years. Still, discussing his parents, his childhood, his friends, lovers, and colleagues, his children, the motivations and stories behind the work — all the intimacies of biography . . . did Josef understand that my questioning would take us there? Would he go there? Having seen him tirelessly involve himself to the "maximum" (his word) in anything regarding his work, I knew that he would want to provide his "I-was-there-ness" to the accurate telling of his story. He grew up in occupied and invaded lands, not trusting what people told him, not trusting words. Would he now trust his own?

So there we were, in January 2014 — seventy-six-year-old Josef, his twenty-seven-year-old daughter, Lucina, and me — in his modest walkup studio in Ivry-sur-Seine, on the outskirts of Paris, embarking on the first of many week-long sessions. We generally met for three to five hours every morning, give or take a field trip and a few marathon discussions of the meaning of home, let's say, or walls and occupations — talks that went on for many hours, sometimes days, sometimes over years. A few months earlier, Josef had asked me if Lucina might film some of our conversations. As he always says precisely what he thinks, with filter-free abandon, I knew her presence would not subvert his candor. What I hadn't considered was the beneficent eliciting power of her presence, or how these focused sessions together might, over the following years, in emotional lurches, brighten and deepen their relationship.

"Greetings from Valchov." Postcard showing JK's grandmother, great-grandmother, and friends in front of his grandmother's house, Czechoslovakia, ca. 1920

On that January morning, sunlight is shimmering through the grime of his intentionally unwashed east-facing windows. Josef's white hair is longer than usual, covering the collar of his gray fleece. As we settle in, I think how youthful his hands look. There is fruit on the table, and a plate of pastries. Although Josef and I have met here several times over the years to work on his projects, this morning . . . well, neither of us really knows what to expect.

We have always been direct with each other. Pinned to one of the walls is a 1977 photograph of his parents, taken in Paris. Maybe this image can serve as a springboard for this first morning's conversation. As the hours pass and my questions become increasingly personal, Josef's face loses all expression. He crosses his arms, first pressing them tightly against his chest, later dropping them, his hands clenched in his lap, thumbs rotating. He perspires, occasionally wiping his forehead reflexively with the back of one hand. His shoulders begin to hunch, his stomach seeming to contract. His voice is hushed as he tries to summon a response.

Have I ever made anyone this uncomfortable?

Meanwhile, Lucina is overwhelmed by all the equipment — especially as she unexpectedly found herself not only filming that first day, but simultaneously responsible for the sound as well. She is new to the encumbering tripods, microphones, and cameras, and flustered, almost in tears. Lucina is tall and slender, with expressive eyes and fairly high cheekbones; her face is more soft than chiseled: Slavic and American roots complemented with Botticelli-esque contours. This morning she does not say much, but when she speaks, generally at my prodding, there is a deliberate quality to her voice: she enunciates beautifully and lingers on certain words. She clearly wants to succeed at this, whatever *this* is, and her anxiety is palpable. Five hours pass with excruciating intensity, Josef and Lucina following my earnest lead, until finally I suggest that we stop for the day.

Josef is immediately transformed. Suddenly robust, he reaches for a bottle of slivovitz and pours a shot for each of us. "*Na zdraví!*" he roars, grinning — "To your health!" The morning tension disappears as quickly as the slivovitz. Without missing a beat, his Moravian accent richly infused with nearly forty-five years of elsewhere, he announces: "Okay. We did it. I understand now." A pause. "Tomorrow, we start."

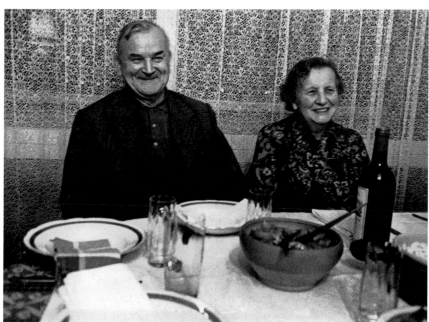

JK's parents, Josef Koudelka
Sr. and Marie Koudelková,
Paris, 1977

I P.P. — Prague Photographer

1.

To be born in a country which is not free means that you appreciate freedom — that you don't think of it as something automatic, and you don't want anyone to take it from you.
—JK

Like Sigmund Freud, Leoš Janáček, Jan Amos Komenský, Milan Kundera, Tomáš Garrigue Masaryk, Oskar Schindler, and Tom Stoppard — to name some eminent examples — Koudelka is from Moravia, in the east of what is now the Czech Republic. He was born on January 10, 1938, in Boskovice, about seven kilometers from his family's village of Valchov, in the Brno Highlands, nearly five hundred meters above sea level.

His birth was something of an adventure. Five years earlier, Koudelka's mother had almost died at home giving birth to his sister, Marie; his father was adamant that this time a doctor should be present when the baby arrived. So on that cold winter's day, Koudelka Sr. got on his motorcycle, and his rotund wife squeezed into the sidecar. With Josef announcing, in ever-intensifying contractions, his readiness to enter the world, they wended their way along the perilous snow-covered roads to Boskovice, and there his mother gave birth to Josef Dobroslav Koudelka (his middle name translates optimistically to "the man who celebrates the good").

Koudelka's parents, both born in 1908, were not yet thirty when he came into the world. For a few years during his childhood, his mother ran a grocery store from their Valchov house. His father worked from home as a tailor for a factory in Boskovice. "He would go to the factory," recalls Koudelka, "and they'd give him

Studio portraits of Marie Koudelková and Josef Koudelka Sr., ca. 1930. Photographer unknown

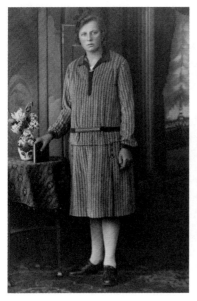

pieces of precut cloth to be used for making a uniform, or things like that. He brought it home and the whole family helped put it together. After two weeks, when he finished, he brought it back to the factory."

Koudelka's father built their Valchov home sometime between 1933 and 1935. The family shared the house with his father's brother, Antonín, who had two sons — Josef's younger cousins Miroslav (called Mirek) and Antonín (called Tonda). Eventually the brood was joined by his mother's sister, Aloisie Martinů — Teta (Aunt) Loisinka — and her son, also named Josef (referred to here by his nickname, "Martin," to avoid confusion). The quarters were tight, but they all became close: Martin and Tonda both told me that young Josef was like a brother to them, and for Martin, who grew up with only his mother, "Josef's father was like a father to me too."

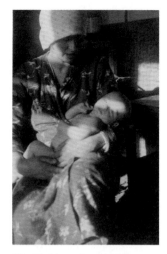

JK with his mother, Marie Koudelková, Valchov, 1938. Photographer unknown

In 1938, the year of Koudelka's birth, Germany annexed the Sudetenland; the following March, Adolf Hitler proclaimed Bohemia and Moravia a German Protectorate, initiating an occupation that would last until the end of World War II, in May 1945. The population of Valchov endured those years in a suffocating state of fear and apprehension, aware that life as they knew it could at any moment be ripped apart. Koudelka remembers that on one harrowing occasion two bombs fell close to the house. He also recalls: "When the troops were passing through Valchov on their way to the front, we had to accommodate them." This might mean putting them up for the night. After one group had stayed over at the Koudelka home, young Josef made a memorable discovery: "When they left, I remember, it was the first time I saw a [photographic] slide — it was a color slide. I don't remember what it showed. I was about four years old. One of the soldiers had left it by mistake."

"Everybody," Koudelka tells me, "was against the German occupation."

In that time, the fighting was mostly happening far away, but still there were . . . Czechs who'd escaped and were now in the Russian Army, parachuting into the territory that was occupied by the Germans. They were partisans who tried to work with and help the local people. The partisans stayed in the forest. They were in hiding, and people from the villages needed to bring them food, which my father did. My sister also sometimes did this, because she was a child and [the Germans] would not guess that she was doing it.

Koudelka family, 1941. From left: JK, Josef Sr., Zuzana, and Marie. Photograph by Teta "Mici" (Mitzivich)

Until her death in 2023, his sister, Marie — who went by Zuzana (married name Berndorff) — divided her time between Canada and Prague, where I met with her in August 2014. Zuzana elaborated on this chilling period in her young life. Apparently, the food that they and others took to the partisans came from their mother's store. She noted how truly fortunate their father was that "he never encountered a trap, a German spy posing as a partisan." This had happened to people they knew — people who were never seen again. One night a gunshot shattered the family's sleep: "We didn't know what was going on. It was a young student from Brno, working with the partisans. He was killed in front of our house." The Koudelka parents secretly listened to the BBC's wartime broadcasts in Czech — an activity strictly forbidden by the Germans. Koudelka says that if

Koudelka family portrait, Boskovice, 1942. From left: Josef Sr., Zuzana, Marie, and JK. Photographer unknown

Koudelka family, Valchov, 1941.
Photograph by Teta "Mici"
(Mitzivich)

the Germans came into a home, they would touch the radio; if it was warm, indicating that it had been on, and they saw that it had been tuned to the wrong station, "that was enough to send you to the concentration camps."

Very young and relatively isolated in Valchov, Koudelka had a limited and localized perspective on the war and its horrific repercussions. He had never encountered a Jewish person, and the only Roma he knew of were those who occasionally traveled through the village. It was not until years later, when he committed himself to photographing the Romani people, that he began to comprehend the horror of their persecution at the hands of the Germans. His friendship and work with the late Roma scholar Milena Hübschmannová amplified his understanding of their history, as he made the photographs that would comprise his first book, *Gypsies*, in 1975.[1] Koudelka recalls that in his youth, when the Roma came through town, the people of Valchov were wary. "There was a drummer," he says, "who went through [the streets] shouting, when the Gypsies were near, for people to 'close in your chickens and your pigs, lock up your houses: the Gypsies are coming.'"

There were about 6,500 Roma living in the Protectorate of Bohemia and Moravia at the beginning of World War II — far fewer than in Slovakia. All but a few hundred of them were murdered in the Nazi camps.

The Jewish community of Boskovice was one of the earliest established and largest in Moravia; Jews constituted a third of the town's population in the mid-nineteenth century.[2] Yet according to Koudelka, "nobody really talked about Jews" in the village of Valchov. In 1943, when he was five, 458 Jews from Boskovice were deported to concentration camps. Of them, only fourteen survived and returned in 1945.[3]

Although Valchov was not a wealthy village by any measure, its inhabitants managed to scrape together enough to survive during the war. Koudelka says: "If you live in the countryside you will never go hungry, because you can grow potatoes. I ate my potatoes every day — and I still love them." Certainly nothing ever went to waste:

JK, 1942.
Photographer unknown

> In that time, you didn't collect the rubbish. Everything that could be used was used. So if you didn't finish the food, you have got pig . . . every family has got the pig, and it was the pig who ate everything that we didn't finish. And in winter, we kill the pig and you have the meat and the fat — for the bread. My father would make the meat into a conserve. It was my job to share the meat with people in the village when we killed our pig. Then, when others in our village killed their pig, they brought meat to us.

Along with the potatoes from their garden, the family had a small orchard of apple, plum, and cherry trees. All this provided the Koudelkas and the extended family with sustenance.

The German occupation had other critical implications. "Because everyone knew the front was coming, they were afraid to have children. In 1938 there were only three kids — me and two others — born in the village." Indeed, there were so few children in Valchov that the Germans considered closing down the village school. Koudelka's Teta Loisinka was a teacher there, and she managed to avert the problem by enrolling him in the school at the age of five (instead of the usual minimum age of six) to add to the number of pupils, and, as Koudelka puts it, "to keep the school alive." Five grades met together in a single classroom — a system the five-year-old Josef loved: "I was taking the same class as the guy who was ten; you could learn all these things that wouldn't normally concern you until later." The school survived the war, and Koudelka would remain a student there until 1948.

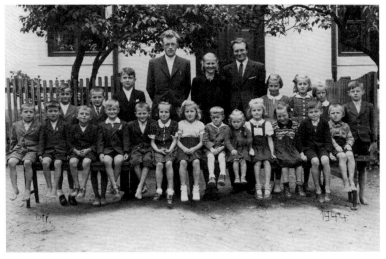

JK (seated, fourth from left) and classmates, first year of primary school, Valchov, 1944. Photographer unknown

When Germany surrendered, nearly three million ethnic Germans were expelled from Czechoslovakia. Edvard Beneš, who had led the Czechoslovak government-in-exile from a post in England, returned in 1945 and became the nation's president once again. In February 1948, however, the Communists, with support from the Soviet Union, seized power, ultimately forcing the resignation of Beneš that June, after elections in May that were, for all intents and purposes, rigged.

It was a chaotic pattern that much of Central and Eastern Europe was experiencing. Polish writer Czesław Miłosz described the uncertain state of mind after the war:

> The Nazi rule had occasioned a profound disintegration of the existing order of things. In these circumstances, the only hope was to set up a social order which would be new, but would not be a copy of the Russian regime. So what was planned in Moscow as a stage on the road to servitude, was willingly accepted in the countries concerned as though it were true progress. Men will clutch at illusions when they have nothing else to hold to.[4]

It was this world of illusions, of the "captive mind" (to borrow Miłosz's term), that awaited ten-year-old Koudelka when he graduated from the one-room school in Valchov and moved to the middle school in Boskovice, where he would remain for the next four years. Around this time, he took out a subscription to a magazine for young people called *Vpred* (Forward). It was

likely through this publication that Koudelka first encountered the world of scouting. Although illegal under the Communist regime, scouting continued undetected, under different guises, such as touring groups. His older cousin Martin, a fellow student at Boskovice, remembers that "Josef was drawn to the idea of the scouts — their customs, their rules — what they had to do to get their badges. . . . Josef always had a strong will and was always coming up with rules and challenges to test it, to be disciplined." He recalls a particular Sunday when the two boys bought ice cream after church and then went to visit the graves of their grandmother and great-grandmother in the cemetery close to Valchov. According to Martin, Josef had vowed that he would not touch his ice cream until they returned home, about thirty minutes away. And he did not — not one lick.

Martin recalls that his cousin was happiest in the family's orchards, and indeed, Josef acknowledges that some of the best moments of his childhood occurred there. He helped plant the fruit trees with his father and remembers the joy of harvesting his favorite fruit. "Every May and June when the cherries started . . . I climbed the trees and ate all the ripe ones. I loved this." Later on, he would equally savor his father's infamously potent slivovitz, distilled from their own plums.

The first three decades of Koudelka's life were delineated by the German occupation, which began the year he was born, followed by the Czechoslovak Communist seizure of power in early 1948, and then, most significantly for him, the 1968 Soviet-led invasion of Czechoslovakia and subsequent "normalization" policies. All these things happened *to* him. He has since owned, as much as one can, the events of his life. He has few indulgences; his needs are minimal. In part because of this, his fellow photographers have tended to view him as somehow pure, uncorrupted. Elliott Erwitt recalls Koudelka being christened "Saint Josef" at Magnum: a wanderer without a home — "no place I might want to return to," as Koudelka says — unhampered by possessions. A loner.

But not alone. Ever since his emigration from Czechoslovakia at age thirty-two, Koudelka's life and work have engendered a quintessentially Koudelkian support system: people with the devices ready to make the phone call, send the fax, the e-mail, the text message; a friend who can offer a place to sleep; or the couch or floor at Magnum's Paris office, where he has always stashed a sleeping bag on a high shelf for those times when he wants to work there until midnight and resume at dawn.

He has been called "larger than life," but Koudelka's essence derives from his obsessive, at times even myopic, engagement *in* life. He's too present to be legendary, as he's so often described. To reduce him to legend is to consider only the construct, the surface of the man. Conveniently for him, this label allows him to reveal nothing. He easily wears the persona of the jovial, hardworking nomad in his signature uniform of battered black jeans

and multipocketed olive-green shirt (why waste time thinking about what to wear?), who lives life however he wishes — but this characterization is ultimately facile. Although the words "mistake" or "regret" rarely enter his vocabulary — in Czech or any of the other languages he has adopted (English, French, Italian, Spanish) — Koudelka, when fallible, is a far more compelling and sympathetic individual. He says:

> I direct my life as much as I can. But when something happens in a different way than I was wishing it to happen, I try to accept it. Whatever happened, it had to happen. This is my rule. In photography we are making from a negative the positive. I function in a similar way. From what I didn't want to happen, I try to do something positive. I don't like to suffer . . . and I say I am responsible for my happiness.

Koudelka's reflexive urge to find or create a positive spin in any negative occurrence can often frustrate those close to him who wish his silver linings arrived less swiftly, and with more introspection or empathy. But, as he says, he does not wish to suffer and adapts his perspective accordingly. It is simply not an optimal use of his time to dwell on what he cannot control. His consciousness of time partners with his insistence on freedom. Neither is ever to be taken for granted.

Since at least 1969 Koudelka has endlessly been keeping notebooks. Some of these he calls *katalogues*; others are diaries or journals; there are also scrapbooklike compilations of clippings of articles, quotes relating to a theme, and annual agendas. These books have varying and evolving purposes and formats, and he cites them regularly in conversation. The writings in their pages are in a rainbow of colors, with selected words and passages highlighted. Some entries describe his systems of being in the world, while the more diaristic notebooks might contain reflections upon an interaction, say, or upon a lesson learned. Most often, there is a bottom line in Koudelka's written ruminations: something he decides or acknowledges about himself that allows him to take charge of the situation, whatever it may be, and to move on to what comes next. He is exactingly self-reflective in certain instances — albeit framing events as he sees fit, while tenaciously recording their particulars.

At one of our sessions in Ivry-sur-Seine, he read some passages aloud from an early diary, translating it on the spot for me from his handwritten Czech:

> Overnight, I should leave the luggage in the "left luggage" and just take the sleeping bag, and go out to find the place to sleep. . . . Every time, when I wake up in the morning, and if I'm not too cold, and if I look around, and there are not many people around me, I have incredible pleasure to be alive. . . . It's very good to have nothing because wherever you go you will find more. . . . In the moment that you start to defend what you have, you are lost.

These notebooks are Koudelka's confidants, his memory keepers. He insists on facts and has little faith in the reliability of human memory — his own or anyone else's — especially as eroded by time. During our conversations,

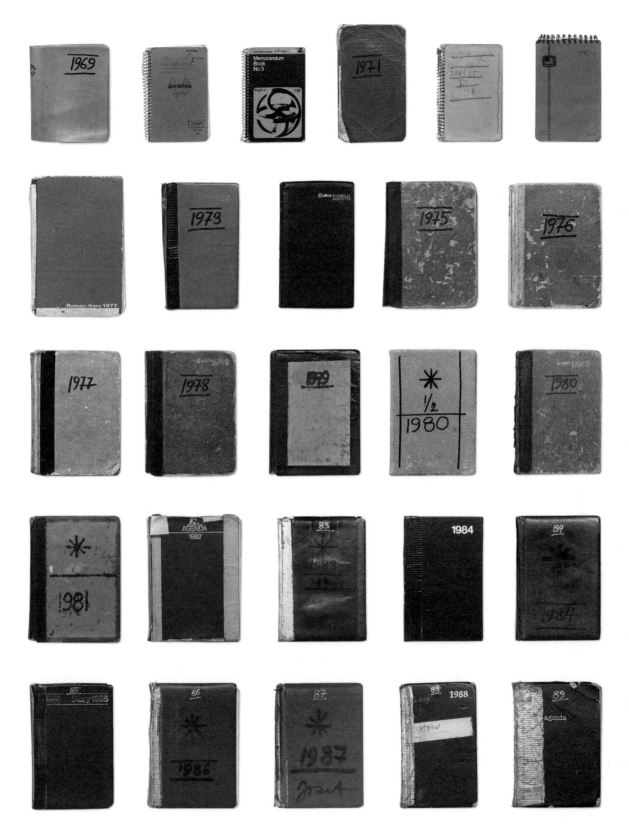

Covers of JK's diaries, 1969–89

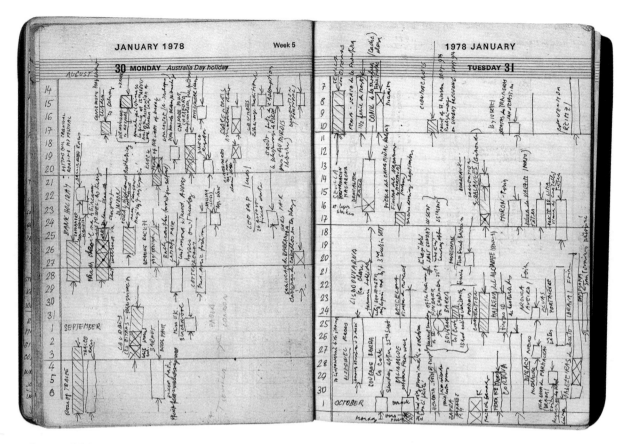

Pages of JK's 1978 agenda, noting festivals and fairs for August and September

when I ask him a question about a specific event from the past, he often insists on checking what he wrote at the time in his diaries. If he cannot find it immediately and I suggest that I'm curious about not only what he recorded at the time but the act of remembering itself — what remains resonant for him — that notion appears to hold no interest for him. "Memory is a creation," he tells me.

The ultimate documentarian, Koudelka has been carefully tracking his life since he was thirty-one years old. Perhaps this ongoing personal archiving — the diaries, agendas, maps, and the more autobiographical photographs he made after exiling himself from his homeland in 1970 — is a way to override memory with fact. He explained a particular admonition to himself that he found in a late 1970s notebook:

> Here I wrote: "Photograph . . . what is your aim to photograph, your subject. But don't forget to look and photograph what is around you too." Sometimes you forget to look around — I try to force myself to look at everything. I wrote: "Photograph also your life, because you live in this period and you document the period by photographing your life — but for yourself."

These "life" images serve as visual footnotes to both his experience and his work. Over the years, Koudelka has frequently used a self-timer to make portraits of himself, and has sometimes handed his camera to others so that they might photograph him. For a time, he would also position his sleeping bag in the frame and then make a photograph, to indicate precisely where he'd

slept. As his Magnum colleague Leonard Freed once said to him: "Josef . . . your contact sheets are your autobiography."

Koudelka's notebooks also serve as a default script, a life glossary of his preferred responses to frequently asked questions — or at least what he deems the same questions.

Koudelka's lexicon — no matter what language he is ostensibly using — is a conflation of all the languages he speaks, and his word choice can be intuitively poetic. When speaking in English of a sense of connection to the land, he often employs the French word *terre*, as it reflects what he means: the ground, the earth itself. He wishes to be correct, always, but he does not trust his linguistic skills. This is apparently another reason for formulating whatever he wishes to express once, precisely as he wishes to express it, and then relying upon that formulated response in perpetuity.

Here, however, we are trying for some new questions and answers, and fresh twists on old answers, as over time, or in a new context, perhaps Koudelka has reconsidered some of his initial responses.

Or not.

2.

Koudelka strives for perfection. This is part of his obsessiveness — even while he recognizes, though doesn't quite accept, the impossibility of perfection. He must be absolutely certain he has taken a body of work, and all its manifestations, to its "maximum." He returns again and again to sites, to earlier photographs, to previous publications — their edits, the juxtapositions and sequences — to compare and contrast, just in case. He has to be sure he cannot surpass himself. Once he is at last certain (at least momentarily), he states: "I did all I could do. I couldn't do more."

He told me this after he returned from a seventh trip to Turkey, in October 2016. When I suggested that he would therefore not need to go back again to photograph, say, Aphrodisias, he assured me of the opposite: "Of course I will go back!" Repetition is a nuanced action for Koudelka, with specific images and bodies of work, and with their publication and exhibition: "It is necessary to repeat in order to go further. To accomplish the *maximum*."

His most consistent, and one of his closest, collaborators was the late French publisher and editor Robert Delpire, from whom, says Koudelka, "I learned so much, without him

JK's diaries, organized chronologically and flagged, primarily in response to Melissa Harris's research, for *Josef Koudelka: Next*, 2019. Photograph by Tomáš Pospěch

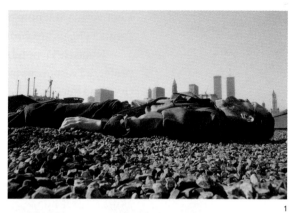

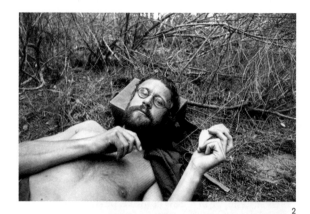

1

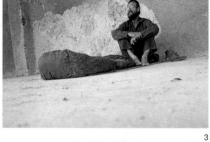

3

2

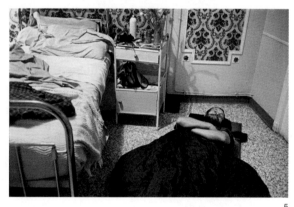

4

5

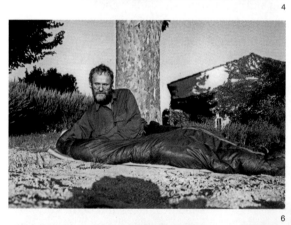

6

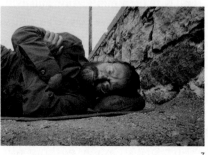

7

8

1 United States, 1983

2 Spain, ca. 1971.
 Photographer unknown

3 Greece, 1981

4 Greece, 1983

5 In the hospital after
 Lucina's birth, Boulogne-
 Billancourt, France, 1986

6 At Martine Franck and
 Henri Cartier-Bresson's
 home, Luberon, France, 1989

7 Greece, 1983

8 At Henri Cartier-Bresson's
 studio, Paris, 1983

(All but number 2 made with
camera on self-timer)

teaching — but through our projects." They began working together in the early 1970s and continued until Delpire's death in 2017.

Discussing Koudelka's obsessive habit of repetition, Delpire said:

All his work is marked, first, by a sort of theatrical organization of reality; then by his taste for repetition: his need for going back to the same places, retracing his steps, working numerous times on the same motif. . . . It is repetition that drives him. . . . And the tireless, interminable analysis — because urgency is a notion that he ignores — of the photographs he has made.[5]

The Turkish photographer and filmmaker Coşkun Aşar was thirty-four when he met Koudelka in 2008. Over the ensuing years, he researched Turkey's countless spectacular archaeological sites in preparation for Koudelka's work on the project that would come to be known as *Ruins*. They began their travels by car in Turkey in 2011, with Aşar at the wheel — and making all arrangements for their time on the road as well. He explains that, as Koudelka does not use a tripod (or indeed any equipment but his camera), no special permissions were needed to photograph. Aşar leans toward the metaphysical when discussing Koudelka's time travel, his traversing between what he has done and what he will do. Paraphrasing Heraclitus of Ephesus, Aşar says: "'No man ever steps in the same river twice, for it's not the same river and he's not the same man' — but Josef is going to try!"

Koudelka's propensity for revisiting certain subjects would seem aligned with his gradual shift of focus away from people — at least their physical presence — and toward the human impact on the landscape through time. Among his markers for human intervention in the landscape, past and present, are stones, which have an increasing presence in his photographs. Other elements contextualizing his images — wind, light, water, a bird, a dog, a tree — are never quite still. The stones, though, are immutable. Unaffected by globalization, gentrification, fashion, or the world's ongoing homogenization, stones exist as he finds them, whenever he finds them. And on each repeated visit to a given site, from the same perspective, at the same time of day, at the same time of year — all relevant data recorded and regularly referenced in one of his notebooks — they provide the bearings for him to see what, if anything, has changed. The passing of time is a critical element on Koudelka's palette. He is interested in what remains, in what he has seen and photographed before — in a sense, defying change (while always taking note of it), defying time, with the hope he might make the "same" photograph, only better.

Søren Kierkegaard wrote: "Life must be understood backwards. But with this, one forgets the second proposition, that it must be lived forwards."[6] This seems a well-founded rationale for the past/forwardness of Koudelka's way of being and thinking, one echoed in the title of this book: *Next*. A somewhat paradoxical choice, perhaps, for a biography of a man whose process is all about going back, returning — to places, to projects. But this is the nature of his vision. He lives looking, moving forward. When the work — always years

of intense labor — on an exhibition or a publication is completed, Josef summarizes with a brisk, heartfelt affirmation for team Koudelka: "We did it!" He smiles broadly, his blue eyes shimmering and engaged, followed by a round of bear hugs. Then, a breath later — why linger? — Josef Koudelka exuberantly declares: "Next!"

3.

While Koudelka's work is rarely picturesque, there is always beauty uncovered and revealed — early on, perhaps in the lines and expressions of a face, and later, as people began to recede from view, in the contours and patterns of a terrain, in the pathos of loss and ruin, or in the potential for renewal.

Michelangelo famously spoke of liberating his subject from stone; one might say that with his landscapes, Koudelka operates similarly. He patiently summons his subject, the visual essence that will be transformed, via his vision, into his photograph. As Delpire put it:

> *In seeing, framing, isolating the chosen subject, isolating it in its context, Josef makes it exist. And it is only once this sometimes instantaneous, but mostly belabored, work is complete that a tree, a landscape . . . is. They are born under Josef's eye, an eye that doesn't create an image but rather invents a subject, whether living or not.*
>
> *This is where he is different. It is not a reality that he appropriates for himself. He doesn't give form to what exists. Nothing exists before him. Nothing can exist without him. He knows this. From there, undoubtedly, comes the ultimate rigor to retain total mastery over the beings he creates, no matter what he or we would like to make of it.*[7]

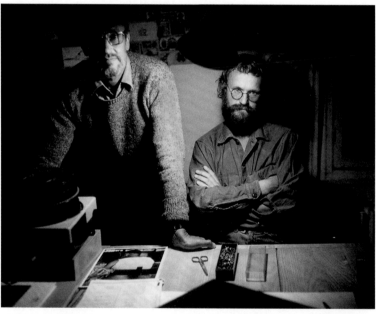

Robert Delpire and JK, 1978. Photograph by Sarah Moon

Koudelka sometimes choreographs with light and shadow in order to elongate perspective. At other times he destabilizes depth of field to the point of abstraction, layering planes to construct a dimensionality in which stones may brush up against horizons — now seemingly incised. While he acknowledges few if any influences — like armored Athena, he burst into the world fully formed — his Ivry studio walls suggest a complementary idea. Since leaving Czechoslovakia, he has faithfully visited museums whenever he travels, absorbing the paintings he finds compelling, and visiting them — his "friends," as he calls them — again and again. Often he'll bring home

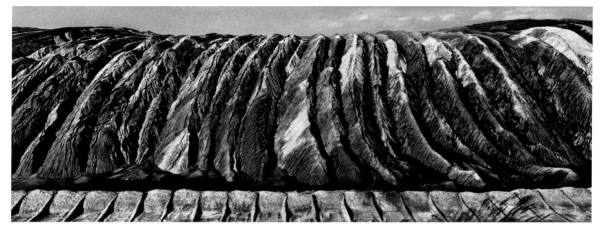

Germany, 1997

postcard reproductions of those paintings he finds especially instructive or captivating — visual touchstones in which the artist has realized something that resonates for him. The studio walls are papered with these reproductions, almost all of which have faded over time to bluish or sepia tones from regular exposure to daylight. This works for Koudelka, as he's less interested in the color than in the composition.

Consider Paul Cézanne's Bibémus quarries, one of many postcard reproductions tacked to his wall — "How beautiful it is!" Koudelka comments, outlining its geometric forms gently with his index finger. That beauty echoes in certain of his own landscapes — similarly sculptural and planar, where shape, not dimensionality, is the formal organizing principle. At times Koudelka may foreshorten or otherwise skew the perspective for effect: think of his 1963 image of a wake, *Slovakia (Jarabina)*. A reproduction of Andrea Mantegna's late fifteenth-century *Lamentation over the Dead Christ* — a sublime example of foreshortening — also graces one of his Ivry walls.

His eye moves to reproductions of other classic works of the Italian Renaissance: an Annunciation by Fra Angelico, and Piero della Francesca's *Flagellation of Christ*. "Have a look at the divisions," he says. "If you photograph with a 35mm lens, you'll photograph the same way, with these divisions. These two show 35mm-type divisions." Henri Matisse's 1940 *Still Life with*

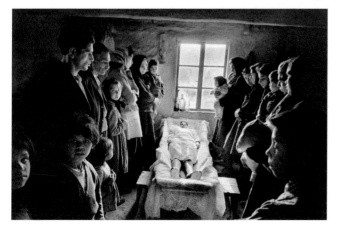

Slovakia (Jarabina), 1963

Oysters, conceived horizontally, is hung vertically by Koudelka for the cropping lessons it offers. Hans Memling was an early favorite — Koudelka first saw his work in Spain, at the Capilla Real in Granada, and from there developed a taste for the Flemish masters. About Oskar Kokoschka's *Tiger Lion* (1926) — the massive shoulders and fierce face of a feline looking up from a bloody rack of ribs — he notes the "wonderful cropping," adding "this is fantastic, because I would probably never photograph an animal like that." Koudelka's animals often

feel more like creatures "found" in a landscape, formal elements lending shape and shadow. Still, their presence, their life, in generally desolate environments, often suggests something wistful rather than an emblem of wildness or freedom. Like his landscapes, they seem at times to carry the weight of humanity. Dogs, horses, birds, and other creatures make cameo appearances in enough of Koudelka's earlier work that in 1990 he published a portfolio of eighteen prints titled simply *Animal*.[8]

Each image on his Ivry walls has earned its place by virtue of its lines, angles, spatial plays, perspectives, or content. There is an absolutism to Koudelka's convictions: "These are the Crucifixions by which you must judge all others," he insists, indicating Matthias Grünewald's panel for the Isenheim Altarpiece, and Masaccio's Cross that hangs at the Museo di Capodimonte in Naples. Balance is what most compels him — "balance of space, of volumes; this is the rule of composition."

Balance of volumes brings to mind Koudelka's earliest love: airplanes. "Airplanes fly," he tells me matter-of-factly, "because there is balance." This passion began when he was twelve and joined a group of model-airplane hobbyists in a nearby town. His father, who Koudelka says "always supported anything that had to do with my education, or working with my hands," gave him a subscription to an illustrated how-to monthly for young engineers and hobbyists. Some of the model aircraft that young Josef built had motors or propellers, but most were gliders. Made of wood and glue, they could be a meter or so long. Josef would order the construction materials from Prague or would get them in person from a shop in Brno, the largest city in Moravia, about sixty kilometers from Valchov.

Flight became an early obsession. As a boy, Koudelka recalls, "I had a dream that I knew how to fly. Behind my village there was a hill, and in my dream I'm on the top of the hill. If I put my arms out wide, run down the hill, and get some speed — I could fly." A dream based on muscle memory, perhaps: "Sometimes to get the model planes in the air, I would run in the meadow behind my village, and release the plane using a light rope."

In 2014 Josef, Lucina, and I took a train from Prague to Boskovice, and then proceeded to Valchov. We saw the intimidatingly steep road that young Josef ascended by bicycle as a child ("You were a hero if you pedaled up all the way," he told us, making sure we understood that he did just that), and the sweep of meadow from which he often launched his airplanes. His cousin Tonda recalled Koudelka's impressive skills as a plane builder. "All the kids in the village waited for each new plane," he told me. "It was a big preparation, the launch." Still, recalls Koudelka: "The first time I saw the real plane, it was a huge event. They said: 'Sunday, the plane will come.' So everybody went to see what the plane looked like. It landed in a field near Boskovice. It was a very small plane, but because it was the first real plane I had ever seen, for me, it was big."

On our field trip we also saw the orchards that had brought Josef such joy as a child, and which stayed in the Koudelka family — through the German occupation and Soviet invasion, Koudelka's exile, the death of his father in 1981,

1

3

2

4

5

6

1 Scotland, 1977

2 Turkey, 1984

3 Spain, 1978

4 England, 1972

5 Ireland, 1978

6 France, 2004

the death of his mother in 1988, and the Velvet Revolution in 1989. Later in the 1990s, his family considered selling the house. Koudelka agreed readily enough, with one exception: "Sell everything," he told them. "I don't need anything. But I want to keep this piece of land where I planted the trees with my father." His cousin Mirek, who was still living in Valchov, told Koudelka that he and his son wanted to plant new ones. Some years later he visited this land with his cousin's son, and subsequently told Mirek: "I am giving up this land. It's yours. It is most important that the trees are taken care of. You can make sure of that."

JK and Melissa Harris on the train to Boskovice, 2014. Photograph by Lucina Hartley Koudelka

Trees of all kinds have appeared in Koudelka's work from the earliest days, sometimes providing spatial divisions or a sense of scale, and often operating symbolically — signs of survival that connect people to their *terre*, their land. Conversely, a tree may suggest when that tie has been broken — or destroyed — as land becomes a pawn in struggles for power and resources. This is evinced in Koudelka's 1994 project *The Black Triangle*, which looks at the devastated landscape at the foothills of the Ore Mountains near the Czech-German-Polish border; and in *Wall*, his 2013 investigation into the imposed "separation barrier," still under construction, partitioning the Israeli and Palestinian landscape.

Always steeled for some inevitable, human-induced vertigo, Koudelka has an innate sensitivity to ecological imbalance, which is as entrenched as his insistence on compositional balance. Does this make him an environmentalist? Is he an advocate for the landscape? Is he rabidly against anything he perceives as an "occupation" of one's land? Does he think about politics? Absolutely yes. Does this define his work? Absolutely no. He has strong convictions, whether or not he articulates them. Although he is loath to tell anyone how to think, it is possible to see much of his landscape-oriented work as an evocation of ecosystems out of balance — where humanity and nature, past and present, ideal and expedient, poor and rich, East and West, fate and choice brush up against one another in sometimes pernicious ways.

Prague, 1958

By the late 1980s the emphasis in Koudelka's photographs shifted from predominantly humans — whose physical presence all but disappears — to all forms of landscape, unpeopled but haunted by the presence of humanity. "I am interested in contemporary man's influence on the landscape," he says. "I walk these devastated landscapes and find them tragic, but still beautiful, despite all that man has done to destroy them. Nature is fighting for survival." This may

1 Black Triangle region
(Ore Mountains),
Czechoslovakia, 1991

2 Greece, 1994

3 Israel-Palestine, 2011

29

be the only circumstance in which Koudelka trusts memory as somehow pure, uninflected. Not his own memory, but rather the traces of humanity on the land: the landscape's DNA. If the sacred exists for him, it is in nature, where he has, on occasion, experienced something akin to the sublime.

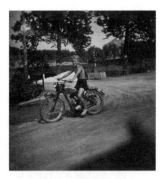

JK on moped, 1946.
Photographer unknown

4.

Koudelka was born, baptized, and raised Roman Catholic. Although attendance at churches declined in Bohemia and Moravia after World War I (and religion was smothered almost entirely under the Communists after World War II), "With my parents," Koudelka says, "I went to the church. I believed in the God, and as children we prayed at home." He recalls a local priest whom his father befriended (they often shared a drink after Mass):

> This priest was very human and was trying to make a good Catholic out of us. He hit us — but more for show, in fun. He was not punishing us. He really was good at being a priest. He explained the Ten Commandments, and that you can't say "Oh, Jesus Christ" — because you can't say God's name like that. But then he said: "Guys, if you have a toothache, it's such a pain, you can say anything that you want." I liked that!

When Josef was a baby, his parents would place him in a hamper near his father while he did his tailoring work. There were three sewing machines in his workshop; Josef can still conjure the soothing aroma of the steam iron as his father pressed garments on a big wooden table. In the background, Czech swing or popular dance music played on the record player and his father whistled along. Josef's mother, too, often sang old songs. "They used to find me kicking my legs with the music," he laughs. "They always said: 'He's going to be a musician.'"

Josef Sr. could be severe with his children. Zuzana told me: "Our father was very, very strict, and very, very tough — with an explosive temper at times — wanting to be sure that we behaved correctly, with respect, and that we would be good people." Josef recalls his father's man-up harshness with a touch of pride: "He wanted to make me strong, so he would put me in the cold water in the brook by our house." Zuzana and Josef both remembered their father disciplining them physically, usually with his belt. Josef adds: "But sometimes he would just look over to where the belt was hanging and that was enough to make us behave. This is what fathers did then." Their mother, Marie, provided a refuge. He says:

JK with model airplane, Prague, 1953. Photographer unknown

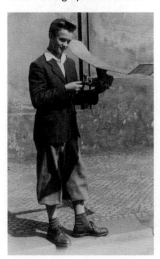

> My mother was exactly the opposite of my father. My father . . . he had so much energy. My mother . . . was kind and soft, and very fragile emotionally. She wrote these poems — very sincere. She was the most good person who I met in my life. I am sure it was not easy for her to be with my father. . . . I've come to a conclusion that I am this strange mixture: sometimes I have this softness of my mother — which probably my father was trying to eliminate from me, to try to make a man of me — and sometimes I have this toughness of my father.

His cousin Martin says that Marie was very protective. "I mean, very: 'Don't go there! Don't hurt yourself! Be careful!'" Martin also vividly recalls their maternal grandmother, Marie Kočvarová, as a healer of sorts: "a down-to-earth person, who knew herbs, and was very smart. People were coming to her for teas, for all kinds of aches and pains and sickness, and she was curing them. We picked plants for the teas in the forest." Koudelka describes this grandmother as "mysterious."

While clearly a practitioner of tough love, Josef Sr. has, across the many decades, remained his son's moral compass: he demanded honesty and a strong work ethic from himself and his children. Today, Koudelka thinks of his father as an ambitious man who came into the world at the wrong time and place.

> *He was born an entrepreneur. It was not about making money. Of course, he wanted to make money — but more, he wanted to keep trying and testing new things, new ideas, moving ahead all the time.*

Koudelka's niece, Dagmar Berndorff, speaks of Josef Sr.'s remarkable resourcefulness. Dagmar grew up with stories her mother told her about life during the war:

Josef Koudelka Sr.'s workshop, Valchov, 1940s. Third from left: JK's uncle, Antonín Koudelka; right: Josef Koudelka Sr. Photographer unknown

> *When other people couldn't get anything or were struggling to get by, my grandfather was extremely creative, a really good businessperson. He just managed to get them everything that they needed. [Zuzana] said she even had a watch, which was kind of unheard of at that time. And when he got the first car in the village, he used it for transporting everything — even goats.*

Dagmar's brother, Dave Berndorff, describes the car, which the family acquired after the war:

> *This was a car made of various components salvaged and pieced together. . . . The chassis was from one brand and the body was from something else. It was all jury-rigged.*

Zuzana remembers that in the economically bleak postwar years, in order to provide for their family, "our father worked all the time, so hard. He wanted for me and Josef to get a very good education. And it was difficult for him, for our family, as we were not Communists. Our father was very and openly against the Communists when they came to power in 1948." Their father, as a tailor, was viewed by the governing powers as self-employed. He had always taught his children to say what they thought, and was himself direct and outspoken — and staunchly opposed to any government that attempted to dictate what and how people should think and believe. This did not go unnoticed by the authorities. Koudelka says:

> *After the German occupation, when Czechoslovakia eventually became a Communist country, my father called the local Communists "dictators." He said they lie, they don't like to work, and they want only to command people. My father was never in any political party, [but] my family was labeled as against the state — that the government shouldn't trust us. This label went*

with us — me and my sister — through the entire period, through school and everything that we tried to do.

Despite the oppressive brutality of the German occupation and then Communist rule, Koudelka's childhood had its idyllic moments:

Every day, when I finished school, my job in the afternoon was to take our two goats, which we had for milk, and go find some land where they could eat. It was nice, because most of the children in the village, they were doing the same thing, so we used to meet. The goats ate, and there was this beautiful little brook, and we were fishing for trout — we were catching them in the hands. Then we used to make a fire together and put the trout on the fire, and also potatoes we picked. It was wonderful. I remember the face of one of our goats from when I was little. I don't remember faces unless they are so interesting. But I remember that goat's.

Certain other faces provoked his attention. Zuzana recalls that later, when she was studying fashion design at art school in Brno, she would come home for visits and her brother would look at her fashion magazines, staring at the visages of the models. "I didn't understand makeup — those women with the black around their eyes," he muses. Another early visual memory is of a trip to Prague with Teta Loisinka and his cousin Martin, when he was about nine. There he saw something he had never before encountered: a massive billboard. "It must have been an advertisement of some sort — I saw people on a building, and I couldn't understand why these people, these figures were there. Why did they put these people on the building?"

Koudelka's first instruction in art took place when he was about thirteen, at school in Boskovice. He remembers being intrigued by Impressionism. Aside from this, there were few visual or culturally oriented references in his life until Zuzana began to bring art books home from college. He would pore over the books, eventually trying his hand at drawing people and faces. Years later, he concluded:

I can't paint. I can draw only a little. I think what is wonderful about photography is that you can jump over this handicap of the hand, and that finally it is the eye and the machine that can do the work. I think potentially we all have something to say; the problem is how to express it well.

Photography: the eye, the machine, and the medium's bond with time. Photography, he would eventually come to realize, was his mode.

Prague, ca. 1947. From left: JK's cousin Josef (Martin) Martinů, Aloisie Martinů (Teta Loisinka), JK, and a student of Loisinka's. Photographer unknown

Koudelka family goat, Valchov, 1946. Photographer unknown

Zuzana says that, as a young man, her brother did everything on his self-devised schedule. She recalls his sometimes exasperating retreats to his own world when they were youngsters. Yes, he would help her with the dishes — but first she'd have to wait thirty minutes so he might finish constructing an airplane, or complete schoolwork. He often built things out of

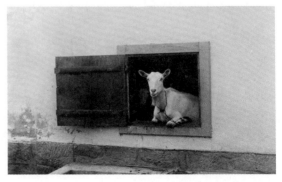

JK making a model airplane, Valchov, ca. 1950. Photographer unknown

wood. Two doors down from their Valchov home lived a carpenter who made furniture. Koudelka loved the scent of the wood and was so fascinated by the work that for some time he thought he might become a carpenter. Closely observing their neighbor, he acquired sufficient skills to build himself a miniature tractor.

His cousin Tonda says: "His approach to life was such that he had a precise, minute-by-minute plan — for his work, the tasks, whatever he wanted to build, and he always wanted to build something. He was always in his upstairs room, and always had a plan for himself, what to complete, every day, all the time . . . I was able to get close to him only when he planned a break."

The attic room in which Koudelka took refuge was an addition that Josef Sr. had built onto their house, and which his son instantly claimed as his workshop: "It was my space. It was my kingdom." In 2014, as we stood in that room (the current owners having welcomed us inside), he peered out the window and reflected: "The trees were lower then." It's easy to imagine his tinkering projects laid out here, just as his photographs are laid out by the east-facing window of his Ivry studio; while they are very different spaces, each offers a similar quiet solitude and gauzy light.

Along with the woodworking — culminating in his passion for model airplanes — photography was becoming a serious interest for the teenage Josef. A friend of the family, Mr. Dyčka, was a baker from a neighboring village who made and delivered bread once a week; he was also an amateur photographer with a dark-

Attic in Valchov, 1984. Photograph by Jill Hartley

room. Koudelka remembers observing Dyčka showing landscape photographs to his father.

What else was forming Koudelka's visual experience? During holidays, young Josef would go to his paternal grandfather, a farmer in the Moravian village of Buková, where he helped tend to the wheat fields. As a boy, he loved the solitary time cutting the grass in the meadow, and especially the aroma; on many days his only companion was a horse. Hanging in the living room of his grandfather's two-room house was a seascape — Koudelka thinks it might have depicted the Bay of Naples. "I could never imagine that water can be blue . . . the sea!" And there was Teta "Mici" (Mitzivich), his mother's cousin, who visited the Koudelka family regularly from her home in Vienna, bringing her glass-plate camera. "Almost all the pictures that I have of my youth are taken by Teta Mici," says Koudelka. It is the first camera he remembers ever seeing — he still has it.

He also still has the first camera that, inspired, he acquired himself, as a teenager: a 6-by-6-cm twin-lens reflex Bakelite camera. He earned the money to buy it

by picking wild strawberries and selling them to a man in Boskovice who made ice cream with them. After he shot his first roll of film, his father took him to Mr. Dyčka, who showed him how to develop it and make contact prints.[9]

Josef Sr. also encouraged his namesake to play music. As a little boy, Josef studied the violin, and in his early teens he took up the accordion. He was sixteen or seventeen when he and Zuzana headed to a folk music festival in Strážnice, in South Moravia — a hundred or so kilometers south of their hometown. Their father drove them partway, but the car broke down and he told them to continue on their own: they hitchhiked the rest of the way. Zuzana recalls the festival vividly: "It was so beautiful — all the folk groups in their national costumes" — bright reds, flared skirts, puffy shirts, sometimes a broad hat, embroidered aprons, ornate and vibrant. "Everybody was happy, everybody was singing the wonderful folk music." The festival was a galvanizing experience for the teenage Josef. "I think it changed my brother," says Zuzana. "So much life!"

In his 1967 novel *The Joke*, Koudelka's compatriot Milan Kundera describes the unique thrill of Moravian folksongs. They are "in terms of tonality, unimaginably varied. Their musical thought is mysterious. They'll begin in minor, end in major, hesitate among different keys.... And they are similarly ambiguous when it comes to rhythm ... it has its own mysterious laws."[10]

Koudelka was electrified:

I know where I come from. I know this very exactly. But it is not the town where I was born, or the village where I grew up. It is farther south in Moravia — this is the place I identify with most, where I can define myself by the music and the songs.... The principal instrument is the cymbalom [a large dulcimer]. Then you have the clarinet — one or two, two violins, and you have the double bass, lots of strings....

I feel that I must be made from the same earth, the same terre*, as the music and songs I love so much, which move me the most, which for me are the most beautiful in the world.*

It is this land in southern Moravia that he claims as his roots.

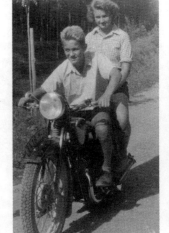

JK and his sister, Zuzana, on a Jawa 250ccm motorcycle, Valchov, 1952. Photographer unknown

5.

In 1952 Josef Sr. took his fourteen-year-old son to Prague, where Koudelka would spend the next four years attending Průmyslová škola letecká, a secondary school for aeronautical engineering. Despite his family's anti-Communist reputation, his father had exerted some sway in the process: "With the help of my father, who knew somebody, I succeeded in getting in, and getting the government funding to live in Prague." The school was, he says, the only one of its kind in Czechoslovakia; many graduates would ultimately work in factories that built aircraft. Koudelka was required, immediately after his first year at the engineering school, to work for a month at the Aero aircraft company in Prague.

He describes this as "practice in the industry. I was fifteen years old, working on Russian fighter jets making the fuselages for them. We made everything except engines." He returned to Valchov only on holidays and in the summers, during which he worked with land surveyors measuring the land around Boskovice.

Prague is a vibrant and architecturally eclectic city, with Romanesque, Gothic, Art Nouveau, and other styles of buildings clustered tightly but scaled low. Streaks of light bounce off cobblestones, the Vltava River helps distinguish its neighborhoods, the Pražský hrad, or Prague Castle, looms high on the hill. It must have felt like another planet for young Josef. During his years at Průmyslová škola letecká, he lived in dormitories that were not affiliated with one particular school, but housed boys attending several secondary schools in the city. A dozen cots in two rows lined the stark dormitory rooms, which resembled army barracks.

In the beginning, he was quite homesick, a feeling that he soon compartmentalized, repressed, and then dismissed — an emotional strategy that would turn out to be useful in his future exile. While he was at school, his family left him on his own. "It was very strange," he says. "Most of the families were visiting their children, but my parents did not. From my village, to go to Prague was like going to America. It was a big expedition."

The first person Josef met at school was fifteen-year-old Karel Šálek, from Bohemia. When I met Šálek in 2015 he was in his late seventies and retired from a career in aeronautics, having worked at Pan Am and several smaller airlines as well. He has a commanding presence — tall and solid, with thick white hair — yet with a graceful manner and a quiet, almost fragile voice. He recalled their first day of high school:

> Josef and I were the first guys that came to the dorms; there were eventually twelve of us all living together in the room. And from that first moment we somehow hit it off, and we got along easily. There was an obsession: we all were crazy about airplanes, and that's all we talked about.

Šálek tells me that Koudelka was a conscientious student, and something of a perfectionist. Whether to the delight or the consternation of his dorm-mates, he had brought his accordion along, and practiced it constantly. He was, Šálek recalls, enthralled by folk music as well as folk dancing. In the mornings, the two boys would take a thirty-minute streetcar ride from their dorm in central Prague to the school, on the outskirts of the city.

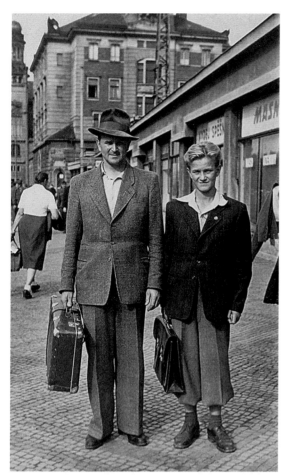

Josef Koudelka Sr. with JK, after leaving the train station, en route to JK's new secondary school, Prague, 1952. Photographer unknown

Young Josef was confused in his first few weeks at school. He had never before lived away from home, and everything he was learning in this rather officious state-sponsored institution was different from what his parents had been teaching him. The dogmas that "everything is for the best under the Communist regime and the Soviet Union is the perfect model to follow" were constantly hammered into the students. His father worried that he might become brainwashed. However, after Koudelka had been there for a month or so, he understood that he was not alone in questioning the school's mandates:

> *All my fellow students — we were not just boys, there were also three girls in the class — were in a similar situation. In school, we could say only what was permitted to say. . . . But later, when we talked to each other in private, my schoolmates said something different. Then I realized that what they taught us in school was a lie.*

This understanding that he was being calculatedly deceived was pivotal in Josef's young life: it instilled in him a skepticism that he holds to this day.

> *My father was not a political man, but he brought me up to always tell the truth. I think that this marked me for all my life. I was born in a country with a system where words didn't mean much: people could say only what authorities wanted to hear. So I have a certain problem with words. I don't believe what people say.*

He believes in beauty and the possibility of truth; he is hopeful, positive, joyous — while often bracing himself for the worst. A realist who revels in being alive, he is not a cynic. In May 1970, after decades of oppression under the Nazis and then the Communists, the moment arrived when he first experienced the freedom of being able to speak, uncensored, and he was exhilarated: "When later I had the possibility to say what I think, I never wanted anybody to take this possibility away from me." Still, his experience at engineering school left him forever wary of words and taught him to use his instincts instead: "I realized that I could learn more about people if I looked at their faces and listened not to what they said, but how they said it."

"Nobody from our group got brainwashed," says Šálek. "On the contrary, we just hated it, resisted it . . . and got through it."

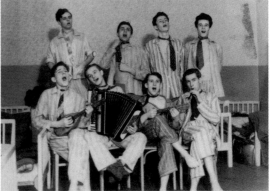

Group portrait in the dormitory of the Průmyslová škola letecká, aeronautical engineering school in Prague, 1953. Second from left, seated (with accordion): JK; second from right, standing: Karel Šálek. Photographer unknown

With music and airplanes, there was one more passion that kept nudging at the young Josef. Šálek was a photography hobbyist who had an old Rolleiflex, a twin-lens reflex camera. When he was home from school, he would stay up late working in the family kitchen — which he had converted to a darkroom — to make enlargements. He brought some of them to school and showed Koudelka. It was a revelation: despite his work in Mr. Dyčka's darkroom, the possibilities of enlargements were new to him. In this period Koudelka was still using his Bakelite camera; soon he began borrowing Šálek's camera.

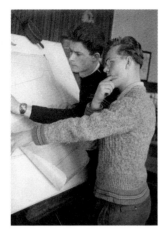

Karel Šálek and JK at drafting table, Prague, 1954. Photographer unknown

JK with Rolleiflex, Poland, 1958. Photographer unknown

JK (at left) on an outing with university friends, 1960. Photographer unknown

When they graduated from high school in 1956, he and Šálek celebrated over milkshakes at a milk bar. It was also then that Josef Sr. bought his son a Rolleiflex — "because of Šálek's influence," says Koudelka.

Later that year, when Koudelka entered the České vysoké učení technické v Praze (Czech Technical University in Prague), he became the second person from his village to attend university; the first had been his cousin Martin. While his family's openly anti-regime stance had not caused him much trouble during high school, now it presented clear obstacles. After two years of studying engineering at the Technical University, Koudelka applied and was accepted to a university in Ukraine that specialized in airplanes. But the local authorities in Valchov would not permit him to go. He was forced to continue studying in Prague, where it was not possible to concentrate on aeronautical engineering. Not to be thwarted, "I took classes in automotive engineering — the closest specialty. Then, the engines were similar. . . . I did so with the aim that when I finish, I will go back to working with the airplanes."

In this period, university students in Czechoslovakia underwent compulsory military training. After his second year at university, in 1958, Koudelka and his classmates spent a month at the Turecký vrch training grounds in the Bratislava region of Slovakia. Additionally, there was state-mandated "practical" civil work. Koudelka did his in 1959 in Dresden, in what was then East Germany, at a camera factory. His university thesis — on gearshifts and the transmission mechanism — did not entail writing; instead, he had to construct the apparatus itself. He graduated in 1961. After finishing school, students had a final military commitment; for Koudelka it was an additional six months in Bratislava, the capital of Slovakia, begun in late summer of 1962.

In Prague in 2014, I met two of Koudelka's friends from the Technical University: Zdeněk Přikryl and Vítězslav (Víťa) Jelen. From them I first heard the term "Safez": a nickname for a group of young men who first bonded in 1958. The word has a rather cryptic origin — a "very complicated etymological development," as Přikryl put it, relating to an obscure gear wheel with unique cogs — but coined (Přikryl explained) "to replace a common, not very polite,

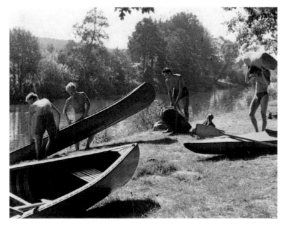

salutation." Ultimately, the "Safezos" (their plural of Safez) comprised seven close friends who took canoe trips and went skiing together and were deeply supportive of each other — they remain friends to this day. Jelen and Přikryl made it clear that the Safezos were not a clique — it was not about exclusivity in any way, and they were not always together — they simply took great pleasure in each other's company.

I visited Přikryl in the book-filled living room of his Prague apartment. He offered me a coffee and glanced over a list of details he'd jotted down in preparation for our conversation. I was curious about the rules of the

Safezos. Koudelka had explained some of their doctrines: "It was like a divine rule," he had told me, "that if a Safez comes to you and says: 'Let's kick the legs out,' you have to immediately leave everything and go and travel with him. And on the trip, you could never sleep in the same place twice, not even under the same nice tree, because it would already start to smell like, feel like home." When I mentioned this to Přikryl, he chuckled: "Don't believe him. Those are Josef's rules that he invented for himself." (On this point, naturally, Josef begs to differ.)

Like Přikryl, Jelen came to our meeting equipped with a list of reference notes; he stroked the pages with his long fingers throughout our conversation, as if he were reading braille. His serious demeanor and erect posture soon relaxed as he spoke of "Pepa" (a diminutive of "Josef," used by many of Koudelka's old friends). Jelen affectionately described the effect of Koudelka's "Moravian nature" on the Safezos. "Pepa was something like a waterfall, a volcano among us. He brought so much life with his way of laughing." Jelen recalls that Koudelka taught them all Moravian folksongs.

Every old friend I spoke with remembered with great warmth how photography took hold of Koudelka as a young man: "He brought the Rolleiflex everywhere." Šálek described him making contact sheets, enlarging individual images, and making "cut-outs." Working with the 6-by-6-cm format, Koudelka would cut out from the frame anything he deemed inessential, experimenting with all kinds of cropping, often radical: "The Rolleiflex is a square. So then I try to cut it, because not everything in the frame is important. You learn to look and to realize … first, you start to learn what the camera does and what the film does."

These investigations helped educate Koudelka about composition, leading to his earliest panoramas, in 1958 — often dramatically cropped images. That year, Koudelka had his first exhibition of photographs, presented in a corridor of the engineering building of the Czech Technical University. Přikryl remembers the show, and one image in particular: a landscape, made in Slovakia, with a hill on one side, and a carriage with two oxen. Another panorama in the exhibition was made in Poland, where he had ventured clandestinely. Here, the profile of a nun is articulated by her habit, with sand, water, and horizon: a geometry of forms. Bright light, shapes, and contrast play with scale and depth of field in this extremely enlarged image. The exhibition also featured a square-format beach scene from Poland, focused on a configuration of barbed wire — but the footprints in the sand and the bare legs, seen from the knees down walking off the upper-left corner, provide a sense of place, the long shadows suggesting the time of day. Another Safez, Pavel Kučera, a fellow student with a deft hand at carpentry, made the wooden frames for the show.

Some of the "Safezos," Prague, 1960. From left: Pavel Kučera, JK, Zdeněk Přikryl, and Vítězslav (Víťa) Jelen. Photographer unknown. (Safezos not present: Antonín Bukovský, Ladislav Laďá, and Mark Moix)

Spread from JK's notebook of early studies, 1958

Over the postwar decade, the structures supporting Czech photography had undergone many major changes. After the Communist takeover in 1948, the authorities systematically nationalized photography studios and publishers, destroying important archives and closing down periodicals in the process — or forcing publications to represent ideological platforms. Censorship was rampant. Amateur photographic organizations were eliminated or were folded into the Revoluční odborové hnutí (Revolutionary Trade Union Movement, founded in 1945), in which they were rebranded as proletarian workers who practiced art as a hobby.[11] Propagandistic socialist realism celebrating the Communist agenda became the dominant — and the only officially approved — aesthetic.

After the death of Joseph Stalin in 1953, however, the clench of socialist realism slowly loosened in Czechoslovakia. In both form and content, the arts began to expand, and a new humanistic period bloomed, with increasing attentiveness to everyday life.[12] Photography historian and curator Antonín Dufek has singled out 1958 as a turning point: "an institutional milestone for photography," during which two important exhibition spaces for the medium were established: Fotochema in Prague, and the Kabinet fotografie Jaromíra Funkeho (Funke Photography Center) in Brno.[13] This is the photographic context in which Koudelka would initially root himself, as would fellow Czech photographers Miloň Novotný, Dagmar Hochová, Markéta Luskačová, Pavel Dias, Matěj Štepita-Klaučo, Bohumil Puskailer, and Přemysl Hněvkovský, among others.

It was not photography, however, but music that would first broaden Koudelka's immediate horizons. He recalls that, during his second year at the university, "the Communists were supporting folk music, and so a lot of groups were playing it. I liked the music and wanted to play in a group. I saw

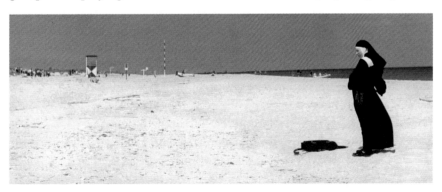

Poland, 1958

the announcement posted for a group that needed somebody to play the *dudy* [Czech bagpipes] and would accept somebody — even if he didn't know yet how to play." And so Koudelka took up the bagpipes — an instrument not of his home region of Moravia, but of South Bohemia. In early March 1960 Eva Zapletalová, a musician and fellow university student with Koudelka, noted in her diary: "Our folklore ensemble was joined today by a new bagpiper — Pepík. . . . It was precisely this instrument that our excellent music was lacking. We learned that Josef Koudelka was in his fourth year of mechanical engineering and hailed from Moravia, from a small village not far from Boskovice. . . . We gladly welcomed the new bagpiper."[14] He joined the ensemble, called Vycpálkův soubor (after the teacher, musicologist, and folklorist Josef Vycpálek, who had died in 1922); they performed folksongs and dances not only in Prague but also in traditional folk festivals around Bohemia and Moravia.

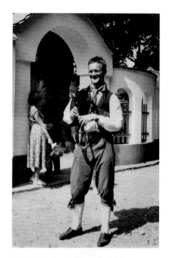

JK with *dudy* (bagpipes), Czechoslovakia, 1960. Photographer unknown

Koudelka had learned to play the bagpipes from a schoolteacher in Prague who taught him (as he describes it) "how to play around the melody." His teacher had learned to play the instrument with an old shepherd in West Bohemia, a *dudy* player named Bíba, for whom the popular "Bíba Polka" was named — one of the tunes Koudelka learned on the bagpipes. It happened one Sunday that Koudelka was on tour with Vycpálkův soubor, and he found himself in a pub listening to an elderly man playing the bagpipes with great spirit. Impressed, Koudelka ventured: "Do you by any chance know the 'Bíba Polka'?" The man answered: "I am Bíba!" Bíba offered two rules to the young musician: one, Koudelka must agree never to teach anyone else to play the bagpipes — "He was afraid that too many bagpipers would make it harder for him to find work"; and two, he must never perform without payment. From time to time, Koudelka went on the road and played with Bíba. Apparently, the old bagpiper saw Koudelka's schooling as something of a magnet for the public. "This boy is an engineer," Bíba would bark before passing the hat around to the crowd.

Folk music troupes were sometimes permitted by the Soviets to travel outside the Czechoslovak borders. There was one particular expedition that would help inspire Koudelka's lifelong wanderlust. In 1961 he journeyed with a group of twenty to thirty musicians and dancers by bus to Italy to perform at the Communist festivals known as *feste dell'Unità*. After World War II, the Partito Comunista Italiano (PCI) had evolved into the second largest political party in Italy, after the Christian Democrats. By the 1960s the PCI was receiving major support from the Soviets (although Italian Communism, while vehement, was its own brand — "less rigid than the Czech Communists," says Koudelka — in part because of the country's own history and location in Western Europe).

Koudelka exuberantly describes his first trip to the West:

We were singing and playing music all the time, and I was looking around. Usually, when we played, they would distribute us, and we stayed with

families. Before we went there, also they prepared us for what we are going to see in this capitalist world — even though we were invited by the Communists.

The Italian audiences loved the performances. Koudelka remembers playing a bagpipe solo one evening at a university in Rome. He was still relatively new to the instrument, which is notoriously difficult to play tunefully. As he plugged along, he heard people whistling at him from the audience and he began to lose heart. "I thought that they were whistling me off. No, on the contrary — they wanted me to play more!"

On this trip, he tried out a friend's single-lens reflex (SLR) camera for the first time and shot six rolls of 35mm film. "I found it was very interesting to use, because — unlike with the Rolleiflex — I could hold this camera to my eye." From this point on, Koudelka more or less stopped using his Rolleiflex and borrowed SLR cameras from friends until 1963, when he bought his own.

This trip to Italy gave Koudelka his first taste of an outside world of which he had had no inkling. Here, the magical dream of the blue sea in his grandfather's picture of the Bay of Naples came to life. Almost twenty years later, he would confess to his close friend the photography writer and editor Romeo Martinez: "Many things were set in motion during this trip, and they reflected themselves in my way of looking at the world."[15] Later, when he was forced to choose between the risks — for him and his family — of remaining in Prague and the uncertainties of self-imposed exile, the sense of possibilities ignited by this trip bolstered his will to leave.

It was while traveling with this folk troupe to festivals throughout Czechoslovakia in the early 1960s that Koudelka first got to know Roma musicians and made his earliest photographs of the Romani people. The Roma would captivate Koudelka's eye over the following two decades, but it was their music that initially seduced him. Martinez put it this way: "Gypsies have always been great players of musical instruments, great singers, and outstanding music makers. They express the mysteries of their centuries-long adventure especially through music. It is certain that before their visual reality, it was their music that left a profound mark on Josef's whole being."[16] Koudelka agrees that music was a crucial link with the Roma; he would tell the journalist Karel Hvížďala:

Taking photographs in Gypsy settlements wasn't always easy. But it was the music that got me started again and again. I think my interest in folk

Czechoslovak folk music ensemble on the beach in Italy, 1961

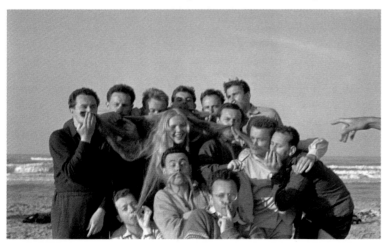

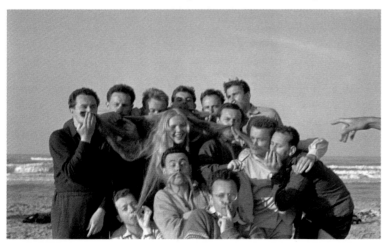

music helped me when taking photographs. . . . Gypsies are good psychologists: they probably understood that if I liked their songs, then I must have liked something more.[17]

The haunting, hypnotic harmonies, often in minor keys, caressing or pulsating — the chantlike resonance, the primal melodies: all this bewitched Koudelka.

Koudelka had been photographing throughout his time at university, and in December 1960 a selection of his pictures was published for the first time in the weekly *Mladý svět* (Young World) magazine. Nonetheless, he did not yet grasp that there might be a way to devote his life to this endeavor. And his love of airplanes still beckoned.

After graduating from the Czech Technical University in late 1961, he had one month free, and then went to work at Prague's Ruzyně airport in the beginning of 1962. Here he was reunited with his high-school friend Karel Šálek (who had attended a different university in Brno), and the two young men happily shared an office. Šálek found Koudelka to be significantly less pious, and far more gregarious: "He had stopped drinking milkshakes and was on to something else," he told me with a laugh, adding that Koudelka was also now "completely involved with photography, spending all the money that he earned on the supplies for his photography."

In August 1962 Koudelka began the final six months of his military training. While in Bratislava, he met the Roma poet Dezider Banga, and was further inspired to photograph the Roma settlements. "I will never forget the first time I visited a settlement." It was sometime in the following year:

> *I was walking alone and there was this big plain and in the background were the High Tatra mountains [along the border between Slovakia and Poland] covered with snow. In the distance I saw these wooden cottages and I heard a lot of noise. I summoned up my courage and decided to go there. I heard the Gypsies before I saw them. As I was approaching the cottages, I saw this group of people coming toward me. First were little children, then the bigger kids, and then the women, and then the men. They had seen me coming. I thought to myself: "How is this going to finish?" But I continued walking.*

He ended up staying with them in their settlement and photographing over the course of several days. It was the first of many such interactions. Some of the Roma he met there evidently developed a fondness for the young wanderer. He found them to be very welcoming, and even

JK's first published photographs, in *Mladý svět* (Young World) magazine, December 1960

JK's factory identity card for Czechoslovak Airlines, 1962

protective of him: "I slept sometimes in the cottages and sometimes outside because I wanted to see the sky. To make sure no one hurt me, some of them would sleep next to me. If they found a pencil, they would bring it to me, thinking maybe one of the children had stolen it."[18] Around 1965 he bought a small, battery-operated Czech tape recorder and brought it along on visits to their settlements to record their music and singing.

Koudelka has never found himself without access to a darkroom. In high school, he and Šálek used a darkroom at one of the local camera clubs in Prague. In the university dormitories, there was a darkroom for student use, where he pulled many all-nighters. On graduation day, in fact, Koudelka barely made it to the ceremony — he had spent the night in the darkroom and overslept. His parents were in attendance and getting increasingly anxious, until finally they saw their son onstage. Koudelka recalls that the school official awarding him his diploma hissed with a scowl: "Comrade, next time, come on time."

In the military barracks in Bratislava, too, there was a darkroom, and because of this and his proximity to the Roma settlements he wished to photograph, he ultimately asked to extend his military service by a month — staying through February 1963 — before returning to work at the airport in Prague, where he also had access to a darkroom.

Ultimately, Koudelka felt unfulfilled by his work at the Ruzyně airport. He was supposed to be working on the maintenance of planes for Czechoslovak Airlines, but he had little to do, as the principal engineering work had to take place in Russia. He would serve in a variety of positions at the airport in Prague, before eventually moving to the Bratislava airport, which he much preferred: there he helped to maintain a fleet of about sixty crop dusters for Agrolet, the division of Czechoslovak Airlines dedicated to agriculture. Sometimes he traveled to Slovakia to meet with the pilots in his charge; he took advantage of these occasions to make brief side trips to visit the Roma settlements.

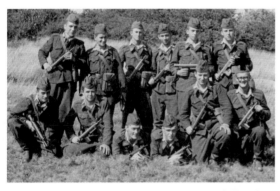

JK (front row, far right) during military training in Bratislava, 1962. Photographer unknown

Koudelka describes his work at Agrolet:

These were little planes where I got to really work on them. It was a great job. I loved it very much. I was independent with big responsibility — for the engines. Every winter the mechanics needed to pass the technical exam with me.

But I was never permitted to get the pilot's license, not even for a glider, because, again, I was from a family that was not in agreement with government policy. They thought that I'd fly away!

6.

One night in 1960, the photographer and critic Jiří Jeníček looked for the first time at twenty-two-year-old Josef Koudelka's photographs, illuminated by the light of a store window on Prague's Nekázanka Street. The young photographer had attended Jeníček's lecture at a local camera club earlier that evening, prints in hand, and the respected older man offered to take a look at his work. "He was immediately nice with me," Koudelka recalls. "He said: 'You have an eye,' and invited me to his flat the next day to show him more." Jeníček, who affectionately called him "Koudeláček," soon became a "sort of father figure for me in photography," says Koudelka. He also credits Jeníček with discovering the photographer Miloň Novotný — eight years Koudelka's senior, a decidedly "humanist" photographer, and "the photographer I respected the most at that time."

Before Koudelka graduated from university, Jeníček urged him to put together what would be his first serious exhibition; his only previous show had been the 1958 presentation in the corridor of the engineering faculty building at the Technical University. It opened in early 1961 at Prague's Divadlo Semafor gallery, in the lobby of the theater. Founded in 1959 by performers, musicians, playwrights, and songwriters — central among them the multitalented songwriter performers Jiří Suchý and Jiří Šlitr — this vibrant space embraced a variety of art forms, practices, and sensibilities. Koudelka recalls:

Exhibition invitation to *Josef Koudelka* at Divadlo Semafor gallery, designed by Jáša David, 1961

> *Semafor had exhibitions of photographs, so I decided (at Jeníček's suggestion) to take them some of mine, to ask them if they would like to make my exhibition. I left the photographs there and went home for Christmas. It was unbelievable: a telegram came to my parents' place saying that they will give me an exhibition in a few weeks.*

Of course, the presentation would require a set of exhibition prints — meaning excellent quality, enlarged photographs. Koudelka was terrified. He told Jeníček: "I can't do that! I've never made any large-sized prints. I don't know how to do it." The older photographer assured him he could do it and helped him to select the images for the show. The theater provided a box of 30-by-40-cm photo paper with which Koudelka made the prints. It is a set that he continues to use in exhibitions today, more than sixty years later.

At Semafor, Koudelka hung photographs representing three years' work, the earliest of which he had included in his 1958 show at the university. Jeníček made a speech at the opening, on January 26, 1961, championing the young photographer's talent. He spoke enthusiastically of "the unusual viewpoints from which Koudelka has looked at the objects of his pictorial interest, and . . . the visual, sometimes even bizarre expressivity of the figures of living creatures, which, stripped of brutal documentary quality, appear as silhouettes in many of his photos."[19]

The exhibition led to a selection of Koudelka's photographs, including the image of the nun on the beach, being published as a spread in the March 1961 issue of *Československá fotografie* (Czechoslovak Photography), the national

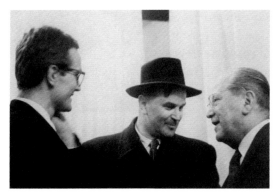

JK, Josef Koudelka Sr., and Jiří Jeníček at the Divadlo Semafor exhibition, Prague, 1961. Photographer unknown

amateur photography monthly; another image was featured on the cover of the January 28, 1961, issue of *Literární noviny* (Literary News). In November of the following year, the show would move to the Divadlo poézie (Theater of Poetry) in Bratislava.

At the Prague opening in 1961, Jeníček introduced Koudelka to a woman who would have a profound and extended impact on his life and career: the photography historian, curator, and writer Anna Fárová. Years later, she recalled that Jeníček gave her an unusual directive about Koudelka — telling her that she "had to look after him. There was some special emphasis in that."[20]

Fárová was stunned by Koudelka's work. This newcomer, she later wrote, *demonstrated an uncommon power of expression, a vision that incorporated modern graphic methods with remarkable inventiveness and freshness of form. The center of gravity in the exhibition was less the study of content and context than a palpable quest for unusual forms and original composition, often underscored by a distinct viewpoint.*[21]

She described the work as a "huge surprise" — but, impressed though she was, she noted: "For me there was something lacking: the exhibition did not have a theme per se. There were only single shots, and form predominated."[22]

Fárová, born in Paris in 1928, was a decade older than Koudelka. Her French mother, Anne Moussu, was a French teacher, and her Czech father, Miloš Šafránek, at the time was the Czechoslovak cultural attaché. When Fárová was five, her parents divorced, and in 1938 she and her mother moved to Czechoslovakia. Fárová's father, who was no longer a diplomat, remarried and moved to the United States in 1939; she would not see him again until 1946, when he returned to Prague.

I met with one of Fárová's two daughters, Gabina Fárová, in Prague in 2014, four years after the death of her mother at age eighty-two. Together we looked through an old photo album, as she described how her maternal grandfather brought American illustrated magazines such as *Life* back

JK's photograph on the cover of *Literární noviny* (Literary News), featuring a review of his Divadlo Semafor exhibition, January 28, 1961

to Prague with him ("Here," she reminds me, "we did not have those magazines"). Anna Fárová's husband, Libor Fára, was a graphic designer and artist. Gabina remembers her father making collages from images in these publications. Anna herself wrote about the important role they played in developing her own photographic sensibilities: "From these images, mostly documentary, we learnt how to look at photographs." She and her husband would pore over copies of the French magazine *Verve* as well: "That was where we first realized that a photograph could be published like a work of art."[23] This realization, along with her belief in humanist photography, her fluency in French, and her innate drive,

helped connect Fárová to the photography world at large. She came to know and work with many of the Magnum photographers (Henri Cartier-Bresson among them), as well as curators and editors worldwide. At the same time, she was committed to photographers from Central and Eastern Europe, from André Kertész to František Drtikol, from Josef Sudek to Josef Koudelka.

Fárová's relationship with Koudelka over the following five decades was both intense and, at least initially, productive. It was Fárová who first introduced his work to curators and photographers and others in the field not only in his own country, but abroad. She wrote appreciatively and intelligently about his photographs, and curated exhibitions of his work. More personally, when Gabina was born, in 1963, Anna and Libor asked Koudelka to be her godfather.

"Josef was really part of our family," said Gabina, whose earliest memories of him remain dear and vivid. Once, at age four, she asked her convivial godfather about the great puffy sack he always carried — what was that thing he was never without? He took the little girl to the local park. "Josef said: 'Let's see what we can do with this bag.' He spread open his sleeping bag, and we lay down, looking at the rabbits, and people were just looking at us. . . . I was so happy to know what the bag was for!"

Covers of *Divadlo* (Theater) magazine featuring JK's photographs, 1962–64

Anna and Josef's relationship would take many forms both personally and professionally — sometimes acrimonious (at least on Anna's part); ultimately estranged — with emotions ranging from deep caring and mutual respect to mutual vexation. For nearly fifty years they would remain, one way or another, connected.

"I got involved with theater by chance," says Koudelka. It was 1961, and a friend of his from the university, Milan Blum, had seen Koudelka's photographs. A relative of Blum's was an editor at the monthly *Divadlo* (Theater), and he knew the publication was looking for a photographer. At Blum's suggestion, Koudelka visited the magazine's offices, and to his surprise they immediately sent him off to the Bohemian town of Kladno, forty kilometers west of Prague, to photograph a performance of Bertolt Brecht's *Mother Courage*.

It was Koudelka's first time photographing the theater. He became friendly with Mariana (Marie) Lakatošová (later Šejnová), who worked as the secretary for *Divadlo* and ensured that Koudelka was continually given assignments. She was of Roma descent — "Her father was a Hungarian Gypsy musician," Koudelka tells me, "and her two brothers may still be musicians."

When Koudelka was working for *Divadlo*, it was a horizontal-format publication, 17 by 25 centimeters, with a page count topping one hundred in most of the issues from the 1960s that I thumbed through. The front and back covers were given to stand-alone images that might have little or no relation to the interior content. Those photographs were generally full bleeds; the only text over them (in the 1960s at least) being the magazine's name in capital letters, sometimes an issue number. In the interior, the photographs and occasional

line drawings served primarily as illustrations, although there were some exceptions. The magazine — often comprising three different weights and textures of paper — has the feel of an old paperback book.

While shooting theater for *Divadlo*, Koudelka could photograph only from the audience's perspective — often sandwiched between the first row and the stage, with limited mobility. He never used a tripod, as that would have further restricted his movement. Rather than the audience presence providing a beneficial adrenaline rush, he says, he often felt that he was annoying the nearby theatergoers. "My camera always made noise, so I felt I was disturbing the audience."

In Prague in 2015 Koudelka and I visited Marie Šejnová, his *Divadlo* ally. Now in her eighties, she was unwell and confined to her bed. The two had not seen each other for decades. He embraced her warmly, saying with heartfelt appreciation and the kind of nostalgic affection that's singular to very old friends: "You kept me alive for a long time — because you kept giving me jobs!" Šejnová responded in kind: "You were the *best* photographer."

Koudelka left soon — he had come only to hug her — and once he'd gone Šejnová looked at me conspiratorially. We both knew that Koudelka has always been driven primarily — perhaps exclusively — by visual prompts. It seemed unlikely to me that he had studied Brecht's text, for example, before shooting *Mother Courage*. I asked her if she thought he ever actually read the plays he was photographing. "No," she said astutely. "It was not literal like that with Josef. It was his intuition." Although Šejnová was quite fragile, her pale blue eyes remained alert and focused. She was clearly animated by the pleasure of revisiting those moments of her youth.

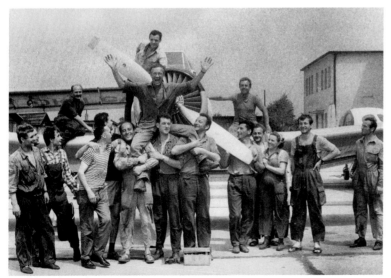

JK (held aloft on shoulders) with coworkers from the Agrolet company, Prague, ca. 1965. Photographer unknown

Divadlo was giving Koudelka his first small professional photography jobs, while he continued his work as an aeronautical engineer for Agrolet at the airports in Prague and later Bratislava, taking care of the crop dusters through 1967. In 1965 he had become a member of the photography section of the Svaz československých výtvarných umělců (Union of Czechoslovak Artists) — the only government-recognized position that would permit him to leave his state-sanctioned job, and work as a freelance artist. This was something of a complicated endeavor: "If you wanted to get recognized as an artist, you needed to present a portfolio," Koudelka says. "There was a committee, and they decided if you were good enough or not. And if you were

accepted as an artist, you didn't need to have any more stamps on your identity card saying that you are working. If you were not accepted, without these stamps, you could be arrested, because it would mean you were not working."

Still, in the decade following Stalin's death in 1953, "everything started to be freer," recalls Koudelka. In 1965, with his union membership in hand, he intended to resign from his position at Agrolet, but his boss countered with the suggestion that he stay on part-time, which he did for a while. But the muses of freedom and time — the possibility of devoting himself completely to photography and especially his project on Romani communities, while continuing his work in the theater — proved too enticing. In 1967 he left Agrolet:

> *I loved airplanes, but there would be so many years before the new planes would come and I would have the chance to learn something new again. . . . I didn't want to die when I was thirty years old. I wanted to progress. With photography I was learning all the time. And also, I felt free. I can pick up the camera, pick up the film, and I am responsible only for me.*

Nevertheless, Koudelka was nervous about sharing this news with his father, who had been very proud of his engineer son.

> *I remember meeting him in Prague and telling him — I was afraid that he*
> *was going to be really angry and disappointed that*
> *I was going to stop being an engineer, to become a pho-*
> *tographer. But instead, he told me: "My son, I think*
> *probably it's not good to do one work . . . only one job*
> *all your life." I was relieved.*

Anna Fárová and Libor Fára in their studio, Prague, 1966

In the period leading up to the Prague Spring of 1968, it appeared that the arts in all media were beginning to flourish once more in Czechoslovakia. Freedoms were being restored; censorship was decreasing. And globally, the 1960s were a revolutionary time for theater — bringing to the fore such innovative directors as Jerzy Grotowski in Poland, Peter Brook in England, Julian Beck and Judith Malina in the United States, among many others. Works by groundbreaking playwrights, from older ones such as Alfred Jarry and Anton Chekhov, to later ones like Brecht, Samuel Beckett, and Eugène Ionesco, to contemporary Czechs like Josef Topol and Václav Havel, were being premiered, or reinterpreted and staged as never before. Design — graphic, industrial, and other — had been forever changed by practitioners such as Alexey Brodovitch, the influence of the Bauhaus (although it had closed in 1933, its impact was indelible), and Czech book design and graphic artists such as Oldřich Hlavsa, František Muzika, Jiří Rathouský, Zdenek Seydl, Jaroslav Šváb, and Josef Týfa.[24] It was an extraordinarily fertile and creative moment.

Libor Fára was *Divadlo*'s art director. He had seen Koudelka's early photographic experiments at the 1961 exhibition and would later use some of the images from this show as *Divadlo* covers — creating a compelling tension

between Koudelka's pictures (including some that had nothing to do with theater) and the magazine's content.

Koudelka, however, was often unhappy with Fára's treatment of his theater images in the magazine's interior: "For Fára, photography was mostly something to be used for design." One dynamic exception was the gridlike layout of Koudelka's 1964 reportage of Peter Brook's production of *King Lear*, performed by the Royal Shakespeare Company at the National Theater in Prague, with Paul Scofield as Lear. Here, three spreads of carefully edited images are sequenced cinematically: gestures build upon one another; Lear's countenance shifts expressively from image to image as sanity gives way to madness. Koudelka had managed to photograph *Lear* from one of the boxes of the theater, and this position afforded him more mobility and an excellent vantage point. In 1964, Fárová wrote of these photographs in the pages of *Divadlo*:

> There are . . . several ways to approach this with the camera. . . . [One could] also submit photography to a process like the one used in the artistic conception of Brook's Lear. *That means taking the transformation of ugliness to the outermost limit, to sublimity and beauty. It's with these principles that Koudelka has made his photographs of* King Lear. *The series of his photographs for this production both observe the action on stage and decipher the ultimate sense of the whole performance, the costumes, and gestures. The first part of Koudelka's photographs capture the composition and, elsewhere, the intentional lack of composition, as well as the movement, interrelationships, and rhythm. The second part monumentalizes the individual details, brings one close to situations of conflict in the gestures, and testifies to the style and structure of the play.* [25]

For Koudelka, *King Lear* was simply "the most beautiful play I ever saw in my life." Indeed, the famous line from the play's closing passage might well have been spoken by him: "Speak what we feel, not what we ought to say."

When possible — particularly when *Divadlo* wanted more than just one image — he would try to attend several performances of a play, so that he might really be inside the action. Whether consciously or not at the time, he was beginning to habituate himself to what would become his lifelong practice of repetition, without repeating himself. The more times he experienced a performance, the more precisely could he achieve his unique vision. "When it comes to theater photography," Fárová would later write, "Koudelka was influenced by no one; on the contrary he has turned out to be a great influence in our country." [26] In another context, she extrapolated about the effect of his experience in the theater on Koudelka's artistic evolution in general — and specifically on his work with the Roma.

> Theater helped him also in [his] own topic, Gypsies, which he photographed at the same time, and could not have dealt with so masterfully had he not had the technical experience of photographing the theater in difficult lighting and with very limited time. [27]

Pages from the June 1964 issue
of *Divadlo* (Theater) magazine,
featuring JK's photographs
of the Royal Shakespeare
Company's production of *King
Lear*, directed by Peter Brook,
at Národní divadlo, Prague,
1964

Koudelka appreciated Fára's rendering of his vision with *King Lear*. He also enjoyed the designer's company, so continued to work with *Divadlo* magazine from 1961 to 1969, photographing with his SLR camera and a variety of lenses. Later, Anna Fárová would distinguish her ideas about photography from those of her then-husband with regard to Koudelka's evolution as a photographer:

> *I neither saw nor understood commercial photography, and that was the difference between my approach and Fára's. I understood photography as something independent, whereas Libor saw it from outside in connection with letters and typography. I looked at it from within, to see what was in it.*[28]

Through his work for *Divadlo* and his reaction to Fára's approach to it, Koudelka was forming his own graphic sensibility. Simultaneously, he continued his "experiments," which he describes as "work done in the dark-room with images made with various cameras, beginning in the mid-late 1950s through the early 1960s." The goal of these experiments was to rid his photographs of anything deemed extraneous. In these investigations of positive and negative space, Koudelka silhouetted his subjects (often their faces), methodically exploring his visual options as he advanced to whatever came next. The artist Pierre Soulages would later comment on Koudelka's process of visual paring-down in this period: "There is an instant when the violence of the succinct contrast between black and white is geared to reveal what is most *essential*, relegating nuanced grays and stylistic affectations to second place. It is a question of choosing the essential in order to achieve the most dramatic presence."[29] This minimalist aesthetic deeply permeated his theater work. Curator Matthew Witkovsky sees a direct connection between Koudelka's experimental photographs and his work in the theater. In the latter, says Witkovsky, Koudelka's "experiments gained a new, dramaturgical motivation; heightened grain, cropping, and enlargement all gave the photographer an auxiliary directorial voice, as if he were controlling lights or staging after the fact."[30]

In 1964, along with *King Lear*, Koudelka photographed what was by all accounts a brilliant production of Alfred Jarry's *Ubu Roi* (1896). In this work, Jarry seems to have been playing with some of the same revelatory dynamics that would occupy Koudelka in his forthcoming work with the Divadlo za branou (Theater Beyond the Gate). Before the very first performance of his absurdist, scatological play, Jarry himself had addressed the Paris audience: "Our actors have been willing to depersonalize themselves . . . and to act behind masks, in order to express more perfectly . . . the soul of these overgrown puppets you are about to see."[31] In Prague, this well-known work was presented at Divadlo Na zábradlí (Theater on the Balustrade), where Koudelka found himself working again alongside Libor Fára, who served as set designer. Here, Jan Grossman wore many hats, including artistic director, as did playwright Václav Havel, who worked as a stagehand before becoming the theater's dramaturge — a role that drama critic Kenneth Tynan characterized as "literary manager, a post that in Europe quite often means not only play selector and script editor but house

playwright as well."[32] More than two decades later, in 1989, Havel would become president of Czechoslovakia. In that capacity, he would oversee the country's peaceful 1993 division into Slovakia and the Czech Republic, as president of the latter until 2003.

The *Ubu Roi* production in Prague was a great success, and clearly hit a nerve with Czechoslovak audiences. Fárová later considered how the play resonated with its moment:

> *In the mid-1960s we were all full of that production . . . Jarry's technique of absurdity and nonsense, something between stupidity and genius, Ubu's obvious impudence, dreadful amorphousness and shamelessness, occasionally seductive joviality, that was something that we felt to be a parallel to our feelings about life at that time.*[33]

In 1966 a theater-trade book was published with the title *Král Ubu: Rozbor inscenace Divadla Na zábradlí v Praze* (Ubu Roi: An Analysis of the Theater on the Balustrade Production in Prague). It was designed by Fára and included texts by Grossman and production shots by Koudelka. Although initially excited by the prospect of this book when Grossman proposed it, Koudelka ultimately disavowed it — again, he felt his photographs were used merely illustratively: "It was published without my agreement, and I don't consider it my book." Koudelka had a clearly developed concept for these photographs: he wanted to parse each scene to expose "the details that the audience might otherwise not perceive." This idea had determined how he chose to photograph the play. He even put together a book dummy that he felt showcased the photographs as he wished, but Fára had his own notions. When it came to making the actual book, Koudelka grumbles, "they made it a record of the performance with all of these little pictures instead of using the best pictures in the best way."[34]

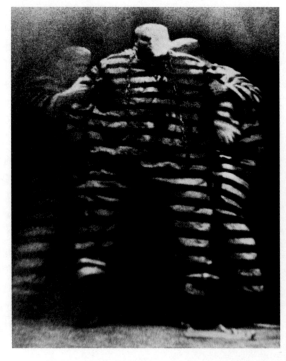

Alfred Jarry's *Ubu Roi*, directed by Jan Grossman, Divadlo Na zábradlí, Prague, 1964

Among the many productions that Koudelka photographed for *Divadlo* in 1965 were Beckett's *Waiting for Godot* and Ionesco's *The Bald Soprano*. In all, his work was featured on some seventeen covers, and 235 of his images were published in the magazine between 1962 and 1969. The photographs were mostly of theatrical productions, but included other cultural events as well, including the Merce Cunningham Dance Company's 1964 "World Tour" performances in Prague.

Koudelka's work in the theater exposed him to some of the most significant and boundary-pushing writing and artistic sensibilities of the period. But nothing could have predicted how his methodology would evolve once he began working with the Divadlo za branou, co-founded in 1965 by director Otomar Krejča. Here, Koudelka encountered a sensibility that complemented his own. As Fárová would later write:

Otomar Krejča, director of
Divadlo za branou, Prague,
1966

[It was in] Krejča's theater, with his stringent style of direction and aesthetic structuring, that Koudelka . . . demonstrated the quality of his consummately original approach toward theater photography, which effectively conveyed the essence of every performance. He also helped to define the visual identity of the theater. Koudelka participated in the overall promotion of the theater as well. He prepared posters, billboards, and printed programs. He approached these activities with equal intensity. The result transmits to the audience the atmosphere of the performance through expressive portraits of the actors that characterize the creative aim of the director and the overall artistic message of the performance.[35]

One of the principal actors at Divadlo za branou was Jan Tříska, whom I interviewed in 2014. He told me that Krejča decided to start the theater "as a protest, when he was, more or less for political reasons, ousted as director of the National Theater." Tříska was a co-founder in the project, as were actress Marie Tomášová (Krejča's wife), dramaturge Karel Kraus, and playwright Josef Topol. More traditional than the Divadlo Na zábradlí, Divadlo za branou quickly became celebrated for its remarkable productions, until 1972 when the company and its performances were banned by the regime.

Koudelka and I met with Marie Tomášová in 2014 at his Prague apartment. She characterized Divadlo za branou as having been dedicated to the most truthful rendering of a playwright's vision, and her late husband Krejča as "very educated, but someone who allowed himself to be guided by instinct, by his intuition." Clearly, though, Krejča controlled every last detail of the productions — nothing was left to chance, nothing improvised. Everything, as Koudelka recalls, was considered and "decided a long time ahead." When comparing his approach to Koudelka's, Krejča referred to "'directed acting' in which . . . the actor plays his role so that it becomes his own." He likened that to Koudelka, writing that he "has found the quintessence of the art of photography in the 'directed picture.'"[36]

It has been many years since Koudelka and Tomášová have seen each other, and there is joy in their embrace when she arrives. As the three of us leaf through some of his photographs from Divadlo za branou, I am struck by this former leading lady's self-possession, her sheer presence. She is moved by the reunion — the cadence of her voice is the tell — as she discusses first her husband, then Koudelka's evolution as a photographer. She has prepared for our conversation and is focused and clear. Koudelka playfully refers to Krejča as a benign "dictator." "The actors just were slaves for him. But everybody wanted to work with him because he was so good."

Tomášová elaborates:

Krejča said that the actors and the director are servants, or messengers, of the text or the author. It's their job to convey the text. He was very original in his approach, and he was also very thorough. So if there was a comma or ellipses in the script, he would direct them. Aeschylus and Topol and Chekhov were his favorites: they were poets . . . Krejča believed that we — the actors, the director — were in the service of the poet.

Krejča and Kraus had seen Koudelka's photographs in *Divadlo* magazine, and approached him when they launched Divadlo za branou, asking if he'd be interested in photographing their performances. Koudelka responded with his terms and conditions for collaborating. His first was: "I wanted to follow the productions from the preparations through the rehearsals through the end." The second: "I also asked to photograph at least three dress rehearsals so that I could develop the photographs after each, study them and, during the next rehearsal, try a scene where there was a certain potential, a new possibility to photograph it better." Given his dislike of the artificiality of theatrical lighting and the confines of the proscenium stage, this approach allowed him to basically ignore both. It was likely the third condition that inspired Krejča to refer to the "originality" of this photographer's requests.[37] While photographing these rehearsals, Koudelka demanded to be able to move freely among the actors, on stage. (He was never shooting Divadlo za branou productions, onstage or off, when an audience was present.)

I didn't want to photograph performances passively from where the audience sits. I had already done that when taking photographs of plays for Divadlo *magazine. I wanted to go further: to photograph the performance in the same way I photographed real life outside the theater . . . to be able to react to situations between the actors directly on stage. . . . I knew I was asking a lot. No director or actor likes anybody getting in their way onstage, but Krejča accepted my terms.*[38]

Koudelka was not interested in "documenting" the play — "a whole in itself." He instead considered "another possibility: to take the play as an initial reality, and then to make something different out of it — to transform this reality."

Koudelka's work with Divadlo za branou was not about representation but about a kind of unmasking, in pursuit of the essence of his subject: not the individual, not the individual as actor, but the character itself. He is, in this way, an interpreter in the same manner as the play's director. His photographs have none of the linearity and illustrative qualities of conventional theater photography; rather, they are often abstractly impressionistic: "I was looking for a detail that I cropped, re-photographed, enlarged, possibly deformed with a wide-angle lens, and I extracted things from that, which were mainly interesting for me."[39]

Krejča referred to Koudelka's photographs as a "metaphor" for the performances, speaking of their "broader, higher truth." He wrote: "When looking at them and remembering the performances, I have a deceptive feeling of reversal.

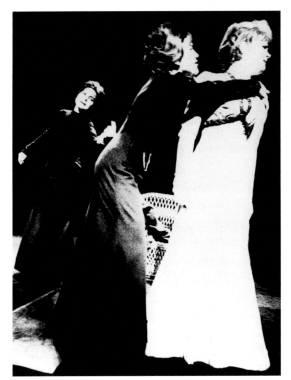

Anton Chekhov's *Three Sisters*, directed by Otomar Krejča, Divadlo za branou, Prague, 1966

It is as if he did not take these pictures of our performances but rather that we performed for his pictures."[40] One of the Za branou actors put it to Koudelka this way: "You didn't photograph the theater. You photographed the soul of the theater."[41]

Josef Topol wrote *Kočka na kolejích* (Cat on the Rails) in 1965 for the opening of the new Divadlo za branou. It was while rehearsing this play that the cast members Tomášová and Tříska first experienced Koudelka. "The actors start to know you, but it was not easy for me at first," recalls Koudelka. "Then," he adds almost mischievously, "when I did not get the access I wanted, they did not get the pictures they wanted. So I could soon work as I needed. Eventually, it happened that Krejča would say: 'If Josef is not photographing — something must be wrong.'"

Krejča wanted to pay Koudelka fairly for his photographs, but he had no money to do so, as this was not an approved cost in the theater, which was state-funded. Ultimately, the director finagled a way to employ him as a stagehand — as this was a budgeted expense. Koudelka's photographs had become invaluable to Krejča. In turn, if there was something Krejča really wanted photographed, Koudelka would do it.

For any theater company, but especially one like Za branou that did not consider itself remotely avant-garde, such a dynamic between actors, director, and photographer might seem unimaginable. According to Tříska, however, Koudelka's "catlike" presence was never annoying to the performers. "It was," he told me in 2014, "a matter of concentration. He did not disappear for us, as we did not disappear for him. It was a silent collaboration. Rather intense. He probably had to be aggressive to get his shots. But we didn't mind. The level of concentration was very high on both sides." Was there any interchange, any dialogue? Tříska says summarily: "I think Josef minded his lenses, and we minded our lines." And then: "He had an inspiration, determination, and audacity."

One extraordinary talent that is shared by certain photographers who focus on intimate situations is the ability to become somehow invisible, habituating their subjects to their presence in such a way as to, if not go unnoticed, recede from view.

Krejča described Koudelka's presence in this way:

He gave us an unusual show: he was an enlightened walk-on player, causing no trouble at the rehearsal, sidling easily among the actors — or rather their characters. But he was not performing. Totally absorbed by the drama, he moved in a way that did not disturb the choreography of the characters.

[Looking at the photographs] we recognized the actors, but their faces were not their own . . . in those performance shots Josef found and caught the emotional knots — each actor's most fully charged moments — when the traits of their characters, shaped by an organic emotion, took on the rosy hue of human flesh. . . . [Josef's photographs] are never simple documents of raw reality. They are rigorously true and eloquent images of something that is, of something essential. They have become signification, signs, logos, translating both the language of drama, of theater, and the mystery that makes theater go beyond mere capability.[42]

Theater critic Georges Banu saw Koudelka's 1966 images from Krejča's production of *Three Sisters* and was inspired to attend a performance of Chekhov's play at Divadlo za branou. Stunned by what he'd seen, Banu wrote afterwards: "This endless disillusionment; this inconsolable pain that emerges from the deep shadow of hope. The experience of theater was for me synonymous with the astounding impression of photography: those graphic and timeless summations of Chekhov by Koudelka."[43]

At Koudelka's Prague apartment in 2014, Marie Tomášová looks at his photographs of her from nearly fifty years earlier. She seems awestruck as she revisits their extraordinary dynamic together on stage. "There was no posing," she says. "We never prepared for Josef's photographing, so the naturalness and the feelings that arise on the stage come through. . . . The theater is something that is horribly fleeting: as soon as the words finish and the movements stop, everything falls into oblivion. And yet, thank God, there are witnesses here in Josef's photographs."

Tomášová has followed Koudelka's work through the present and is drawn to his "sympathy with the misery of people, with animals, with man, but also with the landscape." There is one image that, for her, documents how "Koudelka sees not only with his eyes, but with his heart" — one she might well have seen near the time when it was made, in Romania in 1968, shortly before the Soviet-led invasion of Prague. It would first be published in his 1988 book, *Exiles*:

I look at the photograph of a horse with its head hanging down. . . . There is a man squatting in front of him with an open mouth. He's probably saying something. . . . We don't know what the horse is thinking or feeling. We do know one thing — that Josef is the same way as those two creatures. That's the empathy and the sincerity with which he does his work.

This photograph was purchased by New York's Museum of Modern Art in 1971 and was included in its 1981 animal-themed appointment calendar (along with Paul Klee's cat and bird, Henri Matisse's goldfish, Edward Hopper's cow, and more). During the course of my conversations for this biography, many individuals close to Koudelka focused on it as a signature image that continues to move them, perpetually fixed in their mind's eye. Among those who spoke of it is Koudelka's friend, a frequent writer about his work, French philosopher Gilles Tiberghien: "It's all there," he says, "all the grays, the whites, the way he composes the scene. . . . It is a world reconciled — the symbiosis of what might be

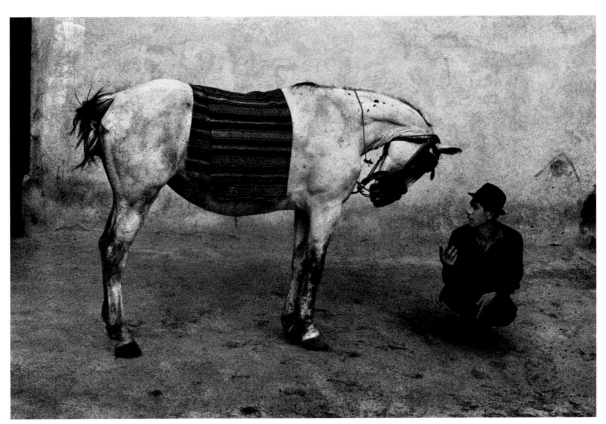

Romania, 1968

my most beautiful dream, it is the earth — the relationship of man and animal in the world. There are no barriers. This creature who has an unbelievable beauty, and this man who possesses the intimacy of the world." The French-Lebanese writer Dominique Eddé, who has been close to Koudelka since 1991, observes that this is one of the few images by him in which there is eye contact between two beings. She says:

> I see more tenderness in this image than any other. Even though we are not able to see the horse's eye. . . . If I was to say what animal Josef would be if he was one, I would say a horse — the stability, the strength, the movement. . . . With this image, we are directly in touch with Josef's intimacy. This image is, in my view, about the superiority of nature and the humility of love. Both in one. Josef's vision of life.

Just four months after the Soviet invasion, Koudelka took his one and only gig as a wedding photographer, when Jan Tříska married actress Karla Chadimová. Before Tříska shared the wedding album with me, I asked him: "Why Josef?" To which he responded: "It was December 1968. In those troubling, sensitive days, our wedding was a social event. Josef was an obvious choice." Among the guests were Anna Fárová and Václav Havel. The photographs, as Tříska himself observed, are "beautiful — gloomy and grainy." Clearly Koudelka approached the wedding, its ritual and staging and given roles, much like the rest of his photography at the time.

The same December, *Josef Koudelka: Divadelní fotografie, 1965–68,* an exhibition of his theater photographs curated by Fárová, opened at Divadlo za branou; it ran through February 1969.

Years later, in the mid-1970s, Koudelka ran into Otomar Krejča in Paris. The director asked him if he would photograph a production he was working on at the Comédie-Française. By then, Koudelka had little interest in photographing theater, believing he had learned all he was going to learn in that arena. The discipline of photographing in the theater — looking at and experiencing the same scene over and over again and photographing it in a multitude of ways — had, however, instilled in him his lifelong habit of returning to a subject in order "to get the best out of anything." Koudelka thanked Krejča at the time, saying he was "grateful to him because, by allowing me to photograph in his theater the same way I photograph real life, I learned to see the world as theater." Ultimately though, "to photograph the theater of the world interests me more."[44]

Photographs by JK of the wedding of Jan Tříska and Karla Chadimová, seen in the couple's wedding album, 1968

7.

One January evening in 1963, nineteen-year-old Markéta Luskačová had plans to meet Jiří Chlíbec, a musicologist with an interest in folk music who

worked at Prague's Ústřední dům lidové umělecké tvořivosti (Center for Folk Creativity). A student at Charles University in Prague, Luskačová had a burgeoning inclination toward photography. She spent her free time "visiting the library at the Uměleckoprůmyslové museum v Praze [Museum of Decorative Arts in Prague] and reading all I could find there on photography," she tells me when we meet at her home in Prague, in August 2014. What then happened she describes as "kismet." Chlíbec called her to say that they would be joined at dinner by a couple of other friends — including a man who had recently finished his studies in engineering and his military service: the twenty-five-year-old Josef Koudelka.

Luskačová's first impression of Koudelka was of a "very high-spirited" young man. Later, as they were drinking wine, Chlíbec mentioned that his friend was not only an aeronautical engineer but also a photographer. Luskačová told me: "Meeting Josef in January 1963 felt like a godsend." She turned to him: "'Listen, you should teach me photography.' He said: 'Nobody can teach you photography. You either see or you don't see.' I said: 'Josef, I don't want you to teach me to *see*, I want you to teach me where to press what.'" Koudelka laughed, and agreed.

They met the next day. Along with a camera, Koudelka brought a small piece of paper for Luskačová on which he had written directions for various photographic opportunities and their optimum exposures, depending upon the sunlight, cloud coverage, and so on (she still has this slip of paper). Luskačová pointed out that he had not written any instructions for full sun. He responded: "When there is full sun, lie in it, enjoy it — and don't take pictures." Apparently there was, she began to understand, a rule for everything.

The new friends started meeting regularly at the university dining hall after Koudelka finished his day working at the airport. In the Communist era, Luskačová explains, students could depend on school for plenty of sustenance. "These canteens had soup, and university students could take as much as they wanted. And tea — as much as they wanted. And baskets of bread. You could go back for seconds and even third helpings of things like pasta, dumplings, and potatoes." As a student, she paid three crowns daily for a meal coupon — so ninety crowns a month (about four US dollars today). And every day she would exchange her coupon for a meal, which she then shared with Josef. As they met most evenings, Koudelka began paying the monthly ninety crowns, and they would draw a line down the middle of their one dish and dig in. "We immediately became good friends," Koudelka told me.

In February 1963, some weeks after Luskačová and Koudelka met, Jirí Jeníček died. Koudelka purchased the photographer's equipment from his widow. It was also at this point that he bought his own first SLR camera — the East German Exakta Varex. Luskačová recalls: "Josef was making a small wage as an engineer, but he also had to pay for the new equipment, so for him it was great to have some food without spending too much money."

Equally important, Koudelka had access to cheap film, which further helped minimize costs. Photographer Pavel Dias was a friend who worked with Jiří Chlíbec at the Center for Folk Creativity (Chlíbec had introduced the two photographers in 1964 or 1965). Dias was a graduate of the Filmová a televizní fakulta Akademie múzických umění v Praze (FAMU: Film and Television School of the Academy of Performing Arts in Prague), and as a student had worked at the eminent Barrandov Studios, also in Prague. Although no longer employed there, Dias was able to purchase from Barrandov very inexpensive leftover 35mm "kino-film": film for movie reels, which could be cut and used in a still camera. As Dias explained to me:

[At the Barrandov Studios] they cut off all the extra unexposed pieces of film from the reels and, for two or three crowns, they sold it first to employees. So we had high-quality raw material — 35mm kino-film. Josef asked me if I could buy him some. . . . He took so many photographs, and to buy regular still camera film would have been much more expensive, and anyway was not always easy to get. . . . I usually took the whole three hundred meters of black-and-white stock, one roll in a tin box. Josef usually wanted two of those "loaves" — a full six hundred meters.

During the first year of her friendship with Koudelka, Luskačová did not yet have a camera: "Josef was lending me his camera when I was trying to see if I was any good at picture taking. He was working at the airport, so during the work week I could have his camera." Koudelka initially presumed that she knew very little about art, but in fact, he now says, "she knew much more than I did." Her grandfather, who had worked as a book designer, had an excellent collection of art books. ("Art was his love, and he was sharing it with me generously," says Luskačová.) This grandfather had also been a close friend of the Czech photographer Josef Sudek. "Thanks to my granddad," she continues, "I was fairly well versed in the history of art when I started to take photographs."

In the summer of 1963 Luskačová traveled six hundred kilometers from Prague to the eastern Slovak town of Levoča, where she encountered pilgrims — predominately Roman Catholics of the Marian cult — journeying to Mariánska hora (Marian Hill). This pilgrimage tradition dates back to the fifteenth century. Although she does not recall photographing on this trip, Luskačová knew she had a subject in pilgrims. She would later say:

Yes, it appears that I am drawn to religious imagery. . . . But my early Slovak photographs should be viewed within the frame of time and place in which they were taken. In communist Czechoslovakia, the expression of faith of any kind was against official Marxist ideology and was oppressed. In my childhood the communists raided the monasteries at night, arresting nuns, monks and priests. They spent their prison sentences working in uranium mines, which destroyed their health. People who practiced religion were called "reactionary elements," and were often able to work only as unskilled laborers, even if they were university educated. Their children were often

denied education, being labeled "undesirable backwards elements." My photographs are not only of people practicing religion; they are a testimony to human integrity.[45]

"It was a way of being," she told me, "that had no chance to survive for much longer."

During this period, Luskačová was working grueling twelve-hour shifts moving heavy parcels at the post office at the main railway station in Prague. "The night shifts were quite hard, because it was so cold," she says. "Also, the maximum weight for the parcels was twenty kilograms — and many were this heavy." But by spring 1964 she had saved enough money to buy her first camera, a secondhand 1932 Leica.

Over the course of the summer that followed, her new purchase in hand, Luskačová attended religious pilgrimages in Slovakia on weekends. The first one she photographed was in Levoča; there she "learned from pilgrims about another pilgrimage place, and slowly, when I gained the trust of pilgrims, I learned about other pilgrimage sites and dates." No official announcements were made, in order to keep information from the disapproving Communist authorities. She would leave Prague on a Thursday or Friday to meet up with the processions of families from remote villages as they progressed through the hills, worshiping and doing penance at shrines and chapels. Luskačová was drawn to the rural peasant communities and their traditions, their faith, and

Markéta Luskačová (right) and a pilgrim, Slovakia, 1967

their stance against industrialization. She sensed early on that photography was the most effective approach in rendering all that she was seeing and experiencing. She shared the work with Koudelka, who told me: "Markéta immediately started to take direct and good pictures."

"I had a big subject," Luskačová says, "and I wanted to continue." Ready to commit herself fully, she considered leaving the university to devote all her time to photography. She went to see one of her professors at Charles University to tell him she was quitting the program. Her teacher explained that, under the Communist regime, it was not so simple: if she were to leave school she would have to be fully employed in a matter of weeks — or she would be deemed a "social parasite," and likely prosecuted. He persuaded her to stay on at school and to make photographs during the summer holidays, when most of the pilgrimages take place. Luskačová eventually wrote her thesis on these rituals and graduated from Charles University in November 1967.

Early on in their friendship, Luskačová began examining Koudelka's photographs alongside him.

"Josef showing me his pictures was a big part of our friendship — how it started." She continues:

> He was showing me on the contact sheets . . . little details in his pictures. He would take details — of faces from the theater, say — and print these little details as large as possible. He took such a small piece of the whole frame, printed it so enormous, and then he took a photograph of that and reprinted it again — so it didn't even look like photography. He was the only one doing that.

JK with Dagmar Hochová, Prague, 1992. Photograph by Karel Cudlín

An important friend and supporter for Koudelka and Luskačová was the humanist photographer Dagmar (Dáša) Hochová — his elder by twelve years, and a committee member in the photography section of the Union of Czechoslovak Artists. In this capacity, Hochová had helped Koudelka to become a member in 1965, and Luskačová in 1969 — just before it would have become impossible for her: "One year later I would never get in with the theme of religion." Hochová too spent time with Koudelka examining his photographs in the 1960s: "They were good. And it was fun to be with him. He was very ambitious and very skilful but mainly he had several outstanding photos right from the start, which were completely different from the photos usually taken by others."[46] Matthew Witkovsky notes that these collegial meetings during this period in Koudelka's life were formative: "He formed an advisory committee of sorts — the first of several in his career — composed of Fárová, and photographers Luskačová and Dagmar Hochová, whose opinions he would solicit by showing them work prints from his sojourns." Koudelka "wanted to know how three people with different sensibilities would react to them," and he would have them indicate which images they liked and disliked, along with any other comments, on the backs of his images.[47]

JK at Levoča pilgrimage, Slovakia, 1967. Photograph by Markéta Luskačová

While Luskačová was photographing pilgrimage sites in the summer of 1964, Koudelka was not far away, photographing in Roma settlements. He had never before seen a pilgrimage, and he was curious; he proposed that the two of them meet at the end of a given week to observe and photograph the Sunday pilgrims. "I remember the first pilgrimage that I went to. It was with Markéta. It was in this beautiful meadow in the middle of the mountains with a little church. . . ."

(At this point in his story, Josef momentarily digresses. "The place was called Ľutina — the local people pronounce it the same way as I say the name of my daughter, Lucina." Josef pronounces her name in such a way that the c is neither soft nor hard, but something

like "ts" in English: "Lutsina." Almost dreamily, he reminds "Lutsina" about her lovely namesake in eastern Slovakia.)

Luskačová winces as she recalls:

I would tell him the date and the place, and sometimes he would turn up . . . which for me was a nightmare! Josef was photographing in a way that I could not photograph at all. He was all over the place. He is Josef, you know: his gestures are big, he takes up a lot of space. But he was my friend. I didn't say "Don't come." But . . . before starting to take pictures I would pray: "Lord, please let him not come."

Koudelka too, recognized that the rhythm wasn't working:

I was very excited. I had never seen anything like that. Now I will never photograph together with someone like that. My rules are: The ideal thing is to photograph alone. But of course I have often traveled with other photographers, so the rule is, I go where I want to go, and you go where you want to go — but in a different direction. If you see a photographer photographing something that you think is very interesting, don't go to photograph the same thing. A better picture is waiting for you on the other side.

JK with two Exakta cameras, Slovakia, 1968. Photograph by Bohumil Puskailer

Koudelka adds: "I never wanted to do a project on the pilgrimages. I was very conscious that this was Markéta's project and respected that. I just wanted to get a few good photographs of the pilgrimages." He continues: "I loved Markéta's photographs very much. I thought she should exploit her subject completely, so no photographer could do it any better than her."

Koudelka has always had a remarkable ability to surround himself with the kind of friends, colleagues, and collaborators that we'd all want in our lifeboat. People seem to go out of their way (sometimes far out of their way) to be there for him. Luskačová recalls a time when he was using the darkroom and photographic equipment at the Prague airport and was having a problem with the fixer. Her phone rang, she says, at three or four o'clock in the morning. Koudelka launched right in: "Do you have fixer at home? Could you bring it?" Luskačová says:

Now, there were no night buses to the airport, and I had no money for a taxi . . . but I said: "Okay, I will." I called somebody who fancied me, woke him up at four o'clock at night, because I knew that he had a scooter. He arrived at my place, and he drove me, and the fixer, to the airport. I got some night porter to call Josef and I handed him the fixer.

What is amazing is that Josef did not ask me how I got there. He simply said: "Thank you very much, Markéta." I had to pay the man who fancied me! But for Josef it was absolutely normal that in the middle of the night he

wakes me up, and in the middle of the night I deliver to him the fixer. . . . So this streak in Josef was there from the beginning.

As Luskačová suggests, this "streak" may be bewildering at times, but for the most part, everyone in his sphere has come to accept it as part of Koudelka's obsessive, all-in way of being. And with Luskačová, he extended himself as well; he would immediately help her out if, say, she was in the middle of shooting and ran out of film — a commodity in very short supply at the time. "It wasn't that you would go to the shop and buy it," Luskačová notes; it had to be obtained on the black market. If she ran out of film while on one of her expeditions, she would call Koudelka in Prague, "and he would send me a package of film to where I was, by poste-restante." She brightens, remembering: "We were helping each other a lot when we were young."

The exchange of support was both practical and illuminating. Koudelka brought his willful, animated clarity to their conversations about each other's photographs as well. "It was always nonstop with Josef," she says. "All my pictures from Czechoslovakia went through Josef's hands. All Josef's pictures from Czechoslovakia went through my hands."

8.

In this period Koudelka was photographing both Roma communities and theater people. "With the Gypsies," says Koudelka, "it was theater too. The difference was that the play had not been written and there was no director — there were only actors. It was real, it was life . . . all I had to know was how to react."[48]

As Fárová had postulated, the theater had also prepared him in practical ways for photographing the Roma. He learned "how to shoot pictures in poor light conditions and how to develop them to get the result I wanted."[49] At first with the Roma, he was photographing with an SLR camera, and 25mm and 35mm lenses. "I knew something about composition, and you learn through the tools that you are using." Among the equipment that Koudelka bought from Jirí Jeníček's widow in 1963 was a 25mm wide-angle Zeiss Flectogen lens from East Germany (Jeníček had received it mistakenly when ordering a 3.5-cm lens years earlier). For Koudelka, it turned out to be an eye-opening instrument. "This lens changed my vision," he would later remark. "My eyes, my vision became wide angle."[50] To me he said: "Without this, I would not have been able to do with *Gypsies* what I did. I needed to work in very small spaces and I needed to isolate things. I wanted to have everything in focus — even in such minimal light. The 25mm lens permitted this."

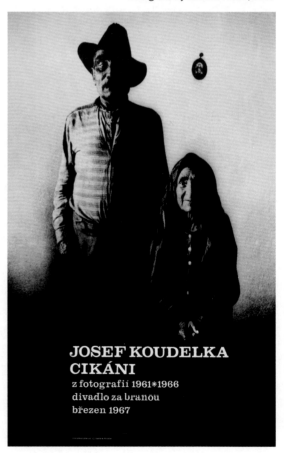

Josef Koudelka: Cikáni (Josef Koudelka: Gypsies), offset lithograph exhibition poster, designed by Ludvík Feller, 1967

JOSEF KOUDELKA CIKÁNI
z fotografií 1961∗1966
divadlo za branou
březen 1967

This is the process. The draw of the Roma project is more ineffable. At first he had been mesmerized by the music; his other senses were soon equally enthralled:

> *I picked up my camera, and I went. Photographing Gypsies was not very easy, and sometimes I wanted to stop. But I knew I couldn't stop, and . . . it was the music that made me start again. There was the discovery, and there was the fascination, and the feeling that you have to do something, and nobody can stop you, and that you will go to the end, as far as you can go with it.*
>
> *Jirí Jeníček told me: "Photography makes the subject, and the subject makes the photographer." With the Gypsies, I made my subject.*

While at some level, it may have been the "otherness" of the Roma that compelled Koudelka, his images rarely if ever exoticize them, and therein lies some of the work's power. Recalling the Italian neorealist films focusing on the poor and working class, and like the Farm Security Administration Depression-era images of farmworkers, poverty, and everyday life by Dorothea Lange and Arthur Rothstein for example,[51] Koudelka's photographs neither judge nor romanticize. His portraits — formal or otherwise, and "frequently posed by the subjects themselves"[52] — reveal days lived hard, and moments of connection and pleasure. Does Koudelka in some way empathize with these subjects? Not exactly. But in his images of the Romani people he offers a sense of humanity and dignity, both poignant and epic. From the beginning, Koudelka has always been drawn to uniquely expressive faces and gestures, to dramatic, ritualized moments, to the idiosyncratic, to the individuating element. Uniformity repels him — perhaps no surprise, given the political context of his young life. Lines are etched on weathered faces; dark eyes, often hooded, never shy away from the photographer's gaze; mischievous kids posture; musicians play.

Fárová considered Koudelka's early work with the Roma in her contribution to the brochure accompanying his first solo exhibition of these photographs, *Josef Koudelka: Cikáni, 1961–66* (Gypsies, 1961–66), presented in January 1967 in the foyer of Divadlo za branou:

> *He doesn't submit; he determines. He uses reality — the living, shapeable, and changeable material of the photographer — for his precisely defined and uni-directional developing intentions. The negatives that resulted from unadjusted reality are adjusted by him in the darkroom [when he prints]. . . . He simplifies and condenses the subject matter. He purifies it of random and secondary elements. He monumentalizes by excluding disturbing details. He perceives the events of life in overall features. . . . What is remarkable about Koudelka's photographs is his usurper vision. . . . The selected photographs of the Gypsies do not provide a precise objectively valid report; they do not seek to be a documentary, and anyway they are not even a personally biased statement. Rather, they are a willful stylization with the arbitrary use of reality.*[53]

Koudelka had never been interested in a project made up of only portraits. Still, he understood that, "in order to have access to the Gypsies, I needed to give

them pictures, so I started to make portraits of them. If you take a portrait, it's an agreement between you and that person, and Gypsies had never really seen photos, except for identity cards. But I also knew I needed to make other pictures which are coming from the spontaneous situation that I did not construct."

In 1967 Allan Porter, the American editor of the Lucerne-based magazine *Camera*, traveled to Prague for Interkamera, an international photography event serving Central and Eastern European photography proponents who were unable to travel easily to the West. Porter had succeeded Romeo Martinez, who had guided *Camera* as its editor from 1956 to 1964. Founded in 1922, the magazine was ambassadorial in its commitment to introducing the work of exceptional photographers (Europeans, mostly) to an international audience; by the 1960s the journal's texts appeared in German, English, and French. In Prague, Porter met Fárová at a dinner, after which she brought him to the Divadlo za branou to see Koudelka's *Gypsies* exhibition, which was to be taken down the following day. She apologized for the photographer's absence; he was, she explained, in Moravia photographing. Porter would later recall being "filled with exaltation by what I saw,"[54] and he immediately decided to publish a portfolio of the work in his magazine. Fárová selected the images and wrote an introduction to them. The piece appeared in *Camera* in November 1967.[55]

It was the first time Koudelka's photographs had been published outside of Czechoslovakia. Among the international viewers who saw his work was Peter Keen, photo editor at London's *Daily Telegraph Magazine*, who subsequently contacted Koudelka to see if he might serve as a potential Czech correspondent — an encouragement that would later play a meaningful part in Koudelka's trajectory.

Porter would not meet Koudelka in person until 1969, when the American returned to Prague. In Fárová's apartment, the three of them prepared for the next publication of the Roma work in *Camera*, in the March 1970 issue devoted to the theme of "The Community."[56]

Fárová continued in her self-assigned role as champion of Koudelka's photography. She was responsible for introducing his work to John Szarkowski, the influential director of the photography department at New York's Museum of Modern Art. She and Szarkowski had been corresponding and exchanging publications for many years by the time she wrote him on April 13, 1967, about a body of photographs "which I find exceptional from the point of view of subject and by the beauty of the photographs. It is the work of a young Czech who is called Josef Koudelka." She described his photographs of the Roma, adding a note of coaxing urgency: "These villages are in the process of disappearing, the populations will be dispersed . . . but [these photographs] are not mere documents."[57] She followed up soon after, sending Szarkowski twenty-seven prints from the series, writing Koudelka's name on the back of each print. They caught the renowned curator's attention. "I find the work of Koudelka to be of considerable interest," Szarkowski wrote back on October 6, "and would like to retain a few of the prints that you sent, in order to have this photographer represented in our collection."[58] He asked

KOJ 81008W00127/18

KOJ 80007W00161/20A

KOJ 73005W00534/24

KOJ 79001W00049/46

KOJ 77003W000067/11A

KOJ 77006W00129/14

KOJ 77002W00024/29-25A

KOJ78003W00097/9A

Collaged page from one of JK's *katalogues*, ca. 1985

the price for four or five prints. Fárová discussed it with Koudelka, and then got back to Szarkowski. Peter C. Bunnell, then an assistant curator at MoMA, wrote to Fárová on May 24, 1968, confirming the purchase of four prints: "We agreed on a price of $15.00 each, making a total of $60."[59] The remaining twenty-three prints were returned to Fárová.

She would carry on introducing Koudelka's images to people in the field who could be instrumental in his career and who could help to disseminate his photographs globally. In summer 1967 Fárová included his work in a group exhibition called *7+7*, presented at Prague's Špálova gallery. But she contributed in other ways as well: Koudelka credits Fárová's influence on his methodical working style in general, and especially with regard to *Gypsies*:

In that period, Anna was very important, because she was looking at my pictures from the beginning of the Gypsies. *She used to say that, as much as she might have been important for me, I was important for her, because it was the first time she was witnessing the creation. Usually, she said, she came in at the end. "I am" — the word in Czech she used was* "uklízečka" — *the cleaning lady, the woman who comes in and cleans the floor and puts everything in order, in the right place. She taught me to be systematic. She has got the idea of structure, and she divided these pictures into categories which were important. She said: "So this is the wedding; this is the funeral; these are the interiors; these are the portraits; these are people outside; these are groups; these are families; these are verticals; these go across. . . ." She made these categories, and I put them in the separate envelopes, these little work prints. So it really helped me to work systematically: I knew what I was missing in this way, and what I should concentrate on.*

In later years Koudelka would continue to employ such thematic groupings — children, faces, textiles, sleep, festivities — as well as distinguishing features in composition and format, as a method of organizing and considering his work. By the late 1970s, he was cutting out thumbnail prints of his

images from enlarged contact sheets and gluing them into variously organized *katalogues* — testing and playing with possible juxtapositions and sequences of form and content.

Photography scholar Michel Frizot describes certain pages in the *katalogues* as

> organized around figures isolated in space, geometrical perspectives, fractured and discordant spaces, centered or dynamic compositions, interplays of shadows, silhouettes with complex backgrounds, figures in the foreground, compact groups, children, hands, empty spaces, found objects, disparate primary signs, and so on. . . . [Koudelka] thought of himself as a "collector of photos," with no favorite themes. Essentially, he just wanted to be a collector of his own "good photos" and organize them so that they interacted with each other.[60]

About the Roma, Koudelka has no interest in making anthropological generalizations. "I'm not an ethnologist. I never considered myself an expert on the Gypsies." Still, throughout his work with their communities, he sought out and learned from experts intimately immersed in the Roma language and culture. Among them was Milena Hübschmannová, who would eventually initiate an academic program devoted to Roma life and culture at Charles University. Hübschmannová fought adamantly against their forced assimilation into mainstream Czech society, which was mandated under Communism. In the 1960s she and Koudelka sometimes visited Roma settlements together. Koudelka also befriended the linguist Jiří Lípa, who wrote about the tragic fate of the Czechoslovak Roma under the Germans, and the ethnologist and sociologist Eva Davidová, who documented her work on the Roma photographically. In time, he got to know the Romani physician Ján Cibuľa and the judge Gustáv Karika. Koudelka's work with the Roma was thus grounded in time spent, fact, trust, and friendship.

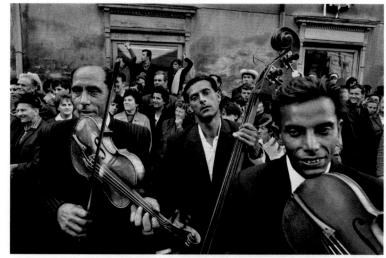

Moravia (Strážnice), 1966

When Koudelka was in his late twenties, in the mid-1960s, he was happy. Having been officially deemed an artist by the state, he had a right to a studio, which he obtained through the Union of Czechoslovak Artists. He was living in this basement studio on Pospíšilova Street in Prague's Žižkov district, and he was photographing constantly. He was learning at every moment, had a subject that excited him, and was surrounded by friends who wanted to help him realize his projects and innate talent.

One afternoon he was walking along the banks of the Vltava River. While taking pictures, he saw a couple repairing a small boat. They got to chatting; the woman asked him what he was doing, and he explained that he was an aeronautical engineer, as well as a photographer; he mentioned his work in the theater, and on the Roma.

"We had a canoe," the woman, Irena Zítková, tells me, five decades later. "I told him I was an editor at Mladá fronta [Young Front] publishing house. I asked him if he would come visit me. There was an immediate mutual sympathy. All of a sudden we're friends." Zítková and I are sitting in the famous Grand Café Orient, in an old part of Prague, in the cubist building known as the House of the Black Madonna. She exudes warmth and is solicitous — it is clear she wants me to understand. We are both editors and we seem to have an immediate mutual sympathy as well, as we discuss events of half a century ago. Derek Paton is with us, interpreting, as he has done during most of my interviews in Prague. Lucina is there as well. Koudelka whooshes in — the usual force of nature — to embrace Irena. He announces: "I consider Irena the mother of the *Gypsies* book," and then he whooshes out again, so she might tell me the story herself.

Koudelka dropped by her office at Mladá fronta soon after that serendipitous first encounter and showed her some of his photographs of the Roma, which she found very compelling. Zítková, a fiction editor, shared the work with her colleagues who worked with illustrated books. There was an immediate consensus that the photographs were strong and the project very worthy, and Mladá fronta wanted to produce a book of it. But, says Zítková, the grittiness of the images, and indeed the subject itself, were challenges. "It was a hard time to do it. Terrible. Politically, Gypsies were not acceptable as a topic in those days. . . . Everything was meant to be shown, to be seen, as *prosperous*."

As for Koudelka, he was instantly keen on the idea of making a book — curious about how his work might be orchestrated into the rules of a linear and bound presentation. Until that moment, he says, "I never thought about publishing these photographs, because my photographs were not permitted. I thought a book would be impossible."

In fact, Zítková was attracted to Koudelka's work for precisely these reasons: "The Gypsies in Josef's photographs were not sanitized — how they live, how they dress, how they eat. I thought it was important to show how it really is, to demonstrate that they have to live in better conditions."

While Koudelka has never considered his work a form of social advocacy, he fully understood the plight of the Roma. The individuals who had been lending their expertise and insights to his project were generally activists who wished to improve the lives of the Romani communities, and to protect them from being absorbed into the dominant culture against their will, and in this way erased. He reads a diary entry to me from 1975 (as always, he is responding to my questions in English, translating extemporaneously from what he wrote

in Czech). "Why the Gypsies?" he wrote. "You knew that you couldn't help the Gypsies. Gypsies existed, and you existed, and you felt something about it." He elaborates: "I wanted to show how the Gypsies live. Of course it would have been good to help change their conditions."

When his images of the Roma began to circulate, Koudelka says, he was "invited" to an office of the Central Committee of the Communist Party to meet with one of the apparatchiks responsible for "the Gypsy question." Koudelka was advised to "leave it alone" — if he did not, he was warned, he would run into problems. "They put a stamp on all people who meant well for the Gypsies, making it so hard for us to work." Indeed, at one point when he was photographing at a Roma settlement, he was arrested — ostensibly suspected of being a recently escaped convict: "I was in a Gypsy settlement. I'd had lice, so I'd shaved my head. And the police came. They arrested and interrogated me, saying I might be the prisoner who escaped."

Although it seemed in 1967 that state-mandated restrictions were loosening, Koudelka remembers that when he had his first solo exhibition of the Roma work that year, permission had to be obtained from a Communist "supervisor" — "a euphemism for 'censor,'" Zítková explains. "At that time," she reminds me, "officially the Gypsy problem didn't exist. You couldn't even speak about it." After some hesitation, and thanks in great part to her persistence, Mladá fronta committed to the book — and the publisher and other editors were prepared to stand behind it.

Cover proposal for *Cikáni* (Gypsies), designed by Milan Kopřiva, 1968

Designing a maquette was the first critical task. Koudelka told me that some years ago, wishing to jog his own memory about this process, he contacted Zítková to have her version of the story. She told him: "We gave you this graphic designer, and you said, after one meeting: 'He's not right for the book.'" Koudelka laughs heartily as he tells me this. "In fact, he was really the absolutely best person they could give me for the book. Everything I first learned about how to create a book, I learned from Milan Kopřiva."

Koudelka soon understood the distinctive nature of Kopřiva's eye. Like his own, it was perpetually hungry — "He looked at everything, *everything* around him." Kopřiva considered typography a powerful and crucial element, but more important to Koudelka was Kopřiva's rare sensitivity to photography. In the end, what perhaps most convinced the skeptical photographer were some suggestions Kopřiva made with regard to the book — which Koudelka liked, and would not have ever thought of on his own.

Koudelka had been a frequent visitor to the Národní technická knihovna (National Library of Technology) in Prague, where he looked at foreign

magazines on aviation, and sometimes perused the Swiss graphics monthly *Graphis*. But he had been exposed to few, if any, photography books. Anna Fárová and Libor Fára had an extraordinary home library. When Mladá fronta agreed to publish his book, Koudelka immersed himself in their collection:

> *I went to their home to have a look through the books, and I'd take notes. I tried to realize how the photography books are being made. Anna showed me whatever she had in her library. I was most impressed by the photos in a little catalog for an exhibition of the American Farm Security Administration photographers.*

He also discovered the work of Henri Cartier-Bresson — which, according to Fárová, he initially found "too psychological, based too much on coincidence or on the fleeting moment."[61] Kopřiva introduced him to Weegee's 1945 *Naked City* and William Klein's *Tokyo* of 1964.

Thus equipped, Koudelka began to formulate ideas about how his own book might take shape. Markéta Luskačová reminds him that when he took these ideas to Kopřiva, the designer's response was succinct: "Josef, it is going to be completely different." Koudelka smiles. "And he was right. He knew what he was doing." Creating the book was a collaborative process. "We were discussing everything — the selection and the layout. Kopřiva came up with the idea of the vertical format, the gatefolds, and photographs going across a spread — two pages — which worked very well with the more complicated pictures." The horizontality of the spreads and the gatefolds also echoed the 25mm wide-angle lens Koudelka had used for so many of the photographs. Other spreads featured a single image opposite a blank page, or two images facing each other.

As the design began to come together, the book's text needed to be addressed. Initially, it had been suggested that the renowned poet Karel

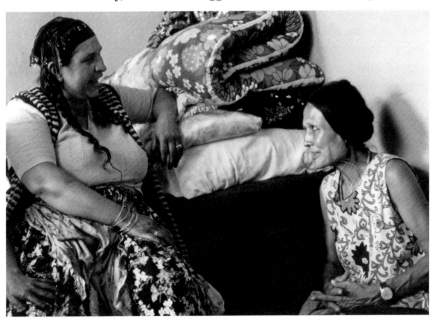

Milena Hübschmannová (right),
Turkey, 1986

Šiktanc might contribute a series of accompanying poems — but Koudelka had no interest in pairing his photographs with poems, and they were quickly set aside. He says: "I was compiling information for the text on Gypsies by myself, from different sources, beginning from when they left India. I wanted it to be composed only from the facts." As for the discussion of the images themselves: "I wanted the text on me and on my photographs to be written by Anna Fárová. That would be her participation in this book. She did not participate in the maquette or layout or selecting pictures for the book — that was Kopřiva and me."

Koudelka's desire for straightforward facts about the Roma stemmed partly from an urge to avoid what he saw as a heroizing attitude toward them that some Roma advocates — including his friend Milena Hübschmannová — tended to adopt. She proposed a text for Koudelka's book that he ultimately rejected:

> Milena was a fantastic woman — I have great admiration for her — but she was much too emotionally involved with Gypsies. For me, Gypsies were like any group of people — some great, but some who were not so good. Not for Milena . . . for her, everything that the Gypsies did was good. There was this group of Gypsies in Prague, on the principal street, and they were stealing, sometimes using the children. But for Milena — no, they were not stealing. They were beautiful people who were out with their children. . . . She was just not able to accept — which I loved in her! I loved it, because I was not like that. But her text was . . . too romantic. I called her "Santa Sara" [the patron saint of the Roma people].
>
> But still, she knew so much, and it was great to see the Gypsies with her.

Given his predilection for photographing alone, I asked Koudelka about the dynamic when working alongside Hübschmannová. He had taken her to visit some Romani settlements in Slovakia, and in early August 1968 they traveled together to Romania. Most of the time, Koudelka told me, they worked separately, as he was photographing and she was recording oral histories. One of her projects was interviewing Roma who had survived Auschwitz. "Gypsies did not want to talk about the concentration camps," he recalls; "she really needed to push them to speak."

At the start of their 1968 trip to Romania they were joined by Grattan Puxon, an activist who has devoted his life to fighting for the rights of the Roma and Travellers (as they are known in Ireland and parts of England), and who is married to a woman who is Romani. Puxon formed Britain's Gypsy Council in 1966. He had come to Czechoslovakia in 1968 especially to meet Hübschmannová, along with Koudelka, even though the political situation in the country was becoming increasingly uneasy. Puxon told me:

> Our plan was to travel in her car to Bratislava and other towns, as I wished to meet with Roma leaders in preparation for the First World Roma Congress [which would eventually take place in April 1971]. I found the atmosphere very tense. . . . Nevertheless, we set off through the countryside, which appeared

Rebels performing at Lucerna concert hall, Prague, 1967

peaceful. Josef had his camera and a load of film, which I felt only added to the danger.

Puxon says that Koudelka seemed shy at first, but later relaxed enough to joke around. "He always carried that huge stock of film. He told us he had two hundred rolls on that trip. . . . Nobody would stop him from taking pictures." For the most part, Koudelka photographed Roma who lived in settlements and were no longer nomadic. Puxon explains that many Romani people in Czechoslovakia had been forced to change their way of life beginning in the 1950s, as authorities had removed the wheels from wagons, impeding their ability to travel. Others, in older settlements, had quarters where they stayed during the winters, and traveled only in the summer.

Puxon spoke of Koudelka's images:

He caught exactly the life of Roma out in the villages: the poverty, the small dwellings, the unmade-up roads. I had been living the same way in Ireland, except there we were continually moved on: wagons and horses had to be hitched almost every day because of the police. . . . I was glad that Josef was capturing this life . . . but in a way it was too late.

9.

"I was not political," Koudelka states definitively.

To be political in Czechoslovakia in that time meant being in the Communist Party, which I was not. But in the period of the Prague Spring in '68 everybody in the society became involved in politics. Czechoslovakia had been a country where nothing was possible, and suddenly, everything was possible, and everything was changing very quickly. What was happening in Czechoslovakia was about regaining freedom.

Louis Armstrong (left) performing at Lucerna concert hall, Prague, 1965

In January 1968 Alexander Dubček was elected first secretary of the Central Committee of the Czechoslovak Communist Party, with promises of immediate reforms — on many of which he delivered. In the years leading up to his election, the repressive Soviet grip had already loosened somewhat, but Dubček's policies began to officially restore freedom of expression and mobility that had not been enjoyed in Czechoslovakia since before the German occupation of World War II.

Koudelka, like many reflecting on this period, credits activist writers with making one of the earliest calls for more freedom. In June 1967, at the Fourth Congress of the Svaz československých spisovatelů (Union of Czechoslovak Writers), Milan Kundera opened the meeting, and was followed by many other writers who bravely stood up and spoke out against censorship, and on matters of truth and conscience.[62] It was also in 1967 that Miloš Forman, one of the key film-makers in the Czechoslovak New Wave, made his satirical prod at the Communist system, *Hoří, má panenko* (*The Firemen's Ball*) — the last film he would make in his homeland before emigrating to the United States a year later.

This period of apparent liberation, which would soon come to be called the "Prague Spring," touched everyone but had singular resonance for artists. For the first time in Koudelka's life, artists working in any and every medium felt they could express themselves openly, without fear of recrimination. There was some trepidation, but the sense of relief was palpable. The future seemed full of hope and promise, not only in the larger cultural sense, but also in the pleasures of everyday life.

Five years younger than Koudelka, Pavel Rohan was a student of mechan-ical engineering in Prague when they met in the early 1960s. Born in the United Kingdom and raised in Czechoslovakia, Rohan is now based in London, where he long worked as a journalist for the BBC. We spoke on the phone, and he recalled the lively mid-1960s in Prague, where he and Koudelka often ran into each other at concerts, some of them held in the "hall of residence," described by Rohan as "a Soviet-style compound consisting of six blocks and a huge refectory with a stage where the concerts were held." He characterized the bustling music scene as "the Czech rock-and-roll era" — and there was also a lot of American-style jazz being performed. "Josef used to hang around the concerts, taking photographs of the musicians."

Pavel Dias recalled going to hear Louis Armstrong with Koudelka in 1965 at Prague's Lucerna concert hall. There was a jam session afterwards: "Josef, with his Exaktas in a metal case covered in light leather, was hopping around Satchmo and his friends and snapping one photo after another." In these years Koudelka photographed everything from jazz concerts to dance performances to Czech bands such as Rebels and Plastic People of the Universe. He and his friends were mostly broke — they could not afford to buy tickets — but, as Markéta Luskačová explains, there were ways around this inconvenience:

> *Five minutes before the start of the performance, theater ticket offices were giving away the remaining tickets for that evening for free to university stu-dents. . . . It was good for the theater, and the actors always prefer to play in front of a full audience. And it was great for us! You just had to be clever and plan to see the theater performance at the end of its run, and then there was a 99 percent chance that there would be a free ticket . . . and one could get two tickets. So Josef and I were in the theater very frequently.*

PAUSE

In late 2018 Josef made the out-of-the-cosmos announcement (out-of-left-field doesn't begin to describe my shock) that he would share his contact sheets with me, now that they had all been digitized. Manna from heaven! My appetite to understand the minutiae of 1960s daily life in Prague was huge. When I'd asked him about the specifics of the era — the clubs, the parties? How were people dressed? What were they eating and drinking? Did they dance? — he responded with shrugs. Plainly in the hierarchy of memories, these old impressions were, for him, trifling at best.

The contact sheets provided an enlightening, comprehensive visual record of every particular. It truly seems that Josef was never, ever without his camera. Get-togethers in his studio; young men and women, elegantly dressed, heading out to dance; smoky, dimly lit clubs; buoyant crowds; and always musicians fill these pages in all their thumbnail-sized, Holy Grail glory.

Gathering at JK's studio, Prague, 1967. Karel Hvížďala is on the couch, with head resting on hand

As we pored through the sheets at his place in Prague, I could sense his mood shifting from duty-bound (I had come all that way from New York just for this, after all) to exhilarated curiosity.

At first I felt a bit like the straight man in a comedy routine. "Josef, do you have an image of Markéta when she was photographing?"

His automatic response: "No."

But then, after some cheerful coaxing and eye-rolls on my part, he slowly began to scrutinize the notebooks of contact sheets, precisely organized by date and place. Watching Josef's eyes scan the page is like watching a raptor preparing to dive-bomb its prey. He's not peering through a loupe, and he has not looked at most of these contacts for perhaps fifty years, yet he zeros in on — and recognizes — all the people I'm hoping we'll find. In fact, many hours, many days later, Josef has pinpointed everyone I was looking for, and is exultant — with both the success of the hunt and the

pleasures of the reminiscence. More impressionistically, the long yearned for, newly regained freedoms at the heart of the Prague Spring were explicit and implicit throughout.

10.

On the night of August 20–21, 1968, everything changed. At 4 a.m. Koudelka, back from Romania, was awakened by a phone call from his friend at *Divadlo* magazine, Marie Šejnová. She was wildly upset: the Russians, she shouted fearfully into the phone, were invading the city.

As I sat with her in her Prague apartment in 2015, Šejnová recalled the events of that fateful night:

> *We were having a party at the* Divadlo *offices with some Dutch guests. And we heard airplanes — one plane after another. A friend came home from the airport. She said: "The Russians are here, the Russians are here!" because she saw the planes.*
>
> *I called Josef immediately. He didn't believe me right away when I called. We were a little drunk. Even with what had happened in Hungary [in 1956], no one thought that anything like this — no one dared to think this could happen. So any news like that could be considered a joke. No one thought it would really happen here.*

Certain it was a drunken prank, Koudelka in fact hung up on Marie. Twice. On the third call, she insisted that he open his window and listen. He did so and immediately recognized the sound: military planes.[63]

Forty years later, Koudelka would inscribe a copy of his book *Invasion 68: Prague*:

> *To Marie, who on the night of the 20th to 21st of August 1968, woke me up and screamed into the telephone: "The Russians are here!" And because of you, I took my cameras and went out into the streets to photograph. Marie, this book wouldn't exist without you. Thank you.*

JK photographing Soviet invasion of Prague, August 1968. Photograph by Oldřich Škácha

Hearing the planes, Koudelka quickly dressed, grabbed his two Exakta cameras and 25- and 35mm lenses, and whatever film he had, and impetuously took to the streets in the early morning light — with no notion of what might lie ahead.

He first went to the headquarters of the Československý rozhlas (Czechoslovak Radio) in Prague, a fifteen-minute walk from where he lived, assuming he might find some reliable information there. Ironically this was the site where, at the end of

World War II in 1945, the Russians helped defend the Czechoslovaks against the Germans. "The Russians actually had come to liberate us. Then," says Koudelka. At 5:30 a.m. on August 21, the station was alerting listeners to an illegal radio transmitter of the Soviet armies that was broadcasting misinformation in "bad Czech and bad Slovak"; Czechoslovak Radio meanwhile beseeched the public to remain calm, not to provoke: "Do not give anyone a pretext for armed interventions." The station then pledged its allegiance to "the legal government, the Dubček leadership of the Party, and the Czechoslovak president."[64]

Posters, Prague, August 1968

From that moment and over the following seven days, Koudelka would shoot about ten thousand images on 261 rolls of 35mm kino-film. He threw himself into unrestrainedly bearing witness to "the end of a beautiful dream of freedom," as Soviet-led Warsaw Pact tanks invaded Prague, while the people of the city — unified in solidarity, whatever their individual politics — peacefully, determinedly, resisted. "Everybody was Czechoslovak," says Koudelka. "That's all that mattered. It was an exceptional moment and it brought out something exceptional in all of us."

Koudelka had never considered himself a photojournalist; in his thirty years, he had in fact seen almost no photojournalism. That week, however, his intuition and passion drove him to document — for evidence, for proof, for truth, and against the fallibility of memory: "I found myself facing something bigger than myself. It was an extraordinary situation, where there wasn't time to reason, but it was my life, my story, my country, my problem."[65] All that Koudelka understood about the emotive authority of a given gesture, of facial expressions, of individuals interacting with each other in unspoken yet communicative ways, was based on his years photographing both the Roma and theater. Those experiences, combined with his deep disdain for false narratives, as well as his innate shrewdness and physical agility, is evident in this galvanizing reportage. He already knew how to see. Here, he learned a new way to look, having to rely on his physical and emotional instincts more than ever before. Control, while never lost, gave way to crucial spontaneity. A sense of purpose, charged with adrenaline, took hold.

In a way, these inescapably close-up pictures of the Czechoslovak people banding together in nonviolent defiance represent the last time Koudelka would be visually drawn to the sense of community that so permeates his images of the Roma settlements, and even Divadlo za branou. It is also perhaps

the only time that Koudelka was possessed by an urgency to record all that he saw. Even with his countless images of the posters that the Czechoslovaks created and put up all over Prague, this was not about making what he thought would be great photographs. Rather, "I knew the posters would not exist tomorrow, and I wanted a record. I wanted a record that showed how the people were resisting peacefully, without weapons, but with their words, their drawings and graphics, and with clever ideas."

Czechoslovak President Ludvík Svoboda later summarized the situation in Prague on August 25, four days after the start of the invasion:

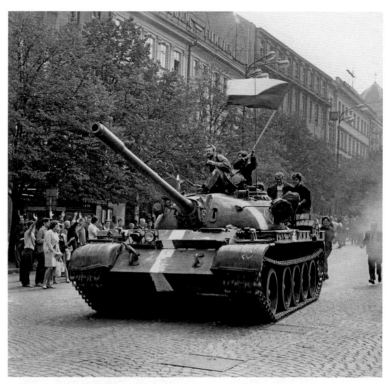

JK photographing atop a Soviet tank, Prague, August 1968. Photographer unknown

> *Prague changed overnight. The occupiers were tearing down slogans, posters, and appeals to the citizens. To no avail! New ones were up by morning. Prague is like one huge poster. "Occupiers go home!"*[66]

In another stealthy move, street signs and numbers locating people's homes were quietly taken down by Czechoslovaks of all ages. Signage at intersections was painted over or destroyed, so that "only those people who should know would be able to find their way around the city."[67] Or, as President Svoboda put it: "Let the occupiers, traitors, and collaborationists find their way!"[68]

At the same time, Koudelka noted that he felt a kind of sympathy for the young Russian soldiers, many of whom seemed genuinely to believe that they had been dispatched to liberate the people of Czechoslovakia:

> *They were completely confused. They didn't know where they were. They were surprised that the Czechoslovaks didn't want them there. Strangely enough, I felt no hatred toward them. They were young men like me. I knew they weren't responsible for this. The tragedy was that I lived under the same system as they did, and what happened to them could also happen to me. One day I, too, might find myself in an armored vehicle somewhere in Budapest or Warsaw.*[69]

Decades later, in an interview with Anna Fárová, he described the tanks:

> *They were carrying foreign soldiers who were wearing berets. Then came the armored personnel carriers, which is shown in my vertical photograph, and how people are moving towards them and pushing them back. . . . The people there formed a mass and they wanted to stop them. The drivers really did stop*

their machines; they didn't want a real clash. I think that at least at first they had orders to avoid bloodshed.

The soldiers were completely baffled.[70]

In recent years, a number of writers and journalists have noted Koudelka's interest in photographing endings: the death of things. Although it has never been his conscious intention to focus on this, he acknowledges that the observation makes sense. If something is going to endure as is, why photograph it?

I am interested in photographing what is going to finish soon, trying to show what still exists and what is not going to exist anymore. I know that everything is one day going to be finished. I knew the Gypsies would become more and more assimilated. The invasion of Czechoslovakia: the dream of freedom — freedom of expression, freedom to travel . . . that grew during Prague Spring would no longer exist. So many of the landscapes I have photographed — landscapes that have been destroyed by man — I see these landscapes as showing the end of harmony between man and nature.

It might be said that Koudelka has spent his photographic life focusing on the ephemeral, and that his own habit of returning to his subjects and to places is a way of tracking disappearances in real time. But there is another perspective from which to consider this. Koudelka photographs people and things that stand firm, resisting eradication. Czechoslovak civil-

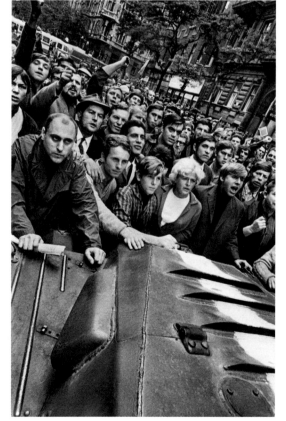

Crowd pushing against Soviet armored personnel carriers at Czechoslovak Radio, Prague, August 1968

ians in the face of Soviet tanks. The Roma persisting in their way of life despite political and social pressure to conform and assimilate. Actors, in character every night, creating indelible impressions for all who experience the production, long after the play has closed. A landscape — devastated, razed, walled — and yet renewing itself. Resilience. What if there are no real endings for Koudelka, but only evolving realities, springboards to whatever comes next?

Moving, continuing, never stopping. I am not leaving anything. . . . It's not that I suddenly drop the Gypsies, or the theater. . . . I may not photograph them anymore because life has changed and I am not confronted by the same situations. But one builds on what came before.[71]

This commitment to continuity complements his fundamental hopefulness, even when confronting the most tragic situations — and a sense of tragedy decidedly infuses many of Koudelka's subjects. Years later, he looked back at those fateful days in 1968 and observed: "I never could have imagined that when people are united by something, in this case a threat, they would be able to change so much."[72] He elaborated: "I felt that everything that could happen in my life was happening

in those seven days: Drama. Celebration — which could easily lead to tragedy. Love. Death."

Over the course of that week Koudelka returned to his studio where he lived on Pospíšilova Street only to replenish his film supply. During these brief hiatuses, he was always afraid that he might be missing some important activity in the streets. At least once, however, his absence from the action might have saved his life — when an explosion outside the radio station killed many people.[73]

British photographer Ian Berry was one of the few foreign journalists who made it to Prague on the first day of the invasion. Years later he described how important it was to move swiftly, as the Russians, when they saw anyone taking photographs, would give chase, spraying gunfire, overhead but near enough to terrify. He said:

> *The only other photographer I saw was an absolute maniac who had a couple of old-fashioned cameras on a string round his neck and a cardboard box over*

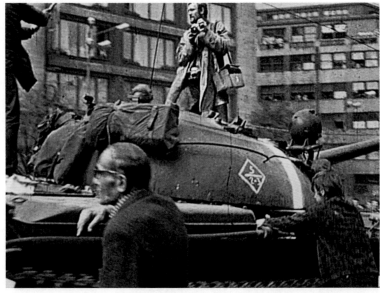

JK photographing atop a Soviet tank, Prague, August 1968

> *his shoulders, who was actually just going up to the Russians, clambering over their tanks and photographing them openly. He had the support of the crowd, who would move in and surround him whenever the Russians tried to take his film. I felt either this guy was the bravest man around or he is the biggest lunatic around.*[74]

Journalist Karel Hvížďala was there during the invasion and remembers seeing Koudelka "jumping — no, flying — across the tanks photographing everything. The Soviets were chasing him. People were hiding him in the shops." One of Koudelka's folk music bandmates recalled: "All of a sudden, I saw that he was standing on a tank and photographing this soldier who had his finger on the trigger. And I bellowed at him: 'Josef, you fool, jump! He's going to shoot!'"[75]

Koudelka adamantly dismisses any notion of his own courage. "Bravery," he says, "is something else. It is what those Russians had, the ones who had already lived through Stalinism and went to Red Square to protest the invasion of Czechoslovakia." He is referring to the group of eight Soviet dissidents who, on August 25, 1968, stood up against the Soviet invasion by peacefully demonstrating in Moscow's Red Square. Five were subsequently arrested, two were sent for psychiatric evaluation, and one recanted. In October of that year, the first "trial" took place: five were found guilty. A sixth was deemed insane.[76]

One of the eight protesters in Red Square that August day was the poet Natalia (sometimes transliterated as Natalya) Gorbanevskaya, a young mother pushing her newborn in a carriage. She was arrested and detained that first night while their homes were searched, but was then released most likely because she had recently given birth. Gorbanevskaya was re-arrested in December 1969, and was first detained in Moscow's Butyrka prison and then sent away for two years, during which she was shuttled between the Kazan Special Psychiatric Hospital and the Serbsky Psychiatric Institute. Before her own sentencing, Gorbanevskaya vigilantly followed the earlier trial of the other protesters, and wrote a detailed account of all that had transpired. This was smuggled out of Russia to the West, and eventually published in English as *Red Square at Noon*. Years later, discussing her own KGB-enforced psychiatric punishment, she said: "It's almost impossible to describe." One of the horrors was that "you are locked up for an unspecified amount of time. It can be forever. . . . They set out to destroy you."[77]

When Koudelka considers these courageous Soviet dissidents and the principles for which they willingly sacrificed their own freedom, he does so with unreserved reverence.

In the foreground of the photograph is an arm bearing a wristwatch; the hand is clenched. Prague's Wenceslas Square is in the background, utterly deserted. This was to become a signature image both of Koudelka's work and of this pivotal moment in Czechoslovak history. Koudelka says:

> It was August 22. We heard there was going to be a big protest in Wenceslas Square at 5 p.m. and it was already filled with people. But right before, Czechoslovak Radio and the police urgently told people to clear out of the Square, to not demonstrate that evening as planned, so as not to give the Soviet occupiers a pretext for a massacre. The protest was not real. The people realized we were being set up and listened. That's why I thought that I had taken the photograph of the hand with the watch at 6 p.m. in the evening. But you can't rely on your memory.

Koudelka had never been sure whether the watch read noon or six o'clock in the evening. This was frustrating, as when he was preparing his book *Invasion 68: Prague* in 2007, he wanted to sequence the images chronologically. Serendipitously, nearly four decades after the fact, he received a call out of the blue from a Czech named Milan Jílek, with surprising news: "I am the one you photographed — with the hand!" (Koudelka was skeptical at first, but Jílek had indisputable backup for his claim, telling Koudelka: "I have proof, because I photographed *your* hand.") Koudelka finally understood that indeed, the image was taken at midday: "My memory was so clear about wanting to take that photograph when no Czechoslovaks would be in Wenceslas Square, and I thought the time should be documented." In fact, he had forgotten that the square had also been temporarily emptied of people earlier that day because

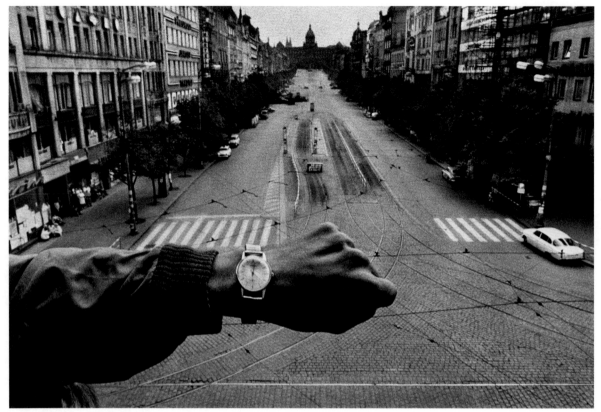

the Czechoslovak Communist Party had called a general strike against the occupation between noon and 1 p.m.[78]

But on that same August day, when Koudelka climbed to the top of one of the buildings near Wenceslas Square in order to photograph, from above, the protest that he still thought was happening at 5 p.m. (before learning it had been a ruse), the Russian soldiers saw him. Likely assuming that he was a sniper, they started chasing him. Koudelka was afraid not only of what might happen to him should they catch him, but also about the fate of the rolls of film he'd already shot that day and still had on him. He ran through the building and hastily stashed fifteen or twenty rolls of exposed film with a friend from the theater who just happened to live in the building, before the Russians eventually gave up the chase. It was the only time he had ever entrusted his film to anyone. He told his friend he'd come back as soon as he could to retrieve it.

By August 27 the invasion had ended. Koudelka's voice still gets hushed as he recalls learning that "one of the key conditions in the Soviets' agreement to remove their tanks from the streets of Prague was the re-establishment of censorship" — freedom of expression without fear of reprisal being perhaps the most cherished achievement of Prague Spring. This period of "normalization," during which the restrictions of hard-line Communism were restored, and which lasted until the Velvet Revolution in 1989, is often referred to as the Soviet "occupation."

When Koudelka returned to his friend's place to recover his film a few days later, he learned that the man had already given the rolls to someone to take to Radio Free Europe in Vienna. ("I wanted to kill him!") Within days, Koudelka was on a train to Vienna.

You could still leave Czechoslovakia then, and I had a passport. There were controls, but you could get through. Radio Free Europe in Vienna had already sent four or five rolls of the film to their main office in Munich, where they developed these rolls. I was told that they were not interested. Luckily the rest of the film stayed in Vienna so I could at least recuperate those rolls. But I never got back the film that had been sent to Munich.

Koudelka took the rolls he retrieved from Vienna back to Prague, but realized he had no images from the night of August 22: "The rolls that went to Munich that I never got back were most likely the images I photographed in Wenceslas Square that evening. If I had these evening photos, I would have understood right away that the hand photo was taken earlier in the day."

Years later, he spoke with Fárová about his images of the Soviet invasion:
It is not important in them who is a Russian and who is a Czech. What is important is who is holding a weapon and who isn't. And the one who isn't holding a weapon is actually the stronger, even though that is not immediately clear.[79]

The images are, he tells me, "proof of what happened." In subsequent years, Koudelka would encounter Soviet soldiers who had participated in the invasion of Prague, and who continued to insist that they had come to liberate Czechoslovakia. When he takes issue with this assertion, reminding them of the bloodshed, he says, these ex-soldiers often deny that any killing took place. "So I can show them my Prague 1968 photographs and say: 'Listen, these are my pictures. I was there.' And they have to believe me."

Otomar Krejča would later write about this work:
The curtain went up late that night, in the very early hours of the morning, on an apocalyptic performance. The first rays of summer outlined the monstrous

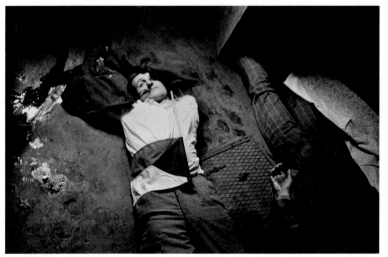

Bodies of two Czechoslovaks killed during the Soviet invasion, Prague, August 1968

shadows of huge cargo planes that landed with the rumble of thunder. Hundreds of other monsters, regurgitating the stench of oil, bulldozed through squares and streets named after saints and great men. In the turrets of tanks, young eyes, wide with fear, contemplated the majestic peace of old Prague. . . . In a flash, Josef saw the drama spill over from theatre into the mortal theatre of life.[80]

Koudelka's coverage of the Soviet-led invasion gave the young photographer — already mistrustful

of words and of memory — an immediate appreciation of how photographs could irrefutably record and corroborate the facts. This would manifest itself in his daily life, for example in those images he began taking in the early 1970s "to document my life — where I sleep, what I eat. . . . These are not self-portraits. They show what happened, where and when."

As an act of political protest over the crushing impact of the invasion of Czechoslovakia, twenty-year-old Jan Palach, a student at Charles University, set himself on fire in Wenceslas Square in mid-January 1969; his was the first of several suicides or attempted suicides by self-immolation. Palach's funeral evolved into a mass demonstration. More protests followed, not just in Czechoslovakia, but in other Communist countries as well. Still, by spring 1969, the stranglehold of Communist oppression and the harshness of pro-Soviet "normalization" policies began to pervade the daily lives of the Czechs and Slovaks — especially after Dubček was replaced by the Slovak Gustáv Husák as the head of the Communist Party in April. One by one, the reforms that had been realized during the Prague Spring were rolled back, and alliances between Czechoslovakia and the rest of the Socialist bloc were strengthened.

11.

By September 1968 Prague had grown quiet, its spirit broken. Koudelka, understanding how critical it was to protect his record of the events, and seeing "nothing more to photograph," furtively developed all the film from his coverage of the invasion and the ensuing weeks. He then made contact sheets and began to make prints — some of which he gave to Fárová for safekeeping. He had to be vigilant. The Soviets could not be allowed to find out that he had taken these photographs, let alone that he was going to try to get them to the West. The photographs would inform the world of the brutality that had transpired — which the Soviets continued to deny. If confiscated, they would place Koudelka, his family, and anyone attempting to help him in great peril, and could also be used to implicate anyone seen in the pictures resisting the Soviets.

Koudelka knew that he must act quickly. The first of several people he enlisted for the potentially dangerous task of smuggling this work out of Prague was a twenty-two-year-old Englishwoman he met one evening through his friend Pavel Rohan. Elizabeth Skelton had traveled to Prague in early fall 1968 to be with Rohan, her boyfriend at the time. When we spoke on the phone in 2014, Skelton described Koudelka in that period as "a wild man," adding:

> He didn't have social graces, he didn't exude charm the way he does now. He was sort of impatient and he never really talked to me much. He had this big black beard, long black hair, and he was kind of gangly. He would walk into a room and he would be really hyper. But at the same time, it didn't seem like it was about wanting to draw attention to himself. He just had this huge energy.

One night shortly before Christmas of 1968, Koudelka arrived at a party at Rohan's carrying a large envelope. "It had maybe ten to twenty photos in it," says Skelton. "He knew I was going back to England for a little while over the holidays to see my parents, and he asked if I could take the envelope with me." Even if Koudelka had known at that point that he'd be traveling to London the following spring, it would not have mattered: foreigners carrying luggage did not provoke Soviet suspicion as a Czechoslovak doing so might. Skelton recalls that Koudelka asked her to drop the package off at London's *Daily Telegraph Magazine*, to the attention of Peter Keen, the picture editor who had contacted him after seeing his work in *Camera*.

Until she was on the train, it had not really occurred to Skelton that there might be any risk involved:

To be truthful, I had never really considered the consequences had one of the Russian guards (and there were many on the train) opened my suitcase. I knew I would be in trouble, and I had not prepared an explanation. So I was quite nervous when they came into my compartment. I was pretty politically naive. I'd just stuffed them at the bottom of my suitcase.

She made it safely to London and delivered the photographs to Keen. But they would not be published immediately. It was now December 1968, four months after the invasion, and while the images were clearly powerful, the content was no longer timely. But the British picture editor did safeguard the work for Koudelka.

There was a thwarted plan, Koudelka tells me, to get a second batch of images out of the country in the hands of Václav Havel, whom he knew from the theater world, and who had been invited to the United States by the playwright Arthur Miller (they'd met briefly in Prague in 1969 when Miller, then president of PEN International, was there to show support for Czechoslovak writers). Ultimately, however, Havel was unable to obtain permission to leave the country. Nevertheless, in April 1969, another group of Koudelka's photographs was smuggled out of Prague. This time they were carried by the American photography historian and curator Eugene Ostroff. Magnum photographers Henri Cartier-Bresson and Elliott Erwitt had independently suggested that Ostroff meet with Fárová while on a visit to Prague.[81] She took the opportunity to show the curator a group of Koudelka's invasion photographs that were in her possession. Ostroff asked if he might take some back to the States with him to show Erwitt, at the time the acting president of Magnum Photos.

Erwitt was riveted by the handful of images that Ostroff showed him and was keen to see more. He contacted Fárová to ask if Koudelka might send Magnum his negatives — or at least a selection — from his coverage of the Soviet invasion. Koudelka, still stung by the loss of the negatives his friend had given to Radio Free Europe, was reluctant to part with them. But Fárová, who had worked with several Magnum photographers, assured him that the agency could be trusted. And it was clearly safer to get the work out of Prague. Finally, Koudelka agreed.

But how?

At some point in our nine years of conversations, he has a flash of recollection: "Joe Cooper!" Retrieving the name from the depths of his memory pleases him. Joseph D. Cooper was an American physician and amateur photographer who had written and published "pocket companion" manuals for Leica, Pentax, Minox, and other camera companies. Cooper traveled to Prague in 1969 to attend a medical conference and, through Erwitt's guidance, arranged to transport Koudelka's negatives back to the United States in his luggage.[82] Meanwhile, in order to make some money for eventual travel, Koudelka sold a group of prints in early 1969 — at least twenty: ten of the Soviet invasion and ten from the Roma work — directly to an American professor named Allan Stone, who had a professorship at Charles University in fall 1968.[83]

As some mobility still remained possible for Czechoslovaks through much of 1969, in spring that year, the Divadlo za branou troupe traveled to London to perform at the Aldwych Theatre as part of the World Theatre Season festival. In conjunction with this, Koudelka received permission to make his first trip to England that April to mount a small exhibition of his photographs in the theater's foyer.[84] He was also allowed to return to London in July and remain for what would be a transformative three-month period.

To commemorate the first anniversary of the Soviet invasion of Prague, London's *Sunday Times Magazine* finally published a selection of Koudelka's photographs on August 24, 1969. Magnum had provided the images for publication, but did not, of course, divulge the photographer's name — information that Fárová had made clear would have endangered Koudelka

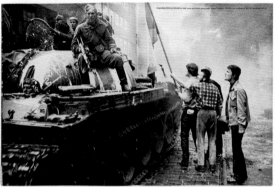
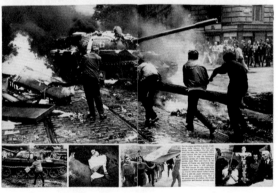

"Anniversary," *Sunday Times Magazine* (London), August 24, 1969, featuring photographs by JK

and his family, colleagues, and friends. Instead, on the back of the photographs was written "P.P." for "Prague Photographer." The anonymous creator of the pictures had not been alerted to the publication, but as he was in London, he happened to see the issue of the magazine the morning it came out. "It was a strange feeling," Koudelka later told Karel Hvížďala, "to see my photographs published and not to be able to tell anyone they were mine."[85] The accompanying copy in the magazine informed readers: "We mark that anniversary today with these pictures, taken by a Prague photographer a year ago and newly smuggled out."

In the United States, Magnum arranged for a selection of the photographs to appear in *Look* magazine, where they were published September 9, 1969. "Czechoslovakia," reads the headline; "Exclusive photographs smuggled from Prague document the sorrows of a year ago, when a people struggling toward

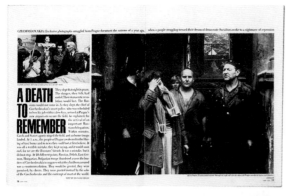

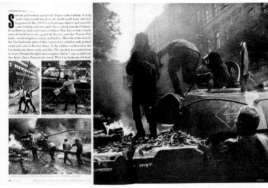

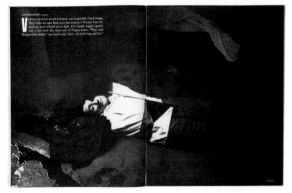

"A Death to Remember," by Leonard Gross, *Look*, September 9, 1969, featuring photographs by JK

their dream of democratic Socialism awoke to a nightmare of repression." (Oddly, the same issue of *Look* features a story on "The Suburbanization of Svetlana: Stalin's Daughter Talks about Her New Life" — in Princeton, New Jersey.)

Print media were not the only outlets for Koudelka's Soviet invasion photographs; they were also featured that August on the *CBS Evening News* — again courtesy of Magnum.[86] Erwitt had taken a selection of the images and sequenced them into a short, slide-show-like film — crediting them to an anonymous "Czech photographer." The segment was introduced by Walter Cronkite, with Charles Collingwood narrating what had happened during that week in Prague a year earlier. The piece incorporated an excerpt from Morley Safer's onsite reporting during the invasion: Soviet gunfire explodes in the background as the Czechoslovak people carry out their nonviolent resistance.

Although Koudelka was not yet a member of Magnum — was not yet even contemplating that possibility — he was permitting Magnum to distribute this work. For its part, Magnum was happy to support the young photographer, knowing full well that the material was unique and of consequence. In this way, the association benefited Koudelka and the agency — both financially and in terms of disseminating important content. In 1969 the unidentified "Prague Photographer" was awarded the prestigious Overseas Press Club's Robert Capa Gold Medal for his 1968 reportage on the Soviet invasion of Prague.

The reach of these images expanded: They were incorporated into two films (and credited to Magnum). They are seen in the final minutes of Costa-Gavras's movie *L'aveu* (*The Confession*, 1970), based on Artur and Lise London's 1968 book of the same title.[87] Artur London, who had held a leading position in the Communist Party in Czechoslovakia, was arrested by state security forces in 1951 and became a co-defendant in one of the most infamous of many show trials that took place in Central and Eastern Europe under the Stalinist regime. Accused of crimes against the state, tortured into making false confessions and denouncements, London was sentenced to life in prison, only to be released in 1956, three years after Stalin's death. In the early 1960s he and his wife moved to Paris. Their memoir ends with their return to Prague in August 1968, filled with hope — hope that was immediately shattered:

> The very day that I arrived in Prague with my wife . . . I witnessed the invasion of my country by 600,000 men and 6,000 tanks of the Warsaw Pact armies. I had been five hours in Prague when it began. So my life contained

this chapter, too, which was possibly the worst from a moral point of view.[88]

Koudelka's invasion photographs also make a cameo appearance in Philip Kaufman's 1988 film adaptation of Milan Kundera's *The Unbearable Lightness of Being* (and in some related ephemera). Kundera's 1984 novel is set during this period in Prague; one of the main characters takes to the streets and photographs during the invasion. (It wasn't the first time that Koudelka's and Kundera's paths had crossed. In 1981, alarmed that Russia would send tanks into Poland because of its Solidarity movement,

Peter Keen, London, 1970

Koudelka and Kundera joined forces, with Robert Delpire, on four eight-page supplements for the French newspaper *Le matin de Paris*. Kundera wrote the preface, the main text was by Petr Král, and the photographs were Koudelka's.)[89]

During his time in London in the summer and fall of 1969, Koudelka at long last met Peter Keen of the *Daily Telegraph Magazine*. They quickly became good friends, with the British photo editor taking Koudelka under his wing and looking out for his interests, both of them knowing that he would have to return to Czechoslovakia in mid-October. Among other things, Keen explained to Koudelka what it meant to have an income from selling photographs for editorial purposes and made it clear that he must be attentive to this. "I needed to know, Peter told me, how much money I had — how much money I made from the sales to the *Sunday Times* and *Look*." It was more money than he had ever seen: Magnum's fiscal records of 1970 show a net from the sales of Koudelka's work at $9,274.17.[90]

Over the course of that fall, Keen wrote several letters to Erwitt at Magnum on Koudelka's behalf. Although Koudelka was not yet a member of Magnum, the agency had continued to distribute his invasion images worldwide for publication and had expressed a larger interest in his work. A plan was discussed for the money his Prague images had garnered — income that could not be paid to him directly. It was decided that Koudelka's nine-thousand-plus dollars could be passed to him in the form of a grant or scholarship from Magnum that would allow him to continue his work with the Roma outside Czechoslovakia. The presence of such a sum in the form of a grant would, it was hoped, facilitate Koudelka's travels being approved by the Czechoslovak authorities, who would consequently give him the required permit (generally translated and/or referred to as an "exit visa") to leave. Koudelka had had such a scheme in mind well before the Soviet invasion. As early as March 1968, he had (through Allan Porter) reached out to Nathan Lyons at the George Eastman House in Rochester, New York, about the possibility of a "scholarship" to continue his work on the Roma, or for that matter on some other subject concerning "social photography" in "some foreign country."[91] Porter had also apparently written to John Szarkowski at the Museum of Modern Art, after the museum acquired Koudelka's work, about the possibility of a working grant, but Szarkowski could offer no advice.[92]

A few of Keen's notes to Erwitt are written in the first person, as Koudelka—apparently drawing from conversations with the photographer. He expresses Koudelka's gratitude to Erwitt, Eugene Ostroff, and Joe Cooper for their help, and indicates his interest in a grant or scholarship. In one letter from 1969, Keen represents Koudelka's sense of a possible direction, writing in his voice:

> *I feel that my work in Czechoslovakia is beginning to come to an end and although I do not wish to emigrate I would certainly like to work abroad for a year.... I am interested in social problems. I well remember for instance the photographs I have seen of Security Farm [Farm Security Administration]. This is the kind of work which gives me satisfaction.... I have worked very much on the Gipsy problem and next year I want to extend my work with the Gipsies into other parts of Europe and also to India from where the Gypsy people originated. All this of course depends very much upon the political situation. If this gets worse I will probably be forced to change my plan. One of the ways in which I might get an exit visa would be to get an invitation to work abroad.*[93]

Verso of one of JK's 1968 Soviet invasion prints (initially credited to "P.P." for "Prague Photographer"—his name was not added until later), among his first photographs to be distributed by Magnum Photos, New York, in 1969

In the years to come, Koudelka would fulfill many of these hopes, while others would transform or disappear. Three years later, in 1972, Cartier-Bresson would offer him a plane ticket to India — a land close to Cartier-Bresson's own heart. He wanted to be sure Koudelka had the opportunity to photograph the Roma there, in order to better understand the roots of the Romani communities he was photographing in Europe (a long history that is at best vaguely documented). Although Koudelka had been contemplating this idea in 1969, and may have had it in mind even earlier, he ultimately refused Cartier-Bresson's offer. "I realized I was not interested in photographing Gypsies around the world," Koudelka told me. "My interest was very specific to where I was from, and ... later, it was about where I was in exile. But always and only Europe and the UK."

Koudelka returned to Prague in October 1969. A few weeks later he received a letter from Erwitt confirming him as "the recipient of a Magnum Photographic Grant. This award is accompanied by the sum of Nine Thousand Dollars."[94] Over the following nine months, other required documentation was prepared and provided to the Ministry of Culture in Prague.

In the meantime, in January 1970 Koudelka took it upon himself to photograph at the funeral of the artist Emanuel Famíra, a vocal supporter of the Soviet invasion. "I thought some of his friends had probably been members of the Communist Party since it started, and were okay when young, but had become reactionaries ... and I'd see it in their faces." At some point while he was shooting funeral attendees, "The

89

Internationale" — the Communist anthem for workers — began playing. It was at this moment that he felt a hand firmly grip his shoulder. He was admonished not to turn around, and then discreetly led out — the police did not want to draw attention to his removal. Forced into a police car, he was subsequently interrogated and his film was seized. Koudelka had, without knowing it, been making portraits of Prague's secret police.

Nevertheless, and despite ever-tightening restrictions on travel, he managed to obtain an eighty-day exit visa. He was to fly from Prague to Marseille on May 21, 1970. From there he would travel directly to the Camargue in southern France, where he planned to photograph the annual Roma pilgrimage in Saintes-Maries-de-la-Mer, on May 24–25. Soon after, he would go to Paris, and then to the United Kingdom.

Koudelka's father drove him to Ruzyně airport, just outside of Prague. On their way, he revealed to Josef Sr. that he had taken photographs of the Soviet invasion and told him how they had been published anonymously. It was a charged moment as his father let the news sink in. "He understood that I was probably not coming back — even though this was only an eighty-day exit visa. My father always told me that if he had been young like me, he wouldn't stay either." Still, the son wanted to keep open the possibility of return. He had a round-trip ticket in hand.

He has with him only the most necessary belongings: two cameras and an ample supply of film; socks, underwear, an extra pair of glasses, a sleeping bag, and 157 prints from his *Gypsies* work, as well as the most critical negatives from that series and a second dummy, made for him by Luskačová, identical to his original working dummy (kept by Mladá fronta). His heart is pounding. Having boarded the plane, all he can think about is the moment of takeoff. Until he is in the air, anything is possible. He is remembering when, just weeks ago, he was pulled out of the funeral for photographing the secret police. What if the authorities come onto the plane? They could remove him at any second. They could confiscate everything he is carrying.

This scenario plays out over and again in Koudelka's mind.[95] What if the authorities had learned that he was "P.P.," the maker of the images that bore such stark witness to the Soviet invasion and occupation? As Koudelka once put it, those photographs "repudiated the lies . . . refuted the story of how the Czech people were happy to see the Russians arrive."[96]

And then, at last, he is airborne, without incident. He exhales. He is heading west, his precious photographs and negatives safely in hand.

Koudelka was relieved to make his exit from Czechoslovakia, but he had left much behind. He feared for his friends and colleagues. He feared for his parents — and that fear would persist through much of the rest of their lives. In 1976 the police did pay a visit to Koudelka's father, telling him that they were pursuing legal action against Josef for not returning to Prague when his eighty-day

exit visa expired, six years earlier. They pressed and threatened Josef Sr., but he did not divulge the whereabouts of his son or any other information — not then, and not ever. Rather, "My father showed the interrogators a shoebox of all the postcards I had been sending home from all over the place, and said: 'He's here.'" Koudelka's father understood that the authorities at that point probably also knew that Koudelka was the author of the now world-famous images of the Soviet invasion. This was not just about violating the terms of his permit. Without Josef Sr.'s cooperation, the authorities could get nowhere and were finally forced to drop the lawsuit. As Koudelka puts it: "My father refused to be a witness against his son."

And what of the negatives, contact sheets, and prints that Koudelka didn't take with him? Elizabeth Skelton, Eugene Ostroff, Joe Cooper, and Allan Stone had all played roles in getting certain photographs and negatives out of Czechoslovakia — but many remained when Koudelka left for Marseille. Again, there was a requisite subterfuge. Even before Koudelka became part of Magnum, the cooperative had committed to helping extricate his archives from Prague. Photographer Marc Riboud, then vice-president of Magnum Paris, wrote him in December 1970: "It's probably [a] question of opportunity of someone going there."[97] In the spring of 1971 Charles Harbutt, who had taken on the role of president of Magnum after Erwitt, was in Prague for the Interkamera fair. There he installed his traveling exhibition of work by Magnum photographers, *America in Crisis*, which had first opened in New York in 1969. Also at Interkamera was Sergio Dahò, photographer and technical director of the Italian magazine *Il diaframma: Fotografia italiana*. Dahò was a great admirer of Harbutt's work, and the two photographers ended up spending a lot of time together during the fair. As Dahò chronicled in a 2018 e-mail to me, the day before Interkamera closed, Harbutt invited him to his hotel, Dahò assumed, for a farewell drink. It turned out, however, that the American had something else planned.

On the bed in Harbutt's hotel room were, Dahò recalls, two identical suitcases made of rough leather — cheap, battered, but sturdy. Dahò vividly remembers the exchange that followed:

> He asks me if I have the instincts of a spy. I answer that I don't know. . . . Do I know Josef Koudelka? Only by name. I have seen some of his photos of Gypsies. . . . I know that he is a Czech photographer. . . . Am I returning directly to Milan the next day? Definitely: my visa expires, I will have to leave the hotel before noon, and I have an afternoon flight.

At this point Harbutt opened the suitcases. They were full to bursting with Koudelka's negatives. He laid out for Dahò the circumstances of Koudelka's exile, saying that, except for a set of Roma prints and negatives that Koudelka himself had taken with him, all the photographs and negatives that had made it out had, by necessity, been smuggled by Westerners. This material had been surreptitiously passed to Harbutt by Anna Fárová, after Markéta Luskačová had collected the negatives from Koudelka's studio. Harbutt explained that he would be leaving a piece of his own luggage behind in Prague and instead carrying one of the suitcases filled

with Koudelka's negatives — but he couldn't take both, "because boarding with two identical suitcases, the same weight and size, would attract too much attention and would be an invitation to check the contents." He needed to find someone to take the other suitcase — preferably someone with a completely different schedule and destination. Would Dahò be willing to do this? Yes, he would.

The two men hugged, and Dahò left with the suitcase. He did not sleep much that night:

> The next day, at the airport, I notice a disturbing Soviet military presence, more than in previous days. In the terminal there are more soldiers, armed to the teeth, than passengers in transit. To calm down, I try to convince myself that, in the end, it is they who have invited me, that I am about to fly with a ticket kindly offered by one of their government institutions, on a Tupolev plane belonging to their state airline, and that my passport contains a special visa they have granted me for a week, without objections. They have no reason to search my bag. And in any case I am doing the right thing. After a couple of hours of panic I am on the runway, awaiting takeoff, and after another couple of hours I am admiring the Alpine landscape covered in snow.

Safely back in Milan, Dahò still faced the problem of getting the work from Italy to the Magnum office in Paris. Carrying them in person would mean two more chancy passages through customs — "certainly less risky than in Prague," says Dahò, "but surely embarrassing in the not-unlikely case of an inspection." In the end, he decided to send the box by post. "I have a sturdy wooden crate made, I line it and wrap the negatives in a waterproof canvas, use the best possible packing materials, and send it by insured, registered mail. I breathe easier."

Meanwhile, Harbutt alerted Russ Melcher, Magnum's Paris office manager, with a note about the imminent arrival:

> Russ —
> 1) 22 kilos of Koudelka's negs were brought by me to NY others are coming to you via . . . Sergio Dahò. . . .
> 4) Fárová says under no [underlined three times] circumstances use Koudelka's name with the 1968 material or she & others will be in bad trouble
> 5) Fárová wants Koudelka to tell her what to do with all the books of contacts, etc. The exhibition prints she will put in her museum archive.
> 6) Koudelka's girlfriend sends her regards with a lump in her throat[98]

Dahò may have breathed easier once the negatives were en route to Magnum, but there was still a hair-raising moment when, two weeks after sending the box, he received a telegram from Melcher asking if he knew what had happened to Koudelka's negatives. Dahò tells me: "This time I risk having a heart attack. I rush to the main post office and launch an investigation. Another fifteen nightmarish days will pass and then finally, I receive a document that confirms: the package was duly delivered and the receipt bears the signature of Russ Melcher." (It turned out that Melcher had received the package, placed it in a cabinet — and then forgot all about it.) The negatives were safe.

It would be thirty years before Koudelka would meet Dahò for the first time, in Milan, and could thank him in person.

In spring 1970, as Koudelka was preparing to leave Prague for Marseille, he was trying to learn English and taking stock of what might be necessary for whatever came next. He realized that he needed a new camera. His Exaktas were constantly breaking, and outside Prague — especially as the cameras got older — it would be extremely difficult to find someone to repair them. Pavel Dias remembered:

> *On the Czechoslovak market, Nikon F1s appeared with complete and at that time very modern high-quality accessories. One could get hold of them, even though there were not so many. I went to Teplice, in Bohemia, and discovered two of those Nikons in a shop. An acquaintance of mine worked there, and so I reserved them for Safez.*

In order to buy the new cameras, however, Koudelka needed to make some money. He had a friend, Kristina Vlachová (born Jana Slánská), who had told him that she wanted to make a film in which the main character was to be based on him. At the time, Koudelka didn't take her seriously.

> *But I made a mistake. She wrote the film script. The director of the movie came to see where I was living, and then they decided to buy some pictures from me. With this money, I could buy new cameras. I left Czechoslovakia with two Nikons, and 28-, 35-, and 50mm lenses.*

Vít Olmer's black-and-white film (based on the screenplay by Vlachová), *Takže ahoj* (Well Then, Goodbye), came out in 1970, after Koudelka's departure from Czechoslovakia. His prints of the Roma cover the walls of the main character's basement flat in Prague. However else he may or may not resemble Koudelka, the film's male protagonist, Jan Kubícek (initials J. K.), is committed to his work above all else — and is ultimately indifferent to the woman who loves him. And he is preparing to leave.

Dias went to see Koudelka in his studio the evening before his departure. "We sipped Moravian plum brandy from a milk bottle. He played something on the bagpipes with his back toward me, the audience — something like Miles Davis at his concerts. And the next day, he left."

Well then, goodbye.

Cover of *Film a doba* (Film and Time) magazine, February 1971, featuring Vít Olmer's film *Takže ahoj* (Well Then, Goodbye). JK's photographs are visible on the walls behind the actors (Valerie Chmelová and Antonín Sládek).

II N.D. — Nationality Doubtful

1.

A little over a week after Koudelka left Prague for Marseille in May 1970, he wrote a postcard to Anna Fárová. He sent it from the Camargue, where he was photographing the Roma in Saintes-Maries-de-la-Mer:

> *The Gypsies send their regards to all of you. I am doing what I can here, and it is generally known that I cannot do much, so at least while photographing I am eating up and drinking up the Gypsies. . . . When I return I will probably go immediately to Romania in order to recover.*

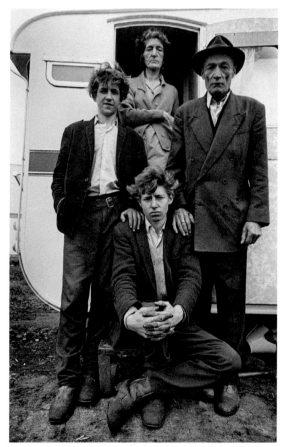

Gypsies, Cardiff, Wales, 1969

> *Now I am going with the last Gypsy to Paris and then to Scotland for that Gypsy meeting.*[1]

It would seem that he truly believed he'd be returning, once his eighty-day permit expired. It was only when he left southern France en route to the United Kingdom and passed through Paris, visiting the Magnum office for the first time, that he was gravely warned against going back to Czechoslovakia: "They told me that even though my invasion pictures were not signed by name, it would not be a problem for the Czech police to figure out the author — that they probably already knew it was me, and for this reason, they recommended that I not return to Prague. But I was still thinking then that it may be possible." Once he was in the United Kingdom, his travels would take him to the Epsom horse races outside London, the Appleby Horse Fair near the Scottish border, and Ireland.

On his first visit to Britain, in 1969, Koudelka had taken a concentrated and rigorous English-language class in the Welsh town of Barry, during which he wrote in his diary (he reads this to me with a laugh): "I am saying first in English: 'I am very good.' And then in Czech I am saying: 'Hit yourself! You are really not very good.'" During that period in Wales, he photographed a Romani community in Cardiff; and then in October he attended

a traditional horse fair at Yarm, in North Yorkshire. But during most of that stay he was in London, where he began to make friends. His innate shyness and insecurity with the language were countered by his sheer exuberance.

In May 1970 he was back in the United Kingdom on his exit visa, and London became his base between projects. As he was always looking to save his money for travel and photographic expenses, Koudelka's friends — Michael and Colleen Chesterman, Peter MacMahon, Kristýna Melíšková, and Alan Walker, among others — regularly offered him housing.[2]

In July 1970 Koudelka was still thinking that he might return to Czechoslovakia. "Everything there was still so uncertain," he says. Marc Riboud wrote the Czech minister of culture, Miroslav Brůžek, requesting an extension to Koudelka's permit and also permission for him to travel to Spain and Portugal to photograph key Romani communities there. Koudelka had this letter delivered to Markéta Luskačová in Prague and asked her to take it by hand ("so they couldn't say I'd never sent it") to the person in charge of his file at the Ministry of Culture, a Mrs. Zvoníčková. The letter, written in French, is dated July 10, 1970.

> *We have been very happy to learn that you have allowed Mr. Josef KOUDELKA to accept the scholarship that we have offered him so that he might bring to conclusion and complete his reportage on "The Life of the Gypsies in Western Europe."*

JK at the Magnum Photos office, Paris, 1971. Photographer unknown

> *Nevertheless, we were surprised to learn that his permission to stay abroad was for only eighty days, while the scholarship had specifically granted him a period of one year. . . .*
>
> *If Mr. KOUDELKA had to return at the end of this eighty-day period, it would be a great pity for numerous reasons: he would then be able to produce only a fraction of the body of work that he has begun to undertake. He would likewise lose the remainder of his scholarship, because one of the conditions of this scholarship is that the payments must be staggered and consecutive. We would also be completely deprived of the opportunity to see the creation of the photos that we are sure Mr. KOUDELKA is capable of taking, and which would undoubtedly be better than those taken by anyone else in Europe at the current time, and which we, at MAGNUM, want to help to produce.[3]*

Although she agreed to do Koudelka's bidding, Luskačová remains flummoxed by his insistence that she hand-deliver the letter, and even more so by the request for an extension to his permit. She feared — understandably — that she would be deemed complicit by association. As she told me:

JK's travel documents, 1971

When delivering the letter by hand to the Ministry of Culture, I would have to give them the number of my identity card, and it would be recorded. . . . I was considered Josef's next of kin by Mrs. Zvoníčková. She would regularly ask me to come and talk with her about "our boy." I was always scared to go there — it was always a waste of half a day, always a nervous, scary day.

I didn't think he was coming back. Yet I would always maintain, when she asked me if he'd come back, that he would, if only they would prolong his permission and let him stay until he finished photographing the Gypsies.

At one point . . . I brought Mrs. Zvoníčková a postcard from Josef, in which he wrote about how much he was missing the folk music festival in Velká nad Veličkou in South Moravia — he used to love to go there. I brought the postcard to Mrs. Zvoníčková as proof that he would come back.

Nonetheless, Koudelka was told at the Czechoslovak Embassy in London that his application for an extension would be considered only after he returned home. "Of course," he says. "I knew if I went back, they would never let me go out again and they probably were going to put me in prison. When you lived behind the Iron Curtain, you knew that whatever they told you was not true."

With Erwitt's assistance, Koudelka was granted asylum in the United Kingdom. The decision to seek asylum was not unconflicted for Koudelka. He recalls sitting for hours in Hyde Park on a late summer day in 1970, wondering whether or not to return to Czechoslovakia. The main reason he decided not to go back was because he feared that the Czechoslovak authorities would figure out that he was "P.P."

"I had no desire to go to jail. So I decided to accept what had happened, not to return, and do what I was unable to do in Czechoslovakia: see the world."[4] He said to me:

I realized the house has burned down — the house, meaning my life as I knew it. I said to myself: "You can't go back. You have to build here; you have to build a new and different house now."

Because Koudelka had lost his Czechoslovak passport in a fish and chips joint, in order to be able to travel, he was subsequently issued a *titre de voyage* by the British authorities. Thereafter, although Koudelka consistently gave his

nationality as Czechoslovak, the British border controls — unable to confirm his place of birth — always registered his status in his travel document as "N.D." — Nationality Doubtful.[5]

In one of Koudelka's diaries from the early 1970s there is a variation on an often-repeated theme:

> *Never stay for a long time in one place. . . . When you stop somewhere . . . things start to stick to you. When you go from one place to another place, you are cleaning yourself.*

When staying with his friends in London, he never wanted to get too comfortable, and was also always conscious of not overstaying his welcome. He rarely remained at one flat for long during his first year in exile, and avoided returning to a place too often — with a couple of exceptions, the first being the Chestermans' home at 2 Regent Square, where he stayed with some regularity in 1970.[6]

Although Koudelka's principal reasons for staying with friends were pragmatic, there were of course collateral benefits. He was included in social gatherings and daily familial rituals. He was little trouble, did not require even a bed — preferring to sleep on the floor in his sleeping bag — but, he recalls: "It was nice for me to wake up. . . . Interesting to see the same people in the morning, because you get their normal, their family life in the morning . . . sitting around the table."

Party in London, 1970

For years, Koudelka has appreciated a passage from Marguerite Yourcenar's *Memoirs of Hadrian* (1951):

> *In my twenty years of rule I have passed twelve without a fixed abode. . . . I was too distrustful of all fixity to attach myself to any one dwelling, even to one in motion. . . . I was striving to have no prejudices and few habits. . . . I felt the advantage of being a newcomer, a man alone, scarcely bound even by marriage . . . a Ulysses with no external Ithaca. I must here admit what I have told no one else: I have never had a feeling of belonging wholly to any one place. . . . Though a foreigner in every land, in no place did I feel myself a stranger.*[7]

It was also in 1970 that Erwitt introduced Koudelka to photographer David Hurn, another Magnum member, and the other exception to Koudelka's guest rules. Hurn's flat at 4 Porchester Court, Porchester Gardens, almost immediately became Koudelka's primary London lodging when he was not on the road. There he had access to a darkroom and an area to work, as well as regular engagement with a large and convivial photographic community. Photographers, from the Welshman (and Magnum member) Philip Jones Griffiths to American Diane

Arbus, not only crashed there when in London, but also set up shop — editing and sequencing their images, and sometimes developing their film and making the first prints and contact sheets for a project.

For many years, after being persuaded by the cold to return to Hurn's flat at 4 Porchester Court, Koudelka would spend the winter months developing and printing his endless rolls of film and examining his work to date. Hurn recalls him in the front room, making dozens of successive dummies for what would result in his *Gypsies* book. This circadian pattern persisted: Koudelka has always tried to schedule the printing of his books and other indoor tasks that require his presence and control during the winter, so as not to interfere with his photographing in the warmer months.

To this day, Hurn refers to himself as Koudelka's "Welsh brother." Koudelka paraphrases a passage from his own 1972 diary: "I really love David, and I admire him, and the qualities he has which I don't have. . . . He really is so generous and so nice, so good. David would say that one of the best things a human being can do is to make the time for somebody else." And although always wary of too much comfort, lest he go soft, Koudelka would write in his diary a year later:

> *You idiot, it's wonderful to have a floor where you can sleep and it's not raining on you, and to have a sleeping bag that is not wet, because you were so dirty because you haven't washed yourself for a long time, and you smell. . . . There is nothing wrong with having the warm shower.*

In the late 1970s Hurn moved to Wales — where Koudelka continued to avail himself of his hospitality. When in London, he began frequenting photographer Paul Trevor's flat in the city's East End, regularly staying with him even after Magnum opened its London office (thus providing another sleeping-place option for Koudelka) in 1986.

JK and David Hurn, Tintern, Wales, 1977. Photograph by Keith Arnatt

Revisiting thirty-plus years of friendship with Koudelka, and often weeklong stays (the first in 1977, the last in 2002), had Trevor chuckling during much of our conversation. He recalled slowly going through the bottle of slivovitz Koudelka had parked on an "out-of-reach top shelf in the kitchen. Each time he came over we'd take it down and toast his father with a shot. It was like fire!" The visits were occasionally quite spontaneous: "One night, Josef was sleeping on the floor at Magnum," recalls Trevor. "It was really cold, so he'd wrapped himself up in bubble wrap. Well, all the bubbles started to burst. He's trying to keep himself warm, but the bubbles are bursting!" Finally, the freezing Koudelka gave up and moved to Trevor's place for the night.

There was a period in the 1970s when Trevor was able to get a bargain price on Tri-X film, and Koudelka took full advantage of the supply. Trevor recalls his ingenuity when it came to packing:

He would spend hours preparing hundreds of rolls of Tri-X. He'd first take off all the packaging. He had a system — he had one box for all the unexposed film, and another box to keep the rolls once exposed. Mission completed. He's got film — as light, and taking up as little room, as possible — in his backpack. Enough to shoot for the next six months.

In London, Koudelka was pleased to reconnect with Grattan Puxon, whom he had first met in Czechoslovakia in the summer of 1968 when they had traveled together with Milena Hübschmannová to Romania. By 1970 Puxon was president of the Gypsy Council of England, and as such did all he could to enable the photographer's work on his subject in the region, including accompanying him to meet and photograph the Travellers in Ireland. There, he introduced Koudelka to key figures of the community, among them Johnny Connors, Jim Penfold, and John Keenan. Koudelka had an easy friendship with Keenan, and stayed with him on several return visits to Ireland. Keenan sensed a true Romani spirit in Koudelka, who recalls:

Grattan Puxon (far left), England, 1970

> *John said he felt very guilty because he should have been traveling and he wasn't. But he was a musician and he made pipes, so I talked to him about my bagpipes — they were very different pipes, the Irish pipes. He said to me: "You are a Gypsy. You have nothing, you go everywhere you want, you sleep wherever. I am not a Gypsy anymore."*

Koudelka tells a story of being stopped by the police in Ireland during a particularly turbulent period of the Troubles. Koudelka thinks the police, on the lookout for possible Irish Republican Army activity, were searching for bombs. It wasn't the only time he would be wrongly suspected: "I must be somebody who looks suspicious," he muses:

> *In Holland — they didn't want me to go into Holland. In England, they were searching me for drugs. In Portugal, they considered me a Communist agent. In Spain — because I had long hair and a beard — I was considered somebody*

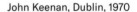

John Keenan, Dublin, 1970

> *with bad morals. In Ireland . . . I realized it was worse if I spoke to the police in their language because they would feel more superior. I made a rule that, even if I spoke the language, if I was stopped by police I would not speak their language. So for example in Ireland, I spoke French, not English.*

Eventually, Puxon arranged to get Koudelka a membership card to the Gypsy and Travellers' Council, an organization that, among other missions, advocated for the rights of the Roma. Its code of conduct specifies:

> *KEEP the good name of our community*
> *KEEP camping places tidy*

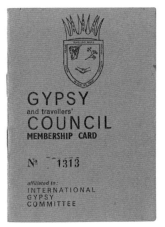

JK's membership card to the Gypsy and Travellers' Council, early 1970s

KEEP within the law when it doesn't conflict with our rights
KEEP up support of other travellers in time of need

In 1971 Puxon was elected general secretary of the World Roma Congress. He moved to Yugoslavia and later settled in the Romani municipality of Šuto Orizari, outside Skopje, in Macedonia.[8] More recently, he has been the chair of the Roma Democratic Transition, working to facilitate global elections in the Romani communities.

A letter from Koudelka, from London, June 14, 1971:

Dear Parents,

Forgive me for not having written for a while. <u>If it happens again in future,</u>
<u>*nothing has happened to me. DON'T WORRY.*</u>
<u>*IT'S JUST THAT I HAVE LOTS OF WORK.*</u>
I am still well, and have a good appetite for food
 and work
and for everything, mainly life.
I can afford a luxury that most people in the world cannot afford
TO DO THINGS FOR MYSELF AND WORK FOR MYSELF
and not for money or some bad and stupid superior bosses.
I have EVERYTHING A MAN NEEDS FOR LIFE
AND AM VERY HAPPY THAT I CAN LIVE THIS LIFE
 THAT'S WHY
 <u>*I THANK YOU VERY MUCH THAT I HAVE BEEN*</u>
 <u>*BORN*</u>
I wish you much good health.
I'm not suffering from any illness, I feel well
and strong. I've learned a lot of new things, by which I don't mean only English and Spanish, but also, indeed mainly, lots of things about life, and I'm learning all the time.
And don't you work so much anymore! DON'T WORK YOURSELF TO THE BONE!
WHATEVER YOU NEED, WRITE TO ME.
I'LL BE HAPPY TO GET IT FOR YOU AND TO SEND IT, TOO.
IF YOU NEED HARD CURRENCY, LET ME KNOW
 IMMEDIATELY.

With best wishes,
Son

. . . I'll be in England until the end of June. Then I'll probably go to Holland and France.

Thanks for the letters that I received from Spain today [Koudelka had asked Magnum to forward his mail to general delivery at the Seville post office, as he was planning a trip to Spain and would pick it up there].
Also everyone sends their thanks for the plum brandy. . . .

Send Markéta koláče [cakes] sometimes.[9]

On June 18, 1971, Koudelka signed over his Žižkov studio at Pospíšilova 4 to Markéta Luskačová. "When I left Czechoslovakia, Markéta did more than anyone to help me protect all the work I had to leave behind — to gather it together and make sure it did not get lost or stolen or damaged. Markéta did enormous work." She had already rescued many crucial items from the space — which was prone to flooding and pervasive dampness — and had assisted with their "emigration" or otherwise redistributed them all, following Koudelka's scrupulous instructions. Some materials went to his parents; most were stored in the attic of Anna Fárová and Libor Fára's flat in Španělskà. He had also encouraged Luskačová to take over his job as the Divadlo za branou's official photographer, which she did from his departure in 1970 until the theater was closed down by the regime in 1972.

Koudelka traveled to Spain for the first time in 1971. In one of his journals is a hand-drawn map of Spain (he loves maps): "I had never been there, and needed to understand it." He drilled himself in conjugation exercises, teaching himself Spanish.

While in Madrid, he made several trips to the Museo del Prado.

Pages of JK's 1971 agenda noting travel schedules, color-coded by country

I saw so many paintings. In that period you could still photograph in the Prado — you can probably see every painting which I like in my contact sheets. . . . When [Cartier-]Bresson told me that the wide angle is not the correct lens . . . I said: "Listen, van der Weyden and quite a few of these guys from the past, their eyes were wide angle too."

On his Ivry walls, Pieter Bruegel the Elder's *The Peasant Dance* (ca. 1569) and Toulouse-Lautrec's *Equestrienne* (*At the Cirque Fernando*, 1887/88) are hung beside one another, as contrasting ways of considering a "wide angle" perspective in painting. (Of the Toulouse-Lautrec, Koudelka also notes "the right angles, the framing," and the "deformation of the horse.") Moving ahead some years,

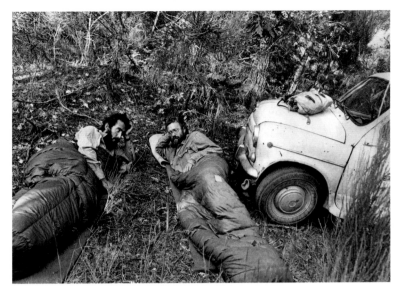

Fernando Herráez and JK, ca. 1973. (Camera on self-timer)

there is Max Beckmann's *Synagogue in Frankfurt am Main* (1919), which Koudelka refers to as "extreme wide angle."

It seems that the more Koudelka discovered painting, the more he viewed reality through the lens of a painter, rather than that of a documentarian. Which — with the exception of the Prague invasion images — he in fact never was. Even the *Gypsies* project, while structured and truthful in its depiction, is more interpretative than it is about ethnographically illustrating the subject.

In Barcelona, he visited the Museu Picasso, which he found to be a revelation. "He was genius, and he knew how to paint, even when he was a boy!" Although today Koudelka admits to finding Picasso's Blue Period "a little too sentimental," he was astonished by the initial encounter:

> It was the first time I saw these paintings from the Blue Period and I knew I can learn something. . . . He was a magician. For me, the artist is . . . the man who can take nothing and make from it a miracle.

The landscape, the music, the art, the people, the food, the rituals and all the possible subjects to photograph . . . Koudelka quickly concluded that "Spain is really the country I feel the closest connection to." Southern Spain in particular stirred his heart — especially Andalusia — but he loved photographing throughout the country. In the north, he was drawn to the annual festival in Galicia known as the Rapa das Bestas ("Shaving of the Beasts"), in which the people of the village capture the wild horses who otherwise live freely in the mountains, cut their manes, and then brand the young horses to indicate from which family they come, before returning them to the mountains to again roam freely. It was at this event that Koudelka met the photographer Fernando Herráez, and the two of them struck up an immediate friendship:

> It was raining and he invited me to stay overnight in his tent. Like that, we became friends, and most of my traveling in Spain in the early 1970s, I did with him. It was a great period. I loved it. I was repeating all the time to Fernando: "We are living the best period of our life. We should realize it. We are going to remember it all our lives."

In Spain in the 1970s Koudelka also met the photographer Cristina García Rodero, who was, like him, photographing traditional and popular festivities. She'd eventually publish books on the subject, including *España oculta* (Hidden Spain). Later she, too, would join Magnum, becoming a member in 2005.

Perhaps because of the connection Koudelka felt to Spain, certain aspects of his subconscious seemed to be more accessible to him there. In Valencia in 1972 he made note of a recurring nightmare:

I used to have a dream that all immigrants have, no matter what nationality. In your dream, you find yourself back in your country — which, after your emigration, you always hope to be able to return to. So you find yourself back home, but you don't know how you got there. You know for sure that you won't be able to get out. And that's not what you wanted. You always wanted to be sure you could leave. The only way is to ask the government for permission to leave again, and you do. And then you wait. Every day you go back to the police, to this long hall, where on the wall is the list of the people who got permission to leave again. But you never find your name there. And you are so angry with yourself that you went back.

When jolted awake, soaked in cold sweat,

I'd be somewhere in the middle of the landscape, and very happy to be where I am, very happy that I am out, and live life exactly the way I want to live, and not how somebody else wants for me to live.

Once Koudelka was in exile, his travels continued to radiate outward. Over the course of decades, along with photographing the Roma, he made his way to important yearly pilgrimages and processions, recalling those he'd seen with Markéta Luskačová years before.

Andalusia, Spain, 1973

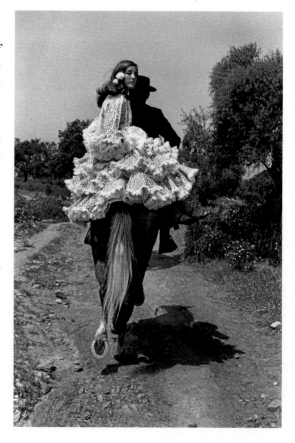

After I left Czechoslovakia I began to take photographs of traditional festivities, religious ceremonies and rituals in various European countries. Some of them have strict rules, often several centuries old. It was like the theater: there was the stage, there was the story. I knew what was going to happen. I photographed them in a similar way. The difference was that the performance took place only once a year and the actors changed every year. I kept going back until I felt I couldn't do better. The maximum.[10]

Koudelka orchestrated much of his life each year around the events of the Romani communities and the dates of these religious gatherings. He often began the spring with Semana Santa (Holy Week) in Spain. From there he would travel to Portugal to photograph one of the pilgrimages in Fátima. The annual meeting of the Evangelical Gypsies eventually became part of his itinerary in France (the location changed each year). In Ireland, regular events included Reek Sunday at Croagh Patrick in July, and the Ballinasloe Horse Fair in October. Each year the route expanded to encompass additional stops — rarely, if ever, did he skip those he had attended in previous years.[11] "I loved the people, the activity, the

Constellation map in JK's agenda, 2005

energy," he says. His habitual return to these communities was a kind of annual migratory pattern, reminiscent of his earlier systematic approach to the Roma of Czechoslovakia, as well as his repeated viewing and photographing of Divadlo za branou performances.

To clarify: Koudelka is deeply averse to repeating himself. He always wants to move forward. To revisit a subject — or even to rethink and republish a book — is for him, perhaps paradoxically, not a repetition but an action toward the maximum. There is often no closure per se. The multiple versions of his books are a clear example of this drive: "I'm not sure it is good to publish my books in so many different ways. If I were to get into the mind of the public, I know the various editions may confuse people. But for me it is interesting to present the same pictures differently, in differently designed books — so I do. I do it for myself, in order to learn and know I've done all that I can do."

This regular returning to projects, events, and places has afforded him a clear understanding of his own work and process. It has also facilitated trust and acceptance from the people he encounters year after year, photographing both the Roma and the festivities. This increasing familiarity soon embraced the larger context — the landscape itself, which slowly migrated from background to foreground in his work, especially once he left Czechoslovakia: "These landscapes become your friend too," he says. Still, the vistas he was photographing in the 1970s and early 1980s were not the "wounded" landscapes that would later command Koudelka's attention. While the work of this period features humans inhabiting and moving in the landscape, eventually only traces of a human presence would remain in his images.

The annual cycle of gatherings and events beckoned him to photograph from the warmth of springtime until the chill of late fall. For as long as the weather cooperated, Koudelka slept outside, on the ground most nights, his map of the heavens always within reach.

> *There is nothing more beautiful than to sleep under the stars. To look at the sky and wait until you see Vega, Arcturus, and all these other stars. The stars become your friends too. What you see above you, it puts things into proportion: what you are and what you represent — what you mean in all this.*

Nobody owned the stars, nobody owned the sunrises, and nobody owned Koudelka.

2.

Koudelka had several converging goals in this period. He desired to photograph the Roma throughout Western Europe, advancing his project. He wanted to retrieve whatever of his materials remained in Prague — or, if that were to prove impossible, at least to be sure everything was safe.

JK washing his clothes in the way he often had to while traveling. ("Every time I saw water, I jumped in.") Spain, 1976. Photograph by Fernando Herráez

There was also the *Gypsies* book, which the Mladá fronta publishing house in Prague had committed to producing, and for which he and Milan Kopřiva had created a working maquette over the summer of 1968, just before the Soviet invasion. The process of making a book dummy (this was of course long before the digital age) was labor intensive: it entailed selecting, sequencing, and sizing the photographs as they imagined them appearing in the book, then cutting out paper to the size of their proposed format for the book; creating duplicate prints to the size they were to be reproduced — from either original or copy negatives;[12] adhering them to the paper with tape or wax or glue; binding all the pages together; and finally creating mock-ups of a front and back cover. There was also the text treatment to consider — depending upon the nature of the writing proposed.

In September 1968 Mladá fronta, with the enthusiastic support of editor Irena Zítková, brought this first, in-progress *Gypsies* (or *Cikáni*, as it is titled in Czech) maquette, which the publishing house had financed, to the Frankfurt Book Fair — the annual high-profile show-and-tell where publishers from around the world bring their forthcoming books in the hopes of rustling up interest in foreign-language co-editions. Despite the trauma of the invasion just weeks before, the draconian restrictions of "normalization" had yet to be fully implemented in Czechoslovakia, and it was still possible both to travel to such events in the West, and to imagine such a book.

But by 1969, freedom of expression was severely under attack, and then all but disappeared. Zítková recalls the painful challenges to publishers in this period:

After the 1968 Soviet invasion, we did what we could with our books. . . . We tried to do what would be interesting to people, but at the same time, somehow find a modus vivendi with the powers that be. You couldn't just make decisions on your own. You weren't autonomous. It always had to go through upper levels, and lots of bureaucracy, higher and higher and higher. . . . The danger was making the book, publishing it, and then having it not approved. And then it goes to be pulped.

Koudelka recalls that, in 1972, Anna Fárová produced the book *Současná fotografie v Československu* (Contemporary Photography in Czechoslovakia), published by Obelisk in Prague and printed in Czechoslovakia. "In part because one of my Gypsy photographs was on the cover and there was also a text about me, it was completely destroyed. So many books were destroyed. . . ."

As for *Cikáni*, if before the invasion it had been potentially compromising to acknowledge — let alone portray — the reality of the Roma world, such a project was now utterly forbidden. Between 1968 and 1971, as Zítková recalls, "We had the maquette, but . . . Mladá fronta kept putting the book off and putting it off. Then, when Josef left Czechoslovakia, it ended. Really, after '68, *Cikáni* was seeming less and less possible."

Yet Mladá fronta did give Josef a contract for the book in June 1970, after he had left the country on his exit visa. The contract was subsequently annulled, in March 1971, and the publishing house officially canceled the book in March

Bukovina, Romania, 2001

1973 — the reasons cited were Koudelka's absence from the country and Mladá fronta's inability to raise the book's projected print run from one thousand copies to four thousand.[13] When we spoke, however, Zítková made it clear that the book's content was the principal cause for its cancelation. Until her death in 2018, she remained deeply interested in Koudelka's work and followed his career closely. "He's trying to photograph silence," she said to me. "There are some wistful photographs. . . . It's the wistfulness of someone who is alone."

The cancelation of the Mladá fronta contract was, for Koudelka, simply (or not so simply) a part of the house that burned down. "Because of the experience making the dummy in Czechoslovakia, living all the time with these photographs, selecting them, putting them together, learning from Kopřiva — I knew what is possible to do with this material. Now I had to go to the next step with it." Unfortunately, this much-labored-over first maquette was, some years later, misplaced, never to appear again.[14]

3.

Since facilitating the 1969 publication of his Soviet invasion coverage, Magnum —
thanks to Elliott Erwitt and later Marc Riboud — had been helping and more or
less representing Koudelka (while of course earning revenue on the distribution
of his 1968 invasion work). But he was not yet a member of the cooperative.
That would change in 1971.

First there was the conversation. "This I remember very well," Koudelka
told Magnum biographer Russell Miller. "I was supposed to meet Elliott
Erwitt in London and the night before I was learning the future tense:
'I shall, you will, etcetera' because I knew he was going to talk to me about
the future." This was in October 1970 — the first time he and Erwitt were
to meet in person.

> *He asked me if I wanted to be an associate member [of Magnum]. I didn't
> know what it meant. I asked him what it meant and he explained and I was
> happy. . . . I left Czechoslovakia and I found myself here, I couldn't speak the
> language very well, I didn't know anybody and suddenly I had a certain secu-
> rity and suddenly I discovered that I belonged to something, one of the best
> organizations for photography that exists in the world. It was very important
> for me, because immediately, I was part of something that was good, I got
> immediately a lot of friends there. So, if I traveled, it helped me a lot — people
> were not afraid to give me the key to a house where I could sleep, I was not going
> to steal! It was something — well, if I had got nothing else, I had a place [to
> sleep: the Magnum office], nobody could kick me out from this place. Everybody
> could kick me out from wherever, but not this place, this was my place.*[15]

Although Erwitt had been corresponding with Koudelka for two years or
so, he was still not entirely prepared for (as Erwitt described him to me in 2015)
the "Spartan, eccentric, charming, and enthusiastic" younger photographer
who stood before him.

Cornell Capa (left) and Marc
Riboud, 1976

There are aspects of Koudelka
and his career that make Erwitt
simultaneously smile and roll his
eyes when he speaks of him: "People
have crowned him. He's absolutely a
mythical figure. He's considered The
Artist — so you forgive him all kinds
of things. But really, I think it's like
water off the back of a duck. I don't
think it affects him particularly. But it
can work for him." Koudelka became
an associate member of Magnum in
1971 (nominated by Erwitt), and a full
member in 1974 — in both cases, the
usual requirement of having to pres-
ent a portfolio was waived.

JK and Elliott Erwitt, 1988.
Photograph by Jill Hartley

After their October 1970 meeting in London, Erwitt requested that the New York office ship the duplicate copy of Koudelka's *Gypsies* dummy (which Koudelka had brought with him from Prague, and then sent to Magnum in New York — probably at Erwitt's request) to Magnum Paris. There is a record of it having been sent, but "unfortunately," as Erwitt wrote to Koudelka that November, "Paris has no record of receiving it ... everyone here has been in hysterics trying to trace it down."[16] Koudelka had no copy or reference for this iteration from which to make another maquette. Fortunately, this was the only item that had been shipped; Koudelka's prints were safe. Earlier, Erwitt had taken 157 photographs that had been housed at Magnum New York — pictures of the Roma: sixty-three made in Romania and ninety-four made in Czechoslovakia — to the Museum of Modern Art for Szarkowski's review, in the hope he might purchase some additional prints for the museum's collection.

On January 11, 1971, Szarkowski wrote the following to Koudelka:

This week I was able to show a selection of sixteen of these prints to our Department's Trustee Committee. They were also enthusiastic about the work, and authorized me to try to acquire additional work for our collection, and appropriated the sum of $500 for this purpose. . . . I do not mean to suggest what price you should set on your prints, but if you would let me know how many prints I can buy for $500, I will select these from the group that we have retained here.[17]

Koudelka was at first reluctant to part with the prints and break up his only complete set of Roma photographs. "But I was told that I was crazy, that I should do it, that it is the dream of many photographers to get their photographs into MoMA's collection. So finally, I agreed."

In May Szarkowski wrote again to Koudelka, informing him that his 1966 image of "two musicians" from Kendice, a village in eastern Slovakia, had been hung in "a new contemporary section of our collection in our third floor galleries."[18] The exhibition featured thirty contemporary photographs from the collection. The esteemed photography curator Anne Wilkes Tucker,[19] at the time a curatorial intern in MoMA's Department of Photography, wrote to Koudelka just months later, in September 1971, about his 1969 image from the Rožňava District of Slovakia: "Your photograph of the Gypsy mother and 3 children, now in the museum's collection, has been included in the exhibition *Photographs of Women*."[20] Organized by Tucker, this show was described by the Museum of Modern Art at the time as "a brief survey of some of the ideas and attitudes about women that have recurred in photography during the past 70 years."[21]

Camera magazine devoted its February 1972 issue to the exhibition — essentially serving as its catalog.

In his *Looking at Photographs: 100 Pictures from the Collection of the Museum of Modern Art* (1973), Szarkowski included a Koudelka photograph that the museum had acquired in 1968.[22] The image, titled *Slovakia (Jarabina)* (1963), shows a young Romani man in handcuffs prominently pressed against the foreground, with a group of onlookers and policemen in the distance behind him. Koudelka plays with scale and perspective here in a way that makes it seem almost as if the man is slanted, while the people in the background appear to be receding. Although Koudelka was pleased to have one of his photographs featured, he told me that Szarkowski's description of the scene in his book is incorrect.

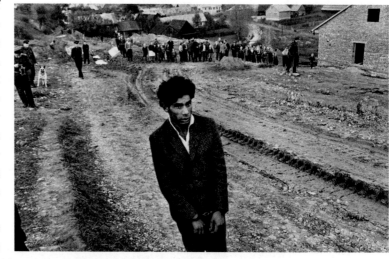

Slovakia (Jarabina), 1963

He writes that the man, the Gypsy, is being taken away to be executed. I told him when I met him eventually that it was not like that. He apologized, and he promised me that in the next edition he is going to correct it, which eventually he forgot to do . . . so the wrong story still exists.

In fact, the man in the photograph was not on his way to his death. In 1963 Koudelka was in Slovakia staying with his Romani friend Gustáv Karika, a judge who would later become one of the founders of the Union of Gypsies-Romanies in Slovakia. Karika told Koudelka that a woman had been murdered in a nearby Romani community. The two men went together to the village, where the police were trying to reconstruct the crime in an attempt to understand what had happened. Koudelka tells me that the man in the photograph indeed killed the woman, and is here reenacting what took place. "My photograph is made on the site of where the murder happened." The man was not executed but went to prison for his crime, which was not premeditated but was rather, Koudelka says, a crime of passion: "He was not a 'murderer' by nature." Two decades after the start of his exile, when Koudelka finally returned to his homeland, he went back to many of the communities where he had first photographed the Roma. In one of the villages, he encountered a young boy who looked uncannily like the handcuffed man in Jarabina, and it turned out that this boy was the man's grandson. Determined to track down the subject of his now-famous photograph, Koudelka joined forces with his old friend Milena Hübschmannová, and together they went to a village in Bohemia where they'd been told the man lived. They found his house and rang the bell.

He came out — I recognized him. I had taken my photo of him with me, and even though I was happy to see him, it was not an easy situation for me.

Finally, I got the courage and I said to him: "We met a long time ago, but you probably don't remember me." He said no. I told him that we had met in 1963 in Jarabina, that I was there when he was arrested, and that I'm a photographer: "I took a picture of you," I said. I was really afraid about how painful it would be for him if he saw the picture. But I put my hand in my pocket and I took the picture out. He looked at it, he put his arms around me, and with great happiness, he said: "It's me! It's me, it's me!"

Szarkowski writes of the image in *Looking at Photographs*: "It shares with the rest of Koudelka's work a sense of myth and a rough-textured lyricism consonant with the rhythms of ancient ballads." The sense of isolation and pathos is palpable.

On December 15, 1970, Riboud wrote Koudelka from Paris: "I am terribly sorry to have no news to report about your dummy. It is a very sad thing."[23]

But it was imperative that Koudelka have a working dummy of *Gypsies*. He wanted to keep refining it, improving it. In early spring 1971 Koudelka asked Luskačová to construct another dummy for him. With characteristic kindness toward her friend, she consented to make it — printing all the photographs once again, following the first and only existing dummy (at that time still in the possession of Mladá fronta). This third maquette was among the materials Charles Harbutt smuggled out of Czechoslovakia in spring 1971 — and it is still in Koudelka's possession.

Through the mid-1970s Koudelka continued to enlist anyone going to Prague whom he thought he could trust to help him extricate materials from his archive there. Luskačová told me: "Josef was all the time sending somebody to bring out this, or that, or deliver a letter, etcetera. Young people loved doing it for him — it was as if entering a conspiracy." This included friends who drove from Switzerland to Prague in 1971 to attend Luskačová's wedding to the writer Franz H. Wurm. Somehow — even after leaving their wedding gifts with the newlyweds — the visitors' cars were more heavily laden on their return to Switzerland. At the same time, Koudelka inundated Fárová with imploring letters and postcards about what needed to happen. A letter of July 1971, handwritten like all his correspondence, gives a sense of the tone; here he chose to use the formal "you" — "*vy*" in Czech:

Dear Madam,

All the best to you and your family. Because I have heard nothing about you, I presume that you are doing well.

Thank you extraordinarily much for everything.

I would be fantastically obliged if in a while you found a way to get the rest of the things:

1) the rest of the archive — negatives

2) the photos that you called "complete works" (Gypsies, Czechoslovakia theater photographs . . .). The best place to send them would be Magnum Paris, otherwise anywhere. IF THAT DOESN'T WORK OUT, IT'S NOT THE END OF THE WORLD . . . It would be good if you could include the

theater exhibition, talk to Kraus or Krejča. It was a lot of work for me, and I am not going to do that again; I don't know whether it hasn't been stolen, bit by bit.

I think that I ask about the second thing in every other letter, so please answer me.[24]

A few months later, he followed up with Fárová:

KEEP THE GYPSY PHOTOGRAPHS, but I cannot give them to you. Even I don't have the whole set . . . keep them as a full set in case something were to happen sometime. Talk to Kopřiva about whether the complete documentation of the whole book could be kept at your place or his. Do not show it much, so that the photos aren't broken, barfed on, or otherwise damaged. DON'T FAIL TO DO THAT.[25]

Koudelka often suggested that Fárová ask Luskačová to assist her, assuring her that Luskačová could help, never hesitating to offer up her services. He wasn't aware that, after all the negatives had been gathered and passed to Harbutt, Fárová had stated unequivocally to Luskačová that "the rest of it (the contact sheets etc.) was possible to be reconstructed by Josef in 'the WEST' from the negatives, and that there would be 'no more shipping out of Josef's archive.'" Luskačová confided to me, however, that she continued shipping things to Koudelka. "I did not want Josef to waste his life by redoing things that were already done," she said, recognizing only in hindsight that by trying to help Koudelka not waste his time, she had forsaken some of her own.

Koudelka was as demanding and insistent in his letters to Luskačová as in those to Fárová, asking her not only to gather materials to which she had access, but to press Fárová for whatever he needed from her. These demands only exacerbated an already tense situation — and were especially damaging to Luskačová; Fárová, had she been so inclined, could have been exceedingly helpful to her career as a photographer, as she had been with Koudelka. Luskačová says:

Anna thought I was Josef's lover, and I think that this was absolutely at the root of all the problems with Anna and me. When Josef left, he would write me letters saying: "Ask Anna to do this, and ask Anna to do that." I would go to her and say: "Listen, Josef is saying do this, or do that." She was a generation older than I was, a married lady with two children. . . . And here I was, this young girl, coming by and giving her orders. I could see on her face how upsetting it was for her, so I wrote to Josef: "What you want from Anna, ask Anna. What you want from me, ask me."

In one undated letter to Fárová (likely from the early 1970s), Koudelka penciled in a note: "Stop disliking [Luskačová] if you can. It's not convenient for me."[26] To me, Koudelka adds: "Markéta was an excellent photographer. . . . I did not know how to get Anna to like her, which would have been good for me, and especially for Markéta."

Still, however vexing and consuming the intricacies of getting his materials out of Prague might have been in the early 1970s, this period would prove to be transformative for Koudelka. And not only in terms of his work. Lifelong,

JK, photo-booth portraits, 1972

supportive, and affirming relationships would be established — and all without any agenda other than to help facilitate for Koudelka what he wished for himself.

First, there was the dinner.

4.

The Photographers' Gallery in London, founded by Sue Davies, opened its inaugural exhibition, *The Concerned Photographer*, on January 13, 1971. Curated by Magnum photographer Cornell Capa (whose older brother, Robert Capa, was a co-founder of the cooperative), the show had premiered in New York in 1967.[27] David Hurn was invited to the opening; Koudelka was staying at his place at the time and went along as his guest. Koudelka recalls: "I was not yet in Magnum. I was nobody. I was shy and so on. I didn't know anybody except David, and I looked at the photographs. Then everyone was going to some fancy restaurant. I remember we went down the stairs. . . . I let everybody walk in before me." Russell Miller continues the story:

> *[Koudelka] found his entry firmly blocked by an elaborately uniformed porter who haughtily insisted that he could not enter without a tie. When Koudelka asked if he could borrow a tie the porter said there was no point as his shabby combat jacket and baggy trousers were not acceptable either. Word of his problem had obviously been passed to the guests inside, because suddenly the door burst open and a furious grey-haired man grabbed the porter by his lapels and shouted at him, "He's better dressed than you! Look at you, you're dressed like a clown. If he can't come in, I'm leaving," whereupon all the other guests left too and gathered in a cheerful Greek restaurant just down the road.*[28]

"They all stood up and left in solidarity with me!" says Koudelka. And the older man who led the group by storming out? It was Henri Cartier-Bresson:

> *Then they put me at a table with Bresson. He didn't know who I was. I couldn't speak much English, and I think I said that I am interested in Gypsies. He said next time when I pass through Paris, would I come to see him.*

Other propitious encounters followed, which made 1971 and 1972 pivotal years for Koudelka. After becoming an associate member of Magnum in 1971, he decided that he might like to try the Leica camera that so many of his Magnum compatriots were using: "I thought that I should learn what it is about . . . to get the knowledge of what it is, what it can do." With the Leica, he began using 50mm and 35mm lenses.

Just as the wide-angle lens had played a significant role in Koudelka's approach to photographing the

Henri Cartier-Bresson and JK, London, 1973. Photograph by Martine Franck. Inscribed: "With friendship and affection, Martine"

Roma, the Leica would be a partner in his ever-evolving sensibility. The compact, lightweight camera also fit his nomadic life of sleeping outside and carrying most of his possessions with him. Again translating aloud for me from his original Czech, he reads an entry from one of his 1971 diaries: "Keep all the time the camera on yourself. It is only possible with Leica. For that reason, you are changing to Leica." They were clearly well matched. Once, he was walking around an East London market when a Romani man approached him and struck up a conversation. Koudelka recalls: "I've got the Leica, the one which was sleeping with me. He looked at her, my Leica, and he said: 'She is not your wife. She is your lover.'"

In 1971 Koudelka was thirty-three years old. His time in exile, rather than causing his life to unravel, had catapulted him into an uncharted world, where anything and everything could be an opportunity. Still, he would later tell Karel Hvížďala:

JK, early 1970s. Photographer unknown

> I have always considered myself lucky to have been born in Czechoslovakia, so that I didn't get used to certain things that were taken for granted in the West. . . . When I lived in Czechoslovakia, freedom for me meant mainly being able to do what I wanted, and, within our limited freedom, I was able to find space for my work. I didn't need to go somewhere far away to take photographs. I knew that if I was worth anything I had to prove it here in my country. When I left, it seemed to me that keeping that kind of freedom was even harder outside of Czechoslovakia, because at home, although there wasn't political freedom, the lack of another freedom — the freedom to make money — forced us to do things we believed in, that interested us, and that we liked to do. . . . In the West, it was different.[29]

Koudelka's wariness of the trappings of money and its potential to corrupt is deeply entrenched. He told me that, when he arrived in the West, "I never wanted to have more money than the money I needed to photograph."

In some ways, Koudelka was the perfect exile — given his nomadism and independence, his moral code and self-inflicted rules. He was corrupted by neither religion nor politics, which was in perfect accord with his mistrust of assimilation and authority. Statement after statement in his notebooks and to friends and colleagues proclaim his ardent resolve never to conform, "to stay different and keep my healthy anger."[30]

As Czesław Miłosz rhetorically concluded:

> The decision to refuse all complicity with the tyranny of the East — is this enough to satisfy one's conscience? I do not think so. I have won my freedom; but let me not forget that I stand in daily risk of losing it once more. For in

the West also one experiences the pressure to conform — to conform, that is, with a system which is the opposite of the one I have escaped from. The difference is that in the West one may resist such pressure without being held guilty of mortal sin.[31]

Koudelka has always traveled light. In his early years of exile the extent of his baggage remained his camera and film (most important), two pairs of socks, a jacket, one pair of shoes, one pair of trousers, two shirts, a towel, his harmonica, and a good sleeping bag.

I didn't want to have what people call a "home." . . . I learned to sleep anywhere and under any circumstances. I had a rule: "Don't worry where you are going to sleep, so far you've slept almost every night, you'll sleep again tonight. And if you sleep outdoors, you have two choices — to be afraid that something might happen to you . . . or accept the fact that anything might happen and get a good night's sleep, which is the most important thing you need to function well the next day."[32]

Packing light works metaphorically as well: neither materialistic nor avaricious, Koudelka had no inclination to accumulate anything but his own images. He survived financially with the help of grants and other financial awards, which he could stretch to cover long periods of work; later there were commissions that helped facilitate his decision not to take assignments. As a Magnum member, Koudelka also earned money when the cooperative sold the editorial rights to his images, although he first had to be enlightened to the fact that selling the rights to photographers' work was, at least at that time, intrinsic to the cooperative's financial health and stability — part of the deal.

Russ Melcher, European director of Magnum from 1966 to 1972, recalled: *Josef would literally disappear for . . . six, seven, eight months at a time. He would come back and he would print, and then he would run around with a bunch of new, small prints and ask people which ones they liked and which ones they didn't. He marked their responses on the back. Then out of . . . whatever he'd done over those six or eight months, he'd choose eight or nine images.*

This went on for one or two years and then I had to sit down with him. I said: "Listen, this is very good and yes, we made some money on your original distribution [the Soviet invasion images]. But this is a cooperative and we need money coming in from photographers. We need to be able to distribute some of your work for editorial use." He really didn't want anything sold that he might use in a book, but he understood. So he gave us an edit, so we had some pictures to sell. They were good pictures, but he didn't feel they were as good as whatever he'd already chosen. I think we didn't use his name at first, so he didn't have to be morally responsible for pictures he wasn't entirely happy with.

In fact, Koudelka early on developed a complex process of selection, approval, crediting, and ultimate release of his images. It is a color-coded system that he still applies to his contact sheets. Those images he finds interesting in the first edit he frames in white. Those he outlines in yellow represent

choices from the second edit; these are the images he believes are good enough to place in Magnum's archive of photographs (the images for which they may sell reproduction rights; although at first he released these with the proviso that only his initials appear in a credit line, eventually he would allow his full name to appear with them). Red outlines indicate the third edit: these are the images he believes are good enough for Magnum's archive and to appear with the full byline "Josef Koudelka" (the exception early on being his coverage of the Soviet invasion). Blue marks represent his final edit — the highest ranking — the photographs that Koudelka believes are the best, and that Magnum is not allowed to distribute: these he wants to save strictly for his books and exhibitions, and has placed in his *katalogues* as such.

One of JK's contact sheets from the Soviet invasion of Prague, August 1968

Over time Koudelka has become somewhat less strict about the dissemination of his work, especially when it is in conjunction with the publication of his books or exhibitions. But he has steadfastly declined the magazine and corporate report assignments that many of his Magnum colleagues have traditionally relied on. On the rare occasion when some photographer took issue with this, implying that Koudelka was not pulling his financial weight with the cooperative, others came to his defense. "Usually," he says, "it was the older generation, and those people who made the most money, who came to my and other photographers' defense, if we were accused of not bringing in enough money."

Later, when Koudelka began to take long-term commissions, he would never agree to a project unless he found it compelling. He has three conditions for any commission he accepts:

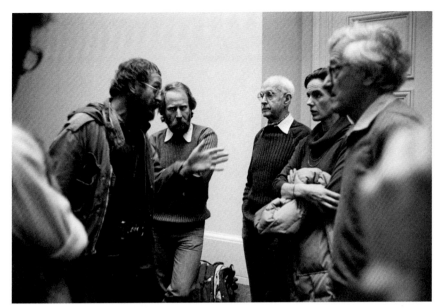

Magnum exhibition at the Musée du Luxembourg, Paris, 1981. From left: JK, Sebastião Salgado, Henri Cartier-Bresson, Martine Franck, and Marc Riboud. Photograph by Guy Le Querrec

I must be interested in the subject, and it must have something to do with me — personally, emotionally, whatever — this is the first thing. And I have to know that what I want to do, I can do well: the guarantee that I have all the possibility I need to make the pictures as I want. And finally, that I have all control to get to the final result the way I think it should be.

In some cases, he has also been careful to ascertain that the funds for the project are not from a source that he finds troubling or that might in any way compromise the integrity of the project.

Koudelka was mindful enough of this period's significance in his life to decide that he should keep a record of it. In a 1971 notebook, he reminded himself: "You have to keep a diary. . . . Use a size larger than this one, and you should also stick inside clippings."

Along with clippings, pasted or taped into these bigger notebooks are letters, postcards of paintings, notes, information on World Roma Congress meetings, and other information he deemed relevant. Also included: the occasional souvenir from a journey — a flea, for instance: "This big flea, she bit me for two days!" he told me, pointing to its infinitesimal remains on the page.

The house may have burned down, but already in 1971, less than a year after he left Prague on his exit visa, Koudelka was building a "new and different house" — and doing so on his terms.

III Building

1.

Before the two photographers had set eyes on each other, Cartier-Bresson had already unknowingly made a critical introduction on Koudelka's behalf when he wrote to Anna Fárová in 1969, asking her to welcome the Smithsonian's Eugene Ostroff in Prague. When she showed Koudelka's photographs of the Soviet invasion to Ostroff and he, in turn, shared them with Erwitt — Koudelka's life was changed forever.

The next crucial introduction Cartier-Bresson made for Koudelka — intentionally this time — was to the publisher Robert Delpire. This meeting, too, would prove essential to the photographer's life and work. Finally, Cartier-Bresson made sure that Koudelka met his own confidant, the photography editor and writer Romeo Martinez, with whom Koudelka would become fast friends, and whom he frequently visited on his trips to Paris:

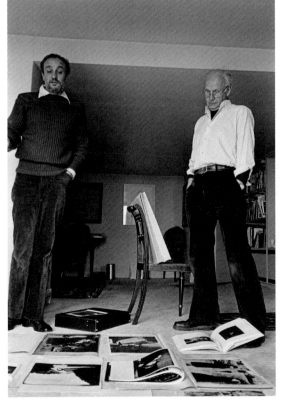

Robert Delpire and Henri Cartier-Bresson, Paris, 1976

He was this older gentleman who liked to speak, and could speak about everything. . . . He was about the same age as Bresson. He was very wise. When I went to see him, I really needed to reserve two to three hours, but then he could tell me something about life that nobody else could tell me.

Martinez knew all the photographers. They went to him. They talked to him. Bresson and Martinez spent half an hour on the phone together every morning. I think they spoke about everything.

Koudelka says, with some indignation: "There exists a biographical book on Bresson, and Martinez is not even mentioned there!" And then, staring at me intently, he loyally declares:

Martinez was somebody very special. Even before Delpire, Martinez was proposing that I do a book with him, in early 1972. I never agreed with his choice of photographs. I agreed with Delpire nearly completely, and with Bresson in a certain way. But Martinez mattered! Bresson and Delpire were important to me and my photography and

my being a photographer — in different ways . . . Martinez, too, was my friend.

Left: André Kertész and Henri Cartier-Bresson, 1980

Right: Romeo Martinez, Paris, 1973

For his part, Cartier-Bresson wrote in 1983:

Romeo Martinez is, in my humble opinion, the father confessor to a number of photographers who come to him to beg for absolution.

His own great sin is never to have asked what the alms are for this parish that he has brought to photography.

He knows more about each of us than we ourselves do.[1]

Koudelka refers to his first meeting with Cartier-Bresson at the London restaurant as a "great accident." Their following encounter came some months later in 1971.

When I was already in Magnum and I was passing through Paris, I called Bresson and asked if we could meet. He asked me to bring my photographs. I was a little afraid because I was told that he hated the wide-angle lens, and that he didn't crop his photographs. And most of my photographs were made with the wide-angle lens, and if I felt it was necessary I cropped them.

Nonetheless, Koudelka brought along his *Gypsies* photographs that he'd taken out of Czechoslovakia. He described Cartier-Bresson's response to his work in a note that July to Fárová:

HCB [Henri Cartier-Bresson] sends his regards. He, to my surprise, likes what I am doing. He even wants me to give him two signed photos, which he would like to hang on the wall. I stayed at his place for a week, and I was very moved how he looked after me.[2]

The photographs Cartier-Bresson asked for were the Romani man in hand-cuffs and the one of the wake, both made in 1963 in Slovakia: "He hung them in his house. I had passed the test."

Cartier-Bresson was born in the same year as Josef's father: 1908. But he did not play a paternal role with Koudelka. While aware of the stark differences in their life experiences, Cartier-Bresson sometimes referred to himself as Koudelka's "*frère aîné*" — his older brother. Koudelka found that he had been adopted into a rather illustrious extended family. For example, when André Kertész came to Paris, Cartier-Bresson called up his "younger brother" so they could meet. According to Koudelka, Kertész was, for Cartier-Bresson, "the big maestro. . . . He said: 'We three are from the same family, and you should know him.'"

It seems that Cartier-Bresson saw something of himself in the young photographer:

Henri used to tell me: "When I was young, I was like you. But there was a difference. I could go back to my mama."

For some strange reason, which I don't understand exactly, we became really close friends. He was from this bourgeois family, he was well educated — which was not my case. But he was one of the closest friends I had.

When it came to their shared medium, Koudelka says: "I was perhaps the only photographer in Magnum who criticized his photographs. He would ask me to. I was probably often wrong but I said what I thought. He respected my opinion and never felt insulted."[3] In at least one case, though, Koudelka's judgment had a very real impact. Upon returning to Paris from a trip to England, Cartier-Bresson excitedly showed Koudelka an image he'd made. "He said to me that he did this wonderful picture, and told me to have a look at it," Koudelka tells me. "I did, and said: 'Henri, I don't think it's so great.' And then I left the house. I heard that after I left he destroyed the photograph."

Koudelka's friend Hervé Tardy knows this anecdote, and notes how harsh his criticisms can be. "About photographs, Josef can be just terrible. He can kill off photographs. He says: 'That one — it's no good. No good.' And it is dismissed."

"But," asserts Koudelka when he is narrating this same story, "it is important to get opinions about your work — especially from people who you respect and who don't want just to please you, but are honest and will tell you if something is good or bad." He can also be

Drawing of JK by Henri Cartier-Bresson, 1980. Inscribed: "For Josef, with friendship from Henri"

121

encouraging — even propulsive — when he feels a photographer is not living up to his or her potential, has given up, has taken a direction that isn't sufficiently interesting, or simply is not working hard enough (by Koudelka standards). In January 1975, with typical candor, he wrote to the Chilean photographer Sergio Larraín, whom he had met in Paris:

Sergio,

You can feel, see and photograph
what we are not able.
You give us enough, but
YOU <u>MUST</u> GIVE US MORE
YOU ARE CAPABLE
Your friend
Josef [4]

Some time after Koudelka's meeting with Cartier-Bresson in 1971, the French master brought Koudelka all his own photobooks and asked him to choose the images he liked the most. "I didn't understand — nobody understood — how he could ask me, who was nobody, to do that!" Some years later, the British photographer Cecil Beaton took note of Cartier-Bresson's interest in Koudelka and his work. In the encyclopedic 1975 publication *The Magic Image*, by Beaton and Gail Buckland, the authors observe that Cartier-Bresson, his brain "dagger-sharp but profound . . . feels inspired by the rugged strength of Joseph [*sic*] Koudelka's work."[5] Elsewhere in the book is an entry on the Czech photographer himself: "Koudelka exerts tremendous influence on such sophisticated people as his friend Henri Cartier-Bresson; in fact, Koudelka's genius is so strong that Cartier-Bresson is willing to be advised to a remarkable degree by the younger and comparatively unknown person."[6]

Koudelka understood that there were places of affinity between his photographic sensibility and that of Cartier-Bresson — and he was wary of them. When the older photographer asked him to go through his contact sheets and select photographs for an exhibition, Koudelka stopped almost immediately after he began: "I thought: 'I can get influenced by doing this, and I don't want to.' I was also choosing pictures which were not him, but were more my kind." Koudelka seems to have felt an imperative to distinguish his own sensibility from that of Cartier-Bresson.

In one of his early notebooks Koudelka cautioned himself: "Try to do the things that you are able to do better than anybody else." And this mandate was not just about subject matter. Cartier-Bresson's approach to his photography could not have been more different from that of Koudelka, who feels that Cartier-Bresson's images, as carefully composed as they may appear, were too based on the ephemeral, "on something that you have to catch very quickly." Still, he recognizes the French photographer's remarkable intuitive ability to perceive and capture these elusive "decisive moments." Koudelka laughs as he recalls a famously favorite photograph of Cartier-Bresson's, made by the Hungarian photographer Martin Munkácsi in Liberia around 1930, showing

three boys in near-silhouette running joyfully into the sea. "Bresson says this is the most beautiful photograph that he ever saw in his life," said Koudelka. "I told Bresson: 'Henri, what you are talking about has nothing to do with the quality. This is the *amour*, this is the love, this is your first love here.'" Indeed, Cartier-Bresson observed that Munkácsi's photograph was "the spark that set fire to the fireworks . . . and made me suddenly realize that photography could reach eternity through the moment. It is only that one photograph which influenced me. There is in that image such intensity, spontaneity, such a joy of life, such a prodigy, that I am still dazzled by it even today."[7]

For Koudelka, it is his *frère aîné*'s sense of visual balance that is most compelling. Cartier-Bresson himself spoke ardently about the gospel of geometry:

> *It is written in the gospel: "In the beginning there was the Word." Well for me: "In the beginning there was Geometry." I spend my time tracing, calculating proportions in small books with reproductions of paintings that I never leave behind.*
>
> *And that is what I recognize in reality: within all this chaos, there is order.*[8]

Along these lines, Koudelka has said, as recently as 2021: "My type of photography is about content first, and then geometry."[9]

Cartier-Bresson loved painting (and was trained as a painter); so does Koudelka — but Koudelka notes that his engagement with paintings comes from the opposite angle: "Cartier-Bresson, through painting, got to photography; and I got, through photography, to painting." Koudelka does not believe that Cartier-Bresson influenced his own work as a photographer — "At least I don't think so," he told me — but he believes to his core that Cartier-Bresson influenced him "enormously, maybe more than anybody else, as a man." He summarizes: "From him, I learned the ethics of photography and of life, how to take a position on something. When to say yes and when to say no."[10] More

Henri Cartier-Bresson and JK, Paris, 1996. Photograph by Paulo Nozolino

specifically, Koudelka explained to me that Cartier-Bresson did not want him to commit himself to photojournalism.

> Bresson said that he questioned how much [Robert] Capa's influence helped him as a photographer. I think he realized that photojournalism certainly influenced his work, and he tried to help me to avoid making the same mistakes he did. He used to tell me: "You have eyes, but you can lose them. Don't touch photojournalism." I should say that he was not only my advisor, but he was my protector in Magnum.

Did Koudelka need a protector? He thinks for a moment before saying:

> Yes, when I first got here, because for example even the first year Magnum told me: "You go to Spain. Get some color film and shoot it for us," so I did. It was the only color I ever shot in my life. Bresson got angry and if they tried to send me somewhere to do something again, he would scream about it. He helped me in this way.

As we are discussing Cartier-Bresson, it is clear Koudelka's thoughts have drifted — unusual for him. He looks away from me, his voice has become a shade melancholic, and he affirms that "definitely," he is picturing Henri. But these memories feather, more than flood, and once more in the present, he states: "It was Jeníček who first told me I had an eye, and it was Bresson who helped me not to lose it."

2.

Koudelka was considering diverse approaches to publishing his work on the Roma in the early 1970s. These included notions of a companion second book, which in a letter to Lee Jones, longtime editorial director of Magnum New York, he refers to as the "international *Gypsies* book."[11] That letter (undated but almost certainly from 1971) was written with the help of David Hurn and Magnum's special projects editor in New York, James "Jimmy" Fox (who would become the Magnum Paris editor-in-chief in 1976). Koudelka wrote:

> I shall plan to work on my Gypsy story until my funds permit me to complete the most comprehensive coverage. I figure that I can last another 2 years economically doing the type of coverage I desire without any other interruptions. At this moment I am not thinking of any other assignments or commercial work, although I would like to be considered if there are things of news interest happening in the areas that I shall be traveling. I have just returned from 3 [possibly 2 — the number has been corrected] months in Spain and at present I am doing various Gypsy oriented stories in England. Perhaps Henri has spoken to you about my plans and shown you some of my prints. . . . I plan to be in England until the end of June, then I shall be going over to Holland until the end of July. In August I then go back to France, and most probably from Sept to November I shall be going back to Spain (in various parts). . . .

The new material is for another book on the Gypsies on an International situation including various countries. . . . I would like to work at my unpressured level continuing this coverage.

Koudelka's letter was written in response to a query from Jones of May 19 (also no year given), which opens: "Dear Josef: This is the first of what I hope will be many letters designed to establish a working relationship between you and the New York Office." She goes on to ask: "What do you hope to have happen with the Gypsy material, in other words what, in the best of all possible worlds, would you most like to see done with it? . . . Is there, in your head or on paper, a final concept of the book?" As a postscript, Jones adds:

I have just talked to Sean Callahan who is the editor of a section of Life *Magazine called Gallery. He and Ron Bailey, the picture editor, are very enthusiastic over your dummy. Like me, they have a lot of questions.*

Jones continues grilling Koudelka about his vision for the project. Were there captions and other texts? Why did he take the photographs? What are possible relationships among them? She concludes: "Eight pages in *Life* would be a very fine way to launch a book, also a good way to get started in this country."

Koudelka was not convinced:

I wish to remain as much incognito as possible and not to have any publicity about my projects at this stage. Therefore I am not releasing any of the prints on the material I have taken so far either for magazine sales or file purposes. . . .

I must tell you also that the book is going to be only of pictures with no text, only at the end of the book will there be "one column" of facts about Gypsies — this is purely a photo book.

But which photos, exactly? Would it be only photographs from Czechoslovakia and neighboring countries taken before Koudelka left in May 1970? Or would it also include the work he'd made since arriving in Western Europe? Might it include all this plus work yet to be done in other parts of the world? Would there be one book, or two?

Even as he mulled over these questions and concerns, Koudelka was beginning to feel less connected to the *Gypsies* work: it was receding into his past. He was told — first by Magnum photographer Ernst Haas and later by John Szarkowski, among others — that the photographs he was making in exile, both in Romani communities and elsewhere, were evolving, becoming more sophisticated, driven by more than a sole subject.

When he shared these comments with Anna Fárová, she countered (perhaps somewhat defensively) that his singular vision had been lost or somehow compromised. Koudelka believes this is because she was not involved with the new work (a selection of which would eventually comprise his *Exiles* project) after having been so deeply engaged with *Gypsies*. In early February 1972 he responded to her criticism with a note that straddles self-deprecation and confidence in his deepening sensibility:

I cannot say I have made a big splash here. . . .

Concerning that discussion about the loss of my point of view and sig-nature style in photography, I can state that I like to get rid of musty things, even though I'm not sure which of those musty things might get better with time. Nonetheless, it seems to me that I would perhaps not have been able to make some of those new photographs previously, whereas I am still able to produce the old ones, but actually it IS NOOOOOOT GREAT, so you needn't look forward to one day seeing a miracle.[12]

Koudelka felt himself moving intuitively away from the *Gypsies* project and toward something else that was not yet fully revealed to him — at least consciously. Still, organizing the material as a book had been part of the goal at least since he'd met Irena Zítková of Mladá fronta in the mid-1960s.

Around this time, Koudelka also became aware of the writer and cultural critic John Berger (whom he would eventually meet more than three decades later, in 2008). A Marxist, Berger was the mind behind the groundbreaking 1972 BBC television series *Ways of Seeing*, and author of the book of the same title, which insisted that viewers consider art not simply formally, but in terms of its political and social context — and thus its larger implications. Koudelka thought about Berger's ideas in relation to his own work: could his images some-how change the community's situation for the better? Should he explicitly address the social conditions of the Roma — showing differences, for example, between their treatment in Czechoslovakia and in England? Koudelka wrote in his notebook around this time: "I am feeling more and more that I am missing that influence with what I am doing." Was he, should he be, as he put it to me, "changing into a more social photographer?"

In 1974 Cornell Capa founded the International Center of Photography in New York, dedicated to showing work by photographers whose practice is motivated by a belief in social justice. Koudelka said:

I remember how Cornell Capa wanted to fit me into his "concerned photog-rapher" category. I told him: "Listen, I didn't do these pictures to change the situation with the Gypsies." Because I knew I couldn't do anything to help the Gypsies in Czechoslovakia. These pictures couldn't even be published when I first started taking them. . . . I knew that I am always going to have a problem. But Cornell told me: "Yes, but you photographed them, and your pictures exist."

As Capa intimated, Koudelka's photographs themselves would have power to effect change whether he intended them to or not. The activist Grattan Puxon says that not only have Koudelka's images helped the Roma, but he has served as a kind of catalyst bringing together disparate parts of the community: "He has been a link between us, between particular key people at difficult times." Were there any negative aspects to Koudelka's Roma project? "I don't like peo-ple to be put on show," Puxon admits. "Nevertheless, many of his pictures hold great artistic composition as well as social revelations." Of Koudelka himself, whom Puxon has known for more than fifty years: "He seemed to be a loner on a single-minded quest. I admire him for that."

3.

In 1952 Éditions Verve published Cartier-Bresson's *Images à la sauvette*; the English-language edition, titled *The Decisive Moment*, was published in the same year by Simon & Schuster in collaboration with Verve. The publication was initiated by Efstratios Eleftheriades, known to all as Tériade, the legendary Lesbos-born founder and publisher (with Albert Skira) of the Surrealist publication *Minotaure*, originated in 1933, and of the equally forward-thinking arts journal *Verve*, introduced in 1937.[13] Cartier-Bresson had known Tériade since the 1930s; their collaborative book project (which features a cover by Henri Matisse) would inspire the French photographer to continue to seek out exceptional editors. Cartier-Bresson found another mighty collaborator in Robert Delpire.

Delpire was studying medicine in the early 1950s when, at age twenty-two, he agreed to assume the editorship and production of the semiannual bulletin of the Maison de la Médicine in Paris. Under his vision, this relatively dry dispatch quickly metamorphosed into a luxe publication, which he chose to call *Neuf*. He reached out to an extraordinary group of writers — among them André Breton, Henry Miller, and Jean-Paul Sartre — and photographers such as Cartier-Bresson, Robert Doisneau, and George Rodger, inviting them to contribute. Soon Delpire left his medical studies for what he knew was his true calling; in 1953 he founded what would become one of the most significant and visionary photography and graphic-arts publishing houses of its time: Delpire Éditeur.[14]

Delpire took risks on then-little-known photographers such as Robert Frank, whose landmark *Les Américains* (*The Americans*) he published in 1958. Along with his book-publishing enterprise, Delpire created innovative ad campaigns for commercial clients such as Citroën, Cacharel, and L'Oréal. In the early 1970s he hired the photographer Sarah Moon for his client Cacharel, and eventually they married. Over his career, Delpire also art-directed innovative magazines such as *L'œil*, and between 1977 and 1979 he produced seven extraordinary photo-driven issues of the magazine *Le nouvel observateur*, adding an eighth and final edition titled "Tout seul" (All Alone) in July 2009. He produced films, including William Klein's 1966 *Qui êtes-vous, Polly Maggoo?* (*Who Are You, Polly Maggoo?*), and curated exhibitions. In 1982 French minister of culture Jack Lang called on Delpire to direct Paris's newly launched Centre national de la photographie, which he led for fifteen years, presenting more than 150 shows.

Sarah Moon and Robert
Delpire, Paris, 1990

Cartier-Bresson's collaborations with Delpire began in 1951, when the photographer's work was first published in *Neuf*, and continued with his 1954 books *Les danses à Bali* (The Dances of Bali) and *D'une Chine à l'autre* (From One China to the Other).[15] Delpire thenceforth enjoyed Cartier-Bresson's full faith and trust as his editor, publisher, and friend. It was in this spirit that

Cartier-Bresson called to tell him about a young Czech photographer who was coming to Paris, and whose project Delpire must see.

In late May 1972 Koudelka visited Delpire at his office in Paris's Montparnasse. "I made the comment that his office is enormous," notes Koudelka, after consulting one of his diaries to see exactly what he wrote at the time about the meeting. Memory jogged, he continues: "He had one floor in the Tour Montparnasse. It was really big and there were a lot of people working for him. . . . I was surprised that a guy like him was dressed, I thought, quite horribly. He wore a terrible overcoat, but in fact — I didn't understand — it was very fashionable."

Koudelka showed Delpire his photographs of Central European Roma — only the work he'd made before leaving Czechoslovakia — and the publisher inquired about his vision for the project at large.

Henri Cartier-Bresson and Robert Delpire at the Fondation Henri Cartier-Bresson, Paris, 2003

I told him that in four years, I want to finish European Gypsies, make the book, and make the exhibition. He told me that he likes it and he wants to do it. And I said that I want to continuously work on the book, I want to eliminate possible mistakes. And he said yes.

Delpire told me years later that, upon meeting Koudelka, he was "smitten — both with the man himself and with his photographs. . . . The strength of his images, their singularity were in perfect accord with his person."[16] He would write in 1975:

Crossing the room and coming to you, Josef Koudelka makes you feel chosen. He stands, lithe and trim, allowing no possibility of retreat. His eye, circled by the thin wire of his glasses, insists on knowing things before seizing them, sorting them out before taking possession.[17]

After that initial encounter, Koudelka showed Delpire the working dummy of the Roma photographs that he and Milan Kopřiva had conceived. Delpire scrutinized the maquette. He had other ideas.

Delpire said he didn't want to do it like that: "I want to do it a different way." I didn't mind, because I had the Kopřiva dummy and I could imagine what that book would look like. For me, it was more interesting to work with somebody who was very good and who would deal with the same material differently. I wanted Delpire to be free. In fact, I would have loved to publish the dummy as it was from Czechoslovakia. But he didn't want to. And that was okay with me.

The two agreed that by the end of 1972 Koudelka would give him all his material on the Roma and Delpire would put together a new maquette. There was some continued discussion of two volumes, but ultimately that notion was rejected. The project soon morphed into one book that Delpire would edit and design with Koudelka, as well as publish: "I told Bob: 'The only thing that is finished for me, because I can't go back to Czechoslovakia, are the Czechoslovak Gypsies, so let's publish the book on Czechoslovak Gypsies.'" In the meantime, Delpire offered the photographer the use of a darkroom in his new base on Rue Bonaparte for developing film and making prints.

When they next met, on February 9, 1973, Delpire had sketched out some possible approaches and layouts for Koudelka's review. He had also, according to Koudelka, "grouped the pictures into sections but had not yet made a selection of which pictures, or suggested a sequence." A memo from Delpire, made two weeks after this first working meeting, outlines a "résumé of the situation." It is touchingly ingenuous: the publisher clearly has no clue of what he's in for over the upcoming two years. He writes of "Gypsies in Czecho-Slovakia" that "the layout is accepted in the principle but we have to improve the binding." Other details are "to be discussed."[18]

In March 1973 Koudelka (likely with the help of David Hurn) wrote a follow-up letter to Delpire: "The Czech Gypsies material represents the best I could give of myself until 1968, so I am equally anxious that the book be the best we could do for these pictures." Delpire had asked Koudelka if he might review his contact sheets in order to see every image the photographer had made of the Roma before his exile, with the idea of perhaps selecting additional ones beyond his master set. In the same note, Koudelka writes: "It was very courageous of you to offer to edit the contacts. However, after going over it again, I think the editing is at its maximum and it would be more worthwhile to spend time on other aspects of the book rather than trying to find one or two new pictures."[19]

With future projects Koudelka would not only allow Delpire access to his contact sheets but would encourage him to indicate those photographs that he believed worthy of consideration. But with the Roma work, Koudelka was certain that, "because of the experience of making the *Gypsies* dummy in Czechoslovakia, living all the time for many years with these photographs, selecting them, putting them together, learning from Kopřiva — I knew all the good pictures. . . . When I was making the Gypsy photographs, above my bed I put

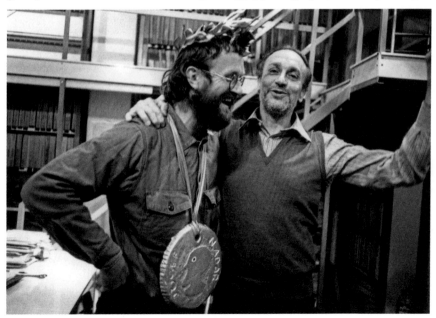

JK and Robert Delpire celebrating JK's Prix Nadar, Magnum Photos office, Paris, 1978. Photograph by Marc Riboud

all the pictures to choose from. And when I couldn't look at them anymore, I'd turn them around so they were white."

In the course of making the book, Koudelka grasped how deeply he could trust Delpire's eye. "Even when I sometimes disagreed with Delpire," says Koudelka, "I understood that . . . closest to my feeling of what is and is not a good picture was definitely Delpire."

Delpire put faith in his gut over his intellect when editing and sequencing photographs. He told me in 2012:

> Fundamentally, I am an intuitive person. Each time I have to make a choice, for instance to select a good photograph on a contact sheet, to build a sequence, even to make a general decision concerning a book to publish, I am always most comfortable if I follow my first impulse. It would be very pretentious to say that I am always right — but if I do make a mistake it's always in accordance with my feelings, my deep convictions. . . . When a photograph touches me profoundly, I do remember it, whatever the circumstances.[20]

And so, a month into 1973, they began. And then they began again. And yet again. And again. And again. . . . [21]

"Good morning, Monsieur Josef," begins one memo from May 1973 that Josef reads to me aloud; it goes on to point out that Delpire has spent the better part of a sunny Sunday working on Koudelka's maquette. "You will find enclosed the 34th version of this dummy in 62 pictures."[22] Forty years later, Koudelka considers that memo, and tells me matter-of-factly: "Of course, there were not thirty-four dummies!" But he concedes: "Of course, there were quite a few."

For the next two years, Koudelka and Delpire made and refined so many *Gypsies* maquettes that Delpire finally told him exasperatedly that he had never in his life spent so much time on any one book. Still, whatever exhausting fusion of challenge and irritation Delpire was experiencing, he clearly thought that Koudelka was worth the effort — a feeling that persisted throughout their four-decade collaboration. Years later, Delpire put it this way:

> It is talent that dazzles me. No matter which kind, no matter where it comes from. The talent of a mason at the turn of the century building a farm. But also those we can name: Kathleen Ferrier singing Mahler. Bonnard painting flowers. Josef Koudelka looking at the sea. . . . It is talent that dazzles me. I am what Jean Genet called an "admiromaniac."[23]

About their bond, Koudelka conjectures:

> I think Delpire identified himself with me as a photographer in exile. Delpire never went into exile, but I think somehow he really felt what photographic exile is. Henri [Cartier-Bresson] was very sensitive about things, and so incredible with me, but I don't think he really understood exile — it was just too far away from his own experience.

Then, reflecting on these two extraordinary friends, he adds, "Bob and Henri, they were so different from me, but they both helped me so much."

4.

The photography historian and curator Stuart Alexander has written:

> *Just as stars and constellations have names and significance that have developed over centuries, so Koudelka has had people in his life, or clusters of people, that form his firmament. Like planets or stars, they have exerted a kind of gravitational pull on him; they sometimes shift in character and change in aspect, but they are still out there.*[24]

Alexander is himself one such planet in Koudelka's life. Another essential individual who early on became one of his most trusted and formidable friends is the renowned and trailblazing artist Sheila Hicks. Her weavings and other fiber or textile-based works complexly engage a multiplicity of textures, colors, materials, found objects, and scales, and are at times remarkably performative, other times exquisitely intimate, and still other times provocative in their definition, even disruption, of space.

Studying for her BFA and then MFA at the Yale School of Art in the mid- to late 1950s, Hicks majored in painting wih Josef Albers, took courses in sculpture, lettering, art history, printmaking, and photography, and studied pre-Columbian art with the historian George Kubler. During this period, she went to Chile on a Fulbright scholarship and traveled throughout Latin America, photographing weavers and archaeological sites. After Yale, she moved to rural Guerrero, Mexico, where she remained, working as a painter and weaver, until 1964, when she relocated to France.

Hicks has lived in Paris ever since. She and Koudelka met there in the autumn of 1971, when he visited her studio in a modest space that had originally served as a wool-mattress reconditioning workshop, in the Passage Dauphine in Saint-Germain-des-Prés.

Just as Hurn considers himself Koudelka's "Welsh brother" and Cartier-Bresson enjoyed his self-appointed role as Koudelka's *"frère aîné,"* Koudelka would soon begin to refer to Hicks, four years his senior, as "big sister Sheila." (He recently clarified this for me: "It's 'Big Sister' — like 'Big Brother.' She watches over everything and knows all.")

Earlier in 1971, Cartier-Bresson's wife, the photographer Martine Franck, had photographed Hicks at her studio when the American artist was making a series of silk bas-relief panels for Air France 747 jet planes. During that session, Hicks told Franck that she was soon going to Prague.[25] Franck and Cartier-Bresson were already close to Koudelka and knew well that Josef was anxious to extricate his materials from Prague. "Martine was very practical," Hicks told me, "and so she asked me, would I be willing to meet with someone who needed help in Czechoslovakia?"

Koudelka, who was often in Paris when not photographing, paid a visit to Hicks in her studio (close to what was then the headquarters of Magnum Paris at 2 Rue Christine).[26] In Hicks — with her visual acuity, independence, talent, and candor — Koudelka recognized a kindred spirit. She recalls that he brought a large bottle of slivovitz, distilled by his father, and they drank it together

the night before she was to fly to Czechoslovakia. "Josef wanted me to carry a shopping bag full of things out."

It was not Hicks's first experience trying to help Czechoslovaks coming through Paris. She had put some of them up at her place, and helped in whatever ways she could. From these individuals, Hicks learned: "You had to be careful how you met in Czechoslovakia, because they were being watched all the time." Still, she agreed to help Koudelka. In June 1968, Milena Lamarová and Dagmar Tučná, curators at the Museum of Decorative Arts in Prague, had presented an exhibition of Hicks's work in the castle of Jindřichův Hradec, south Bohemia, and subsequently bought one of her large pieces. As she was to be paid in Czechoslovak crowns, Hicks tells me she decided to "return and use the money in Czechoslovakia. I wanted to bring my small children — my son Cristobal and daughter Itaka — and go with friends on a Christmas ski vacation

Sheila Hicks, Paris, 1984

in Czechoslovakia." As an American woman on holiday with her two young children, she and Koudelka hoped, Hicks would not arouse suspicion. Still, she remembers that he was very cautious. "The people who had left Czechoslovakia didn't want their families to be targeted. They, including Josef, were all very careful not to talk about anything."

In late 1971 Koudelka wrote to Anna Fárová in Prague to say that she would soon have a visitor:

Dear Madam,

This lady is a friend of HCB and Riboud, also of [Bruce] Davidson and others. She knows everything about them, and also something about me. One can talk to her about everything. She's good. She speaks various languages, including French, and one — and therefore you too — can learn all sorts of things from her. Try to talk to her or send a letter with her or messages, or nothing. . . .

PLEASE SEE TO THE FOLLOWING:

Send as many contact prints as possible with this lady — I am waiting for it — ONLY FOR IT — when she returns, I will immediately go and work. I would prefer WHOLE BOOKS OF CONTACT PRINTS. If this turns out not to be feasible I propose:

—removing the contact prints from the pages and carefully and reliably numbering the contacts. . . .

PUT TOGETHER THE CONTACT PRINTS FROM EACH NOTEBOOK SO THEY DON'T GET SHUFFLED.

DO NOT FAIL, FOR THE LOVE OF GOD, YOU WILL HAVE HALF MY KINGDOM AND MY FIRSTBORN SON!!

If she isn't able to take everything with her, and someone else is there, say, on New Year's Eve, he should take the rest to the country he is going to and telephone MAGNUM PARIS, to say where the photos are. BUT SOON.[27]

Fárová and Hicks met at the bar of the hotel where Hicks and her family were staying and arranged for the handover of Koudelka's materials. Did Hicks know what they were? "I didn't look," she told me. "I didn't want to know, in case the Russians asked me." What was her impression of Fárová? "It's strange, you're not in a situation that you're liking or not liking people," she said, "because you're just agents. You're just passing things to each other. . . . During the Russian period, you learned to become very observant and not very forthcoming. And you learned to be very careful about who you trust, as was Josef. He still is."

In 1992 Hicks and Koudelka conversed about her return to Paris from Prague:

> Josef: *I told you that bringing my things out could be dangerous, but you insisted that you'd manage. I'll never forget coming to get you at Orly airport. . . . You walked through the customs with two big bags full of my photography archives and your two little kids. I couldn't believe it.*
>
> Sheila: *Well, I mixed your archives with our ski equipment.*[28]

Koudelka received a follow-up note from Fárová, written January 16, 1972. He was not surprised by her chilly tone. "She sometimes could just not be nice to some women," he told me. "After I wrote to her that she can learn something from Sheila, Anna wrote to me about their meeting." Koudelka does a simultaneous translation for me of Fárová's letter: "The lady, Sheila Hicks, I sent with her the contact sheets and the theater magazines. . . . When Sheila was here, Markéta was not here, so I arranged everything myself. . . . I don't know what she told you about me . . . but anyway I must tell you, I didn't learn anything from her, as you suggested to me."[29]

On January 31, 1972, Hicks sent Fárová a postcard of the Louvre's *Winged Victory of Samothrace*. On the back she wrote in English: "We passed the black and white packages to the Gypsy rover and he went to London to try his fortune in a dark room. . . . Thanking you for your kindness in Prague."[30]

It was winter. Koudelka now had more of his treasured archive in his possession, and he was hunkering down to print.

Koudelka's long friendship with Hicks is grounded in loyalty, trust, and an abiding respect for each other's work. With him, she is something like a lioness: protectively wary and sometimes fierce in looking out for Koudelka's best interests. A clearheaded, unsentimental sounding-board for the photographer, she has helped him negotiate everything from clothing in need of mending to strategizing with his galleries or with museum curators.

Hicks suspects that his profound trust in her stems partly from her willingness to disagree with him.

He has been through hell. And he is a hopeful, wishful, enthusiastic person. He would like things to work. He would like other people to agree with him, that it just sounds like a great idea. I just sit quietly and listen to where he wants to go and what he thinks. Then I have a tendency to say: "What if it doesn't work exactly that way?" . . . Josef doesn't analyze things intellectually . . . it's more emotional, intuitive. . . . He just blurts out the emotional responses to things.

Koudelka knows that Hicks will always be there for him:

Sheila is a real friend, which for me means that if I get into trouble — in real trouble, in big trouble — I know that I can rely on her, that she's going to come, put the hand in the shit, and take me out. I think that she knows that I would do the same for her.

Sheila knows my photography. She has got a very good eye. I was showing her my photographs since we met. I was asking for her opinion.

Koudelka very rarely admits to an artist's work having an influence on his photography, but he once stated in a conversation between the two of them: "Definitely Sheila's work influenced me." Hicks has pointed out that many of Koudelka's images featuring textiles are in fact part of his early work on the Roma, made before they had ever met. His response: "Well, I've always felt close to rags. My dad was a tailor, you know, and I grew up with sewing machines running all the time in my house. But my recent photos where textile materials do appear were definitely influenced by your work."[31]

Hicks's son, filmmaker Cristobal Zañartu, was six or seven when he first met Koudelka. The child was often in his mother's studio — even when she was away on one of her many trips. When we spoke in 2016 at a café near Saint-Sulpice in Paris, he described Koudelka's visits:

I grew up with Josef being this friend of my mother's who would come after school. This guy would show up, making a lot of noise, and then he would just take off all his clothes in the kitchen and put them in the washing machine. So he was walking around in his underwear. There were only women in my mother's studio and they would be hemming his pants, darning his pockets, because they were full of holes. The game was, "You can't leave. You look like a bum. We can't let you walk around. You're going to get arrested. So we need to fix this hole and this hole . . . and your clothes need to be clean. . . ."

But sometimes the clothes were just too far gone — in which case Hicks might make use of them in her own work. She says:

That was when I was working with laundry, recycling old clothes to make art. The idea was to take used textiles — things that had been worn and had former lives and show them as art. It was a way to breathe new life into them. The things you gave me had really been lived in, really worn out. And your colours — always green because you only wore faded greens.[32]

At times, she says, there was virtually nothing left of the clothes at all: *They were just stitches floating in the air! So we were forced to retire them from your wardrobe and after a while I used them in my exhibitions. Fragments of shirts, trousers. The darning was particularly beautiful — very much like handwriting.*[33]

Hicks often included Koudelka in her family gatherings as well, and Cristobal Zañartu and Koudelka eventually formed their own independent friendship. Zañartu told me:

When I was twelve, thirteen, fourteen, he became my buddy. He would come and give me a very big slap on the back, and I loved it. Then little by little we started talking more, and then I started getting interested in photography.

When I was fourteen I got my first camera. He'd make fun of my camera and how careful I was with it. "Stop treating it like jewelry. It's a tool." He was the first one telling me how to relax, and how photography was not spending your life behind the camera. He told me to look at paintings, and mostly, to always be sure to look at everything around me.

Reflecting on the unique connection between Koudelka and his mother, he added:

They're out of the same mold, like brother and sister. There was never anything sexual, but really close bonding because of their demanding eyes, their demanding, uncompromising way of looking at things. And both of them feeling like they're orphans in this world.

5.

In 1972 Koudelka accepted his first commission since arriving in the United Kingdom. The project, titled *Two Views*, was the premier photography initiative sponsored by the Arts Council of Great Britain. Koudelka and seven other photographers were invited to document specific towns and their citizens, from their perspective as outsiders. Koudelka had hoped to do his project in an ethnically diverse community but was asked to photograph Kendal, located on the River Kent in the South Lakeland district of Cumbria. The English market town held no interest for him, but he treated it as a "formal exercise" — photographing "people on the street or in shops in a uniform way, in situations that were 'as typical as possible, without directing them'"[34] and printing the resulting images like large postcards. He found Southend-on-Sea, a holiday resort in decline, about sixty kilometers east of London, far more interesting; he visited there several times, sleeping on the beach, stashing his two Leicas "in the socks between my legs" (as he wrote in a 1972 diary).[35]

Because Koudelka lived so frugally, this commission went far to help fund his ongoing work on the Roma. And the Arts Council continued its support by treating him as a resident of the United Kingdom, giving him grants and scholarships — Koudelka credits Hurn for much of this. "It was David Hurn who helped me so much, helped me to get the grants, and just was always my friend and there for me." The Arts Council urged Koudelka to pursue subjects that interested him in the UK, which it would then sponsor. Barry Lane, who headed the photography division, was committed to the country's photographers. Subsequently, the Arts Council would publish *British Image* two times a year, in this way sharing some of the projects resulting from the photography grants.

Southend, England, 1972

The Arts Council awarded Koudelka a six-hundred-pound grant in 1973 for "Gypsies in the British Isles" — a continuation of his work on the Roma in the United Kingdom. A portfolio of these photographs was presented in *British Image 2* in 1976;[36] the publication also includes work by Ian Berry, Chris Killip, Dennis Morris, Patrick Ward, and Markéta Luskačová, who had moved to London in 1975 and was now living with Killip.

6.

Around the time Koudelka was working on his images for *Two Views*, he appealed, yet again, to Fárová — still hoping to get all his materials out of Czechoslovakia:

Josef Koudelka Repairs His Jacket, England, ca. 1976. Photograph by Chris Killip

> *What I need.*
>
> *Considering that I am bringing to a close all the material about the Gypsies, and I want to make a new book dummy with Delpire by the end of this year, this time of all the Gypsies together. I need them to bring me:*
>
> *1) All the large original enlarged photos for the book. So that you have at least something, I can make copies and send you slides to project (unless you've already done it yourself).*
>
> *2) All the small, 13 x 18 working copies (Gypsies of Czechoslovakia), as selected by you in separate envelopes, into groups (woman, woman+child, interior . . .). In other words, photos from the rough selection.*
>
> *3) The large boxes of small 13 x 18 Gypsies photos (envelopes of settlements where I photographed): <u>no</u>. But please, if you can, go through it very quickly yourself, and if you like something, send it too.*

It's urgent, because M. [Marc Riboud — who would see Fárová on December 11, according to her notes written at the bottom of the original letter] can immediately give it to Delpire. It will save me a lot of time and work.

4) What isn't urgent. The books with contact prints, nos. 1, 2, 3, 4 are apparently at my parents' home (J.K., Valchov, no. 70, near Boskovice).

One day it would be useful for me to have them here too.

Write to me and let me know if you need something or how I can help you.

Josef

And one other thing. Just so there's no misunderstanding, I want to work on the Gypsies for the next three years, but now I want to bring to a close all the photographed material.[37]

In another undated note, likely from April 1973, an increasingly disgruntled Koudelka writes:

So, Madam, even though I am cross with you, I hope you're doing well.

<u>*What do you need?*</u>

I need?

He goes on to reiterate aspects of his previous request, and to add some additional and urgent items — many relating to the writing for the future *Gypsies* book with Delpire, and extensive research he had done before leaving Czechoslovakia. He hoped she would reach out to Milan Kopřiva, Jiří Chlíbec, possibly Milena Hübschmannová — whoever might be necessary to gather important information on the Roma that he wanted for reference for the text that would ultimately accompany the book. Markéta Luskačová was still in Czechoslovakia at this point, and he suggested to Fárová: "I think Markéta could help you with all of that. What's with her? I have no news."[38]

Joining forces with the smuggling effort, later in 1973 Robert Delpire, Sarah Moon, and Martine Franck would travel to Prague — returning to Paris with contact sheets, photographs, and even Koudelka's "beloved bagpipes."[39]

Josef Koudelka at Martine Franck and Henri Cartier-Bresson's Home, Rue de Rivoli, Paris, 1976. Photograph by Martine Franck

As complex, and sometimes mutually vexing, as the collaboration with Delpire could be over the following years, Koudelka was confident that they would eventually get the selection, sequence, and sizing of the images for *Gypsies* to his liking. They were still at the beginning of the process in 1973, and he was eager to learn from Delpire. It was the essence of the written content on which Koudelka was now especially focused. He had only ever wanted a brief, scrupulously informed text, uninflected by sentimentality. But his own context for considering the writing had become much more nuanced and variegated. Koudelka was now acquainted with the ideas of John Berger. His friendship and travels with Puxon, among others, in tandem with the Magnum ethos at the time, had made him question his own role and the notion of advocacy. This, combined with the prevalent hostility toward the Roma, their forced assimilation and marginalization, had opened up the possibility for a tone that acknowledged as unconscionable the human rights abuses the community was forced to endure.

Will Guy was a PhD candidate in sociology at the University of Bristol when he met Koudelka. While neither of them remembers the specifics of their first encounter, it seems inevitable that their paths should have crossed. Guy had done his doctoral research on the Roma in Czechoslovakia, and in 1971 he had accompanied the Czechoslovak Roma delegation to the first World Roma Congress in London as an English-language interpreter. Today he is affiliated with the Centre for the Study of Ethnicity and Citizenship at the University of Bristol. "Josef was surprised," says Guy, "that an Englishman was carrying out ethnographic fieldwork in the same areas of Slovakia where he had photographed between 1962 and 1968." In 1972 Guy had co-authored an article critical of government policy toward the Roma in Czechoslovakia. "This was very risky," he told me, "as it included extracts from internal government reports, supplied by officials, revealing that key policy elements were illegal and violated the constitution." Koudelka invited Guy to write an essay on the Roma that would, recalls Guy, "be the opposite of stereotypical romantic stuff about 'mysterious yet carefree Gypsies.'"

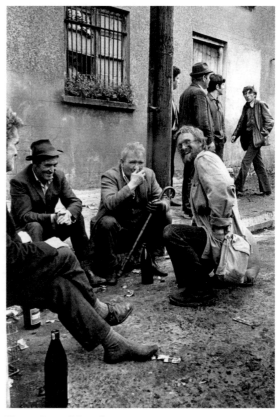

JK at Puck Fair, Ireland, 1972. Photograph by Markéta Luskačová

The text he ultimately contributed to the first published iteration of *Gypsies* is, says Guy, "explicitly political."

> I criticized the racism of the Communist government's 1958 assimilation policy, where it was argued the Gypsies had no culture worth preserving. I also characterized their situation as comparable to that of despised migrant workers in spite of their valiant efforts to improve the living standards of their families.

In *Gypsies*, the text and the images in no way illustrate each other. While Koudelka respects writers' freedom to do what they want, he doesn't want to tell readers and viewers of his books how to look at or think about his work: he wants the photographs to speak for themselves, just as he believes the facts will speak for themselves. What Koudelka wanted from Guy was accuracy. He also wanted to understand completely every word of the text, even in a language in which he was not yet fluent. "Josef interrogated me on the precise meaning of what I had written," says Guy. "I seem to remember him saying at one point: '*Co to* "the" *znamená*?' ("What does 'the' mean?" — Czech has no definite or indefinite articles)."

The two spent a week holed up in Hurn's place at Porchester Court, working nonstop on the book's text (fueled, appropriately, by Czech beer). "It felt," says Guy, "like being in a monastic cell."

With each attempt to select and sequence the images for *Gypsies*, Koudelka learned something new. The process was clearly maddening at times, yet Delpire

remained generally unruffled, pressing onward with maquette after maquette until late 1974, when it became clear to him that they were reaching a point of diminishing returns. The endless finessing was no longer improving the project. At the close of 1974, after some two years of constant tweaking, adjusting, and rethinking, he wrote to the photographer with a sense of *basta*.

> *Monsieur Josef, if you trust me, keep the layout as it is, don't change anything. . . . You are not betrayed. While working, I have constantly kept in mind your remarks, your references, your short explanations. But you made the photos, and I am planning to make the book.*[40]

In early 1975 Koudelka and Delpire finally agreed on a final maquette. "We did it! I used to tell Bob: 'This is half of you, half of me.'"

7.

Michael E. Hoffman was Aperture Foundation's executive director and publisher, from 1964 until his death in 2001.[41] He had first worked with Delpire on the publication of a revised and enlarged English-language edition of Robert Frank's *The Americans*, produced by Aperture and the Museum of Modern Art in 1968.[42] Aperture was founded in 1952 by a consortium of photographers, writers on the medium, and curators with a self-assigned mandate to encourage and support a community of shared interest in photography.[43] In keeping with its noncommercial mission, when Hoffman and Aperture's editors believed in the integrity and strength of a project and its author, it didn't matter how controversial the content might be, or if the photographer had little recognition: it was about the work. Publishing Koudelka's first book in the United States — when neither his name nor his photography were at all familiar to an American audience — would have been a challenge to any publisher. But, given the commitment of Delpire and the enthusiasm of Cartier-Bresson — two trusted advocates — Hoffman's interest in the project was piqued. Upon seeing the work that would constitute *Gypsies*, there was no question in his mind that Aperture must be the book's American publisher.

Both Hoffman and Delpire could be willful and intense, and their relationship was occasionally fractious, but they shared fundamental goals that led to more than forty-five years of co-publishing projects by their respective houses. Delpire, in Hoffman's estimation, belonged to a small group of people who were truly gifted at editing and sequencing photographs in books or magazines (among others he admired were Alexey Brodovitch, Marvin Israel, Hans-Georg Pospischil, Tériade, and Hoffman's own mentor, Minor White). Hoffman welcomed the opportunity to collaborate with Delpire on Koudelka's book, although there were hurdles to be negotiated — especially with regard to format[44] and title.[45] Aperture's edition of *Gypsies* was ultimately published in 1975.

To accompany Will Guy's essay, Hoffman arranged for the Aperture edition to include texts from both John Szarkowski and Anna Fárová, who was

now serving as the photography curator at the Museum of Decorative Arts in Prague. Neither of these texts would be included in the French edition, which comprises only an introduction by Delpire and the essay by Guy.[46]

Although Fárová contributed her text to *Gypsies* without apparent repercussions in Czechoslovakia, her life and work were being upended by the authoritarian regime — culminating in 1977, when she was fired from her job at the museum. She had signed the "Charter 77" document, which criticized the Czechoslovak government for not observing human rights provisions of the Czechoslovak Constitution and of international agreements to which it was a signatory. Issued partly in response to the December 1976 arrest of members of the underground rock band Plastic People of the Universe, Charter 77 was authored by an anonymous group that included artists, musicians, and writers (a large part of the document was written by Václav Havel). It was initially signed by 241 Czechoslovak citizens and distributed in January 1977. The "Chartists," as the signatories came to be known, demanded accountability from the government. In doing so, the Chartists put their jobs, their remaining independence, and their access to government services in peril, and risked increased and targeted repression at the will of those in power.

Koudelka recalls that, because Fárová signed the Charter,

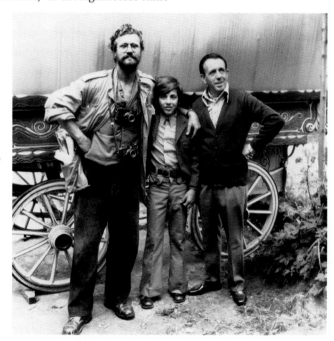

JK with Jim Penfold and son, England, 1974. Photographer unknown

> *she suffered a lot. She was kicked out of her very strong position at the museum. She had secret police watching her all the time. She told me: "We are two exiles." I was the exile, but she was an internal exile. She was an intellectual and moved in the sphere of Prague intellectuals. She was never political — not at all — so I am not sure she realized all the implications of signing it. But she knew Havel very well, and the people around him, and of course they knew very well what they were doing.*

Fortunately, Fárová was still allowed to publish abroad. Perhaps this relative forbearance by the Communist authorities was due to the medium with which she was associated — photography tended at that point to be overlooked. They were less lenient with those who had signed the Charter working in literature and the other arts. Another possible factor was how well known Fárová was and how much support she had abroad. Still, her passport, driver's license, and phone were confiscated.[47] Although they remained in contact, correspondence with Koudelka became riskier. He told me that nothing that the authorities could potentially use against her was ever sent through the mail; it had to be

hand-delivered by someone headed to Prague, as was any information of substance he wanted to share with his parents.

In 1975, almost fifteen years since entering their world, Koudelka finally saw his Roma work published in book form. His reaction, however, was not the elation one might have anticipated after so much time devoted to the project. He told me flatly: "I really felt like a prostitute."

> *Before the book was published, I was choosing the people whom I wanted to show the pictures to, and we could talk about it. But then suddenly the book was published, and anybody who had money could buy it. Of course I was happy that the book was done, that it existed ... but this is really the feeling I had.*

I suggested that another way to look at it was that now everybody who might be interested finally had the opportunity to see his work. Koudelka was unconvinced.

The year *Gypsies* was published, Koudelka brought a copy of the book to England to show a Romani friend named Jim Penfold. Koudelka was concerned that the image captions — in each case, just a place name and a date — might be too spare.

> *He could not read or write, but he looked through it. I said: "Jimmy, what do you think?" I give no explanation for the pictures. I give just place and date. "Did I make a mistake? Should I have put some text for each?" He said: "Josef, your pictures are doing all the talking for themselves."*
>
> *So then I asked him if he liked the pictures. How did he feel about them? He said: "Josef, in the world there must be at least twenty-five photographers who are much better than you. But I must tell you, they are not doing what you are doing. They are where the money is. And I am very proud to be the friend of the man who walks around this earth, who has nothing, but still nobody has enough to buy him."*

8.

Hervé Tardy was a friend with whom Koudelka regularly shared his work. A self-described "passionate Hispanophile," Tardy, at the time they met, was a student at the Institut d'Études Hispaniques at the Sorbonne and frequently traveled to Spain. Thirteen years younger than Koudelka, Tardy shared his fascination with Spanish folk festivities. They first met in 1972 in Pamplona for the weeklong festivities of San Fermín:

> *There he was, photographing running bulls during San Fermín — Pamplona and all that. Of course he didn't have a car (he has never had a car!). I had a "Deux Chevaux" — an old Citroën. At one point I said to Josef: "I'm going to head south." He said: "Can I come with you?"*

They set off to Valencia in the "2CV," which jittered and bounced on its old shocks so dramatically that they were frequently airborne; they took to

joking: *"Mi coche es un avión"* — "My car is an airplane." It was a rollicking trip: "In these moments of euphoria, in my swaying car," says Tardy, "Josef started calling me 'Chiquito Banana' — now, always, I am 'Chiquito.'" It was the first of several journeys the two would make together. Even though Koudelka does not like to have anyone around while he is photographing, he is happy to have a friend to travel with, provided that person agrees to do all the driving. Over the years, those companions — some, working with him on his long-term projects; others, already close, fellow-travelers on their own photographic or cinematographic journeys — have included Fernando Herráez in Spain; Fabio Ponzio (many places); Coşkun Aşar in Turkey; Jaroslav (Jarda) Pulicar and Jan (Honza) Horáček in the Czech Republic and other parts of Central Europe; Gilad Baram in Israel; Cristobal Zañartu (many places); and Peter Helenius in the United States.

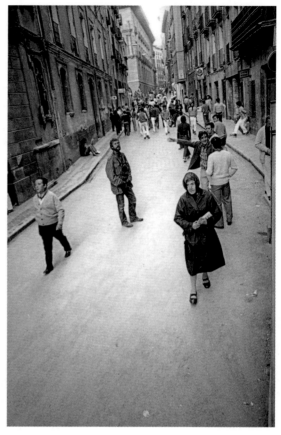

JK in Pamplona, Spain, 1972. Photograph by Hervé Tardy

Each has a version of the same story. Zañartu drove with Koudelka across the United States in 1988, and from France throughout Central and Eastern Europe for six weeks in 1991. Describing himself at that point in his life as "this little Parisian bourgeois geek, in a rock band, with pointy shoes," Zañartu suspects that "Josef liked me because I played music. That was probably my passport to him." He imitates Koudelka's full-throttle voice: "'You have a driver's license, right?' . . . Josef can drive, but he tells people he doesn't know how so that he can be the passenger and look out the window."

For Zañartu, there have been distinct life-lesson perks to traveling with a nomad like Koudelka.

> *He taught me to start approaching the world as a man — to not be afraid. . . . Wherever we go, we look. It's our eyes that will tell us where we sleep, depending on the sunset. We don't need a guidebook; we'll talk to people. It's amazing to discover the world like that. We don't know where we're going to sleep tonight, but it's fine . . . what counts is sunset.*

JK photographing the Palio horse race, Siena, Italy, early 1970s. Photographer unknown

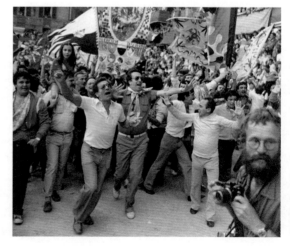

After Zañartu retrofitted a van so they could sleep in it, the two men traveled for six weeks in 1991. Zañartu was somewhat anxious — in part because he didn't speak the languages — but with Koudelka, he said, "it was fine . . . wherever we went we were drinking and making friends. Language didn't matter." What did matter was to be somewhere by sunset that "feels right, for safety, but also feels right visually, so that when we wake up, we are someplace interesting to walk around, and photograph."

But for this last part, they would not be together. "He didn't want to have anybody photographing with him." Still, Zañartu has been able occasionally to observe Koudelka's choreography while shooting: "If you only look at his feet, it's fascinating. He never worked with zoom lenses. So the zoom is with his legs. So it's two steps forward, three steps back."

Koudelka's traveling companions have a unique opportunity to experience his habits and protocols. Tardy recounted the arrival rituals at a new place where camping was not an option — for example, on one of the islands of Cape Verde:

We arrive at a small island, where there might be two hotels or not even that — very little. There's a central square with a hotel. So I say to him: "We'll set up here, at this place. There's a hospital there, the sea is there, the square is there — everything's fine."

He goes: "No."

"Why 'No'?"

He says: "There must be another hotel."

It's very, very hot. So he leaves his stuff and goes out to check out all the spots on the island, and so on. That is one ritual. And then he comes back and says: "This is an okay place. We'll stay here."

I say: "That sounds good." And we stay at the hotel.

The second ritual is about the room itself. Tardy and others have explained that Koudelka, while caring little for conventional amenities, must have a table and a good light so that he can work in the evening. The room with the longest table and brightest light will win every time. Finally, says Tardy: "It's very important to swim. Once ritual one and two have been addressed, he goes swimming immediately: ritual three. There's Josef, in the middle of the Atlantic, with his great long legs, swimming." Tardy goes on to describe a particular "look" of Koudelka's, as he heads to the beach to snorkel with his big walking shoes. (Koudelka now has a prescription snorkel mask.)

JK swimming at Kaputaş Beach, Turkey, 2014. Photograph by Coşkun Aşar

"Josef is someone who actually gives you energy," Tardy says. "You know you can't move slowly with him. You always have to be moving forward. You are in the present, and then there is what's next."

I'm not sure one could have a better friend than Tardy. In recent years, he has produced major publishing projects with Koudelka, arranging for multilanguage co-editions of books, negotiating his contracts, and representing him and his interests at meetings — always strategically, good naturedly, and generously. Koudelka says about Tardy: "He has got all this perfect thinking. He formulates things very well. He is incredible in that sense. And he's a great guy." Like Sheila Hicks, Tardy has been a caring, savvy, and pragmatic figure in Koudelka's life, and the photographer regularly seeks his counsel. About these interactions, Tardy says:

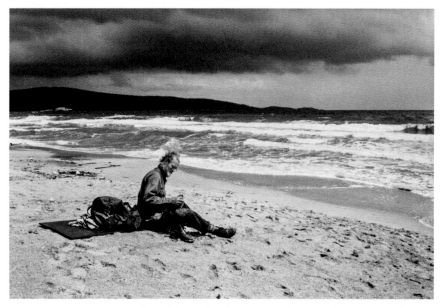

*He cannot tolerate bullshit. He is always questioning others, even when he
is silent. He is always listening to what people are saying. He always wants
precision. . . . When he is bored, he says: "Don't speak to me in Russian."*

And there's language itself. Tardy:

*Josef has always adapted, or combined the languages with which he makes
his own "tortillas" — especially with Italian and Spanish. With my language,
French, he has remained refractory, and never really entered in it. I think this
is because, in a sense, Josef always stayed in his country: he has always been
Czech, and he never wanted to assimilate.*

Tardy became the editor-in-chief of the photographic magazine *Reporter
objectif* at twenty-four; later, in 1977, he joined the French photo agency Gamma,
where he remained for fifteen years. It was during Tardy's early years at Gamma
that his more local adventure with Koudelka took place. Tardy begins his con-
fession mischievously, in a conspicuously loud whisper:

*It was 1978. He didn't have any money or a darkroom he could use for
free anymore. I had the keys to the Gamma darkroom on Rue des Petites-
Écuries . . . nobody ever knew — not even the Gamma people. Almost every
night between 1978 and 1980, I would open the doors of the lab to Josef when
he was in Paris. He made his contact sheets. He worked the entire night at
Gamma and then, in the wee hours of the morning, I would come by, and
he gave me back the key. He was very happy — it really helped him at that
moment.*

This went on for about two years — "a good ride!" gloats Tardy — before
they were finally busted.

Early on, the shifting geography of Koudelka's perpetual odyssey got him into
the habit of sending postcards. It was and remains an endearing way for him
to stay in touch. Other methods: when he finds himself at any of the Magnum

offices, he sets up shop and commandeers one of their phones and a fax machine for the foreseeable future. Through about 2015, Koudelka did not use e-mail (but was happy to enlist others to send and receive them on his behalf, which is more or less still the case). He agreed to accept his first mobile phone in 2018, as an eightieth birthday gift. Otherwise, postcards. He says: "Sending postcards is also a way to give thanks to people who helped me on the road."

Tardy calls him the "Postcard King of the World," with a "clan" of recipients that has over the years included Fárová and Cartier-Bresson (Koudelka: "I tried to send a postcard to Henri every time I went to a museum and saw a beautiful painting"). When his parents were alive, he sent them "as many postcards as possible — every week or two," always being careful not to say anything risky, as he knew his correspondence might well be read by the authorities in Czechoslovakia. Still, he could send spirited greetings and news of how things were going, as in a card to Fárová, dated July 15, 1972, sent from Spain:

> *Josef K. was not killed by a bull in PAMPLONA, and sends his greetings*
> *to everyone.*[48]

9.

Along with Romeo Martinez and Robert Delpire, Cartier-Bresson introduced Koudelka to a third individual who would play an important role in his life: Pierre Gassmann. Born in 1913 in Breslau, Germany (today Wrocław, Poland), he eventually immigrated to Paris, where he founded the Pictorial Service photo lab — known as Picto — in 1950. Some of its earliest clients were members of Magnum, including Cartier-Bresson, Robert Capa, and David Seymour (known as Chim), along with other well-known figures such as William Klein and Robert Doisneau. Picto was as much a forum for the exchange of ideas and tips as it was an exceptional printing lab. Photographers would engage in lengthy conversations with the printers and others, becoming more technically adept and informed, which enabled them to achieve the results they sought in their printed images.

It was at Picto that Koudelka would eventually meet his "Slavic brother" from the former Yugoslavia, his trusted printer Voja Mitrovic. A man with a serious demeanor, Mitrovic is an unwavering perfectionist — and thus an ideal partner for Koudelka. When we spoke in Paris in 2014, it was clear that Mitrovic, like Koudelka, always strives for "the maximum." By the mid-1970s, Koudelka needed a professional printer. With his work in the theater and on the Roma, he had often photographed in less than optimal light. His negatives could be extremely difficult to print because they were, according to Koudelka, "very dense . . . I sometimes left them in the developer all night to get everything I could out of them." He often wanted high contrast and rich blacks in his prints, while at the same time some shadow detail, if it existed in the negative, and tonality in the whites. Mitrovic puts it this way: "You have to have strong

nerves to work with certain of Josef's negatives." And the prints made from them needed to be flawless for Koudelka's exhibitions and books.

Mitrovic was born in 1937 in the Yugoslav town of Foča, about seventy kilometers from Sarajevo. His father was killed during World War II by Italian Fascists, part of the Axis forces that attacked Yugoslavia in 1941. Mitrovic was four years old. "I had to evolve faster toward a profession," he says, "to take care of my mother and my brother." Serendipitously, photography found him:

> I went to high school early in the morning. In my town, there was only one photographer. Every day, on my way to high school, I walked by his shop and photo studio. One day my mother went to have her picture taken by him, and he asked her — because we had two cows — if she could sell him a liter of milk a day. She said okay, so starting a few days later, every morning before going to school, I would drop off a bottle of milk at his studio. In the evening I would pick up the empty bottle. One day he asked me: "Would you like to learn the profession of photography?" So . . . it's because of a liter of milk that I delivered to the photographer that I left high school to learn photography.

Mitrovic moved to Paris in 1966, when he was twenty-eight, and applied for a job as a printer at Picto. He was one of four candidates who did a trial printing. After Gassmann reviewed his work, Mitrovic recalls: "He looked at me — he had an accent like mine — and he said: 'Voja, I am going to take you because all the people who come from the East are good workers.'" He stayed with the lab for thirty-plus years, working with an illustrious lineup: René Burri, Henri Cartier-Bresson, Raymond Depardon, Martine Franck, Marc Riboud, and many others. Mitrovic remembers Koudelka arriving at Picto around 1973. For some time, by Gassmann's arrangement, Koudelka's film was developed at no cost — likely because of Gassmann's friendship with Cartier-Bresson, and the fact that he liked Koudelka and respected his work.

Picto printer Georges Fèvre at work with JK, 1983. Photographer unknown

Koudelka would then make contact sheets, from which he would select the images he wanted to see as small work prints. For a while, Koudelka was permitted to use the lab to make his own work prints (again gratis), sometimes making three hundred 13-by-18-cm work prints in a day. (Gassmann was so impressed that he jokingly offered him a job.) When it came time to create the work for his exhibitions and publications, Koudelka worked with excellent printers at Picto — especially Georges Fèvre, who made the prints

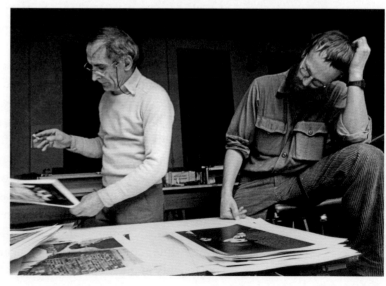

for his first big exhibition in London in 1984. Eventually, Gassmann decided to assign Mitrovic to him. The first three images he ever printed for Koudelka were for *Gypsies.*

About their many years of collaboration, Mitrovic says:

Josef pushed me to the maximum for the quality of each image. . . . He wanted that the blacks are very *black, he never wanted that the whites in the image be* pure *white — there must always be a tonality . . . there must be detail. And if I printed an exhibition of fifty photographs, the fifty have to always be in the same tonality, that there isn't one that is more black, or a lighter one. . . . I never saw someone who was more focused than him, nobody with higher standards.*

They were clearly on the same wavelength. "As we are from the countries of the East we have similar personalities," says Mitrovic. "I understood him better than the others. One day — when he was explaining to me what he wanted — I said: 'Josef, don't tell me anything. . . .'" Koudelka recalls this moment too. They were making the first print ever from a particular negative, and he was telling Mitrovic how he wanted it printed. Mitrovic responded: "'Close your mouth, I know what you want to tell me. We have the same brain.'" So Koudelka said nothing and allowed the printer to work on them overnight. The following day, Mitrovic showed Koudelka three prints with three different tonalities. Koudelka saw that all of them were excellent. They eventually chose one, and that version has always served as the model print.

Koudelka notes: "There are many good printers who are able to do what you ask them to do, but there are not many printers where you can work the way Voja and I developed. Sometimes we would work in the darkroom together. He understood what I wanted." Another time when Mitrovic was printing for a Koudelka exhibition, there was one print with which he was not satisfied, even though the photographer himself was prepared to accept it. Koudelka says:

Because you know how much sometimes even good printers suffer to get the good result, you have the tendency to accept the prints because you know how hard they worked and that maybe they cannot do it better. There was one negative that had never been printed. Voja worked on it very hard. In the evening, he showed it to me. It was a good print. But Voja said: "Josef — come tomorrow evening. I think I can do it better."

"The next day," recalls Mitrovic, "he came and I had succeeded. So I think, as of that moment, Josef really trusted me and my work." His expression becomes more tentative: "Still . . . it can happen that sometimes I make a mistake."

Beginning in the mid-1970s, and until Mitrovic retired two decades later, Koudelka generally reserved the month of February for his printing. Mitrovic says: "I was lucky at Picto that every time I worked with Josef, I didn't have to work with any other photographers. I concentrated only on the work with Josef."

Mitrovic used the Xenon 5,000-watt enlarger to print his work; Koudelka notes that this enlarger had been designed with ventilation because "the light was so powerful, and everything got so hot." It was the strength of this light that enabled Mitrovic to print a tonally nuanced image with shadow detail from Koudelka's dense negatives. Koudelka adds:

> *Unfortunately, these enlargers, so necessary to making my prints, no longer exist, and the two that remained in France were destroyed. Because of this, nobody will in the future be able to make darkroom prints of my work. And even if these enlargers should one day exist again — most people will not have the skills, talent, and technique of Voja.*

For years now, Koudelka has made large-scale, mostly panoramic digital prints for exhibitions and collectors, seemingly viewing this new medium as an opportunity to reconsider previously established formats and interpretations. It is, he says, also "the only possibility for making excellent quality large panoramic prints."

Considering the deluge of change introduced by the digital camera and digital printing, Mitrovic sighs: "Now it's finished but, well, it's progress. However, I don't regret that since 1966, when I arrived at Picto, and for the next thirty years or so, I lived through the best period of [gelatin] silver printing in photography." He waxes philosophical as he considers Koudelka and their respective histories: "If the Russian troops hadn't invaded Prague, if there hadn't been the Second World War, we would not be here together, we would not have met." Reflecting on their alliance, he adds: "He was very demanding, but I never got angry. I tried to be calm, not to be stressed, to give him the maximum." Mitrovic admits that there have been projects that have taken a toll: work on Koudelka's *Chaos* prints in the mid-1990s was so fraught that he says he lost six kilos in the process. "But it was beautiful in the end."

JK at Picto, Paris, ca. 1983.
Photograph by Raymond
Depardon

10.

JK and Voja Mitrovic, Voja's retirement party at Picto, Paris, 1996. Photograph by Tristan Cassiet

The Conference on Security and Co-operation in Europe (CSCE) that led to the Helsinki Accords — drafted in an effort to, among other things, reduce Cold War tensions — began in 1973. The document was signed in August 1975, although the Czechoslovak (and other Eastern Bloc) regimes did not always honor its letter and spirit. When Koudelka's parents, for example, wanted to visit their daughter, then living with her family in Canada, the authorities would not permit Josef Sr. to go. But his mother took advantage of the changes afforded by the discussions, and that year visited Zuzana and her husband, Henry (Berndorff), and their two children, David and Dagmar.

When we spoke in 2014 in Prague, Zuzana and Henry recounted the journey with their children from Czechoslovakia to Canada. In 1966 they had attempted to leave the country but made it only as far as Yugoslavia, where they were stopped and sent back to Czechoslovakia. In December of that year they tried again, this time through Vienna. Henry says: "We put up the Christmas tree, all the presents underneath, and the next day we said: 'Let's go for a trip.'" They had permission to travel for four days, and drove their Wartburg, via Austria, to Trieste, where they requested political asylum.

Eventually the family ended up in a refugee camp in Latina, about sixty kilometers from Rome. Zuzana found work as a housekeeper, but her employer quickly saw that she was educated and had many skills. Soon Zuzana was sewing for this family, while Henry found work in a vineyard. They lived in the refugee camp for six months, then obtained permission to immigrate to Canada, where Henry's sister lived. They left Italy on July 1, 1967 — three years before Josef's exile.

When their mother was granted permission from the Czechoslovak authorities in 1974 to go to Toronto, Koudelka, who had not seen either of his parents since 1970, decided to make his first trip to North America in order to see his mother and sister in Canada. He traveled through New York that June, as usual carrying almost nothing except a box of work prints that he wanted to show them.

In what turned out to be the happiest of accidents, he missed his connecting flight, and stayed the night at Elliott Erwitt's apartment on Central Park West. Erwitt persuaded him to spend at least a little time in New York on this trip, and to try to see John Szarkowski at the Museum of Modern Art. Erwitt thought Koudelka ought to show Szarkowski the small prints he had with him, which

JK visiting with his family in Toronto, 1974. From left: Henry Berndorff, Dagmar Berndorff, David Berndorff, JK, Marie Koudelková, and Zuzana Berndorff. (Camera on self-timer)

primarily represented work he had done since leaving Czechoslovakia. The meeting was arranged. As Koudelka recalls, he handed Szarkowski his stack of work prints, and the curator took them and then left the room.

> *He wanted to look alone. When he got back, he told me that he loved them, and said: "I feel like I want to go out and start taking photographs again," and that we had to make an exhibition. Then he said, which I didn't really understand at the time: "These all feel like Gypsies — not because the pictures are all of Gypsies, but because the photographer is a Gypsy."*

Szarkowski offered him the first exhibition slot the museum had open, in February 1975. Koudelka said he'd rather have it later, in the fall of 1975; Szarkowski agreed (apparently somewhat miffed). Koudelka refers to one of his diaries at the time: "The comment of the people: 'You are an idiot: everybody dreams about having an exhibition in that museum. You should do it and do it as soon as possible.'" During the same New York visit, Cornell Capa offered Koudelka an exhibition at the International Center of Photography (which had just opened in 1974) — but told him that if he had the show that year at MoMA, a show at ICP would have to wait five years. Koudelka appreciated the offer, but in the end chose to work with Szarkowski. His solo exhibition was presented at MoMA from February 24 through May 11, 1975, in the museum's Steichen Galleries.

The show ultimately comprised forty-three photographs, many of them made after Koudelka left Czechoslovakia.[49] Of the relationship between the show and the *Gypsies* book, Stuart Alexander explains:

> *The plan was that the exhibition would complement the [Gypsies] book, which was scheduled for release early in the year. . . . No catalogue was published for the exhibition, but through a special arrangement, 2,500 softcover copies of the American edition of* Gypsies *were printed for MoMA with their imprint when the book was finally issued by Aperture several months after*

the exhibition closed. All copies of the book in English carried a statement by Szarkowski — which misleadingly made it seem that the Gypsies *series had been the focus of the exhibition.*[50]

Alexander notes that many of the photographs Szarkowski was drawn to would, thirteen years later, form part of Koudelka's *Exiles* project. Szarkowski purchased an additional ten prints from the 1975 exhibition for MoMA.

In the same year, the Philadelphia Museum of Art (PMA) purchased twenty photographs from Koudelka, facilitated by Cartier-Bresson's friend Helen Wright, an agent who had recently begun representing Koudelka. Aperture's Michael Hoffman, at the time also the adjunct curator for photography at the PMA, arranged the sale. One of his long-term goals was to focus and intensify the museum's collection through the purchase of a substantial body of work by a photographer, generally in conjunction with an exhibition. Hoffman had, it seems, simultaneously arranged for Koudelka to provide the PMA with sixty prints from the *Gypsies* project for a planned exhibition. For reasons now unknown, the exhibition never happened.[51]

The first US museum show dedicated solely to the Roma work opened at the Art Institute of Chicago in February 1976. This was one year after the AIC had established its department of photography, with David Travis as its founding curator. This show featured the sixty 30-by-40-cm photographs originally intended for the Philadelphia exhibition, which were borrowed from the PMA.

In the same year a portfolio of Koudelka's images — representing his work

John Szarkowski, 1984

from both the *Gypsies* project and what would become *Exiles* — was published in *Aperture* magazine, with one of his photographs featured on the cover.[52] Also in 1976, he received another one-year stipend from the Arts Council of Great Britain, this time for £4,500. He asked that they distribute the money to him in installments over three years. Where did he keep these payments? "My bank," he says, "was Magnum." The cooperative held onto the funds for him, as he had neither a bank nor a home (nor a mattress) in which to keep them safely.

The critical response to Koudelka's MoMA show was mixed. Reviewers seemed to admire the photographs — Gene Thornton of the *New York Times* called them "hauntingly beautiful" — but were uncertain as to the success of the exhibition itself, chiefly because of the lack of context provided for the work. Thornton felt that the caption-free "ambiguous presentation" was unintelligible; the iconography (of Koudelka's work with the Roma especially) was not, the critic pointed out, as accessible as, say, "a crown of thorns."[53] There was a tendency among viewers to want to understand all the images in the exhibition as strictly documentary (Koudelka's affiliation with Magnum may have played a role in this), and as a single body of work. But for Koudelka, the photographs of the Roma were, and remain, distinct from everything else he has ever made. This exhibition,

however, combined photographs of the Roma alongside those that would later become part of *Exiles*. Koudelka had never conceived of these series as being together, and they have never again been mixed: even in retrospective surveys of his work, they are presented as discrete projects.

Aperture's hardbound, jacketed trade edition of *Gypsies* and the special softbound edition of 2,500 copies for MoMA were published in the fall of 1975. *Gitans: La fin du voyage* was published by Delpire in

JK making a picture, 1974.
Photograph by Elliott Erwitt

1977. Although MoMA's paperback version did not include Delpire's "Rage to See" text, his words seemed to anticipate Thornton's criticism of the museum's show. Delpire wrote:

> The contempt Josef has for all commentary, explanation or rationalization, and his refusal of captions and of anything didactic, is a form of questioning carried to the ultimate degree. In the incessant resurgence of questions he asks himself, Josef puts himself and the reader to the test of reality reflected in his photographs.[54]

Koudelka never saw his exhibition at the Museum of Modern Art. A few days after it closed, when he was in Córdoba, Spain, he wrote the following entry in his diary:

> Crickets are singing loudly. Men pass around you, elegantly dressed. . . . You see the stars between your knees. The mosquitoes arrive. You are thirsty and there is no water. Today you have money for two weeks of your life. You are taking pictures with film that you bought from loaned money. Three days ago, your exhibition at the Museum of Modern Art in New York finished. This would be enough to fulfill the life dream of many. But you don't know anything about it, because at that time, you didn't want to be reachable. You have two hundred exposed rolls of film, but you don't have money to develop them. But something is going to be on them.
>
> Give thanks to God and be happy, you idiot, that you are still able to get this "something." When you get only money as an equivalent for what you did — for this something — you are going to be lost.

Koudelka did return to New York City later that year for the printing of *Gypsies*. He has insisted on being on press for at least the first printing of every one of his books, so that he may work closely with the printers — even past the proofing stage, which is often done using a process different than that utilized for printing the final book. *Gypsies* was printed by Sidney Rapoport using his signature "Stonetone" technique. This featured his unique alchemy

of black and special gray inks run at high densities, and a randomly patterned halftone screen. The goal was to achieve "an illusion of depth, of highlights, of feeling, that the original silver image has" and that, at that time, conventional duotone printing could rarely achieve.[55] The Rapoport Printing press, on Hudson Street in Manhattan, was for many years the go-to printer for Aperture and many other publishers of fine photography. Rapoport brought a singular interpretive artistry to the craft of taking a photographer's prints and realizing them, in keeping with the artist's singular vision for his or her work, as a book — a process very different from darkroom printing.

One afternoon during that New York trip in 1975, Koudelka found himself wandering through a bookstore in Greenwich Village, where he met the woman he refers to affectionately as "La Bruja" — the Witch. Tall, with long legs and sharp features draped by straight black hair, Moira North was a figure skater visiting from Canada with a touring troupe of ice dancers. "I was a showgirl, skating with a 'Peggy Fleming Special' at Radio City Music Hall" at the time, she tells me. Exploring the city, she had wandered downtown to the Village.

> As I was reaching for a book, someone on the other side of the table in this bookstore reached for the same book. I looked up and saw this very handsome man, and he said: "Well, so who's going to get it?" In a very un-Canadian way — I actually surprised myself — I said: "I am." And that was the beginning of my relationship and friendship with Josef.

The book was on Picasso, who dominated their conversation until it became more personal, each recounting what had brought them to New York. Koudelka told North about *Gypsies*, and that it was currently on press.

> He didn't have the book, but he had the cover, and he brought it to me at the Hotel Wentworth, where the skaters were staying. We went out a couple of times. . . . Then we stayed in touch. . . . Josef and I carried on a conversation through postcards, and we became close.

North later moved to New York, and Josef often stayed at her place. Some years after, she and her husband, photographer and picture editor Jay Colton, asked Koudelka to be the godfather of their son, Christopher. In 1977 Markéta Luskačová and British photographer Chris Killip had a son, Matthew; they, too, named Koudelka the godfather. If one qualification for godfatherhood is having time for one's godchildren, Koudelka would seem the least likely of candidates, but clearly Anna Fárová, Luskačová, North, and their respective partners (all of whom were also friends with Koudelka) felt there would be something positive — North says "inspirational" — about Koudelka's presence in their children's lives.

11.

When Koudelka was in New York in 1983, he and North met for lunch. At some point, he said coyly: "I've got something to tell you." North pushed him to divulge more, but he was tight-lipped. North was having a party for the skaters at her loft that night and Koudelka was invited. He was bringing a guest. "You'll meet her tonight," he said. North recalls:

> That's when I first met Jill — after they'd separated and gotten back together. He brought Jill to the party. He came over and he whispered to me: "I'm in love."

Slim, with chestnut hair framing her finely featured face, Jill Hartley appears earthy and feminine in images of her from the mid-1970s. Before arriving in Paris in 1975, she had studied drawing at the Art Center College of Design in Los Angeles, and later, ethnographic filmmaking at the University of Illinois in Chicago. "Fed up with academia" (as she told me), Hartley got a job as an assistant film editor and eventually worked as an art director on a PBS alternative news program; it was here that she made her first photographic essays.

From left: Philip Jones Griffiths, JK, and Bruno Barbey, Paris, 1974. Photograph by Alécio de Andrade

At the same time, Hartley was breaking up with her husband. As part of her new life, she decided to take her savings and "set off for Europe for a year with a couple of Leicas." She settled in Paris in the fall of 1975. Hartley had only high-school French, so she enrolled at the Alliance Française, and eventually took a job as a caregiver for an elderly couple. On a visit to London, she stayed at the home of her friend Colin Young.

> Colin invited Philip Jones Griffiths over for lunch one day. Philip was a student at the National Film School in Beaconsfield, where Colin was the director [and co-founder]. I showed him a box of my photographs and expressed my desire to team up with a writer and work on a reportage. Philip wrote two names on a scrap of paper: Gilles Peress and Josef Koudelka — saying I should look them up at Magnum Photos when I returned to Paris. Gilles was in Spain doing a story about the death of Franco. . . . I left a little note for Josef in his Magnum mailbox. And that's how we started.

All these decades later, Koudelka still has that note. He pulls it out and asks me to read it aloud:

> Josef, I am a friend of Philip Jones Griffiths. I am an American photographer staying in Paris for a short time, and I am interested in getting some assignments, if possible, and working on some of my own projects while in Europe. Would very much like to meet you if you have some spare time in the next couple of weeks. . . . Jill[56]

Koudelka, who was thirty-seven, would later tell the twenty-five-year-old Hartley that he had liked her handwriting. Hartley is a bit fuzzy on their first meeting, although one memory burns bright: "I do remember him walking me to the metro station at Saint-Michel — on a side street, not on the

JK and Jill Hartley's "last supper" at the Magnum Paris office before she returned to the United States, 1976

quai — then kissing me suddenly before I descended the stairs. . . . It took me by surprise."

At that time, Koudelka was living and storing some of his things — including his negatives — in Cartier-Bresson's painting and drawing studio, above a butcher's shop and across the street from a firehouse on the Place du Marché Saint-Honoré. Hartley and Koudelka would often meet there. Their first trip together was to the carnival in Basel in early spring 1976; not long after, they traveled to some of the festivals in Spain that Koudelka had been attending for many years. Hartley: "However, we didn't photograph together — we would split up and he would make an appointment to meet for lunch." She traveled on her own that year as well.

Hartley's round-trip plane ticket was valid for only a year, so in the fall of 1976 she returned to the United States. She and her husband were not yet officially divorced, among other matters. But her plan was to come back to Paris soon:

Jill Hartley and JK, Paris, 1976. Photograph by Sarah Moon

Josef and I had left this thing hanging. . . . We fell in love, that's for sure, but I can't explain it beyond that. So we separated with the idea that we would be again together, but it was up to me to figure out how. I had to get a job; I had run out of money. But meanwhile, I'm thinking about how I'm going to manage this. Say I do get money to go back, then what? How will I survive? He's going to be traveling around photographing, and I also wanted to be traveling around — what could I do to earn a living?

Before Hartley left Paris, she and Koudelka had a farewell dinner in the Magnum office, celebrating their love, even though the pragmatic details of their future together remained undefined. Koudelka has subsequently referred to this as "our last supper" because, he says:

She never came back, and never gave me any news about herself, never gave me any explanation. So I tried to cut her out of my mind. I considered her as somebody who was not serious, who had betrayed me, who didn't keep her word.

Back in the States, Hartley had to collect possessions she'd left in Chicago, and then go to Los Angeles to deal

with her divorce. While in LA she borrowed a friend's darkroom so she might develop her film from the year in Europe. It was through this friend that she met the Czech photographer Antonín Kratochvíl. They soon began taking trips together. Kratochvíl invited Hartley to Poland (she would continue to photograph there over the following ten years) and they eventually moved to New York. "This wasn't the plan," she says, "but I couldn't resist. It was the beginning of seven wonderful years working together constantly."

Looking back, Hartley surmises:

I'd had serious doubts about how I would survive in Paris — work as a fille au pair while Josef traveled around? Where would we live? Obviously, the two of us sleeping in the Magnum office under a table wasn't a great idea. Josef and I hadn't thought out the details, and I wasn't an heiress.

I would have liked to be able to fly over to Paris and tell him that: that it couldn't possibly work, and somehow to finish it. Instead, the romance was left hanging in the air and Josef was always there in the back of my mind, like a regret.

12.

Koudelka had last seen his father when they drove together to Ruzyně airport in May 1970. That ride had cemented much for father and son. Josef Sr. appreciated his son as a principled man and talented photographer with the guts to document the Soviet invasion, and understood the necessity for him to begin a new life in the West. For his part, the younger Josef understood that he had his father's approval in every respect.

In 1974 only Josef's mother had been allowed to leave Czechoslovakia to visit Zuzana in Toronto. With the signing of the Helsinki Accords in 1975, and signatories of Charter 77 trying to hold the Czechoslovak regime accountable to its international agreements, it became possible for both his parents to obtain permission to travel. The three reunited in Paris in 1977. Koudelka:

It was fantastic to see my parents. My mother was crying. I was playing the bagpipes and singing. I was staying in Cartier-Bresson's studio, with the butcher on the first floor. We had to go through the butcher's to go upstairs. My mother said: "My son, but the meat . . . so much meat! . . . there is not this much meat every day?" Because in Valchov, the butcher came once a week, and you were very lucky if you got a little piece of meat.

He recalls that his parents really didn't want to tour Paris. "I took them around, but it was not interesting for them. They wanted to see me, see that I was happy." They also had not yet seen *Gypsies*:

I took my book and I showed it to them. I had written a very long and affectionate inscription — all these good things that you would write to your parents. Then they were leaving, and their book I had given them was lying on the table. They had packed up their luggage, but it was still lying on the table. So I said: "Listen, the book . . ."

My father said: "My son, you keep it. It's too heavy." But I am sure that the reason was different. The truth is that they were living in fear. They were afraid that they'd be crossing the border, the police would have a look at the book, and they would question them about me, and it might have served as proof as to where I lived and what I was doing.

But I loved the answer: "You keep it. It's too heavy."

That was the last time Josef saw his father. Koudelka was still unable to return to Prague before his father died four years later, in 1981, at seventy-three — a consequence of his extremely high blood pressure. Koudelka was traveling in Spain at the time, incommunicado, and would learn of the death three months after the fact. "I am glad that I didn't see my father then," he says, "that I remember him still alive."

Before visiting him in Paris, Josef Sr. had regularly been sending his son (care of Magnum) bottles of his flamingly potent slivovitz. As exporting homemade spirits abroad was not permitted, he would sometimes send the firewater in plastic instead of glass and label the bottles "vinegar." Josef Sr. had sent Markéta Luskačová a bottle of slivovitz in a bottle labeled "Martini," she recalled, via Eva and Peter MacMahon, who had visited Josef's parents shortly before his father's death: "When I realized it was the last bottle of slivovitz that Josef's father made," said Luskačová, "I did not drink it. I gave it to Josef." Koudelka took a drink from it, "to remember my father. . . . The only other times I drank from it was when Bresson died — to remember him," and again some years later in remembrance of his friends and collaborators Robert Delpire and Xavier Barral, and then his sister, Zuzana.

Marie Koudelková and Josef Koudelka Sr. returning to Prague after their first and only visit to JK in Paris, 1977

13.

In 1979, for *Camera* magazine's fifty-eighth year, its editor Allan Porter decided to devote the entire August issue to Koudelka. The photographs for this monographic publication were selected by Koudelka and Delpire. The layout, too, was designed by Delpire, who likely received no remuneration for the work. Koudelka's friends and collaborators regularly engage beyond the call of duty — often forsaking all financial and other concerns — to help him realize his desires. Sometimes this entails the most byzantine orchestrations, but to this day I've never known of anyone not willing to join in (despite some grumbling and maybe an occasional eye roll).

Porter's introduction to the issue includes the following passage by Koudelka:

My contact sheets are a personal record of my life. They are my diary. . . . I shoot
a great many photographs and I am trying to discover new possibilities within
the medium that I can explore further. The most important thing for me is
to keep on working and I am afraid to stop. I want to avoid what I have seen
happen to other photographers, who have restricted themselves, perhaps
unnecessarily, and ultimately run out of inspiration. [57]

All twenty-two images of the sequence had been made between 1970 and
1974, the first years of Koudelka's exile; none were more recent. He claims in
the introduction: "In the last four years I did not make any prints as I was busy
photographing. It was only last winter [1978–79] I made 6,000 prints." Now
he laughs, saying, "Well, it probably wasn't 6,000." Sixteen of these would be
included in *Exiles*, published almost a decade later, in 1988.

Koudelka made sure that Fárová received a copy of the *Camera* publication,
writing her in advance on July 9, 1979, with a kind of preemptive response to
what he presumed would be her negative reaction:

I'm afraid that you'll be disappointed with Camera — *with the photographs,*
that's why I want to explain it a bit.

It won't be a monograph. It comprises 22 photographs, most of which
are from the period 1970–74. Many of them were at the exhibition in the
Museum of Modern Art, New York. That is to say, nothing new, nothing
old. Nor anything from my book. I did not want to publish much, nor much
that was new. Though I am trying and photographing like mad, it is really
hard to make a good photograph. I was using Camera *to test certain things,*
both in the choice of photos and in the graphic design. I didn't want to put
everything there. Again, it is only part of what I do. I think that many people
are not going to like it. [58]

Fárová wrote back from Prague on December 10, 1979, with a critique of the
Camera issue, saying she felt the work lacked a "unified statement" and instead
suggested a more haphazard, "this is what I have seen in the world" approach.
Her words are simultaneously encouraging and harsh:

You, Josef, are a terribly good photographer. But it's too bad that you actually
say nothing with what you photograph. [59]

Conversely, Cartier-Bresson responded enthusiastically, writing to
Koudelka in August 1979 (in English): "The choice to my mind of pictures is
superb, a great intensity, sensitivity, rigour." [60]

As with all of his projects, Koudelka felt compelled to try different ways
of considering the photographs that would eventually comprise the *Exiles*
body of work. He had to get to know them, see which images he didn't grow
tired of, which remained resonant for him over time. By trying them out in
different publications and exhibitions, variously contextualizing, pairing,
and sequencing them, he would learn what worked. But it would take time.
And this project was unlike the *Gypsies* project, with all its particulars. As
Koudelka reflected recently:

With Gypsies *and* Exiles, *the process was completely different. With* Exiles, *you have discovered a world that you don't know anything about, and you react to it. With* Gypsies, *I knew what I had gotten myself involved with. Learning from Anna, I knew what I was missing. With* Exiles — *it happened more intuitively.*

"No categories," Koudelka wrote in a diary entry from the early 1970s — perhaps another indication of an expanding way of experiencing the world: "No fascists, no Communists. No Russians. Above all differences, there is the human being."

14.

In the mid-1970s Koudelka regularly slept on the floor of Paul Trevor's darkroom when in London. The photographer Chris Steele-Perkins got to know him a bit in this period, sometimes running into him at Trevor's place. Steele-Perkins, Nicholas Battye, and Trevor constituted the UK collective known as the Exit Photography Group, and at times they would show Koudelka their projects. Steele-Perkins remembers a "quite out-of-the-blue" call from Koudelka sometime in the late 1970s, during which the Czech photographer suggested that he consider submitting a portfolio to Magnum. "I was truly surprised," says Steele-Perkins. "He didn't say much else — only that he thought it would be a good idea, and he'd support me." For Steele-Perkins, it was perfect timing, as he was increasingly interested in working outside the United Kingdom. A good agency would be helpful, he believed, and the idea of a cooperative suited his sensibility. (Although Steele-Perkins is the only photographer Koudelka has ever proposed to Magnum, he has sometimes advocated for the membership of certain photographers, including two controversial nominees — Martin Parr and Antoine d'Agata.) Steele-Perkins put together a portfolio. "I showed it to Josef at some point, who rubbished a bunch of pictures," he says, "so I took them out. . . . It all went smoothly. I became a member in 1979. I guess Josef was doing a bit of banging on tables, or pulling strings, or whatever in the background. . . . He apparently felt that I was the kind of person that could make a difference at Magnum in London."

Koudelka told me: "I thought, here was this young guy who was photographing, and he has ideas and he has energy. And in fact, he really helped change completely the situation for Magnum in England." Working with Peter Marlow, Steele-Perkins would establish Magnum's London office in 1986, and then, with the support of Hiroji Kubota, Magnum's Tokyo office in 1989.

Several individuals have described Koudelka's distinctive presence at the infamously fraught annual Magnum meetings. Elliott Erwitt:

Once in a while he makes a few declarations and vanishes. He's taken, if I may say so, a little bit the position of Henri Cartier-Bresson, who, if he came, would say a few words and leave — after having put his stamp on something

Magnum Photos office, Paris, 1992. From left: Sebastião Salgado, Henri Cartier-Bresson, and Abbas

or given an opinion. With Josef, generally, it's a very tough opinion about other people's work. Josef is quite rigid about that.

Others, too, have noted how carefully he seems to choose when to speak, and when to unblinkingly observe. François Hébel, director of Magnum's Paris office from 1987 to 2000, refers to a "painful crisis" in Magnum's history — when, in the early 1990s, Sebastião Salgado decided to leave the cooperative:

> *We had a meeting room that had a window to the outside. . . . Salgado was telling all the reasons that he wanted to leave. Henri [Cartier-Bresson] was very upset that Sebastião wanted to leave, so he came to that meeting — which he rarely did. Also, Sebastião was vice-president in charge of Paris. There was this critical moment when Salgado said: "I'm leaving, I'm leaving." Henri took his chair and positioned it in front of the door, and sat on it, so Salgado could not go out the door. Salgado is saying: "I want to leave." And meanwhile Abbas had gone to the loo or whatever, and was behind the glass wall, peering into the meeting from the outside, waiting for the door — that Henri was now blocking — to open so he could get back in. (Abbas also really wanted to be the vice-president — he and Salgado always had this thing. . . .)*
>
> *So who takes a photograph? Josef! You have Salgado agitated, Henri like a sphinx, and Abbas, waiting. . . . Nothing escapes Josef. He has such an understanding of human beings. He understood this human comedy of what was going on, more than anyone else.*

There were other strained moments. Koudelka told me that, in the early 1980s, despite his friendship with Cartier-Bresson and Martine Franck, he did not vote in favor of Franck's acceptance into Magnum. (Nevertheless, Franck became a full member in 1983, and it bears noting that she and Cartier-Bresson remained dear friends and supporters of Koudelka for the rest of their lives.) "At Magnum, different people support new applicants for different reasons," said Koudelka. "I made a rule that I will judge people only on the basis of the

photographs in the portfolio they apply with. Despite the fact that I liked Martine very much, the first portfolio that she presented to Magnum was just not very good, which I was sorry about." Agnès Sire, who began working at Magnum Paris in 1981 and eventually became its artistic director, reflected:

> Josef and Martine were very close. I think Josef felt lots of affection for her, as if she was his sister. They were born in the same year. But on the other hand, Josef was quite difficult with her pictures. Martine was not the kind of photographer who wanted to impose a new vision. She was a very honest photographer — and honesty is a good quality for a photographer. But sometimes you could feel that Josef thought she was keeping in her selection too many weak photos, like many of the other photographers he was criticizing frankly. Lots of photographers were willing to show Josef their selections to test how "good" or "bad" an image was — as seen through his filter.

I asked Sire if she knew whether this affected Koudelka's bond with Cartier-Bresson and Franck. She thought not; Koudelka was considered by many, she said, a "diamond in the rough" — and allowances were made for his unpolished edges.

Steele-Perkins reflects on Koudelka's presence at more recent Magnum meetings:

JK and friends on the Rue Mouffetard, Paris, 1989. Photographer unknown

> He doesn't talk very much. . . . When he has something to say, it tends to be listened to. . . . His main outbursts are about pretension. . . . He clearly loathes it when somebody spends too much time pontificating that they are an Artist — this will quite often set Josef off. It's not that he has anything against art. It's the pretensions that very often went with somebody applying to Magnum who wallowed too much in the art world. This person was very unlikely to get much support from Josef.

Recently, Koudelka has supported Antoine d'Agata's work, which is markedly different in both form and content from his own. The Marseille-born photographer has made dramatic portraits — sometimes color, sometimes black and white, occasionally blurred, always intense — of addicts and sex workers, among other subjects. In his work, bodies stretch and contort; the sense of flesh overwhelms; facial expressions are often cold, detached. In palette and mood, many of his images have an affinity with Old Master paintings. When we met at Magnum Paris in 2016, d'Agata was modest and shy, saying: "I don't think Josef actually likes my photography but I believe he respects the way I try to invent my own path, not to make any concession." Koudelka's perfectionism has made a particular impression

on d'Agata: "The way he thinks about a photograph is fascinating. It's scary to me to have so many requirements out of one image, to want to make it so perfect." Twenty-three years younger than Koudelka, d'Agata has followed his habit of sometimes staying overnight at the Magnum office. "It can be hard in the morning," he told me. "Once Josef kicked me — and he kept on kicking! 'Come on, wake up! Time to have coffee!'" D'Agata finds deep humanity particularly in Koudelka's *Exiles*, and marvels at Koudelka's sustained clarity of purpose. "I'd been traveling for twelve years around the world before I became a photographer," says d'Agata.

Brick Lane, London E1, 1980.
Photograph by Paul Trevor

Chris Steele-Perkins has a salient memory of a period when, if Koudelka was in Paris, he would eat his Christmas dinner with people who on other nights might lack shelter and go hungry. Koudelka elaborates:

> A Catholic organization, the Petits Frères des Pauvres, that helps poor
> and homeless people . . . used to make a Christmas dinner for them in the
> center of Paris. I didn't want to be alone, so usually every Christmas Eve
> I went there. . . . They served a really good dinner.

The holiday feasts would sometimes go until midnight — after which he would head back to the Magnum office to sleep. Koudelka photographed at these dinners but does not like any of the images he made: "The light was flat, and I knew my pictures were not good." Still, as possible subjects, *clochards* have long held his interest, and they make cameo appearances throughout his work.

15.

In 1979 Koudelka learned that, although he had been a resident of Britain for nine years, he would not be issued a British passport unless he changed his way of being in the world: "There was a condition. I would have to stay put for — I think it was for four years. And that would be impossible!" As he had sought and received asylum in the United Kingdom, his status was still that of refugee.

> I realized I had done all that I could do in these nine years, moving around
> England and Ireland. Also, my interests were changing. But mostly, to get
> a passport, to get citizenship, I would need to stay still for a period of time,
> which was the last thing I wanted. I needed always to be able to move, as
> I was doing.

Koudelka has been known to quote Bruce Chatwin's 1987 book *The Songlines* — "To move in such a landscape was survival: to stay in the same

place suicide. The definition of a man's 'own country' was 'the place in which I do not have to ask.' Yet to feel 'at home' in that country depended on being able to leave it."[61]

It was time for the photographer's next life-altering decision. A base of some sort was a pragmatic necessity, but being able to leave that base whenever he wished was as essential to him as breathing.

Cartier-Bresson did not see it as a decision. He wrote to Koudelka in 1979 to say that he and Franck were making a space for him. Koudelka consults his diary on this and reads: "We are putting the atelier back in shape. . . . You can sleep and eat there whenever you like." And then Cartier-Bresson added: "I spoke to Bob [Delpire], who said he had in his house plenty of room for your archives in a place not damp. We could help you move with our car."

So in 1980 Josef Koudelka moved to Paris.

When I decided to leave England to move to France, Henri sent me to see the French consul in London. He said: "She knows about you." (He had told her about me.) She gave me a form to fill out, which I didn't know how to fill out, so she filled it out for me. She was a very nice lady. I couldn't speak French, but she filled out: "Speaks French perfectly."

He laughs as he remembers it: "And when she needed to fill in how much money I was making and I told her, she said: 'We have to add one zero or two zeros more,' and she did. With this form, I would have a chance, possibly, when I got to France, to get a travel document from the French government." When he moved to France in 1980, Cartier-Bresson went with him to police headquarters. Koudelka says: "Everybody knew Bresson," and initially they spoke with an acquaintance of his there, who explained the situation to her superior. At first Koudelka was told that, as he already had been granted asylum in England, he could not apply in France — unless he could prove that he had been persecuted in England. But (likely with a prod from Cartier-Bresson) the acquaintance then told her superior: "'Yes, but if France doesn't get him, the Americans will.' That worked, and I got new refugee status — in France."

Then came the permit that would allow Koudelka to roam as he wished. With amusement, he recalls the suggestion of Raymond Depardon, who had recently joined Magnum:

Raymond said: "Josef, I've learned that now you are planning to settle in France. Do you need passport?" I said: "Listen, Raymond, of course I will need passport, but I just arrived, so I have to wait. . . ." The rule was seven years. He said: "I know the girlfriend of the president. I can arrange something."

Koudelka then says wryly: "In England, even if I had been a good friend of the queen, it wouldn't have mattered." In the end, there was no problem, since Koudelka was issued a travel document that served him for seven years. In 1987, "after seventeen years with no passport," he became a naturalized citizen of France. To this day he carries both a French passport and a Czech one.

IV Forces of Nature

1.

On a stop in Rome en route to southern Italy in April 1981, Koudelka was meandering through the city's splendid baroque Piazza Navona. This was his second visit to Rome — the first had been when he traveled there from Prague with the folk ensemble. On this spring day the nonstop activity — in the square itself and animating the *caffès* and *gelaterias* scattered on its periphery, overlooking Bernini's gleaming *Fontana dei quattro fiumi* (Fountain of the Four Rivers), among other fantastical water works and sculptures — was as intoxicating for the forty-three-year-old photographer as it had been for the twenty-three-year-old bagpiper.

Two young Italian photographers, Fabio Ponzio and Roberto Koch, were at the time enjoying some gelato at the popular Tre Scalini bar-restaurant when they spotted a figure across the square. "Practically two hundred meters away," Ponzio recalls, "I see a man with a beard, dressed all in olive green, deep in thought, walking with two cameras hanging from his neck."

Piazza Navona is large, and the figure was quite far off. Still, Koch and Ponzio exchanged glances. "Doesn't he look like Koudelka?"

"Maybe."

"Could it really be *Koudelka*?"

As the man in green turned off the piazza onto a side street, Koch stood up and dashed after him. "And when I got there, I said: 'Are you Josef Koudelka?' And the answer was: 'Do you have a place to sleep?'" Koch immediately invited Koudelka to stay at his place:

> So he came to the house and spent the night. But the morning after — because I had a very small apartment that I was sharing with other friends at that time (it was my first experience living away from home) — he saw that on the same floor there was an apartment that was Contrasto's office. He said: "Could I move in there?"

The two young men were dazzled. Having Koudelka staying with them, says Ponzio, was "as if Mahatma Gandhi had arrived at a hippie commune." Koudelka is characteristically matter of fact about the arrangement: "I started sleeping at their studio whenever I came to Rome . . . for the next ten years or so."

His hosts provided him with all the storage space he needed too. As Ponzio recalls:

I will never forget his shoebox. Josef, I swear, he put all the rolls of film he had taken in this shoebox. There must have been a hundred rolls in there. He taped it all up and gave it to me, saying: "I'm leaving you this box. I will stop by to pick it up when I return from southern Italy, in a month. Or two months, three months." For us, it was like having a relic of San Gennaro, understand? A box full of Josef Koudelka's rolls of film! Which we kept safe there, like that.

It stayed there and then, when he returned, he took it back. And this was our beginning.

Koudelka, Koch, and Ponzio tell me the story of their meeting in three separate conversations, but they all have a vivid recollection of the event. Beyond finding a place for Koudelka to unroll his sleeping bag, that serendipitous encounter marked the beginning of many collaborations and shared journeys.

Koch and Ponzio co-founded the photography agency Contrasto in 1980; within a few years, however, they went in separate directions. The

JK in the Contrasto office, Rome, 1981. Photograph by Fabio Ponzio

agency ultimately came to represent Magnum's photographers in Italy and evolved into the publishing house of the same name, under Koch's direction. Contrasto has been the Italian-language co-publisher for most of Koudelka's books, and Koch and his wife, Alessandra Mauro, Contrasto's editorial director, have initiated their own projects with him as well. Ponzio was a news photographer in Italy for *Time*, *Newsweek*, and other international magazines until 1987, when he began a twenty-two-year project in Central and Eastern Europe called *East of Nowhere*; the work was published in book form in 2020.

After that first meeting in Rome, it would be more than a decade before Koudelka and Ponzio began traveling together, but Ponzio could already imagine these future journeys — the freedom of being on the road with Koudelka.

We are in Josef's Prague apartment in 2015. He reads the following entry from one of his notebooks, variations of which appear in other notebooks over the course of years:

Nobody can help you.

No one ever can help you.

It's you who has to help yourself.

I question him about this, in order to better understand. So many people in Josef's life have repeatedly, often without being asked, stepped in, stepped up, and reached out, making every effort to help and support him. I know he is not blind to this. After a few minutes of spirited conversation, it becomes apparent

that while he may accept and appreciate the food, the floor, the care, the friendship, the assistance that is offered him, he has never wanted to depend on it or expect it. In fact, as Lucina — still filming us — suggests to her father: "You are always prepared for the worst." Josef puts it this way: "I'm not a beggar. I'm not a parasite either. I don't want to rely on the help of others."

At these moments, Koudelka is his most feral. He seldom goes dark, and if he does, his considerable will and essential hopefulness combine to make certain that it is only a transitory state — never quicksand. Still, he tries to be prepared for all eventualities resulting from his endeavors, positive or otherwise. The effort helps him to feel in control. Ponzio generously insists that we must always remember the where of Koudelka's past — the Moravian countryside. And the when — the circumstances and context of his childhood. The oppressive environment, the atmosphere of threat, the expectation of betrayal — everything was out of his control. Koudelka's Magnum colleague Ferdinando Scianna concurs. Scianna considers Koudelka's wish to control everything in light of the author Milan Kundera (who is, like Koudelka, a Moravian, and a friend of Scianna's). Scianna notes that Kundera has a similar drive: "Both come out of the situation," he says, "where a lack of control, of precision — the use of the wrong word . . . could change your life forever."[1]

Koudelka recognizes that his perspective, especially early on, could perhaps have allowed for more nuance, more breadth, some empathy, and more generous engagement. He acknowledges that he has gained a lot from his time with Ponzio:

> His Italian influence made me more human. I learned to be more tolerant. I was much more Stalinist, in a way, where everything is either black or white, right or left — there is no other way. I learned that I should try to make the effort to be nicer. I learned enormously from Fabio.

For his part, Ponzio cares deeply for Koudelka, recognizing photography as the lifeblood of Koudelka's friendships. Ponzio:

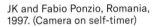

JK and Fabio Ponzio, Romania, 1997. (Camera on self-timer)

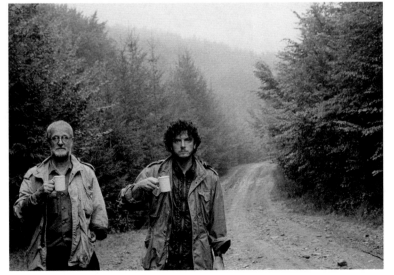

> Josef interprets life through photography. This leads to an entire series of consequences in terms of relationships. . . . With him, it is impossible to be friends if photography is something you don't share — not because he is limited but because everything passes through the filter of photography.

When I ask Ponzio about the dynamics of conversing with Koudelka, he brings up two points. The first concerns language itself, Koudelka's unique concoction of French, Italian, Spanish, and English that Hervé Tardy has dubbed his "tortillas," and that

Ponzio describes as "Koudelkese" — it is, he notes, "practically a neo-Latin language." The second is Koudelka's unwillingness to tolerate any discussion of matters that don't interest him, saying: "Josef decides first if a discussion may even begin. And then, when it is over." What does interest Koudelka? What has gripped his attention, his vision, his photographic desires and imagination since the mid-1980s? Nature, certainly. But in his work nature is rarely conveyed as either a Romantic or a transcendentalist might do, except when he visually can't help himself. Ponzio muses: "Fundamentally, Josef is in love with nature." But rather than indulging this passion, he says, Koudelka anticipates the loss of the ideal — pivoting from nature itself to the nature of humans:

> When something breaks. When there is some human intervention. Then, he photographs it in terms of human behavior. Seen overall, his work also has a strong moral aspect, because it is tied to ecology. It is fair to say that Josef completely relates to Kant's sense of awe for "the starry heavens above me and the moral law within me." This fits Josef perfectly.

Those who are closest to Koudelka, like Ponzio — especially those who've traveled or worked with him — accept him on his own terms, even when his behavior might be construed as selfish or insensitive, and even during moments of hair-tearing exasperation. Koudelka rarely if ever misrepresents himself, and the man — especially when understood through the filter of his work — seems to inspire a disarmed sense of inevitability that one allows for any force of nature. When I met with Scianna in Milan in 2015, he spoke of the challenges Koudelka and his talent can present:

> If the extant god asked me what photographer I'd like to come back as in the next life, whose talent I'd like to have, I would ask him if I might have the talent of Josef. But, if this same god asked me whose photographs I'd like to have, if I had to be all alone forever on a desert island, I would prefer to have the pictures of Elliott Erwitt. I think a photograph by Elliott can save your life — you want it in your pocket during surgery.
>
> Can a picture by Josef save your life? I don't know. But I do know it can cause great trauma.

Scianna elaborates, invoking *The Loser*, the 1983 novel by Austrian writer Thomas Bernhard. In the book, two aspiring pianists are destroyed — losing all desire to continue their studies — after hearing the young Glenn Gould's virtuosic performance of Bach's Goldberg Variations. Gould had realized an ideal in his performance that for them would be forever unattainable. Scianna compares this narrative to his own experience upon first seeing Koudelka's photographs of the Romani people: "It was for me both wonderful and horrible, because

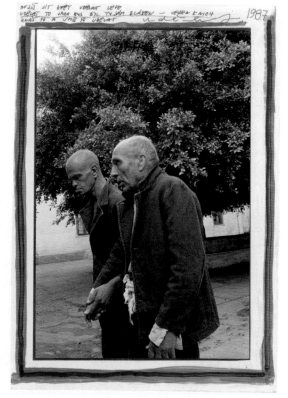

Real Casa dei Matti, Palermo, Italy, 1987. On top, Koudelka noted: "You have to go back to do it better. It must be done like you are one of them. You know how to do it."

I considered those pictures the kind that I would like to do, and I will never be able to do as well. It creates a kind of impotence. We know that no matter what we do, we will never achieve that exceptional quality."

2.

After staying three or four days with Ponzio and Koch in Rome in the spring of 1981, Koudelka headed south. This *giro* would take him to Puglia, Naples, and eventually Sicily. A year earlier, in Sicily, he had met the photojournalists Letizia Battaglia — Koudelka's near contemporary, born in 1935 — and her lover and partner at the time, eighteen years her junior, Franco Zecchin. Along with a handful of other brave photojournalists, Battaglia and Zecchin were risking their

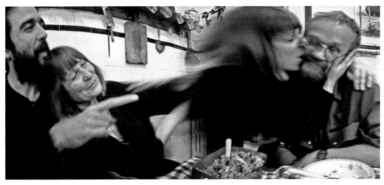

Franco Zecchin, Letizia Battaglia, and JK during Easter Week in Battaglia's kitchen, Palermo, Italy, 1988. Photograph by Sylvia Plachy

lives covering, for Palermo's newspaper *L'Ora,* the relentless horrors of Mafia brutality in the 1970s and 1980s, and its grip on Sicily.

Over the course of about fifteen years Koudelka regularly spent around a month or more annually with Battaglia and Zecchin. The three of them took trips together in a camper throughout Sicily and at times beyond: Sardinia, Turkey, and elsewhere. Zecchin has said that Koudelka had a room reserved in their apartment in the center of Palermo where he left his belongings; it was his, every time he returned to Sicily.[2]

Battaglia, who died in 2022, was herself a willful, single-minded force of nature who exuded passion and determination with her grand, sweeping presence. She reminisced to me in 2016 about her friendship and travels with Koudelka:

Koudelka was already a myth . . . hosting him in our home was gratifying. And going around with him in a little van, taking photographs, was fantastic. . . . Franco Zecchin drove, while I cooked spaghetti on a small gas burner. With Josef, you had to be Spartan. No restaurants, no waste.

We would have coffee at daybreak and then bid each other farewell, each taking a different route. And if you happened to glimpse him from afar while he was working, it was best to change direction. He rightfully loved being alone with his camera.

When it was no longer possible to "profit" from the light — that is, when it was already dark — then it was time to relax. A hot soup, and a good glass of wine.

On these Italian trips, Koudelka often used an Olympus camera — the first of which he dubbed "Sarah," after Sarah Moon, as she'd given it to him; he carved the name to the left of the viewfinder. (A future camera would be named "Elliott"; others were named for his children and still others for more close

friends and colleagues.)[3] Koudelka continued to travel to Sicily for many years, to photograph the Easter rituals and the August festivities.

He also photographed at a psychiatric institution in Palermo, the Real Casa dei Matti — to the extent that he was allowed. Battaglia knew the place well, and it was she who introduced Koudelka to its director and helped him gain access. The conditions in the facility, which dated from 1824, were decidedly degraded. Koudelka turns to a notebook from 1985, translating for me what he wrote about photographing in the hospital: "You have strong stomach, but many times during the day you are about to vomit." Things were slightly more pleasant in the facility's courtyard, which was, he says, "with its big tree in the middle, like a theater stage. And also there was fresh air. So much better than being inside in the rooms." Between 1981 and 1996, Koudelka made a dozen two- to three-week trips to the institution, arriving early in the morning and leaving in the evening. Battaglia never saw his photographs from the Real Casa dei Matti, except for two that were eventually published. Only more recently (as I write in 2021) has he begun to review his contact sheets from this work,

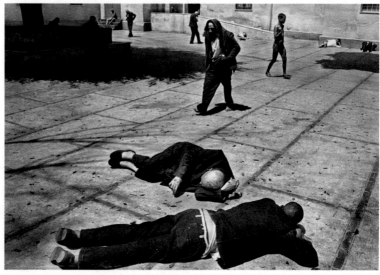

in order, as he puts it, to "understand what I did." As we looked together at some of the images he made there, Koudelka told me: "I was trying to photograph as one of them." Perhaps for this reason, one senses nothing judgmental in the work.

Zecchin especially remembers the intensity of the three of them photographing at Sicily's Settimana Santa (Holy Week), and the accompanying rituals, unique to each city, town, and region. They chose where to sleep each night based on where the procession would pass through the following dawn.[4] Eventually, however, said Battaglia, Koudelka stopped coming to Sicily. People began recognizing him and hovering around him while he photographed the religious processions, so he could no longer work in peace. But over the years, she told me, "every now and then a picture postcard would arrive from him, from different parts of the world. Those ingenuous postcards that amused him so much, and that made you feel his absence even more strongly."

Real Casa dei Matti, Palermo, Italy, 1985

Battaglia and Koudelka would be reunited in Palermo in the fall of 2018, when Palermo's Centro Internazionale di Fotografia (a photography center founded by Battaglia in 2017) presented an exhibition of Koudelka's work on the 1968 Soviet invasion. This was an especially poignant show, given that in 1985 Zecchin and Battaglia went to Valchov on what Zecchin has described as a "recovery operation." There, they met Koudelka's mother and aunt, and

Mojmir Ježek on his boat,
Zingara, Ravello, Italy, 1995

clandestinely extricated for him the last of the negatives he had stored in a chest in his upstairs room.[5]

On one of his early visits to southern Italy, Koudelka traveled to Galatina and Lecce, in Puglia, to photograph festivities. There, he met Mojmir Ježek. "It was a very odd and wonderful encounter in Lecce," recalls Ježek, who was on the editorial staff of the newspaper *Quotidiano di Lecce*. Koudelka arrived in the paper's offices and was speaking with various photographers. When finally he and Ježek met, it was quickly established they were both Czech, and they soon became good friends.

Koudelka and Ježek (now based in Rome) made several sailing trips together — "pleasure, not work trips" says Ježek — in Ježek's old wooden boat, *Zingara* (Gypsy), including one through the Bay of Naples and along the Amalfi Coast, where Vesuvius defines the horizon and the wind in the sails feels epic. Ježek said that Koudelka "didn't stop looking and snapping." Ježek concurs with Ponzio: "Serious things with Josef are only about his Goddess, Photography. Everything else is about action. Doing. 'Let's do. Let's go. What's next?' Josef is not a normal man." Without being celibate or abstemious, Koudelka is, however, decidedly ascetic. He is, according to Ježek, "a kind of monk":

> He has this religion of photography and he thinks only about that. His entire life is based on that. And Josef is always dressed in a uniform — he does not want to think about what to wear. For the thirty years I've known him, he has always worn his photographer-monk uniform.

Cristobal Zañartu, too, has been struck by Koudelka's "monastic" approach on their journeys. He eschews all conventional bourgeois luxuries. He insists upon finding the exact prime spot — the meadow of wildflowers, the grassy hillside — where they might sleep, protected from the elements, and then awaken to birdsong, in beauty, illuminated by a Homeric dawn (rosy-fingered or otherwise). Both men, like Ponzio, convey the essence of their friend's austerity in service to his photography, and, as I interpret it, to his sense of the sublime.

Koudelka's first trip to Naples was in 1979, at the invitation of Paola Cammarano, whom he had met in 1977 at a Roma conference in Geneva; she subsequently invited him to Italy, where their love story began. Cammarano and Koudelka eventually lived together at Via Benedetto Croce 12 — the street named for the philosopher, historian, and political thinker, who happened to be Cammarano's grandfather. Koudelka loved Cammarano, although she was prone (he says) to moments of raging jealousy:

> It wasn't that she would see me with other women, but just that I was always leaving. Once I went on a photographic trip with my friends. When I got back to our room, she was not there, and things were destroyed. In the middle of the room, her mother was waiting for me. Basically, the idea was that I should

marry Paola, and then I would be free to do whatever I wanted. But of course I did not want to get married, and I was always coming and going.

Cammarano died of cancer when she was still quite young, although it was well after she and Koudelka had grown apart. But they were a couple for several years, and during the early 1980s Naples, like Paris, was often a home base for him, one where he thrived:

> *I photographed everywhere, met a lot of photographers and eventually made a lot of friends there. That's how I started to know Mimmo Jodice — at that time he was teaching in the school, and I visited him in his studio. I also got to know Luciano Ferrara, who was photographing with the local newspaper. When there was something the newspaper photographers went to photograph, I often went with them.*

On his second trip, in 1980, he met and befriended the photographer Marialba Russo; they were introduced by Annabella Rossi, a cultural anthropologist specializing in the traditions of southern Italy. Koudelka called

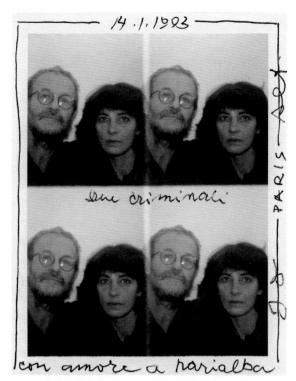

JK and Marialba Russo, photo-booth portraits, Paris, 1993. Inscribed: "Two criminals/with love to Marialba"

Russo soon after arriving in Naples, and the two of them began going on photo outings together in her car (although, as usual, not shooting together). They often went to religious sites in Campania and elsewhere — "She knew where everything was," he says. Russo recalls their first outing: she had packed up her car and was just about to go photograph a pilgrimage when Koudelka appeared, unannounced. He jumped in the car with her — and off they went. Once, Marialba and Josef visited the Cappello di San Gennaro: from that point on, he jokingly inscribed notes and letters to Russo: "To Mary, from Josef."

Discussing that period in Italy in general, Russo reminds me that the era was fraught: there was the terrorism of the Red Brigades and other political, social, and cultural upheavals that could make life feel overwhelming at times. Koudelka appreciated Russo's engagement and intensity: "We were good friends," he says. "And she is an excellent photographer."

Like parts of Spain, southern Italy seemed to beckon to Koudelka, in every sense. Some of the images he was making would appear in future compilation projects — although no publications or exhibitions (at least as of this writing) have been specifically dedicated to the region, or to processions, religious festivities, and pilgrimages.

3.

The move from London to Paris in 1980 brought Koudelka closer to many people who were becoming increasingly important to him: Henri Cartier-Bresson, Martine Franck, Robert Delpire, Voja Mitrovic, Sheila Hicks, and Hervé Tardy,

among others. He spent most evenings at the Paris Magnum offices, editing contact sheets and selecting negatives in preparation for making his 13-by-18-cm work prints the following day at Picto, before unrolling his sleeping bag on the agency's floor for the night.

Even though Koudelka enjoyed the proximity of many friends, colleagues, collaborators, and Magnum's support system — someone was missing. As much as he might have wished not to feel her absence, he still could not get Jill Hartley out of his mind. She had been content in her relationship with Antonín Kratochvíl, and the two of them had purchased a New York loft together in the early 1980s. But there had been no closure with Koudelka: he remained present in Hartley's mind and heart as well. By chance, in New York Hartley ran into Steve Ettlinger, who had been assistant bureau chief at Magnum in Paris in the mid-1970s. They exchanged contact information. Ettlinger went on to become a picture editor at *Geo* magazine, where Koudelka called him when he was in New York in the autumn of 1983, not long after Ettlinger's and Hartley's paths had crossed. Koudelka asked if Ettlinger had Jill Hartley's number.

It had been seven years since they had last seen each other. Koudelka gave her a call in late October.

> She answered. And she said that she wanted to meet me. In fact, I was surprised, because she wanted to meet me immediately. We met in Magnum. We went to the park. I looked at her, and I decided not to like her — for me she was a traitor. . . . But of course, then everything started again. . . . I was in New York for a short time. We started to see each other mainly in the flats of our friends, and Jill told me that she wanted to go back to Paris with me. She made all the preparations, put her best negatives in the bank, and bought her ticket on my flight.

In New York before leaving for Paris, 1983. From left: JK, Gilles Peress, Nan Richardson, and Jill Hartley. (Camera on self-timer)

Up to this point, Kratochvíl didn't know that Hartley was seeing Koudelka. But then, as Koudelka was sleeping in the Magnum office one night, the phone rang, and rang, and rang. He didn't pick up as nobody was supposed to be in the building — the staff had already told him to switch off the lights.

When the Magnum people came the next morning, the receptionist passed me the phone, and it was Antonín. What happened is that Jill photographed me when we were meeting; she developed the film, he saw the developed film, and he realized it was me there. So she needed to tell him what was going on. When I picked up the phone, it was him, and he told me [in Czech]: "You can't take my woman." I said: "Listen, I am doing it because she says she wants to do it."

After this call, Koudelka, now fully awake, spoke to Hartley, since "I really didn't understand what was happening. I told her I'd come over, but Jill told me not to." Before Koudelka left Magnum that morning, he told the receptionist, Arlene Pachasa:

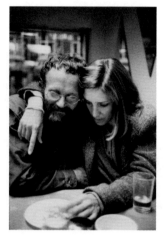

JK and Jill Hartley, 1976.
Photographer unknown

"If by any chance Jill calls, tell her that I love her." When I got back to Magnum later, the receptionist said that she'd called, "and she said that she loves you too, but that she's leaving with Antonín to go upstate."

When Koudelka eventually was able to speak with Hartley, she told him that "in fact, she and Antonín had spoken intensely and at length." They would part. Hartley tells me that the breakup was painful; she and Kratochvíl had been "very good traveling companions — but not very good at settled life in New York." As for Antonín and Josef — both told me separately that there are no bad feelings between them, and Antonín and Jill have remained in touch as well.

Koudelka:

Jill and I were madly in love, but I had doubts about how it could work. I couldn't offer her anything but the Magnum office — sleeping on the floor. In New York she had a beautiful loft. But I knew I should try. If I didn't take her back to Paris with me, I'd be sorry all my life.

Hartley:

When we met again, it was like before. We were still in love with each other. We felt that maybe we could really try it this time, that maybe it could work. It was like having a second chance. I think it was a dream for both of us.

They left New York together in late November 1983, stopping in London on their way to Paris, where they arrived in early December. Hartley recalls they first lived in a series of borrowed apartments — and the rest of the time under the table at Magnum.

I found a tiny space for sale in a courtyard that I thought was affordable. When Josef saw the place, he remembered that Delpire had previously offered us a floor of his storage loft in the courtyard of 278 Boulevard Raspail, if we wanted to live there. He asked about it, and Delpire said of course.

Around 1984 they moved in to the second floor of Delpire's space; it was "small and basic," she says, but she transformed it into a home — moving books downstairs, sanding and varnishing the wood floors, and painting everything.

Delpire had a bathtub and kitchen sink installed for them. The toilet was in the courtyard.

Koudelka thinks back, with some wistfulness in his voice:

I loved Jill, and I was thinking that I wanted to live my life and have a family with her. I was so much in love that if Jill would have asked me to marry her, I would have done it. Luckily, she didn't.

Hartley says that all they wanted was to be with each other:

The problem with being married is that you may get divorced, and that's a lot of trouble. The idea was to be together. . . . But then for purposes of my getting various benefits in France, we needed to get a certificat de concubinage *[cohabitation certificate] after proving we lived together, which was not complicated.*

The witnesses of their "concubinage" ceremony were Agnès Sire of Magnum and Caroline Thiénot-Barbey, the wife of Magnum photographer Bruno Barbey. After Koudelka and Hartley signed the document, they all went for a drink.

4.

Since Koudelka's departure from Prague he had, on some happy occasions, seen old friends and acquaintances who had likewise left Czechoslovakia, whether on short-term permits or permanently. In spring 1984 the performer Eva Zapletalová was traveling with the Naivní divadlo (Naive Theater) from Liberec on a six-week tour of France. (Zapletalová had been a singer and dancer in the folk ensemble with Koudelka in the early 1960s. She calls him "Pepík.") As Zapletalová later recalled, she decided to reach out to Koudelka during the theater troupe's final stop, in Paris:

JK on the Rue Daguerre, Paris, 1984. Photograph by Jill Hartley

We had one day off. I knew that our piper, Pepík . . . had been living and working in Paris for years. Before leaving Czechoslovakia, I had memorized his address — I didn't dare write it down, because Pepík at that time was a "treasonous emigrant."[6]

Zapletalová tracked down Koudelka at Delpire's loft on the Boulevard Raspail. Koudelka and Hartley greeted her warmly. She continued:

That day was my forty-seventh birthday, and they celebrated it with me. I then took the liberty of expressing a wish: "I would be so happy if we could take the bagpipes and play and sing a few Czech songs in the center of Paris." Pepík didn't want to get embroiled in this somewhat eccentric undertaking. He hadn't played the pipes for a long

time, the leather had dried out and cracked. . . . "My dear Pepík, this birthday is an exceptional one for me, and this is my only wish."

She finally succeeded in convincing Koudelka to unearth his bagpipes and dust them off. The three of them went out to wander the streets of Paris, eventually meandering to the Right Bank and ending up at the Place Georges Pompidou in front of the Beaubourg:

There, Pepík took his bagpipes, which were decorated with ribbons, out of the suitcase, and we began to sing Czech songs. He accompanied our singing by playing on the pipes. Parisians and tourists gradually began to stop and listen to us. We walked around the great square, and Pepík got right into the role of a wandering minstrel.

Soon after, they parted.

Throughout the 1970s and 1980s, Koudelka occasionally encountered other friends from his youth as well — often by chance. He ran into Pavel Rohan when photographing at England's Henley Regatta in the 1980s. He'd see Markéta Luskačová (who had legally emigrated to England), and his dear friend, the Czech poet Vladimíra Čerepková, who was living in Paris. And in 1977 he spotted Pavel Dias from afar — the two of them were photographing at the Royal Ascot racecourse. Dias heard someone bellowing his name over and over, and there in the distance was Koudelka.

Later that day, they took the train together back to London. As Dias, who still referred to Koudelka fondly sometimes as "Safez," told it: "Safez proposed that I move to his place, from the bed and breakfast I was staying at." Koudelka was squatting in a room in a little house on the River Thames in the Port of London. He didn't want Dias to have to spend money on a place to sleep. There was no bed nor any other creature comforts, but it was clear to Koudelka that Dias didn't have much money — and he was elated to see his old friend. For his part, Dias assumed that Koudelka, now living in the opulent West, would and should have greater means and comforts, and told him as much. Koudelka found it amusing: "People assumed that when you leave, you have this great and comfortable life."

Dias was grateful for the time with his old friend, remembering:

Lying on the floor, we talked long into the night about all kinds of things. . . . It seemed to me that Josef was trying to persuade me that he felt no homesickness. And yet he naturally continuously asked about home, and the people he had left there, our acquaintances.

JK playing the *dudy* (bagpipes) with Eva Zapletalová (right), Place Beaubourg (Centre Pompidou), Paris, 1984. Photograph by Jill Hartley

JK in England, 1977.
Photograph by Pavel Dias

He recalled a picture he made of Koudelka when parting: "I took a photograph of Josef. . . . The figure of a person leaving . . . but still connected, by his gaze, to the friend from whom he is walking away."

5.

Koudelka and Hartley had been weighing, debating, procrastinating, and returning to the possibility of having a child together. Hartley says that Koudelka was eager to do it, as was she. But she adds: "I first needed to secure things like a place to live, a residence permit, maybe social security, some income, learn the language — the basics." Still, they were both committed to making some sort of life together.

Koudelka knew that having a child would require more financial resources than he currently had: "For the first time," he says resolutely, "I felt like I really needed to make money but I didn't know how or where to find it. Suddenly came this possibility of photographing on a film set. I was saying to myself: 'I am losing my virginity in order to have a child!'" So, in preparation for the possibility of a baby, Koudelka took his first assignment in the fifteen years since he'd gone into exile. (It would also be his last.) It is worth noting here that Koudelka distinguishes assignments from commissions. Unlike an assignment, a commission allows him to determine the focus and direction of a project, within the given subject, as well as the time and resources to do it exactly as he pleases. Assignments, he contends, are far more strictly prescribed — with limitations, and many factors out of his control.

This assignment came in 1984 from the film director Taylor Hackford, who hired four photographers to shoot on the set of his film-in-progress, *White Nights*. (Along with Koudelka, they were Eve Arnold, Anthony Crickmay, and Terry O'Neill.) The film, released in 1985, brought together two astonishing performers: ballet dancer Mikhail Baryshnikov and tap dancer Gregory Hines, with a plot designed, as Hackford put it, "around their unique personalities and talents":

> *What would happen to a celebrated Russian ballet star who had defected to the West ten years earlier if his polar-routed 747 had to make an emergency crash landing in Siberia? Since defection is considered a crime in the U.S.S.R., would the Soviet authorities arrest him? Might they try to persuade him to renounce the West and dance again in Russia? . . . And what if a black American who had deserted in protest against the Vietnam war and had been granted asylum in Russia were to be drawn into a plot by the KGB to coerce the dancer to perform again?* [7]

Hackford, who considered *Gypsies* to be a "milestone of contemporary photography," noted that Koudelka had made it clear that he was taking this, his first assignment since leaving Prague, "so that he and the woman he loved could

afford to have a baby."[8] For a week of work, affirmed Koudelka, "they offered me good money, and agreed that I could photograph what I wanted. . . . During those six days I earned more than what I would usually earn in a whole year." Just as important, Hackford told him to "be himself."[9]

Koudelka found the plotline of the movie to be interesting enough. He worked on the film set much as he had on the stage sets at Divadlo za branou in Prague. Not surprisingly, Koudelka and the Latvian-born Russian émigré Baryshnikov found they had a few things in common. "We didn't really talk much to each other," says Koudelka, "but we understood each other." One of the scenes in the film takes place at a market in the Soviet Union. Koudelka recalls that the American production crew was busy loading up the tables with food for the scene, when Baryshnikov vehemently objected: "He came and said: 'Out, out, out!' And he looked at me, because we both knew it would never be like that, with all that food. . . ."

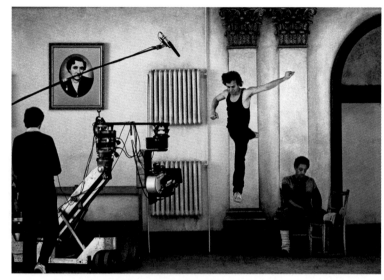

On the set of *White Nights*, directed by Taylor Hackford, with Mikhail Baryshnikov and Gregory Hines, England, 1984

Koudelka's photographs from his week on set chronicle a film-in-process: his images embrace actors and crew, and make no secret of the artifice of the film medium itself. They are variously humorous, movement-filled, still, abstract, moody, and intimate interpretations. His work on *White Nights* may be considered a leap of sorts — a leap of faith, at least. He was dreaming of a life where he might soon have responsibilities to someone other than himself, and he was prepared to address the practical needs of a family, even if it meant doing something that might not compel him especially.

In 1985 Koudelka and Hartley traveled to Mexico via Los Angeles. It was his first time visiting the West Coast of the United States, and his first time in Latin America. In fact, except for visiting his sister in Toronto, and his trips to New York, Koudelka had never traveled outside Europe. In Los Angeles, Koudelka met Hartley's family. "I spoke with them very openly about my life. They were very nice." Hartley tells me that her parents liked him. In LA they purchased two new sleeping bags that zipped together for their forthcoming trip across the border. (Koudelka's zipper was later destroyed by a friend's pet macaw.)

It had been difficult for Hartley to find steady employment as a photographer in Paris; most of the work available was on spec. Trying to plan ahead, she thought there might be some stories she could do in the United States to sell in Paris. With this in mind, she suggested that Koudelka start on the journey to Mexico before her. He didn't take to the idea.

Josef told me if I didn't go with him from the beginning, he wouldn't want to meet up with me later on. But of course he was not helping me pay my way on the trip — and now I wasn't allowed to try and earn the money for it. This was a bit devastating, and I had a kind of breakdown. He refused to understand. He kept telling me that if he doesn't understand, it was because I didn't explain it well enough, and I kept trying to explain things. Anyway, we set off to Arizona where we visited Bill Jay [photographer and founder-editor of Album *magazine, whom Koudelka knew through David Hurn], and then we crossed the border at Nogales.*

(An aside: Another time, I discussed this episode with Josef and Lucina in Ivry:

Lucina: "You drove her crazy!"

Josef, without hesitation: "Yes.")

On that trip to Mexico, Koudelka visited the painter Pedro Diego Alvarado — grandson of Lupe Marín and Diego Rivera — whom he had met through Cartier-Bresson in 1977. On subsequent visits to Mexico over the years (usually for exhibitions of his work), Koudelka forged friendships with many Mexicans, including art critic and writer Víctor Flores Olea, Mercedes Iturbe (whom he'd first met in Paris, and who, as the director of Mexico City's Museo del Palacio de Bellas Artes, presented his retrospective there in 2003), photographer, curator, and editor Pablo Ortíz Monasterio, and photographers Manuel Álvarez Bravo and Graciela Iturbide, both based in the lovely Coyoacán area of Mexico City. In Oaxaca he encountered the Zapotec artist, cultural leader, and activist Francisco Toledo. Not long after they met, Toledo would purchase some prints by Koudelka — when the photographer was still little known in Mexico.[10]

Iturbide's photographs, many of which are ostensibly documentary, have a striking aura of otherworldliness, quiet intimacy, and strength, as seen in her luminous series *La matanza de las cabras* (The Slaughter of the Goats, 1992), and her photographs of Zapotec women of Juchitán. Like Koudelka, she is fascinated by ritual.

JK and Jill Hartley at the home of Manuel Álvarez Bravo, Mexico City, 1989. Photograph by Graciela Iturbide

When we speak, Iturbide acknowledges: "Josef's work has been always a reference for my work." As have several others, she cites as a source of inspiration his 1968 photograph of a Romani man and his horse (a print of which, she told me, hung in Álvarez Bravo's house). She remembers getting to know Koudelka, whom she met at the home of Cartier-Bresson and Franck in the 1970s:

Once I went to the Magnum agency, where he used a small room with a small table and with postcards of

paintings and photographs, but mainly paintings that he liked, pinned to the walls. Josef took us to lunch, and he then gave us strawberries with milk, and a very strong Czech beverage [his father's slivovitz, undoubtedly].

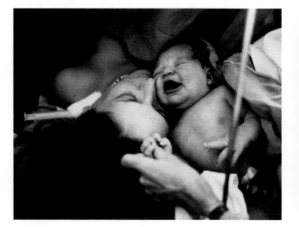

Josef is always very cheerful and frank. Once he came to Mexico and asked to stay at my house. I offered him my bedroom, or the small living room with a sofabed. He said: "Wait, Graciela, I will see where I will stay." He walked around my house; he had a sleeping bag and, in a small bathroom, he found a place to set his sleeping bag and to sleep — like a cat would do!

Jill Hartley, Florence Miailhe, and Agnès Sire, Paris, 1986

Iturbide recalls that he woke up early each morning to wander the city, and was, she says, "always carrying his camera."

For Hartley, there was much that was wonderful about that 1985 trip to Mexico. She felt a deep connection with the country and made a lifelong friend in Alvarado. Still, by the time they returned to Paris, she was ready to separate from Koudelka. "He kept up his solitary life, without any compromises." For some time, however, once they were back in France, circumstances kept them apart — Koudelka was coming and going, on the road working — and Hartley had trouble finding the right moment to break things off.

Koudelka, too, was beginning to understand that their relationship couldn't really work. But when they finally talked about it, they just couldn't split up because both felt they'd put so much effort into being together, and they still loved each other. Lingering also was the idea of having a child. Hartley said: "I had decided that I didn't *not* want to have a child — which means I did want one, and he wanted one. So even though I knew very well that he might not be the best choice, at least he wanted a child, and I decided to make every effort and give it the best chance."

Jill and Lucina, 1986

On September 23, 1986, Lucina was born to Jill and Josef at the Clinique du Belvédère, Ancien pavillon de chasse de l'empereur Napoléon III in Boulogne-Billancourt, just outside Paris.

PAUSE

Just as she was present when this biography began in Ivry in January 2014, Lucina has been with me, filming, throughout almost all my conversations with her father,

and almost all the interviews with her mother as well. There are no secrets from her. Jill is as candid as Josef — although, in the way of memories, their candor may not always align.

Over time, Lucina has become adept with the video equipment, and this, along with her developing eye and instincts, has permitted her to become bolder, to take more risks. She tails Josef through his exhibition installations and openings, his editing and design meetings, his birthdays and dinners with family and friends.

On occasion, she has called me — for example, while traveling with her father in Los Angeles (Lucina as driver and navigator) — fuming. My self-assigned task? To talk her down from moments of total exasperation with Josef.

I've watched their relationship weather some momentary retreats. I've also witnessed the increasing closeness and mutual trust between father and daughter as they spend more time together, having "accepted" (as Lucina tells me in late 2021) that they "will never quite understand each other." Josef is full of preconceptions about Lucina that often must be shaken, and replaced by the reality of his daughter, her talents, her interests and aspirations. Lucina is learning how to better read her father. And he is allowing her in. Her face seems to have softened, opened in the process, becoming more expressive. That's part of her growing understanding of him, I think. But it has been fascinating to watch her Lucina-ness shine, as she moves through her late twenties and into her mid-thirties.

At the same time, I have seen a man moving through his late seventies into his eighties, becoming more accessible, as he tries genuinely (although sometimes cluelessly) to understand his daughter.

And now the story has caught up with her: Lucina has been born. Josef, Lucina, and I are looking at her baby pictures. I begin to feel that Josef sees this biographical project as a conduit of sorts, a way to tell Lucina about his life. I suggest to him that, during our conversations, he is in fact talking to Lucina. He responds: "No. I am talking to you. But I am happy that she listens."

We toast: "*Na zdraví!*" And we continue, returning to the early 1980s and the making of *Exiles*.

JK and Lucina, 1986. Photograph by Henri Cartier-Bresson. Inscribed: "To Lucinka/Like father: like daughter/Very affectionately, Henri."

6.

Koudelka had lived for a very long time with the images he was considering for the *Gypsies* book, and he had experimented with myriad presentations of the photographs for almost as long. *Exiles* was different in every respect. There was not, to begin with, an ostensible subject — it was Robert Delpire

who eventually came up with the "exiles" rubric. Here there was no preconceived notion of which images were "necessary," of "categories." Koudelka says: "I was just traveling around, knowing places where I wanted to go, what I might want to photograph, but without being conscious of what I'm actually getting, what it is building to. Then you look at what you've been doing, and sometimes the images together make some sort of sense." When traveling, he has always carried with him miniature mock-ups of his books-in-progress that he made using contact prints, so that he might continually review and reconsider the juxtapositions and the structure of the project.

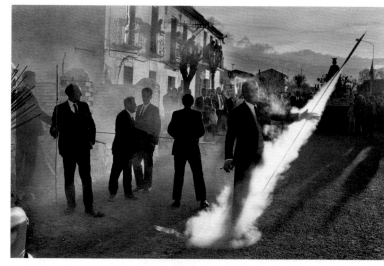

Spain, 1971

Delpire told me in 2013:

The idea of Exiles? *It imposed itself . . . in its variety of subjects, which he has not "covered," but has rather set down, in complete freedom. The title, too, imposed itself. It was useless to do verbal somersaults. It is good like this: short, immediately comprehensible. How did we make the book? . . . We put small prints out on a table . . . discovering subtleties in their associations. Constructing, without haste, a sequence that we looked at afresh after a few days. The pleasure of putting it together! And Josef would call me to tell me that he had found some real improvement. Sometimes just one image added to the sequence. An image that had been overlooked but now seemed meaningful.*

Delpire described the process more viscerally — and without the haze of twenty-five years' distance — in a conversation with the philosopher Alain Finkielkraut and the writer Danièle Sallenave that introduces *Exils*, the original French edition of the book, which Delpire published in 1988. He said:

He photographs with a passion that is unique to him; he has a devouring eye. It is the result of his visual bulimia. He has on occasion placed thousands of 13 by 18 [cm] prints on my table, from which I am to choose. Of those, I hold onto thirty or forty. And only two or three images figure in our final choice, in a book or in a show. To "think through" his work, Josef needs to wade through such a mass of documents.[11]

With *Exiles*, as with *Gypsies*, Delpire eventually grew exasperated with the endless revisions to the maquette. He wrote to Koudelka in January 1983: "Have a look at the eighty-seventh version of your *Exiles*. . . . For me the book is slightly different, neither better nor worse, just different."[12]

Originally, the hope was that *Exiles* could be published in time for the 1984 exhibition *Josef Koudelka*, organized for London's Hayward Gallery

by Delpire and the Arts Council of Great Britain. Koudelka, however, was not satisfied with what he and Delpire had thus far created. Indeed, it would take another four years to perfect the edit and sequence, and then there was disagreement between Koudelka and Delpire with regard to the format — Koudelka wanted the same size as *Gypsies*, and Delpire wanted something slightly smaller, to fit into his Photo Copies book series. Eventually, Koudelka would give in to Delpire's proposed format, at least for the first edition of *Exiles*. In the meantime, in 1984 Delpire published *Josef Koudelka* as a Photo Poche — his small-format book series — in time for the Hayward show. The introduction to that edition, by Bernard Cuau, proposes that Koudelka is "fascinated by death," and that "all Koudelka's work is a book of questions."[13] Like the Hayward exhibition of 132 photographs, the Photo Poche edition included not only work from what would eventually constitute *Exiles*, but also selections from *Gypsies*, as well as a selection of the 1968 Soviet invasion work. In this way Koudelka publicly acknowledged his authorship of the invasion photographs for the first time — without incident. (The distribution of the book would never have been permitted in Czechoslovakia, although I was told by several individuals I interviewed in Prague that clandestine copies made their way into the country.) *Exiles* began to truly crystallize for him with the Photo Poche selection and the Hayward show, both of which built on previous considerations of the editing of this work.

Annotated photocopy of the 1983 first layout of *Exiles*, showing the division into five internal sections (pink lines); red X's indicate photographs that would be eliminated from subsequent editions (although some of these would be reintegrated into still later iterations of the book), 2014

Divided into five sections, with a single image on the right side of each spread, *Exiles* conveys Koudelka's vision without the organizing features of a literal or overt topic, or specificity of place. Along with the earliest photographs — from 1968, made in Czechoslovakia and Romania — the project comprises images from his wanderings in England, France, Germany, Greece, Ireland, Portugal, Scotland, Sicily and other

183

parts of Italy, Spain, Switzerland, Turkey, the United States, Wales, and Yugoslavia. In its own way, it is deeply personal: Koudelka includes images of where he slept, where he ate. Here geometry, shadows, textures pervade landscapes and streetscapes with increasing prominence, sometimes driving the sequence itself. There are animals and people, yet an overwhelming sense of isolation pervades. The contributors to the French edition of *Exiles* elaborated:

> Finkielkraut: *In current photographs the Exile is everywhere; it is like the color, the form, even, of the human condition after who knows what invisible catastrophe — humankind is no longer at home in the world. When [Koudelka] shows us people together, those people don't form a* world, *because faces that do not look at one another lose something essential: the humanity that is born in that spark of attention that is mutually given. . . .*

> Sallenave: *The photograph of his outstretched legs and feet in the underbrush is amazing, heart-wrenching. It is the image of Rimbaud, wandering poet with holes in his shoes; it is also like this that vagabonds are found, dead from the cold, in a thicket. All of Josef's work seems to me to be dominated by the presence or the presentiment of death. It's not that his photographs are morbid; they are nonetheless images touched by death. Individual death, or the death of a world. . . . But his gaze is not becoming colder, or less alive; on the contrary, Josef's photographs emanate a dizzying intensity. . . .*

> Delpire: *What characterizes Koudelka, what makes the unity in his work, is that fury, that frenzy to comprehend and to go beyond the real, to topple over into the uncanny, into the fantastic of every moment.*[14]

Delpire initially planned to write an essay for the book but ultimately decided not to, preferring to include only the conversation. While the photographs are identically ordered in the French and American editions of *Exiles*, and the books' formats are the same, the texts differ. Aperture, which organized the English-language version, chose not to include this three-way conversation published in the French edition, instead desiring a text that would more directly touch on the project's given concept. Koudelka suggested the Polish writer Czesław Miłosz.[15] In due course, Aperture editor Nan Richardson contacted Miłosz, who agreed to contribute a text.

Koudelka was clear about what he wanted. "I asked Miłosz not to write about my photographs, but to write on exile." And indeed, his essay "On Exile," although inspired by the photographs, does not address them directly, but instead powerfully and poetically evokes what Miłosz refers to as "the misfortunes of exile."

> *Slowly we come to the realization that exile is not just a physical phenomenon of crossing state borders, for it grows on us, transforms us from within, and becomes our fate. The undifferentiated mass of human types, streets, monuments, fashions, trends acquire some distinct features and gradually the strange transforms itself into the familiar. At the same time, however, the*

memory preserves a topography of our past, and this dual observance keeps us apart from our fellow citizens.[16]

Photographer Tod Papageorge, longtime head of Yale University's graduate photography program, summed up, for me, the pivotal role of this project in his friend's overall evolution: "With Josef, *Exiles* is like the crucible — the strike point between the work on people and what was to come."

7.

Gilles Tiberghien, who has written frequently about Koudelka's work, tells this story: When Cartier-Bresson first saw Koudelka's next body of work, after *Exiles*, looking "at the younger artist with his piercing blue eyes, he asked just one question: 'But where are the people?'"[17] Cartier-Bresson dubbed these panoramas "spaghetti" or "slices of ham." Magnum photographer Harry Gruyaert told me that Cartier-Bresson also referred to Koudelka's panoramic camera as "'*ta machine à jambon*' — which is the machine for making thin slices of ham."

Tiberghien, who is married to Anne Cartier-Bresson, the photographer's niece, elaborated when we met in Paris in 2016:

> *Henri and Josef were both making photos that were, on the one hand, "humanist." Yet neither one was part of the humanist photography tradition, while each having a humanist core and interest in subjects concerning man. But their aesthetic is tougher than most other photographers — with Henri, it is about geometry; with Josef, it's the very powerful contrast of subject matter with forms, distortions, and particular perspectives. They are both interested in humanity — the face, expressions, life, death, and the forceful things that arise and are experienced. But at a certain moment, Josef stops photographing people in the obvious, direct way, although in fact, man is everywhere. Humans, human activity, are everywhere reflected in his landscape photographs.*

Anna Fárová understood the panoramic camera as an "old dream" of Koudelka's. Of his early "experiments," she says: "We had met during his first attempts to achieve a panoramic photograph by horizontally or vertically cropping a square negative, and here all of a sudden was a camera that matched his thirty-year-old idea."[18]

For centuries, the notion of "landscape" in art has often conjured an untouched pastoral setting. But the challenges of industrialization have invited a world of corresponding depictions that consider human interventions in a once-pristine environment.

In 1984, cultural administrator Bernard Latarjet and photographer François Hers were organizing a project to photograph French landscapes for the Délégation interministérielle à l'aménagement du territoire et à l'action régionale (Interministerial Delegation for Land Use Planning and

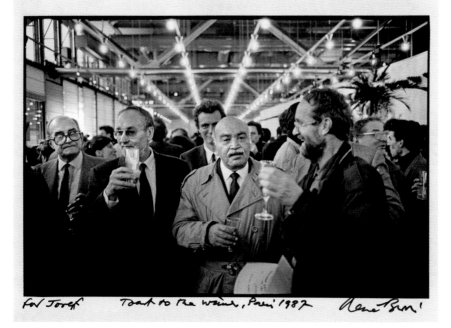

For Josef Toast to the winner, Paris 1987 René Burri!

JK awarded the Grand Prix National de la Photographie from the Ministère de la Culture et de la Communication, Paris, 1987. Robert Delpire (second from left), François Hébel (partially hidden), Romeo Martinez (in trench coat), and JK. Photograph by René Burri

Regional Action, better known as DATAR).[19] Latarjet explains that the idea was to commission artists to create bodies of work on the subject of their choice, within the larger context of the French landscape. They were free to approach their projects in any way they wished and from their own unique perspectives.[20]

It was not the prospect of photographing the landscape that initially beckoned Koudelka. In 1986, when he was approached by Latarjet, at the time director of the Fondation de France as well as of the Mission Photographique de la DATAR, the siren luring Koudelka to the stones was the possibility of using a panoramic camera. Latarjet recalled: "I received a panoramic camera, and he proposed to test it. Josef at this point had never used this." Koudelka tells me that at first he was hesitant about embarking on the DATAR project: "It would take me away from people. In the landscape I like to be alone." But, after borrowing the camera and "photographing everything I could possibly photograph, I saw that, using that camera, I might do something I had not done before." He observes that this fixation was nothing new for him: "All my life, I was interested in the panoramic vision. When [Josef] Sudek died, I tried to get his [panoramic] camera, but somebody else got it." In 2021 he told me:

> I believe that my life as a photographer was saved by starting to work with the panoramic camera, because making panoramas helped me to renew my vision and keep the pleasure of taking photographs. Some photographers lose this pleasure. . . . I had the privilege of keeping it — waking up in the morning and going to have a look around.

Sheila Hicks observes: "What better way to compose space? Don't forget his theater work — so now, there is the theater of space. What better way, then, to reveal, to amplify the abstractions in the landscape than with a panoramic

camera? He works with details in the landscape and he uses them as abstract elements in structuring the picture plane."

A primary purpose of DATAR was to look at the national landscape in a moment of stark transition. Artists were engaged "not to illustrate, demonstrate or denounce" major human interventions in the landscape, wrote Latarjet, "but to enrich the way such transformations are actually experienced." The grounding conceit, he says, was that technology and other human impositions had irrevocably disconnected us from nature:

> [Human intervention] radically changes our vision of time and distance; it shatters the age-old order of the countryside, putting in its place identical stretches of standardized land . . . bereft of landmarks, bereft of value . . . it allows reality to leave us stranded.[21]

Koudelka's DATAR images are his first committed to exploring the tension between the natural world and its destruction — often in the process of furious construction. This work neither judges nor romanticizes. All the images have a central focal point, but some evoke a sense of frenzy that is otherwise rare in a Koudelka photograph — it feels as if he is experimenting, trying to understand how best to embrace and exploit what this camera can do for him. Compositionally, his DATAR images seem to be the seeds for the panoramas that would follow. The strongest of them presage his evolving focus on the dialogue between landscape/nature and industrial structure, past and present.

In the late 1980s Koudelka would explore the potential impact of the building of the tunnel underneath the Channel, on which construction began in 1988. For this undertaking, part of the Mission Photographique Transmanche (Cross-Channel Photographic Mission) — similar in impetus to DATAR — he worked primarily in the northern French towns of Coquelles and Pas-de-Calais. Koudelka began photographing once the construction had started, walking both coasts flanking the mouth of the tunnel. The 1989 publication *Josef Koudelka*, produced by the Mission Photographique Transmanche, brings together a number of the images Koudelka made during this project. The book is bound like an accordion, so that no part of any picture is lost in the gutter, and the panoramas may be viewed all together. The images feature skewed perspectives, surprising vanishing points, and masses: everything is flattened yet sculptural; lines and curves play off each other. Humans make an appearance only late in the book, but the publication's final image — made in Boulogne-sur-Mer, of a powerful surf, the shore protected by a long dike, and then rows of stones of various sizes and textures — is empty of people. This panorama, showing the wild sea crashing up against a man-made wall, serves as a metaphor for several projects that would follow: it is the photograph with which Koudelka has chosen to end the plate section of every major retrospective book through this writing.

Before taking on a potential commission, assuming it meets his requirements in terms of subject and control, his next step is to examine the site

JK, Sollac steel plant, 1987.
Photograph by Harry Gruyaert

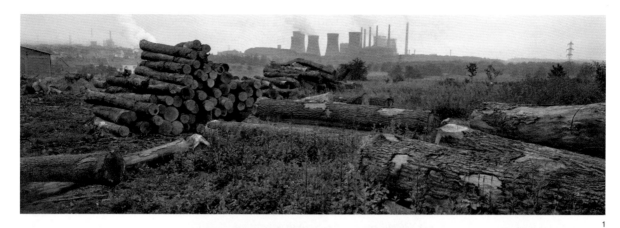

1

2

3

1 France (Lorraine region), 1986
 (DATAR)

2 France (Nord-Pas-de-Calais), 1987
 (Sollac)

3 France (Boulogne-sur-Mer, Nord-
 Pas-de-Calais), 1989 (Mission
 Photographique Transmanche)

to see if the photographic possibilities are compelling enough. He does not accept any pay for this initial investigation (although he does ask the potential commissioner to cover his expenses). With DATAR, however, the exploration began with the photographic equipment itself, which fascinated him: from this moment on, Koudelka would utilize the panoramic camera for all his projects. Latarjet elaborates:

> I think that, to Josef's eyes, the decision to use the panoramic format, sometimes with horizontal dimensions, sometimes vertical, offers two virtues: it corresponds on the one hand to the artist's most contemplative attitude, where his attempt to embrace the magnitude of the space he is looking at responds to the magnitude of time that erases this space. On the other, it gives the image a monumentality that resonates with the monumentality of the landscapes and architecture that it depicts.

No less than the panoramic camera, what made these projects pivotal for Koudelka was his realization that here was a way to address and interpret a landscape that interested him. He could consider it in terms of human intervention — whether in the name of technological or agricultural "progress," war or other conflict, or sheer greed. Along with space, he could take into account the passing of time, not only as an aging force, but also as a regenerative one. Yes, he was often depicting human-wrought calamities, but Koudelka's innate optimism somehow imbues his photographs with the possibility of renewal, even when something has been destroyed or has otherwise disappeared. He also quickly realized he could photograph these varied landscapes in a way that neither tainted nor futilely attempted to replicate his own pleasure in nature.

In 1990 he wrote to Fárová about a project he had done in 1987 with the panoramic camera, photographing the Sollac steel plant in the northern French city of Dunkirk:[22]

> During that winter in Sollac I had the impression that I was struggling with the elements, those that belong to the factory, and those of the surroundings: the sea, fire, ores, machines, and mainly steel. My task was to capture the exterior of the factory. The grey of the sky, the rain, the wind, the cold — the conditions were difficult, and the atmosphere made its way into the photographs. The place fascinated me.[23]

It was Cartier-Bresson who had initially been contacted by Usinor — the enormous steelworks company that was in the process of changing its name to Sollac. The hope was that he would "produce a reportage intended to reassure the employees about the plant's change of name."[24] Cartier-Bresson had no interest in taking this project on — having committed himself fully to drawing by then — and suggested Koudelka. Organized by François Hébel (who had recently become Magnum's director) and Agnès Sire (in charge of Magnum's cultural and corporate projects), the commission ultimately engaged three Magnum photographers: Koudelka would photograph the site's landscapes. Sebastião Salgado would photograph the workers at the site — he was just beginning his mammoth *Workers* project at the time. And Harry Gruyaert would

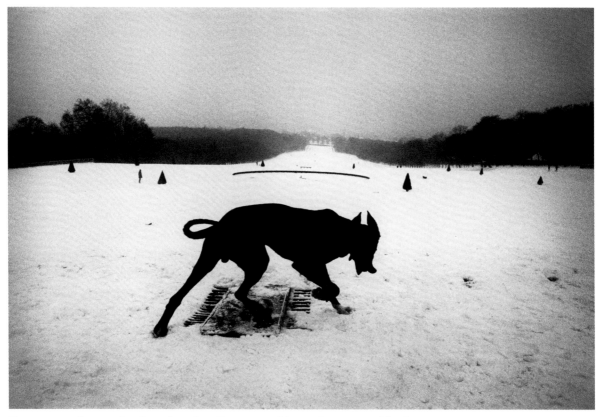

France, 1987

focus on modern technology, in color. Gruyaert told me of a memorable phone call he received from Koudelka the day before they were to meet in Dunkirk. Gruyaert says that his friend was calling from a restaurant, in something of an existential crisis — partly because he did not know what to order. But there was more to it:

Josef says — only kind of joking: "Jesus, my life is finished because I'm too comfortable now. I'm sleeping in a bed, I'm eating in this restaurant, that's the end of me. I'm finished."...

The next night, we go to the restaurant ... and Josef said: "What will we have?" And I said: "plateau de fruits de mer." Josef never had oysters in his life, ... he thought they were "strange, wonderful." So the next day we go back to the same restaurant and he said: "What will we eat?" I said: "I'm going to have a Dover sole or some fish." He said: "I'm going to have a plateau de fruits de mer *all for myself, because yesterday I ate quickly because it was for the two of us."...*

He came with his panoramic cameras — five or six cameras, and he had all his contact sheets with him. It was really just unbelievable, the weight he was carrying. Josef is very physical, and very quick. He is really made of iron.

Josef spent his forty-ninth birthday, January 10, 1987, in Paris with two friends: the Argentine-French artist Sergio de Castro, and Castro's wife, photographer Dominique Souse, who recalls:

It was snowing that day and there was a beautiful light. . . . After lunch, it was still snowing and Josef asked where he could go to take pictures. I told him . . . "Go to the Parc de Sceaux, there are children who go sledding, and the landscape will be beautiful under the snow. . . ." When he arrived, he found this black dog, powerful and contrasting, like a fight with the fresh snow.

This signature image somehow offers both a reflection and foreshadowing of Koudelka's sense of himself in the world at that moment: a strong and solitary figure.

8.

In January 1987 Jill took Lucina to Los Angeles to visit her family. From there they traveled to Mexico, where Pedro Diego Alvarado arranged a baptism for the baby. Artists in attendance included Manuel Álvarez Bravo and Colette Álvarez Urbajtel, Graciela Iturbide, Pedro Meyer, and Pablo Ortíz Monasterio. Alvarado was named Lucina's godfather; Sheila Hicks is her godmother. In the late spring of that year, mother and daughter traveled to Czechoslovakia so that Lucina might meet Josef's family. They spent time with his cousins and friends in Prague, and then continued on to Valchov, where both she and "baby Lucinka" met Koudelka's mother and Teta Loisinka. When Koudelka wrote to Fárová about Jill and Lucina's upcoming trip to "show themselves to '*Maminka*'" he acknowledged that, while he still loved Jill, their relationship was increasingly rocky. He was crazy about his daughter, though: "I wouldn't change that baby even for a million little dogs."[25]

Earlier that year, Hartley had found an inexpensive living space in a converted old factory in Ivry. She could afford to buy it herself, because Antonín Kratochvíl had bought her out of the loft they had purchased together in New York years earlier. Hartley:

I wanted to buy a place of my own eventually. . . . Delpire's place was borrowed and temporary. . . . We hadn't split up yet, but no matter what would happen, it seemed like a good idea not to have joint ownership.

Hartley arranged a meeting between Koudelka and Pierre Bertheau, from whom she had purchased her place in Ivry, so that Koudelka might inquire about any other available spaces. Bertheau, she explains, was involved with real estate but was never a profiteering developer. "He had many friends who were painters and all needed a place to live and work. . . . In the building where he lived in Paris, some architects renovated the place with a long-term lease and low rent for everyone. And that's where he got the idea." Bertheau showed Koudelka the building across the way from Hartley's — in the same complex, and which he was also converting into live-work spaces — inviting him to choose any space he wanted. Koudelka, having very little money, "chose the

smallest place there was, which was this one, where we are speaking now, and which I'm still in after thirty years." Now the challenge was how to pay for this, the first place he'd ever owned in his life. Franck and Cartier-Bresson had the idea of involving Martine's brother, the gallerist Eric Franck, who remembers the transaction: he bought two complete *Gypsies* portfolios from Koudelka (one of which was eventually acquired by Martine), and this enabled Koudelka to put down a deposit on the place.

In July of that year, Koudelka and Hartley separated definitively. Koudelka wrote to Fárová again that September: "I am photographing like mad, probably <u>more and more</u>, but it is not very good." About Lucina, he raved: "THE GIRL IS FANTASTIC. SHE TAMED ME — I AM COMPLETELY IN LOVE WITH HER."[26]

Jill and Lucina moved into the loft in Ivry in 1988 (it had been a raw space; Hartley built the entire interior). Koudelka would move into his only once the building had been renovated, in 1990. Until then, he would once again live in the Magnum offices: "I got the storage room in the back, 2.7 meters by 2.5 meters — it was enough for me. I slept under the table."

Describing their breakup, Hartley says: "It was really disappointing for both of us. We both tried extremely hard." There were particular challenges when it came to finances: "He's got strange ideas about money." She continues:

He wants to do what's right, to share, to be generous. He wants to understand how to interact socially — but often he is truly unable. He's smart in some ways, and simple and removed in others — in ways that have to do with human relationships and daily life.

Lucina is filming her mother as we speak, and here she chimes in:

He keeps everything as basic as possible — even his eating. He appreciates good food, but he doesn't really care that much, and doesn't want to go through the trouble of having a large variety of food at home, or cooking — beyond heating up canned cabbage and sausage for example. In restaurants, overwhelmed by so many choices, he asks the people he is sharing a table with to tell him what they are having, and he'll often just order that.

Lucina Hartley Koudelka and Jill Hartley at Lucina's baptism in Mexico City, 1987. Photograph by Graciela Iturbide

She pauses, reflecting on her own recent experiences driving her father around Los Angeles, and witnessing him install his exhibitions.

He pushes out everything that could distract him from what he is working on.

In retrospect, Koudelka, with Panglossian flair, now believes that the breakup with Hartley was all for the best:

Jill — the woman I loved, with whom I have a child, and whom I wanted to live all my life with — she left me. . . . Of course, I was sad. For about a week I was walking around like a boxer who has been beaten up. But then I realized I had to survive. And look what she gave me! This beautiful daughter, Lucina. And the chance to have my freedom again.

How does Lucina fit into his freedom? This is a quandary that Koudelka, from the time of his daughter's infancy, has tried to parse. The sentimentality of his mother and the tough love of his father have shaped him partially, but

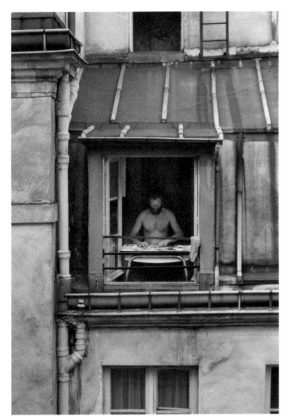

JK editing his photos at the window of the Magnum Photos kitchen, Paris, 1985. Photograph by Harry Gruyaert

Koudelka is so idiosyncratic, and the circumstances so utterly different, that looking through the lens of his own childhood only gets us so far. From the moment Lucina was born, he was smitten. How, then, can her presence in his life coexist with his projects and the wanderings they both demand and inspire, which are lifeblood for Koudelka? How might he acknowledge and strategize this dynamic, not just for himself but for his daughter as well — for whom he also wishes freedom? To these challenges, he says:

When my daughter was born, I was incredibly happy. But immediately I realized that I don't want her to suffer, and I don't want to suffer when we are not able to see each other. I tried to get her to understand that when we are together, I am there absolutely for her, and when I am not there, then I don't exist.

This is a lot, of course, for a little girl to comprehend, and naturally there were occurrences and communication glitches that left Lucina baffled, sometimes frustrated. But there were also many moments of fun, play, and love — easily expressed and easily understood. Lucina recalls blissful summer trips to Magnum photographer Bruno Barbey's house in Corsica, where "everyone would dive for sea urchins, and Josef and I took long walks in the forest." She especially remembers going to museums with her father. Together they would look at paintings, and "he'd explain to me the composition, and what he liked about a particular painting. After each room, he'd ask me which were my favorites."

A few years after the separation from Hartley, Koudelka wrote these words to himself while on a trip to Rome:

You are sitting in front of the Colosseum on the bench. You eat bread with salami. You are drinking the beer. You are a vagabond. You have this little girl who is four. You love her enormously, and you are going to do everything so that she knows it.

As he reads this to me, he tears up, and momentarily rests his diary in his lap, still clasped tightly in his hands, before continuing:

There is no place, and no person, nobody who was born, who has a right to own you, and I hope you will know this and understand, and that you will be happy that you exist as you are.

Stuart Alexander entered Koudelka's life on November 24, 1986. With his amiable demeanor, plus his fervent commitment to photography, the young American quickly established a rapport with the photographer. Alexander had worked with Delpire long distance on the Photo Poche books since 1982, as he was at the time still a graduate student in the United States. Subsequently,

as an independent curator and researcher, Alexander moved to Paris from Tucson's Center for Creative Photography in the fall of 1986, "as an adventure with no job and no financial support." Alexander and his wife at the time had saved up enough money to last them about six months. He had had some initial conversations with curator Ted Hartwell from the Minneapolis Institute of Art about putting together Magnum's fortieth-anniversary exhibition (coincidentally, Alexander started on this project the day after he met Koudelka). Alexander soon began working two afternoons a week for Gilberte Brassaï (the photographer's widow) as well, thanks to an introduction from the curator Anne Wilkes Tucker.

It would not be long before Alexander became a devoted friend and collaborator to Koudelka. Over the following decades, he has organized and written the chronologies, bibliographies, and exhibition histories for many of Koudelka's publications, and contributed essays to several of his books as well. On October 1, 2018, a little more than a year after Delpire's death, Alexander was named directeur éditorial/editor-in-chief of Delpire Éditeur.

JK's work and sleep space, Magnum Photos, Paris, 1989. (Camera on self-timer)

Alexander and Koudelka interacted regularly at Magnum's Rue des Grands Augustins office, where Alexander often worked late and where Koudelka usually slept in the years after separating from Hartley, before he moved into the Ivry studio. If they were both there during the day, says Alexander,

> sometimes he invited me to go with him to a cheap lunch counter on the Rue de Buci. . . . We would line up with the clochards and pay our seven francs for some kind of hot stew and take it to the tiny kitchen at the Magnum office under the eaves. At precisely 1 p.m. Josef would jump up, announce that lunch was over and it was time to go back to work. He

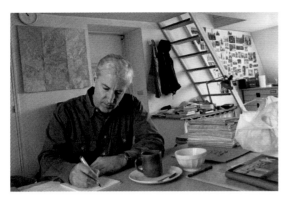

Stuart Alexander in JK's studio, Ivry, 2013

would shake my hand and use a firm hand on my chest to push me out the door.

9.

In 1988, in conjunction with the first publication of *Exiles*, a much-expanded iteration of Koudelka's 1984 exhibition at London's Hayward Gallery opened at the Palais de Tokyo in Paris and at New York's International Center of Photography (ICP). Curated by Delpire and organized by the Centre national de la photographie, Paris, in association with ICP, *Josef Koudelka* comprised a selection of all his work to date, including the panoramas.[27]

Koudelka traveled to New York for the ICP exhibition. Sheila Hicks, also in New York at the time, suggested that he show his photographs to a friend of hers who was working at *Vogue* magazine. Koudelka went with Hicks to the Condé Nast offices bringing a box of his work. As they sat in her friend's office looking at the photographs, they were interrupted by the appearance of Condé Nast's legendary editorial and art director Alexander Liberman. He asked if he might also have a look. Koudelka recalls him saying: "You know, Mr. Koudelka, maybe we can do something together. But I was told you don't take any assignments?" Koudelka said that this was, in fact, correct. Liberman finished looking at the work, and then left the room — only to return around twenty minutes later. Koudelka remembers their conversation:

> "I have an idea. Do you mind if Mr. [Irving] Penn takes a picture of you?" Then he said something like that they would ask a good writer to write something on me, and publish it. I was quiet, and then was about to say no, but suddenly I felt Sheila give me a big kick in my leg. Sheila said: "Josef — what would all your friends say: you, in Vogue!" And we laughed and this convinced me to do it.

Hicks would later set the story straight for me:

> I kicked him to make him realize it would be ridiculous to accept this portrait idea. I wanted them to publish Josef's photos. Either he misunderstood or was tempted or flattered to have Penn take his portrait.

On the day Penn was to take his portrait, Koudelka was instructed to remember to bring his camera — which, of course, he was never without. Penn directed Koudelka to hold his camera a certain way for the photograph, and then — with his glasses on, visible eye squinting, face slightly scrunched, Leica tilted, hands and fingers precisely choreographed — the session began. "I think Penn was really excited. 'Oh, this is wonderful! Wonderful!' he kept saying." Although the article was not ultimately published, Penn included the photograph in his 1991 book, *Passage*.[28] Koudelka likes the portrait, and selected it as the cover image for this biography.

Although by the late 1980s Koudelka's renown had grown exponentially, *Josef Koudelka* introduced the breadth of his work to an even larger US audience. This included New York gallerist Peter MacGill of Pace/MacGill Gallery, and the San Francisco–based gallerist Robert Koch (no relation to Roberto Koch, publisher of Contrasto).

Koch knew of Koudelka's work, but he had an "aha" moment when he saw the show at ICP. He was, he told me, "impressed at the depth of great images" and hoped there might be a way he could represent Koudelka. At one point when Koch was visiting Paris, he managed to reach Koudelka by phone at Magnum's headquarters. But the conversation didn't go far: "[Koudelka] said he didn't want to sell and didn't want to meet dealers." The gallerist finally managed to convince Koudelka at least to have breakfast with him, and the following morning they met at Hicks's studio. "Sheila is a very affable, engaging person," Koch told me, "and really the only person I knew who had any kind of influence on him. . . . She suggested to Josef that he would have to take responsibility, to support his daughter, and this was maybe a good opportunity." Primarily for this reason, he began to work with Koch in California and MacGill in New York.

In 1989 Koudelka published his first panoramic project, with the Mission Photographique Transmanche. Koch organized a show of panoramas and a selection from the *Exiles* series, which opened at his gallery in San Francisco in February 1989. He would present three more exhibitions of Koudelka's work — the last in 1997 — before MacGill began representing him more or less exclusively. Koudelka's first show at Pace/MacGill opened in January 1989 (prints from the *Gypsies* project and early panoramas).

In August of that year, Josef, Jill, and Lucina visited Martine Franck and Henri Cartier-Bresson at their country house in the Luberon. Koudelka brought with him three of the remaining bottles of his father's slivovitz. He gave one of the bottles to Cartier-Bresson, telling him that this and the others were to be reserved strictly for the most momentous of occasions: "Listen Henri, when Mélanie [Cartier-Bresson and Franck's daughter] gets married, you can open it. Only then. And you are going to get drunk with everybody."

A Polaroid was taken at the time. On the back of that photograph, Koudelka noted specific directions for some future treasure hunt. He concluded by writing, with regard to one of the other two unopened bottles:

> *One bottle has a piece of paper, on which is written* LUCINA, 14 AUGUST 1989 *and inside is written* LUCINA, TATA LOVES YOU.

Koudelka dug a hole by the plane tree on Cartier-Bresson's property where he would sleep when visiting. He surrounded the spot with stones to both demarcate and protect the area. There he buried the bottles, designating the third one for a future brother or sister to Lucina.

Henri Cartier-Bresson, Jill Hartley, Lucina Hartley Koudelka, and JK at the home of Cartier-Bresson and Martine Franck, under the tree by which bottles of slivovitz are buried, Céreste, France, 1989. Photograph by Marthe Cartier-Bresson

CÉRESTE 14 AUGUST 1989

Also in the late 1980s, an exhibition of Koudelka's work was organized for East Berlin by the city's Centre Culturel Français.

With the Stasi as sinister enforcer, Communism persisted as an intimidating, oppressive, and demoralizing power there. Cartier-Bresson had nevertheless encouraged Koudelka to accept the invitation to present *Josef Koudelka: Exile* in East Berlin. One of Koudelka's conditions was that he be permitted to include a selection of photographs from his coverage of the 1968 Soviet invasion of Prague. The Centre Culturel initially agreed to his terms, but subsequently received a threat from the Czechoslovak embassy in East Berlin, warning against hanging those photographs. Koudelka was willing to comply, but with a caveat: there would be no invasion prints mounted on the wall, but he insisted on projecting the images, and to this the Centre acquiesced. As travel was permitted between Czechoslovakia and East Berlin, many Czech friends and admirers from Prague came by train to the opening in October 1988; Koudelka had not seen some of them since going into exile. It was a great evening, Koudelka recalls, until the director of the Centre noticed two Stasi cars parked outside. "He told me that we — my friends and I — shouldn't leave." The director brought them food and drink and they spent the night there. By morning, the Stasi cars had left.

The show closed on December 2 and the following day there was a public discussion with Koudelka in the Centre's lecture hall. Josef Moucha, a photographer, curator, and writer based in Prague, attended, as did other colleagues, including Zbyněk Illek, director of Galerie 4 in Cheb, Bohemia. Moucha and Illek were planning to open a show at Galerie 4 in January 1989, titled *Proměny české dokumentární fotografie, 1839–1989* (Transformations in Czech Documentary

A night spent at the Centre Culturel Français in East Berlin, avoiding Stasi agents parked outside. From left: Ivo Gill (back to camera, with glasses), Dušan Pálka, Pavel Štecha, and JK, 1988. Photographer unknown

Photography, 1839–1989). Moucha wanted to include Koudelka's photographs from the *Exiles* project in the show, but says:

> *At the time we thought it was impossible to get his photographs into Czechoslovakia officially through customs. . . . Koudelka suggested to us that we frame pages from his book. So that's how we did it: we framed some pages from* Exiles. *It was the first time Koudelka's images had been publicly exhibited in Czechoslovakia since he went into exile.*

It was the time of *perestroika* and *glasnost* in the USSR, a moment of massive economic and governmental reform, and in May 1989 Koudelka found himself photographing in Moscow, having been invited to the Soviet Union along with seven other photographers. When Magnum first faxed him the invitation, Koudelka thought it was a joke: "I didn't react." But when he understood that indeed, the Soviet embassy in Paris had extended this invitation, "I said okay, if I can go to Moscow, but first Magnum must tell the embassy who I am and that I photographed the Soviet invasion. And if I go there, I'm going to tell everyone." An indication of how things had changed: the embassy was apprised of this, and had no issue with Koudelka's participation in the project, titled *Alors c'est comment l'U.R.S.S. ?* (So How Is the USSR Doing?). Along with Koudelka, the participating photographers included Daniel Boudinet, Harry Gruyaert, Xavier Lambours, Marie-Paule Nègre, Thierry Pasquet, Sophie Ristelhueber, and Patrick Zachmann. Agnès Sire explains that the concept was "simply to have photographers go there and express their feelings. The title suggests this — to arrive in an unknown country but one so close, and to be curious: 'How is it?'"

Koudelka was very skeptical. "I still didn't believe that *perestroika* was real." He soon found himself at the Moscow airport, easily going through customs:

> *Suddenly I saw these Russians. They brought us to the hotel. When I was sitting at dinner, at the table next to us were two people, and they were speaking,*

saying some anti-Russian things. I thought they were police at first — Czech paranoia — testing me. So when everybody left, I joined them after dinner. It turns out they were both from Georgia, so it made sense.

Gruyaert's recollection:

At the time there was so much talk everywhere in Moscow about politics, about everything. Josef pretended not to understand Russian, but he understood a lot. He found it extremely interesting to overhear things people thought he could not understand.

From the hotel, Koudelka made a call to his hometown of Valchov — where, he tells me, there was at the time only one phone in the village, and it was tended by a Communist. "I said: 'I am calling from Moscow where I was invited by the Russian government.' And then I asked them to please get my family, and said I'd call back in an hour. Nobody could believe I was calling from Moscow!"

He sent a postcard to Anna Fárová on May 2 from Moscow, saying:

Hi Anna.

Well, here I am in Moscow, and don't even know how I got here!

The world is strange. Officially invited for three weeks, am living in one of the best hotels. They're giving me a car with a driver and an interpreter. It's fun. Don't know how much I'll do. The good photos are very rare. But I'm glad that I'm here and can see it with my own eyes. I hope that they succeed in making the changes here, and that they last.

JK on the plane to Moscow, holding his French passport and newly received visa for the trip, 1989

VIVA PERESTROIKA!

Best wishes to you and our friends,

Josef Koudelka[29]

To Hervé Hughes, a friend who has been repairing Koudelka's many cameras since 1982, a more haiku-like postcard (in English):

Having good time here

Drinking vodka, eating

caviar

MANY THANKS FOR REPAIRING

MY CAMERAS — till now

everything works.[30]

On the flight back to Paris, the pilot announced at one point that they were flying over Prague. The absurdity still resonates for Koudelka: "I couldn't go there! I could go to Russia, but not to Czechoslovakia."

Toward the end of 1989 Koudelka photographed in Hollywood for about a week, en route back to Paris from Japan. He was staying with his friend the photographer Anthony Friedkin in Santa Monica. Friedkin introduced him to Albert Dorskind, an executive at the media conglomerate MCA Inc., and creator of the wildly popular and successful Universal Studios tour. An avid collector of photographs, Dorskind was commissioning photographers — including Friedkin — to wander and shoot in the fantastical environments of the movie studios, with their eclectic vestiges from past films. "Josef," says Friedkin, "was given free rein to roam the backlot and shoot whatever he wanted."

Olympus OM-2, Josef Koudelka, 1984. Photograph by Hervé Hughes. JK notes his concerns about camera 5 ("Serge") to his camera repairer, Hughes, in French; Hughes's response is in English.

However surreal Universal Studios may have seemed, nothing prepared Koudelka for the events that suddenly unfolded in Czechoslovakia that November. The dissidents came into power. The regime collapsed. This historic moment, which would come to be known as the Velvet Revolution, was a nonviolent and astoundingly swift power shift that had begun in mid-November 1989 with a student protest in Prague. This demonstration inspired increasingly fervent ones against the government, with the number of protesters growing exponentially each day. On November 24, the country's Communist leaders

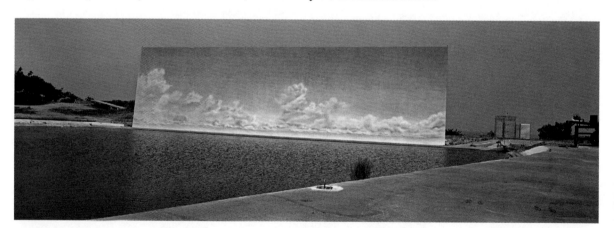

resigned. Three days later the citizens of Czechoslovakia took to the streets in a general strike. On November 28 the Communist Party announced that it would give up all power.

Hollywood, California, 1989

"Can you imagine?" says Koudelka.

I was sitting in the middle of Hollywood, but everything was happening in Prague. Every night I'm looking at the television, seeing these meetings going on in Prague, watching everything change.

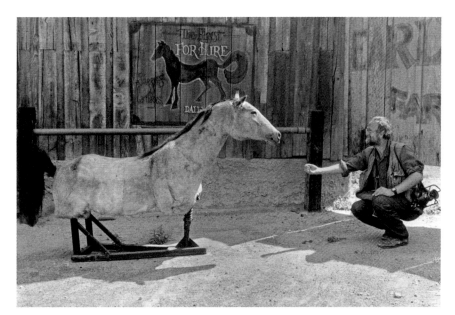

Josef Koudelka with Wooden Horse, Universal Studios, CA, 1989. Photograph by Anthony Friedkin

First I thought: "If only I could be in Prague now!" I was so frustrated. And then I said to myself: "Of course, if you could be there tomorrow, you would do your best to be there — but you can't be there tomorrow. In 1968 you had the chance to live through something so extraordinary. You are never going to live through anything stronger than that. So don't be sorry that you are not there. Enjoy where you are, and do here what you want to do." So emotionally, I found peace.

V Returning

1.

On Koudelka's first trip back to Czechoslovakia after two decades in exile, he traveled with Anna Fárová. They flew from Paris on Wednesday, March 21, 1990, and landed at Ruzyně airport. Koudelka went directly from the terminal to the hospital in Prague to see his old theater friend and colleague from Divadlo za branou, Karel Kraus, who had helped to organize his first solo *Gypsies* exhibition in 1967 in the theater's foyer.

I ask Koudelka what it felt like, that first trip back to Prague. "I was happy, emotional," he says somewhat reflexively. But he prefers, he says, to check "how it really was, how I felt then," and consults his diaries.

Reading to himself before translating for me, he mumbles words he has not considered for decades. His face seems to contract concentratedly, and then relaxes into nostalgia and less decipherable expressions. Satisfied with what he has worked through in his head, he reads aloud passages that he wrote in Naples on April 13, 1990, some weeks after returning to Prague for the first time since leaving in 1970:

> *Only once you get back to your country after twenty years, to the country where you were born, do you realize how much you've changed, and that the town, visually, didn't change much, and the people didn't change either. . . .*
>
> *What changed you was everything that you went through, what you saw, where you lived. . . . Then, of course, there are a lot of things that you have forgotten.*
>
> *People here, they've forgotten less. You were not living in memories. You were running around the world to photograph.*
>
> *You've forgotten so many things. Even the things, even the places that you visited every day, like the student canteen. . . . You go through streets, streets that you knew very well, which you were walking along every day. . . . You look at these houses, as if for the first time. . . . You look at them through the eyes of somebody who is fifty-two years old, and not thirty-two. . . .*
>
> *Along with the gift of having to build a new life for yourself — nobody knows anything about you — if you are lucky, exile does give you this second gift of returning to your country with different eyes. . . .*
>
> *When I lived in Prague I never realized that Prague was beautiful. . . . So finally I come back after twenty years and I am discovering Prague.*

About his return to his own village of Valchov, Koudelka wrote his feelings in real time, that is, while he was there. He continues with his sui generis account for me: reading, remembering, translating, interpreting all at once:

JK returning to Czechoslovakia for the first time in twenty years, on the plane with Anna Fárová, March 21, 1990. Photographer unknown

Valchov: the place of your youth. I wanted to see the trees. Trees that I planted with my father. Cherry trees — the trees that when they started to have the cherries, every day you came and you ate them all. You wanted to see the trees in the forest, which you knew, and where you went to pick mushrooms.

He looks up from the diary to tell me: "When I got to Valchov, all the distances looked much shorter — because when I lived there, I was a small boy." He resumes his reading:

The return from the exile is nearly as strong as leaving for exile....

Everybody here speaks Czech.... At the airport, and when I was walking in the street, it was most strange because I have had a similar feeling in the past — when I was in exile — only after being drunk.... I could hear people in the distance, and I thought they were speaking Czech. Here, it was like being drunk all the time.

Koudelka didn't just record his own observations. He also made note of how people responded to him, after so many years in exile:

They remember everything about you.... It is probably because they lived in the past. They couldn't travel. They didn't move.... They remember ... what you said, where, and to whom, how you behaved.

His friends, he wrote, were still the same in many ways, after twenty years:

They didn't change. They only got older.... You knock at the front door.... You didn't say that you were coming. Nobody knows that you are back. The girl opens the door. She's twenty years old. I tell her: "Please, can I see your father?" He comes, you look at each other for a moment, and then after one minute, two, you are all sitting at the table with a glass of wine.

And then there were the everyday exchanges:

You go to the shop, to the bakery to buy bread.... I am standing in line to get the bread. I am listening to the words of everybody, what they say, how they ask that they want to buy bread. I am nervous.... Are you going to say it correctly? Are they going to recognize that you don't live here? Then it comes your turn. I say: "Please can I have bread?" In Czech, chléb.

"Of course," she answers.

He stops reading and turns to me: "And then she said '*chlebíček*' — diminutive for 'bread.' It sounded so beautiful. I hadn't heard this word for so many years. It was so beautiful, I'm never going to forget it."

He is overcome by his own reverie. His eyes and cheeks are moist, and his voice falters a bit. He then recalls how emotional it was to visit the grave of his mother. She had died two years earlier, in 1988, at age eighty.

Eventually Koudelka turns his eyes back to his words written more than three decades ago:

Koudelka family cross at cemetery, 1990

For some reason, I have also written here something that somebody else said: "God saved us when He kicked us out of paradise. He didn't punish us. He told us that we are going to suffer, but He gave us something that is very important. He invented work for us."

I think for me the connection, why I wrote this there, at this time, is that I think probably it was my work that saved me.

2.

Of course, Fárová and Koudelka could not resist planning an exhibition while on the flight from Paris to Prague in 1990. She would later recount:

It was then, on the plane, that the idea took shape that we would like to work together, as when we had once been friends and worked together. . . . The time was now ripe and . . . it might really be very interesting to show all the various stages that Josef Koudelka's creative photography had gone through. And Josef Koudelka was also interested in that. He went for it. He wanted it. And we were very happy. For me it was a significant moment that an exhibition would be up on his birthday at the Museum of Decorative Arts, my home

institution, which I was thrown out of and then taken back to. And for me that was very much a moral compensation.[1]

After their exiles — hers, internal; his, external (as she described them in this same speech) — what an opportunity it would be to once again join forces. It was thus that *Josef Koudelka: Z Fotografického díla, 1958–1990* (Photographs, 1958–1990) came to be presented in Prague's Museum of Decorative Arts, from December 20, 1990, to January 27, 1991, with an accompanying publication.

Photography historian and curator Jan Mlčoch's bearlike presence metamorphoses into something more like a Cheshire cat when I ask him about this, Koudelka's first comprehensive exhibition in Prague: his expressive gestures evoke Mlčoch's earlier calling as a performance artist. We are sitting on a bench by the Vltava River near the Museum of Decorative Arts, where Mlčoch has been the curator of the photography collection since the time of the Velvet Revolution. He tells me that in late 1989, as things were beginning to change, he attempted to serve as a bridge between the museum and Fárová, who, he reminds me, had been ousted from the museum for having signed Charter 77. He says:

> *What had really bothered her was that no one had stood up for her. . . . The relationship between Anna and the museum was always up and down. . . . Anna was a distinctive figure with an unusual background and many contacts with people in the art world. . . . She demanded respect. . . . Unlike Koudelka, Fárová hadn't been an émigré or an exile — she had not "defected," as we said then. With this show, she returned to working at the museum after thirteen years, just as Josef returned to Prague after twenty years in exile.*

The show was orchestrated by project, somewhat chronologically — an organizing principle that Koudelka uses to this day for his retrospective exhibitions and their catalogs. It included images from his coverage of the 1968 Soviet invasion, marking the first time these photographs were exhibited and published in Czechoslovakia. Koudelka says:

> *The exhibition was not big, but in fact it was the first time I was able to use the pictures that I had left in Czechoslovakia, such as the theater work, and my first pictures, which, before returning, I didn't have access to.*
>
> *When I left Czechoslovakia, some photographs stayed with Anna, but the rest of the prints Anna had brought to the museum, just to keep them safe — they were packed together, and nobody knew what it was. Then, when Anna was kicked out of the museum, after she signed Charter 77, she asked me if she should perhaps take these pictures out of the museum, that the museum was not interested in me, in my work anyway. But we kept them there. In fact, it's really a miracle that nothing got lost.*

The show's unbound catalog is modest but elegant. It is a sequence of ten folded spreads that opens with some of his earliest images, often playing with the panoramic format, and closes with a selection of the images he was making with the panoramic camera at the time — all tucked into the back flap of a folded cardboard cover. Josef Moucha recalls that Koudelka "wasn't completely happy

about it, because there were so many factual mistakes in the text. He crossed out everything that was wrong in his copy of the catalog." Koudelka tells me: "Anna had never given me the text to read so I could correct her inaccuracies." (To this day, he "annotates" copies of his publications for his own future reference.)

Their collaboration on the exhibition was not entirely smooth. "They had certain differences," says Mlčoch, "the biggest being that Anna had the impression that she was the author of the exhibition." Mlčoch became increasingly aware of the growing tension between them — "the sense of an impending storm." In his efforts to ease the tension, he ended up being present for the entire eight days of the exhibition's installation, which otherwise would not have been the case. Mlčoch has great respect for Fárová and her role in advancing Czech photography, citing as important "Anna's many interests that she connected in her work — from literature to philosophy to art history to photography. It wasn't just photography." But he came to realize that "Josef prepares everything well ahead of time, down to the last detail"; consequently, there was not in fact much for Fárová to do — "which was part of the problem." Mlčoch especially enjoyed "being able to follow how Josef continuously polishes the selection, narrows it down, focuses it. Another thing that was very interesting to watch is how Josef works as a graphic artist, that the wall is a piece of graphic art, and then the whole space itself is a piece of graphic art."

At the exhibition's opening in December, Fárová made a speech that drew equal attention to Koudelka's role as creator and hers as curator:

Dear friends and other guests, Josef Koudelka,

It is for me doubly important that it has been made possible for me to again hold an exhibition here, in this place. First of all, it is a logical continuation of the chain of previous exhibitions, which I began to organize almost twenty years ago — namely, František Drtikol, in 1972, Osobnosti české fotografie *(Important Czech Photographers), in 1974, and, lastly, Josef Sudek, in 1976.*

Second, I am following on from this broken chain with this solo exhibition of Josef Koudelka's work.

We have much in common in our status . . . both of us were emigrants. Josef Koudelka outside the country . . . physically, because he left his homeland in 1970, and has returned only today as a renowned, internationally acclaimed photographer with French citizenship. And I, an emigrant in my homeland, a person deprived of being able to work in public, for years a nonperson. . . .

This, the first . . . exhibition of work by Josef Koudelka is not only an exhibition about a return; it is also preparation for a larger exhibition, which we intend to hold in two or three years in a larger space. We are now testing some principles here. . . .

But although this is primarily an exhibition of photography, it is also perhaps something even more important: it has to do with bridging a space of twenty years, a tribute to friends and fellow artists who appeared on

Koudelka's life journey, and a reminder that we all can again freely meet and pick up the thread of remaining ties.[2]

Koudelka believes that, until this exhibition, because he was absent from the scene, his work was generally unknown in his homeland: "The general public never heard anything about my existence. In Czechoslovakia I didn't exist. My name could not be mentioned." Still, it seemed that artists were aware of his work. Moucha says:

Even though Koudelka wasn't in this country and was in exile, he had a tremendous influence on Czech photography. [The photographer] Pavel Štecha used to teach about him at FAMU, at the photography school. People used to lend and borrow books that they had brought from abroad, so we got to see Gypsies, *and eventually* Exiles.

Koudelka's work, says Moucha, served as a model of sorts for many young Czech photographers who felt they could connect to the images. He attributes this in part to Koudelka's roots:

He's a man from a small village — that's what he comes out of. His work has never been from the point of view of the people who run the world, never been from the point of view of the people who are powerful. Everything he has done has been from the position of those below, not the powerful. Even though today he's famous, he doesn't see the world through the eyes of the people who are in charge, who are running things, the bosses. He sees it from the point of view of the people who are like the rest of us.

Koudelka's significance to a non-art audience was expanded when the Prague-based, post–Velvet Revolution, Czech newsmagazine *Respekt* devoted an entire August 1990 issue to his documentation of the Soviet invasion in August 1968. Published as a buildup to his exhibition, this publication features more than forty of Koudelka's photographs and an interview that Fárová conducted with him shortly before the issue's release.

3.

As a young man, Koudelka had photographed the Roma in the area known as the Black Triangle — a border region in North Bohemia that extends into Germany and Poland, with the Ore Mountains articu-

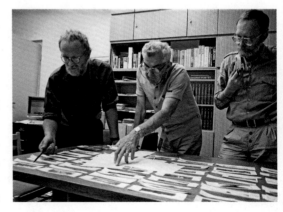

Sequencing *The Black Triangle — The Foothills of the Ore Mountains*, Prague, 1994. From left: JK, Zdeněk Stáhlík, and Igor Míchal. Photograph by Stanislav Vaněk

lating its westernmost corner. For decades, this highly industrialized area had suffered as one of the most egregiously polluted regions in Europe. Northwest of Prague, between the Ore Mountains and the Central Bohemian Uplands, the ancient city of Most and the surrounding district were especially affected. In the early 1940s, while still under the rule of the Germans, Most began to produce a synthetic fuel made from brown coal, a process that devastated the landscape while contaminating the air, water, and soil, and poisoning the laborers

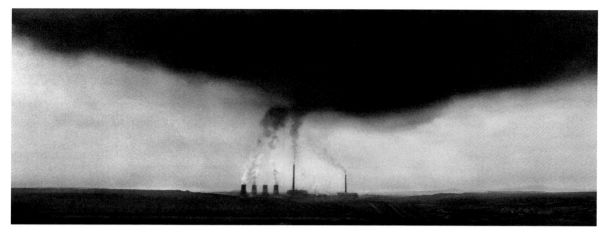

Black Triangle region (Ore Mountains), Czechoslovakia, 1991

who were forced to work there. The situation worsened during the period of "normalization," as the Czechoslovak leadership further industrialized the area, building chemical plants, refineries, and factories fueled by brown coal from local strip mining. Most was demolished, as were other nearby villages. The area's topography is a craggy moonscape — intriguingly inhospitable, rough, with roads that seem to lead nowhere — yet with intermittent hints of life. According to the late environmentalist Josef Vavroušek, parts of the area have been inhabited since Neolithic times.

In 1990 Václav Havel, the country's new president, appointed Vavroušek the first environmental minister of Czechoslovakia. Devoted to integrating an ecological awareness, conscience, and ultimately a significant pro-environmental stance into the country's evolving position as it restructured, Vavroušek proposed and organized the first Ministerial Conference of the United Nations Economic Commission for Europe, which was held in 1991 at Dobříš Castle in the Central Bohemian Region. On June 21 of that year, Havel addressed the environment ministers of thirty-four European countries, as well as from Brazil, Japan, and the United States, condemning humanity's assault on the environment. In preparation for the meeting, Vavroušek gathered a group of photographers, Koudelka among them, each of whom was to focus on an environmental problem of their choice. Koudelka decided to return to the Black Triangle area for this project and would continue shooting there for years following the conference.

His images suggest the ravages of war. Machinery, some of it still in operation, blights the coarse terrain. Before the twentieth century, the region was in a bucolic state, with "rolling hills, where fields interwoven with tree-lined roads alternate with extinct volcanoes covered with vineyards."[3] The area had also held interest for German Romantic landscape painters, including Caspar David Friedrich — Koudelka cites in particular his 1808 painting *Böhmische Landschaft* (Bohemian Landscape), which he saw in Dresden and with which he once hoped to juxtapose his *Black Triangle* images.

In 1994 Koudelka's *The Black Triangle — The Foothills of the Ore Mountains* was published in a trilingual (Czech, French, and English) edition by Vesmír,

with an essay by Vavroušek discussing the environmental, health, and social implications of the destruction of this area.[4] An excerpt from Havel's 1991 speech opens the book:

> *Man is not an omniscient master of the planet who can get away with doing whatever he likes and whatever may suit him at the moment. Paradoxically, that arrogant, single-minded self-complacency has taught us, perhaps more than anything else, that the world is made of an indefinitely intricate and mysterious tissue about which we know damn little and towards which we should behave damn humbly.[5]*

Vavroušek's text concludes with a scathing indictment of human greed, pertaining to the Black Triangle region in particular:

> *The sacrificed landscape beneath the Ore Mountains is just one, albeit the most painful, example of the brutal and counterproductive attitudes to nature, as the future of man and other living creatures appears to be sacrificed to the short-sighted vision of immediate profits.[6]*

In *The Black Triangle*, along with Vavroušek's and Havel's words, each of Koudelka's panoramic images is accompanied with a caption written by the Czechoslovak team of onetime mine worker Petr Pakosta, architectural engineer/urban planner Zdeněk Stáhlík, and ecologist Igor Michal. Koudelka says: "I asked Petr and the other guys to write me thirty questions and thirty answers about the region." Koudelka wanted stark, objective facts about the area's ecological undoing to accurately contextualize the work. The captions comprise an uninflected account of serial abuse — from the destruction of forests to the endless quantities of earth removed to extract seemingly infinite quantities of brown coal, to mountains of hazardous waste, to mines hundreds of meters deep, to percentages of children in the area born with congenital diseases, to the hundreds of kilograms of ashes produced by burning just one metric ton of locally mined coal . . . the violations go on and on. The book's final caption reads simply: "What next?"

JK being awarded Medal of Merit of the Czech Republic by President Václav Havel, Prague, 2002. Photographer unknown

When we met in 2014, the engineer Stáhlík explained that his task had been to coordinate the regional planning and zoning for the district of Most after decades of strip mining. "There is a three-hundred-meter pit," he said. "What do you do, flood it? And then, where are you going to get the water from? Rivers had to be diverted, the landscape was altered. Our natural environment had been sacrificed."

For *The Black Triangle*, Stáhlík recalls, Koudelka was concerned that the book be bound in such a

way as to open flat. All the images are panoramic, and are reproduced as large as possible (without bleeding) over two pages — crossing the book's gutter. Traditional binding, no matter how well done, inevitably swallows some portion of images in the gutter when laid out as such. So *The Black Triangle* is bound in accordion-style (as was Koudelka's Mission Photographique Transmanche publication in 1989), a solution the photographer would embrace for many of his future panoramic publications. The panoramas thrive as individual images, while the whole is both immediate and dramatically cinematic.

 The Black Triangle embodies Koudelka's approach to photographing nature — more precisely, human intervention in the landscape. It also served as a catalyst for several projects that would consider this dynamic. With people and landscape, he has always been visually disdainful of the banality of

Black Triangle region (Ore Mountains), Czechoslovakia, 1990

homogeneity, including any conventional ideal of beauty, seeking out instead those qualities that distinguish and speak to a life lived intensely, from the most dispiriting moments to the most sublime. He tells me:

> *The face of the wounded landscape — it is marked by trouble, by suffering. It is the same as the face of people who have a difficult life. I am interested in real people, real faces — not the ones after plastic surgery. And like this, the artificial landscape, too, interests me less. In this wounded landscape, I admire the fight for survival. . . . Nature is stronger than man.*

 Over the years Koudelka has become increasingly saddened and angered by the plundering of the environment that causes loss of forests, habitats, and species. Along the way, his mode of expressing himself has become increasingly fierce. Whereas at one point — with the DATAR and other early projects — he spoke of humans "influencing" the contemporary landscape, he has come to regard particularly horrific abuses, such as those depicted in *The Black Triangle* (and later in his project *Wall*), as unpardonable injustices "against the landscape: a landscape cannot defend itself against human exploitation and destructiveness."

 Koudelka's faith in nature's capacity for self-renewal — provided that humans take responsibility and action — sustains his hope. In his photographs this hope is often symbolically evoked through the motif of a lone tree — vulnerable, but surviving against all odds. Robert Delpire later said of Koudelka's images:

Berlin Wall, 1988

"The earth is poisoned.... There are only the residues of the life before. A tree like a memory. The sea to close off the horizon."[7] Gilles Tiberghien suggests that the unsettling tension in Koudelka's panoramas is rooted in the interplay between form — and "intolerable beauty" — and content, which he characterizes as "morally reprehensible." Koudelka seems drawn to a particular kind of beauty that exists in an environment where he may work in solitary peace, while observing its intrinsic geometries. At the same time, it is also the subject itself — the sometimes merciless pileup of that landscape's past and present and what this bodes for its future — that compels him.

Concurrent with his *Black Triangle* work, Koudelka was grappling with other existentially distressing subjects, including the Berlin Wall and the Auschwitz concentration camp. He began photographing in Berlin in 1988, while the wall still served to separate East and West Germany, and continued through its opening in 1989, and its ultimate demolition. He first visited and began photographing Auschwitz around this time as well, starkly registering its silent horror. About his work in general during this period, Delpire would note that Koudelka "reconstructs an order on the other side of chaos.... Out of all that destruction ... there arises a harmony, a balance which cannot have its source in war, or pollution, or the dissolution of things; this order belongs to him."[8]

Dominique Eddé and JK, Beirut, Lebanon, 1991. Photograph by Nazarian. (Eddé notes that this Armenian photographer was renowned for "transforming your face, sugarcoating it.")

4.

In the early 1990s, Koudelka photographed in Beirut, a city ravaged by fifteen brutal years of civil war in Lebanon. In these images Koudelka's depiction of time is not about its passage so much as its eclipsing of what was. Dark and foreboding, this work conveys a more immediate form of ruins — of chaos, uncreation, and vestiges of things past.

Lebanese writer Dominique Eddé characterizes Beirut painfully as an "extinct city."

> *Here no one is in a hurry to live, or to die. Like falling leaves, hanging in midair, the hours go by, settling on the still life of centuries. The future is as distant as a childhood fear.*[9]

Those words introduce Eddé's 1992 publication *Beyrouth: Centre ville* (*Beirut: City Center*). She considers the city's destruction at the hand of humans, and the intransigence of existence itself: "The most unsettling part of it," she

writes, "is the obstinate persistence of life. It carries on, regardless of its use to anyone or anything."[10]

For the Beirut project, Eddé and her collaborator, France Cottin, invited photographers Gabriele Basilico, René Burri, Raymond Depardon, Fouad Elkoury, Robert Frank, and Koudelka — from several different countries and with very different sensibilities — to document the city in ruins, before its reconstruction.[11] In her text, she addresses the question of whether photographs make a difference — why take them? And proposes an answer: "Perhaps because they may, after all, deepen our understanding of the loss and provide a path to the future through this open wound which we have, rather too conveniently, come to call the past."[12]

When Eddé and I met in 2016, she said that when she initially approached Koudelka in 1991, at Magnum Paris, hoping he might agree to take part in the project, he answered in his habitual fashion: "No."

> *He was very tough. "No. No," etcetera. Finally I said: "Look, just come. You don't have to make any photographs, and it's okay."*
>
> *He said: "I will come, but I don't have to give you any photographs. You provide the film."*
>
> *I said: "We'll give you the film."*
>
> *He repeated: "I don't need to give you any photographs."*
>
> *I said: "None."*
>
> *He said: "Okay, I'll come." I was able to convince him to come because I was so convinced myself.*

Eddé exudes a low-key sophistication and graciousness. She is contemplative, and confident. And she is clearly compelled by intense and talented individuals: among her publications is a collection of interviews with the renowned psychoanalyst André Green, a captivating book on Jean Genet, and a personal consideration of the life and work of Edward Said, as well as several novels.[13]

We speak about her love affair with Koudelka, which began soon after they met. What drew her to him she describes as his "woodcutter" side. That is, he is a disciplined man of few words who works with almost myopic focus and remarkable skill. And as a communicator, he is efficient in his way: "Josef is

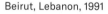

Beirut, Lebanon, 1991

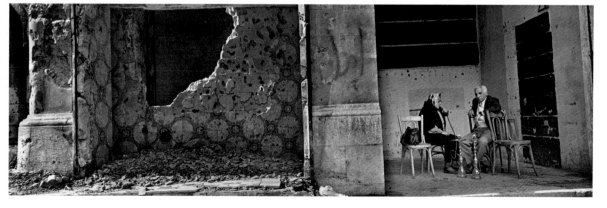

somebody who really is very careful with language, because he fears useless words. He hates what is unnecessary. I understood immediately that I had to be as tough as he was in my way of expressing myself." At the same time, she acknowledges that when it comes to listening, he can be selective:

JK, Beirut, Lebanon, 1991.
Photograph by Dominique Eddé

> *Josef hears very well the music he wants to hear and the sentences that are going to fit into what he's looking for. There he will not miss a word. But if the sentence is something that is taking him away from what he's doing, he leaves it. He does not pay attention.*

The panoramas Koudelka made during two trips to Beirut, in October and November 1991, evince a shattered city where blasted-out walls outline abstracted perspectives, forming shapely positive-negative spaces. In the rubble, there is a sense of disembodiment — of elements randomly separated from the whole that once was. An old couple sits at the far side of the city's Café de la Paix, now surrounded by wreckage, as they might have sat sharing a coffee in the years before these conflicts ambushed their city, their country, and any immediate possibility of peace.

Eddé describes Koudelka roaming the city "like a wild animal, hunting photographs like prey. Standing up, bending over, perching on a crane, lying on the side of the road. . . . The very frontal way in which he approaches misery or beauty is in itself accompanied by a mysterious maneuver — at least inexplicable — which consists of dismissing everything that does not count in that face-off."[14] She was struck by Koudelka's obsessiveness: how he would go back to a situation or place time and again, in different lights, at different times of day, in order to understand the optimum approach. Once determined, she says, "he would continue to return to that same place at the same time . . . to make certain he'd achieved the best that he could do." He did this, she observes,

> *until exhaustion — the exhaustion of the subject; the exhaustion of his energy, and the energy of those of us around him. He's an exhausting person. I was fascinated. I had rarely found so much power or powerfulness, exactitude, and poetry in the same person at the same time. I was coming from a totally different, much more intellectual milieu. He taught me to see and to use my eyes in a way I never had before.*

It has taken Eddé some time to come to terms with the person she knows Koudelka to be — and for whom she now feels "a huge admiration, love, tenderness . . . and sometimes irritation, of course" — and the eventual unraveling of their relationship.

I would say that Josef is the most rude, even brutal, and profoundly human person I've ever known. This apparent contradiction is the central figure of his secret, mute life. He is extremely intelligent. His intelligence is as personal and unique as his photographs: wide angle within very strict limits. . . .

He hurts, but he never means to hurt. . . . Now, this doesn't mean that I'm indulging him — I'm not indulging him at all. I think that Josef is extremely egocentric, but Josef is not narcissistic. It is not about looking at and admiring his own image . . . it is about being focused on his work as the most important thing. He must master his images, but not the image in the mirror. . . .

Like in a Tolstoy novel, Josef is cruel and good. Not nice, not even kind. But good.

Before I met with Eddé at her home in Paris, I asked her how she would feel about Lucina filming our first conversation, and she consented, welcoming Lucina with motherly gentleness. She had squeezed fresh orange juice and offered us pastries, as we sat by the fire in her living room. In our conversation, she was solicitous, yet with a candor not unlike Koudelka's: "I always thought: How is Lucina managing with such an egocentric father?" But then she continued — clearly having already carefully chosen her words, in anticipation of this conversation:

Josef is a giver in a very uncommon way. His generosity is not conventional or obvious. It is not material. He gives everyone around him the gift of his energy. His huge love for life . . . this is entirely authentic and consistent. Josef is, at every moment, present. I can tell you, this love for life is probably the most important gift a parent can give to a child.

Lucina was clearly touched. Her voice shaking slightly, she responded:

Since I was a child, I've had a very natural great love for life. And until now, I never really realized how much of this spirit may come from him.

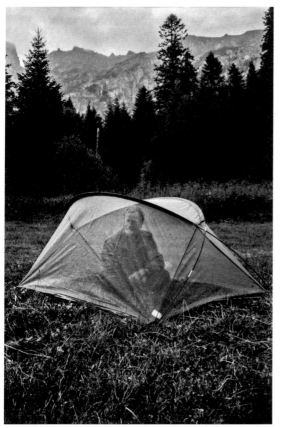

5.

In April 1992, about six months after Koudelka's period photographing in Beirut, Fabio Ponzio invited him to take a trip together around Central and Eastern Europe. Koudelka had traveled the area with Cristobal Zañartu in 1991, visiting Montenegro and Bosnia, among other places, and unprecedentedly allowing the twenty-five-year-old Zañartu to film him. "The day before our departure from Paris, I bought my first camcorder," Zañartu told me. His video, *Voyage with Josef Koudelka* — "'Voyage' because it felt like our van was our spaceship,"

he says — was first presented in 2002, on the occasion of a retrospective of Koudelka's work.[15]

Koudelka, interested in exploring and photographing the region further, quickly agreed to Ponzio's invitation. They left from Padua (after the opening of a Koudelka exhibition there) and drove east, obtaining press credentials in Belgrade. From there they traveled into Croatia, where they saw the tragic aftermath of the country's 1991 war for independence. The small city of Vukovar, at the confluence of the Danube and the Vuka rivers, had suffered a horrifying massacre at the hands of the Serb-dominated Yugoslav People's Army and paramilitary troops. "The city was completely destroyed and abandoned," remembers Ponzio. "The air stank of death." They slept in their car, at a Canadian military camp under the auspices of the United Nations. They went to the hospital in Vukovar, where they found a small group of nurses who seemed to be traumatized — "silent and staring at us." They later learned that more than two hundred people had been rounded up from the hospital, removed to a farm nearby, and summarily executed. They were buried in a mass grave. This was Koudelka and Ponzio's first trip together to the region — they would make about twenty-five trips together over the ensuing fourteen years, the last one, in 2006, to Armenia and Georgia. Ponzio summarizes:

> Symbolically, it can be said that our series of travels began in Yugoslavia in Vukovar, during the Yugoslav war, and ended in Gori, Georgia, in front of the cabin where Joseph Stalin was born.

Over the years Ponzio has come to know many of Koudelka's most entrenched routines, including his soundtrack of choice: "The *only* thing Josef listened to was news on the BBC, once in the morning as soon as he woke up, and then again before going to sleep. It was his connection to the world. He always was there with his radio. Always, always, always." Another "always" was the Photo Notes edition of his 1968 photographs of the Soviet invasion of Prague — Koudelka unfailingly carried a copy of the book with him. He would show it to those who invited them into their homes or otherwise assisted them. Once, in Ukraine, he shared photographs from the book with some of the very Ukrainian soldiers who had invaded Czechoslovakia years before. Ponzio says it was a moving moment that began with disbelief and ended in everyone breaking bread and drinking together. (In 2023, the sad irony is not lost on Koudelka.)

Cemetery in Vukovar, Croatia, 1992

6.

Many of the images from Koudelka's wanderings and commissions would find their way into his next major collaboration with Delpire, the 1999 book and exhibition *Chaos*. They were drawn from Koudelka's panoramic projects, beginning with his 1986 work for DATAR, and continuing through 1997 with selections from other commissions: the Mission Photographique Transmanche; the steel plant at Sollac; *Beirut*; the *Black Triangle* work; photographs made in conjunction with the shooting of the 1995 film *Ulysses' Gaze*; and pictures Koudelka had

made in Wales (a project published and exhibited in 1998 as *Reconnaissance: Wales*) — images of sea walls and harbors, row houses, jutting gravestones, empty boats, and random signage, as well as quarries, estuaries, and roads leading nowhere.[16] Delpire also included images from California and Wyoming, as well as Palermo, the Berlin Wall, Auschwitz, Bosnia, and Croatia, and a multitude of other places throughout Europe where Koudelka had photographed.

Chaos was Delpire's epically all-embracing title. Although he was clearly compelled by Koudelka's subjects, his approach to the editorial compilation of the panoramas — reflected in both the edit itself and the sequence — focuses more on poetically formal, intuitive relationships between images than it does on their respective content. In this way, Delpire revealed his affinity with the photographer's sense of visual order. With *Chaos*, as with so many projects, Delpire and Koudelka were clearly in sync. After *Chaos*, Koudelka continued this approach of liberating his panoramas from the specifics of where and why they were made, and reshuffling and reassembling them in several projects, under such encompassing rubrics as *Vestiges* or *Decreazione* (Uncreation) — both of which were titles of exhibitions and accompanying catalogs from 2013.[17]

The tension between human-caused destruction and faith in nature's resilience is apparent in the images coalescing as *Decreazione*, which was presented at the Padiglione della Santa Sede at the Venice Biennale in 2013 (it was the first time the Vatican had a pavilion at this venerable art event). The show was curated by Koudelka with Alessandra Mauro, along with Vatican curator Micol Forti; the production of the exhibition prints was overseen by Roberto Koch.[18] The eighteen panoramas in the presentation — nine horizontal and nine vertical — together consider various manifestations of destruction and deterioration, from classical ruins in Jordan and Greece to contemporary ruins resulting from conflict (such as in Beirut and Israel) to intentional interventions in the landscape, such as those resulting from mining and extraction. Mauro and Koch understood that it would be in Koudelka's best interest for his work to be presented in the context of the Venice Biennale, which embraces all media and has a vast and international art audience. They also knew that the themes in his work profoundly addressed the concept of "uncreation," a notion the Vatican wished to engage in the presentation.

At the Vatican Pavilion of the Venice Biennale, 2013. From left: Micol Forti (director of Contemporary Art Collection at Vatican Museums), Cardinal Francesco Moraglia, JK, and Cardinal Gianfranco Ravasi. Photographer unknown

Mauro laughs as she recalls how long it took to convince Koudelka to participate in a project that would be under the auspices of the Vatican. His first response: "But I am an atheist!" Mauro assured him that his atheism was not a problem. The exhibition was not about religion; it was, rather, a nonliteral consideration of the first eleven chapters of the Book of Genesis — with its themes of creation, uncreation, and re-creation, and their infinite possible interpretations — intended to provide a conceptual springboard for visitors to the Holy See Pavilion. The notion of "uncreation" suggests destruction, lack

of humanity and harmony in the world — but a condition that may yet lead to re-creation or hope.[19]

Cardinal Gianfranco Ravasi, president of the Pontifical Council for Culture, was responsible for the Holy See's participation in the Biennale that year.[20] "Cardinal Ravasi was very cultured," Koudelka says. "He knew about art, spoke many languages, and the photograph he especially liked was the least obvious one."

The old "Serenissima" shipyard and the recently renovated arsenal area are marvelous sites, with or without art. The Arsenale's cavernous maze of rooms, paint-peeling brick walls, arched windows and doorways, and filtered light seem to float on the surrounding water like some mythical island, guarded

Beirut, Lebanon, 1991

by the iconic white marble Piraeus Lion. Koudelka came up with an innovative method of presenting his work here. "Josef had this idea," recalls Lucina, "to stand the pictures on the floor."

> *He wasn't really sure what that would look like, so he asked me if I could do a three-dimensional image on the computer. I decided it would be easier for both of us if I made a model out of foamboard, He was very surprised. Later on he called me at home and said: "Lucina, you know I really love you, but today I just realized that you're also* useful!"

In the end, the large-scale, framed panoramas were presented on an incline (the verticals clustered in three triptychs), as though leaning, but were still affixed to the wall, raised slightly above the floor. For the father and daughter, this experience opened up a previously unimagined point of connection. Since then, when Lucina — who has a master's degree in object design from the École nationale supérieure des Arts Décoratifs in Paris — travels with her father to his exhibitions, she not only films but also often helps with the installations.[21]

Koudelka subsequently donated all the photographs from the *Decreazione* show to the Národní galerie (National Gallery) in Prague, which exhibited them in 2018 in conjunction with a major retrospective of his work.[22]

7.

Marseille, in southern France, and Košice, Slovakia, were named the EU's European Capitals of Culture in 2013. Much of the programming of the Marseille-Provence region was concentrated around what was conceived as a Euro-Mediterranean vision. Five months before *Decreazione* was presented at the Venice Biennale, Koudelka's exhibition *Vestiges* opened at Marseille's Centre de la Vieille Charité, a former almshouse and hospital built in the seventeenth century, now functioning as a museum. The show, curated by Bernard Latarjet, offered Koudelka his first opportunity to select and display his panoramas of Greco-Roman ruins from the larger Mediterranean world — Algeria, Greece, Italy, Jordan, Lebanon, Libya, Syria, Tunisia, and Turkey — which he had been making since 1991.

Koudelka is a formalist. He is mesmerized by stones — his protagonists — in their countless shapes and incarnations. (He once confided to a friend: "After all these years, the stones and I are on a first-name basis.") Entranced by the angles, lines, and textures of the broken columns at the temple of Aphrodite in Aphrodisias, he confessed: "These are my stones preferred."[23] These sites also affirm his own pleasure in being alone in remarkable environments where time and space are experienced as a continuum. In an interview conducted for the *Vestiges* exhibition brochure, Koudelka told Latarjet that one of the things that attracts him to these sites is "the solitude in beauty — a beauty that encourages and feeds reflection." He continues:

> There is also a kind of poetry and intelligence that results from the combination of perfect sites chosen by builders, architectural ruins, the history they represent and their values. As relics surviving the destruction of time, they have a force that must be made present, that must be "represented."

Koudelka dispels any notion, however, that he is merely documenting archaeological sites:

> I photograph the landscape, which appears or disappears depending on time, which is always there. . . . The creators of these places always knew the perfect site to build on, the most beautiful location of all those they could choose from. I'll go back there. My project isn't finished. Will it ever be finished?[24]

Latarjet has been engaged with Koudelka's work since their first meeting in 1986, in relation to the DATAR project. He considers those and other earlier images in the context of Koudelka's photographs of Greco-Roman ruins: both bodies of work, he notes, evince a desire "to preserve and to recover the sense of the values of worlds whose accumulated ruins and indefatigable hope we internalize. Transfiguring ruins into hopes — this is Koudelka's ambition."[25] Gilles Tiberghien, too, sees parallels between these projects: "The apparent disparity in values between these two worlds — the earlier imbued with spirituality, the later dominated by the quest for efficient productivity — should not be permitted to obscure the fact that they shared trade and war as the driving forces behind their grandeur and their failure."[26]

Some of Koudelka's earliest pictures of ruins, as well as other well-known images — such as that of the lone tree in snowy Greece — were made over a period of two months in 1994, when he agreed to photograph on the set of Theo Angelopoulos's 1995 film *Ulysses' Gaze*. Koudelka was at first reluctant to take on this project:

> I was approached by the French movie producer Éric Heumann. He said that they were going to make a film during the winter in the Balkans. The plan was to travel around in a little minibus, and they didn't want me to photograph the film — I wouldn't be working on the film, but instead, I'd be photographing things around the film. They wanted my vision of where we were, what I was seeing. And there were no restrictions. So, as I knew that there was transport, and that I didn't need to photograph the film, I said yes. I thought it would be interesting to go to those countries. The agreement was no fee, but they would cover my expenses.

Koudelka ended up also being drawn to the charismatic presence of two of the film's lead actors: Harvey Keitel and Gian Maria Volonté (who died of a heart attack during the film's production). Though Koudelka was not obliged to shoot the production process, there were occasions when he did photograph the actors. But rather than conventional on-set photographs, his images offer a larger context for the film's narrative.[27] With Angelopoulos, Koudelka clearly came to a win-win understanding: "Guess what he said after a few days on the set? 'Josef, you're mad. I like your madness. But I prefer mine.'" After viewing the finished film, Koudelka came back at the director: "Theo, you're mad," he said to him. "I like your madness. But I prefer mine."[28] He notes, however, that he has great respect for Angelopoulos's eye for locations, and further: "Because of *Ulysses' Gaze*, I saw places I might not have ever seen, or at least not until later."

Location shooting during the filming of *Ulysses' Gaze*, directed by Theo Angelopoulos, Greece, 1994. From left: Angelopoulos, Giorgos Arvanitis, and the filmmaker's first assistant

Koudelka's understanding of the artifice of filmmaking brings to mind his engagement with the world of the theater in his earliest days as a photographer. As he said to curator Hiromi Nakamura: "Movies are built out of both fiction and reality. But what fascinates me is just plain reality. Photographs have reality."[29] In the summer of 2020 Koudelka would tell Christian Caujolle, photography curator, journalist, and founder of Agence VU:

> The photographer lives in the world. He reacts to what he sees. He tries to shape it in the viewfinder. But . . . there is an influence the world has on the photographer, it is an interaction. . . . I respect reality, I don't re-create it but I use it. I take the part that interests me. . . . The photograph is always an adventure . . . a battle with reality, and I never know how it will end. Each good photo is a victory.[30]

There is also a less tangible reality — which Koudelka rarely trusts — not rooted in what is, but rather in what has been: memory. For that, too,

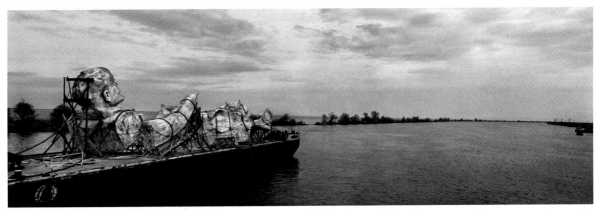

Danube Delta, Romania, 1994

a photograph is more reliable than a film. After attending a screening with Dominique Eddé in December 2017 of a film on Robert Delpire (who had died a few months previously), Koudelka riffed on a passage from Milan Kundera's novel *Immortalité* (*Immortality*): "Memory does not make films, it makes photographs."[31] Koudelka's version: "Memory is made from photographs. Memory is not made from films." Perhaps his panoramas tracing human interaction with a specific landscape — the human influences on that landscape — may be considered the memory keepers of these sites.

The *Vestiges* works seem to embody Koudelka the engineer, Koudelka the time-traveler, and Koudelka the terrestrial nomad. Immersed in these ancient sites, he sees humanity's attempts to connect, to pay reverence to the natural world (along with a pantheon of gods and goddesses). He once told me that the first book he remembers reading as a child was a collection of Greek and Roman myths that he found in Valchov's public library — which he describes as "one room with books to borrow."[32] His mind awoke to notions of marvelous faraway lands, and storytelling and ritual thrilled his imagination; a sense of wonder was ignited. These images, more about the passing of time than about its cessation, reveal what has survived of the classical world, rather than its obliteration. In this way, the notion of ruins is a paradox. As John Berger wrote: "An instant photographed can only acquire meaning insofar as the viewer can read into it a duration extending beyond itself. When we find a photograph meaningful, we are lending it a past and a future."[33]

8.

Cristina Marinelli grew up in Ivrea, near Turin, in northwest Italy's Piemonte region. She and her two brothers often traveled with their parents — her father, an engineer for Olivetti (the company renowned for the manufacture of remarkable typewriters, among other products), and her mother, a teacher who later became a psychoanalyst. After graduating from a photography school near Lausanne, Marinelli spent 1993 in Paris, where she worked as a portrait photographer for *Libération* and other publications. Eventually, she decided to decamp to Prague, where she'd never been. She was twenty-seven.

On a January evening in 1994, Marinelli attended the opening of Henri Cartier-Bresson's retrospective, organized by the Centre national de la photographie in Paris and presented at the Galerie Štěpánská 35, in Prague's Institut Français. After the event, with a photographer friend, she joined a group of FAMU alumni and others who were gathered at a Greek bistro. Everyone was anticipating the arrival of Koudelka, who had been spotted escorting Cartier-Bresson throughout the city in the days leading up to the vernissage. Marinelli recalls watching him as he came down the stairs of the bistro. "A whirlwind. All disheveled, with his usual jacket, always the same one with the big pockets full of stuff, and his large bag." Koudelka and Marinelli spent some time together that evening, and saw each other again soon after. Their story began. She looked, said Koudelka, "like a Gypsy."

Nicola Koudelka and Cristina Marinelli, Paris, 1996

Koudelka had just turned fifty-six when they met. During their time together, he was often in Prague, working on the *Black Triangle* project. Although he was more than twice her age, when we spoke in Turin in 2015 Marinelli told me he was "like a young boy" with her; he could be very "tender, affectionate . . . he had an extremely delicate side." But she adds: "He is also a man who can be solitary . . . he is someone who does what he wants." Still, she says, "in our own way, for a while, we were in love. . . . We met assiduously until the end of June."

Marinelli returned to Turin later that summer — pregnant with Koudelka's child. On February 14, 1995, Koudelka received a phone call in Paris from Marinelli's mother: "Cristina made you a nice present for St. Valentine's Day," she told him. "Your son was born." He immediately traveled to Turin to meet Nicola. Soon after, he asked Fabio Ponzio and Letizia Battaglia to be the baby's godparents.

Upon his return to Paris, Koudelka knew he had to tell Lucina about her new brother. He went to her school to pick her up as usual:

When I was in Paris, when she was in nursery school, I would carry her inside, on my shoulders. When she was in elementary school, I would meet her in front of her school with sweets for the other children. I wanted all the children to see she had a father.

So I say to Lucina: "I have news for you, but let's go home so you can be sitting when I tell you." She was eight years old, and I was really afraid as to how she may react.

I say: "Lucina, you have a brother."

She opened her mouth really wide and said: "Where?!"

I said: "In Italy!"

She ran directly to the phone — I said: "What are you doing?"

And she said: "I want to tell all my friends!" Then she said: "What about Mom, did you tell her?" I said yes.

And Lucina asked: "Est-ce qu'elle est tombée dans les pommes?"

(When Koudelka tells this story, Lucina's question — meaning roughly "Did she faint?" but literally "Did she fall in the apples?" — is always said in French.)

Marinelli recalls that Koudelka seemed ecstatic to have two children in the world — a son and a daughter — and that he came to Turin as often as he could to spend time with Nicola. She wants to be sure I understand that he really made an effort, before saying: "But obviously, Josef is who he is. . . . Josef lives for photography. He has always done this." That November, when Nicola was eight months old, Marinelli — with some savings and the help of her family — moved to Paris so that the baby could have a more consistent relationship with his father and get to know his sister a bit. Koudelka was perplexed: "I thought she was crazy. In Italy she had her family to help with everything." After two and a half years, in 1998 she returned to Turin with Nicola — now three years old.

Back in Italy, Marinelli raised Nicola more or less on her own, albeit with a very involved extended family. Over the years, she says, it became increasingly difficult to explain Koudelka's absence to the boy, who "thought intensely about his father and couldn't wait to see him again." She showed him Koudelka's books and took him to his exhibitions, explaining that his father's projects demanded his constant travel. "Photography was fundamental," she says, "for reconstructing memories for Nicola."

There were periods during which father and son rarely saw each other, as things were strained between Koudelka and Cristina's mother. His relationship with Marinelli had been relatively brief, and her life turned in other directions. (As of this writing, she has completed her studies in psychology and is enrolled in a master's program in cultural anthropology and ethnology at the Università degli Studi di Torino.) However, in the mid-2000s, when Koudelka was photographing for his *Piemonte* project, he saw Nicola regularly, ultimately dedicating the resulting book to him.[34]

JK and Nicola, Valle di Lanzo, Italy, 1999. JK describes this as "teaching Nicola how to fight boys." Photograph by Cristina Marinelli

In 2016, when Lucina and I met with Dominique Eddé, she pointedly asked Lucina if she had ever felt abandoned by her father. Lucina responded with equal frankness. Although her parents had always lived separately, she said, "since I can remember, when I was growing up, Josef was always close by. I saw him every time he came back from a trip." She smiles, remembering: "He lived in the building across from where my mom and I lived, so every time he'd come back from a trip, he would really yell my name. I think it irritated my mom a lot that he wouldn't

223

just call us! But that was his way of announcing he was back. No, I never felt abandoned."

In 1997, when Lucina was eleven and had finished primary school, she and her mother moved to Mexico City. Jill Hartley had published two photobooks in 1995 — *Poland* and *Lotería fotográfica mexicana* (Mexican Photographic Lottery) — and was ready for a change, having grown tired of Paris. She also "wanted Lucina to experience another way of life, learn another language," and had always felt very at home in Mexico. Lucina could, she realized, attend the Liceo Franco-Mexicano, which follows the same curriculum as schools in France. Most importantly, Hartley wished to be closer to her family in California: her father had suffered a severe stroke in 1996 that had left him partly paralyzed, and Lucina would also get to spend more vacation time with her grandparents and cousins. She would see her father during the summers when she'd travel back to France. For his part, Koudelka understood and was fine with Hartley's move to Mexico. At times, though, he felt as if he was being intentionally "eliminated" from his daughter's life — especially after seeing a report card on which his name had been dropped by the school, and she was listed as "Lucina Hartley" (an incident that has since been repeatedly and emotionally discussed and parsed by all). But this tension, while recurring, is momentary. Lucina happily recalls her time in Mexico, and has tried to return there for a period every year when possible. Still, she thinks of Ivry as her home, and as of this writing, Lucina and her partner, Neapolitan architect Vincenzo Iovino, reside in the loft she lived in as a little girl — still a shout away from Koudelka's place.[35]

Bridge for high-speed train, Piemonte, Italy, 2004

Perhaps the regular presence of her father as a child gave Lucina the confidence never to doubt his inevitable return. But she poignantly concludes her response to Eddé's query: "It was my brother, Nicola, who suffered, because he saw our father so infrequently."

Once she and Jill had moved to Mexico, Lucina longed to see her little brother in Italy. So in 2001, when Nicola was six and Lucina was fourteen, her mother decided to take her to Turin herself. Hartley made a vivid and intimate film of their trip, and of the joyful meeting of the siblings. Her evocative sensibility created an almost diaristic patchwork of their journey, a memory in the making with every emotional particular, in real time. Marinelli documented the visit in photographs and remembers that Nicola was thrilled to see his sister.

While Nicola yearned for more interaction with his father, Koudelka, too, had things he wanted to impart to his son: "I wanted him to learn certain things that his mother couldn't teach him" — things that Koudelka felt were "the function of the father." When he visited Turin, he slept as usual in his sleeping bag on the floor:

> Every morning Nicola crawled into my sleeping bag with me, which I loved. He was very sensitive. Once he told me that when he wanted to be alone, he went into the bathroom. I liked that, as I understood he had an inner life.

When Nicola was old enough to visit his father on his own, he would travel from Turin to see him in Ivry or in Prague.

When he was nineteen, Nicola received a letter from Koudelka upon his return home after a visit with him in Ivry. It was, perhaps, motivated by Koudelka's idea of the "function of the father." The letter amounted to, Nicola says, "a nonstop belittlement of what I am, how I was educated by my family, my behavior." Nicola was hurt and infuriated. "I decided to answer accordingly, telling him for the first time, with great clarity and determination, how he had been absent from my life and how I felt unfairly deprived of a father figure." Nicola told his father that, instead of being a support, he'd been "egotistical and brutal, and now presumed to judge me and those who had raised me."

Nicola didn't know what to expect. But when he and Koudelka ultimately spoke, Nicola says,

> My father's reaction surprised me: he said he was happy to read my words! That for him, this was a love letter, and that I was right to a large degree. From that moment on my relationship with my father gradually changed, reaching a level of reciprocal respect.

Perhaps adopting the tough-love approach of his own father, Koudelka maintains: "I sent him that letter to provoke him. He was acting spoiled. His response was excellent."

I met Nicola in 2015, when he was twenty. A tall and lanky young man, he was at the time clean-cut, allowing a full appreciation of his sharply defined features. He was somewhat reserved, with expressions that gave away very little. Ponzio says of his godson: "If I were to compare Nicola to an animal, I would say he is a young wolf. Silent, an observer, an introvert."

At that time Nicola was hoping to take a trip with his father — a journey that was eventually orchestrated with the help, and in the company, of Ponzio. "Fabio often acts as a mediator and tries to calm us down when our feelings become too heated," says Nicola. In the summer of 2016 the three of them traveled to the Czech Republic, along with Lucina and two Czech friends with whom Koudelka has often traveled: Jaroslav Pulicar and Jan Horáček. Koudelka wanted to show his children the country of his birth. Ponzio says that his godson is an excellent traveling companion. "Like Josef," he tells me, "he travels light, can sleep anywhere, can hold his alcohol, and has a strong moral sense." Ponzio smiles. "Otherwise, they are completely different."

Over the following few years, when I occasionally encountered Nicola, I could see that he was increasingly self-possessed and confident, developing a charming bravado. In January 2019 I was in Prague during the week of Koudelka's eighty-first birthday. Lucina was there, and Nicola joined to celebrate. By now, he was living on his own for the first time. He seemed comfortable standing up to his father — with frankness, kindness, and calm — when he saw fit to do so. Nicola says: "I want for him to understand and accept that I am different from him. There are," he observes, "three generations between us." As of this writing, Nicola is finishing a master's degree in environmental economics and policy. With each expression of his resolve and independence, Koudelka becomes prouder of his son.

Koudelka has more than once recounted to me a simple but telling anecdote. He and Nicola, as a little boy, were walking in Turin. Suddenly Nicola took his father's hand and stated: "You are my father, and I am your son."

"I was really moved by that," says Josef, adding:

I was very happy when Nicola was born. I tried within the limitations I have to be a good father. I did not always succeed. I'm sorry that Nicola suffered because of who I am. I am happy that in spite of this he became the young man he is now.

Koudelka occasionally waxes philosophical: "I am grateful to my parents that I exist," he tells me. "I am very happy I have children, and I hope that they are happy that they exist." And then he concedes:

I started to have children relatively late — I knew I wouldn't be able to take care of them as most fathers do. It might sound very strange, but photography is what is most important in my life. This is my deformation. But this deformation helped me to go through life.

9.

By the mid-1990s Koudelka had completed his work on *The Black Triangle* and *Ulysses' Gaze* (and the subsequent exhibition and publication). A revised edition of *Exiles* appeared in 1997. The following year, as his *Reconnaissance: Wales* project was about to be published, and while he was working with Delpire on *Chaos*, Koudelka embarked on an undertaking that would occupy him during the succeeding fourteen years of his life. The subject was limestone.

Jacqueline de Ponton d'Amécourt was the curator of the Belgian Lhoist Group collection. Founded in 1889, Lhoist is a family-owned business producing lime, dolime, and minerals. In the 1980s the company moved to increase its international presence, establishing additional quarries worldwide. As part of this expansion, Lhoist constructed new headquarters and, beginning in 1989, dedicated itself to sponsoring a significant program of art commissions and collecting, initially with the curatorial consultation of Belgian art historian Pierre Apraxine. Over the years, commissioned artists, recognized globally for their talents in a range of media, have all worked site-specifically. Among the artists commissioned by Lhoist are: Bernd and Hilla Becher, Tony Cragg, Rodney Graham, Anish Kapoor, Richard Long, James Turrell, and Not Vital.

D'Amécourt recalls meeting Koudelka at Cartier-Bresson and Franck's apartment on the Rue de Rivoli in Paris. At the prompting of Agnès Sire (Magnum's artistic director at the time), d'Amécourt suggested that Koudelka might participate in one of Lhoist's commissions. Sire recalls that the photographer, quite characteristically, did not jump at the opportunity: "I'm not sure," she remembers him saying. "I want to go there first to see." Koudelka asked to see three Lhoist sites, in order to better understand what they were doing and the photographic potential.

France, 1998

It didn't take long for him to decide. Upon seeing the first site he was shown, in the northeastern French town of Sorcy, he was ready to begin:

> *Every time I went on the bus to Prague from Paris, I would see this big white mass on the horizon — and they brought me there! I said to myself: "It fell on you from heaven."... So I said: "Yes, I'm interested."*

It was clear to Koudelka that quarries could serve as a remarkably visual and substantial subject. His requirements, which Lhoist accepted, were the usual: unrestricted access, freedom to photograph anything he chose, and authorial control at every stage of any project that might arise from his work.[36]

Koudelka's photographs of Lhoist's sites are anything but documentary. His revelation of the spaces are as epic, as compositionally abstract, as sculptural and as mysterious as the Land art of Michael Heizer, or the Nazca Lines of Peru. The human hand is the first intervention in these landscapes. The photographer's subsequent interventions? Elemental images that in some cases make the quarries unrecognizable even to those who have worked there. (Similarly, Koudelka's theater photographs of three decades earlier are sometimes so abstracted as to render the specific play unidentifiable.) Although the quarry images are clearly linked to *The Black Triangle* and earlier panoramic projects, there is also an affinity between this work on limestone and his work on ruins: traces of human activity in the landscape, transformed over time. The writer Geoff Dyer terms Koudelka's time-space dynamism "primal," and observes that these landscapes seem "like they have not so much been taken as dug from the soil that they frame." Dyer concludes: "Far from being timeless, they are saturated in time."[37] Dominique Eddé has also written about the metaphysics of Koudelka's work:

> *The moment that he captures contains centuries. The space that the image encloses opens the field of the universe, both inside and out. It is the theater of opaque skies, where humanity is so miniscule, and yet such a vast mystery.*[38]

There is a substantial tradition of artists focusing on quarries, including, most famously, Paul Cézanne's many paintings of the Bibémus quarries, for which Koudelka has an enduring admiration. But as d'Amécourt observes: "Few artists... have been as observant as Josef Koudelka in terms of both the

beauty of the quarries and the products derived from them." She adds, however: "Koudelka's photographs are not there to please. They portray the company and its activity as it really is, or at least as he sees it."[39]

Koudelka ultimately realized two books with this work: *Lime Stone*, the result of the original two-year commission, was initially published as an accordion-fold, limited-edition book. Gilles Tiberghien contributed an expressive and informative text, conveying the nature of these massive extractions and the consequently altered landscape:

> The edges of the quarry, when they cease to be exploited, take on a grey hue due to the aluminum oxides, which, like ageing scars, change color over time. . . . The process of extraction initially consists in removing the surface vegetation and humus in order to reach the limestone layer whose depth varies depending on the region. The quarry is thus a vast depression into which we gradually make our way. . . .
>
> Koudelka emphasizes the tectonics of the landscape, thus emphasizing its visual organization. . . . We are confronted with a sort of relief map, sharply angled mineral volumes following wavy lines which strip the earth of all decoration to reveal the telluric bedrock. . . . Here the hand of Man is everywhere. Nature is transformed, turned upside-down. There is not a square centimeter which has escaped his touch, which has not been carved out, excavated, tamped, or recuperated.[40]

Lime Stone was followed eleven years later, in 2012, by *Lime*. In both, the captions for the images were written by experts: the quarry directors.

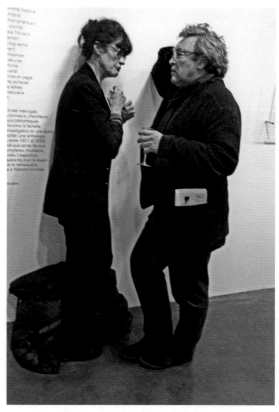

Agnès Sire and Xavier Barral, 2012

Sire notes that Lhoist had not originally intended to produce a book of Koudelka's photographs — but when they saw the work they were so impressed they decided to publish a small print run of the 2001 publication: "Then they said to Josef to choose the designer he wanted to work with." He selected Xavier Barral.

Koudelka went on press with the book to oversee the printing, which seemed to go smoothly. A little beyond the eleventh hour, however, Sire was drawn into a discussion about a fundamental part of the publication — the title:

> Josef saw and approved everything. When the finished book arrived, I got a call from him. He told me: "The book is perfect, but there is a mistake in the title. So I'm refusing the book."
>
> I said: "What's the problem?"
>
> And he said: "With the title they didn't do 'limestone' as I wanted. Graphically, I like and wanted 'Lime' on top, and 'Stone' underneath."
>
> I said to him: "It's a real word, Josef — not just graphic design."

Five minutes after, I got a phone call from Jacqueline de Ponton d'Amécourt.

The issue was the design of the book's title page. D'Amécourt recalls that Koudelka wanted the book to be called *Lime Stone* (as opposed to *Limestone*) "because he thought the power of the two words matched what he was looking for." On the book's cover, the two words were stacked, as he wished. But on the title page, they appeared as a single word.

Sire vividly relives the vexation of that moment:

I couldn't sleep all night. In the morning I called Josef and said: "Josef, I shout at you, and I shout for the first time in my life. Everybody did everything you wanted for three years — the entire project! The book is perfect. Those people are making limestone. It's normal that the word should be written correctly." . . .

I spoke for five minutes, which is long. And he was silent.

At the end, he said: "Give me her phone number. I will call her and tell her I'm sorry."

Koudelka made the call to d'Amécourt as promised. Ultimately, the book's paperboard cover is as Koudelka wished; the title page remains as originally printed, with *Limestone* as one word.

After the book's publication, he was eager to continue working on the subject, and did so over the following ten years. Lhoist agreed to support his additional time in the field and equipped him with a letter from the Lhoist Group chairman, Jean-Pierre Berghmans, ensuring his ongoing access to the quarries. (Or, as Koudelka puts it: "Berghmans gave me a paper saying I can go any place they work.") François Hébel paraphrases the letter thus: "Here you have a great artist; he will show you what you do not see. Give him complete freedom of access."[41]

"It was Koudelka's decision to visit all the Group's quarries," wrote d'Amécourt. "Apart from the Chairman of Lhoist, he may be the only person to have travelled to every single one of their quarries and plants. He travelled up thousands of kilometers, slept in the quarries and conversed with geologists, factory managers, and workers."[42]

Koudelka's appreciation for the dazzling stonescapes ultimately took material form as *Lime*, designed and published by Xavier Barral in 2012, with support from Lhoist. The reproductions in this large-format, hardcover, vertical book are as luminous and silvery as the stones themselves.[43] It represents Koudelka's work from more than eleven years, in eleven countries, in fifty-one quarries.

Barral and Koudelka made the image selection together, but Koudelka worked out the book's structure and sequence on his own.

Xavier asked me if Lhoist had seen and approved all my pictures. I said: "No. They are not going to see them in advance. We are going to finish the book dummy exactly as we think it should be done. When we finish, I will go to Brussels and show it to Berghmans, and he'll say yes or no."

According to Koudelka, Berghmans was deeply moved when he saw the maquette: "Nobody ever said 'take this picture out' or anything like that."

D'Amécourt contributed a text to *Lime*, in which she observes that Koudelka considered this project "a mission that tied in with his preoccupation with the contemporary landscape on which man has left traces of activity.... Koudelka is at one with these quarries. Their familiarity has developed into obsession, reflecting perhaps a form of sought-after solitude."[44]

10.

It was in London, at a party around Christmastime 1970, that Josef Koudelka met Lindsay Ward. Born in South Africa, she had moved with her family to England when she was eighteen. Ward had been living in London for a couple of years when she encountered the thirty-two-year-old Czech émigré. She had just resigned from a job at Macmillan Books and was trying to figure out what to do next. (She would eventually turn to medicine, becoming a general practitioner.)

Ward had been to Czechoslovakia briefly in 1968, in the period of the Prague Spring, and had met Czech artists who were experiencing the creative freedom of that moment. She and her friends from London's Regent Square were aware of the crushing sadness as hard-won liberties were demolished with the Soviet invasion that August, and the subsequent "normalization." When she met Koudelka, she had seen and greatly admired some of his photographs. He was, she says, "an attractive character."

Ward's memories of times with Koudelka all those years ago are of "good fun at the parties. But," she tells me straight away, "without discussing it, I was very aware that Josef wasn't sticking around. I knew he wanted to be on the move and was not committing to anything except for his photography." As expected, the dalliance did not last long: Koudelka eventually left for Spain, and Ward was fine with that. "I knew he was a free spirit — that was part of the attraction." But their brief interlude would make an indelible imprint on their lives, and on the life of someone else. While in Spain, Koudelka learned from Ward that she was pregnant with his child. Although he saw her once or twice in the later stages of her pregnancy when he returned to London, he was not there when she gave birth in 1971.

In 1999, after not having been in contact for nearly thirty years, Ward wrote to Koudelka. He was deep into the Lhoist commission at the time. Recalling this years later, he told me:

> I have lots of respect for Lindsay. She said in the letter something like: "I have a daughter with you. I gave her up for adoption. I am happily married. I don't want anything from you, but I don't have children, and I am going to do something very difficult, and try to find her." Then she said something like, "If I find her, she might ask: 'Who is my father?'"
>
> I said: "Keep me informed."

Ward was eventually able to track down Rebecca Johnson, their biological daughter, and communicated the news to Koudelka, as promised. As it happened, he was having an exhibition that year of *Reconnaissance: Wales* in Swansea, Wales. He and Ward decided to get together in Swansea and discuss everything. "We had a good evening," says Ward. "Josef was more than accepting. By then, I had met Becky, and I told him about her."

Koudelka tells me: "She asked me if she should tell Becky how to find me. I said: 'I don't know anything about Becky, and I'm not sure if she really wants to know me. If she wants to know me, give her my telephone number, and she'll call me.'"

When she and I met, Rebecca explained how Lindsay reached out to her through an intermediary — "just to be certain I was open to the idea of hearing from her," which Rebecca "instinctively" knew that she was. She continued:

My birth mother found me in April '99, when I was twenty-eight. I grew up always knowing . . . that I was adopted. My adoptive parents told me. It was a British, legal, closed adoption at birth,

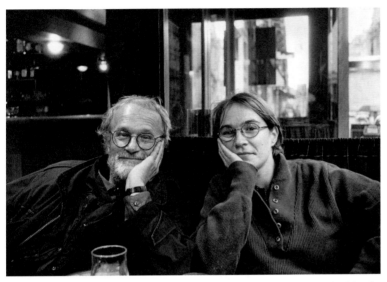

JK and his daughter Rebecca Johnson, shortly after their first meeting, Paris, ca. 2000. Photographer unknown

basically. The way it worked in the UK back then was that you knew nothing — either way. My birth mother didn't know about me, the identity of my [adoptive] parents, and I didn't know the identity of my birth mother. But she traced me through whatever information was available.

When they met, Ward explained to Rebecca that "she'd gone to meet Josef some months before trying to find me. That's the first time I'd heard his name."

That summer, Koudelka had an exhibition in Brixton, the neighborhood in the south of London where Rebecca was living. He says:

I think it was my exhibition of Chaos. *It was very strange, because I came for this opening party, and I was having fun there, and I was thinking: "My daughter is probably here somewhere; she's looking at me and thinking, 'What an idiot this guy is!'"*

Rebecca, it turns out, did go to the show, but a day later:

The Brixton exhibition was at a gallery called Photofusion. I did go to see it, but Josef had been the day before. I was also looking out for him — I asked if the photographer was there.

Not long after, Rebecca contacted Josef, having learned from Lindsay that he would be in London, and they agreed to meet on December 4, 1999. But just before leaving for London to see him, her anxiety got the best of her, and she called him:

I must've been starting a new job because I distinctly remember saying: "Look, I can't come and meet you yet. I'm starting a new job. I'm too nervous." It was all too much. I said: "Look, I'll meet you in three months."

But Josef put me at ease on the phone. It charmed me, what he said, and made me laugh. I just needed a bit of encouragement, a little nudge — then I was there. He said: "You'll still be nervous in three months. You come tomorrow." I thought: "Yeah, you're right — okay." And he said to me: "You recognize me. I wear old army clothes. I have Leica around my neck." So, I took the train down from Birmingham — I had moved back to the Midlands by then. I distinctly remember, I was so relaxed — I'm never relaxed! — I was so relaxed that I fell asleep on the train.

They sat down in a London café, where Rebecca recalls they had coffee and chocolate cake. Josef, too, was nervous, he says,

But I wanted to be immediately correct. So I said: "Becky, I am very pleased to meet you. I don't know anything about you. But I want to tell you immediately in the beginning, if you suffered because of me, please, can you forgive me?" She looked at me, and with her strong Birmingham accent, which I like very much, she said: "I never even thought of you!"

Rebecca remembers the moment:

He whacked me on the back. . . . He said: "I write this down. 'She said she never thought about me.'" . . . Relief gushed out of him. . . . He was so hilarious. It was just fun.

At this point in his telling, Josef laughs effusively, describing this relief. He doesn't really remember what they talked about afterward, but says: "I liked her right away, and I felt immediately great sympathy for her." After which, he merrily adds: "And can you imagine, I have a daughter with an accent like that?!"

Later that afternoon, Koudelka was scheduled to be interviewed by a journalist from the BBC and invited Rebecca to accompany him to his meeting. They both recall the look of astonishment on the interviewer's face when Koudelka nonchalantly said: "John, can I introduce you to my daughter, who I met just one hour ago?"

Rebecca notes:

At that point, no one amongst his friends and colleagues knew there was this other child — there were only two. And I don't know who they thought I was when I turned up with Josef.

I tell her that Josef said they all probably thought she was his girlfriend at first. "Yeah. That's uncomfortable," she says.

I probably said something like: "He's my birth father," to maintain my loyalty to my dad. I think I must've used the words "biological father," because Josef latched on to that. Sometimes he says: "I'm your biological."

Koudelka then told Rebecca about Markéta Luskačová. He was going to her place for dinner later, and wanted to introduce Rebecca to his old friend. She was amenable. They went to Luskačová's flat. "So I open the door," says Koudelka,

and there was Markéta. And I say: "Markéta, may I introduce you . . . " I don't know exactly what expression I used, the adjective I used before saying "daughter," but Becky didn't like it. So Becky said: "No, he's my biological father!" Can you imagine? Becky handled everything so well, and Markéta, after being immediately surprised, was nice, of course.

In July 2000 Koudelka met Rebecca's father (her mother died in 1992): "I know that she does not think of me as her father," Koudelka told me. "Her father is somebody else. She is my daughter, but I am not her father. Her father is the man who brought her up." When Koudelka later had an exhibition in London, Rebecca and the two men drank white wine outside, at a pub on the South Bank. A year younger than Koudelka, Rebecca's father is a retired academic — a former lecturer in cultural studies at Birmingham University. When I ask Rebecca to chronicle the dynamics between Josef and her father, she first describes her father as "pretty reserved and very considerate." She then offers up the following anecdote:

My dad was visiting some students in Paris and arranged to see Josef one night.

Whenever I get a phone call about ten o'clock at night, I know it's Josef. The phone rings . . . my dad and Josef — they're having a drink, and Josef obviously made my dad phone me. . . . My dad said: "I'm terribly sorry, darling. I hope we didn't wake you up?"

I could literally hear the phone being swiped out my dad's hands, and then Josef: "On the contrary, we are happy we woke you up. We drink to your good health!"

JK with his children: Rebecca, Lucina, and Nicola, Prague, 2018. Photograph by Vincenzo Iovino

Rebecca feels profoundly loyal to her adoptive parents, and very protective of the inviolability of those relationships. When I asked her if that's been at all complicated with Josef, she responded:

He's been very respectful toward my dad, calling my dad "your father." "How is your father?" He makes a point in nearly every conversation — not always, but in nearly every conversation — of asking: "How is your father?"

Josef does believe, though, very unambiguously, that he's got three children. Which is factually true.

I spoke with Rebecca in person for the first time in February 2015. She agreed to get together, she said, because it was "something out of the ordinary," and suggested we meet at London's Estorick Collection of Modern Italian Art, where there was a show she wanted to see. We had described to each other what we would be wearing or carrying — but there was no mistaking the young woman I saw before me. Her resemblance to Koudelka is striking — especially around the eyes, and her smile. She reminded me:

When I met Josef, he was only the second person I'd met who's biologically related to me in the world. To see him, to see his coloring — basically, I look

at his coloring, and I look at his creased eyes — that's what hits me. So there must be something to this biological resemblance. I get some . . . reassurance . . . seeing a resemblance. It's possibly the build as well.

We spent several hours together over a grand Italian meal. Her forthrightness also resembles Koudelka's. Given that, I asked what it is like for her to spend time with him.

He is a blast of energy. And the things he says sometimes crack me up.

Conversations I have with Josef, either on the phone or if I visit him, tend to be about his work, his projects. He'll ask about my life and work — particularly when we're having a meal in his flat, he'll get to a point where he becomes a bit of a quieter Josef. And he will listen.

I like being with Josef. I like who I am when I'm with Josef. He brings out something in me. . . . I maybe throw a bit of caution to the wind when I'm with him, slightly. But trusting. I can say that. I feel very safe with him. Well, he can take it. You could, like, pummel him and he can take it!

Although he doesn't admit complexities and emotional difficulties, I think he processes everything, and then he will come out with something actually quite sensible. So yeah, I like looking at his face, his creased eyes, and his hands, his skin color. Good for me to see someone who looks like me.

But I need stability in my life. I need to go home, see my brother, do my babysitting, see my dad. Keep my feet on the ground.

So you'll get a picture of Josef through me, which has me at the center of my solar system, if you like, with Josef as a little comet. Josef will sometimes suck me into his solar system, but ultimately, I'm staying in the heart of my solar system.

Rebecca and I were both laughing now. When I asked her about Josef's relation to *her* solar system, she smiled: "Well, he's a comet: he whizzes past!"

11.

There is no more folklore. There is only the abruptness of that presence, the roughness of that voice. There are only those neatly exact and economical movements, that peasant-like gesture with which he balances the big black bag on his shoulder; the one with which he checks his shirt pocket to make sure that everything he needs is in it. . . . There is only that gimlet eye forever on the alert, the unruliness of a corralled horse. But there are no more anecdotes. . . . There is a body of work. Significant. Respected.[45]

Robert Delpire thus considered Koudelka in his introduction to the publication *Chaos*, at the close of the 1990s. By then Koudelka had lived in Western Europe for almost as long as he had lived in Central Europe before his exile.

Koudelka's world, like much of his work, has allowed for minimal gray. He was still the man who did not need what he did not have, who slept on the floor or outside whenever possible, who for a period would not allow his galleries to sell his work and was fiercely vigilant himself about not ever being

bought. There was still no car, no computer, no cell phone, no television. But there were and continue to be the helpers, advocates, and carrier pigeons — family, friends, and colleagues — regularly transporting and transmitting on his behalf. And whereas Koudelka's complex ideas about money, carried over from his youth in Czechoslovakia, at times may have made him seem harsh or guarded, they continued to evolve and have shifted somewhat over the years, thanks to some gentle encouragement by those close to him and his own increasingly nuanced understanding of human dynamics. Collaboration, he has come to appreciate, does not have to signal compromise, and need does not necessarily equate with weakness or greed. With his deadly radar for pretension and his general impatience for most things unrelated to his work, there was a lot of white noise (at least from his perspective) that he simply banished. Resolute and willful, tenacious and watchful, he thrived — a free-spirited, often solitary, elemental force, or as an Italian friend of his put it, a *cane scatenato* — a wild dog.

JK and Robert Delpire, 2012. Photographer unknown

At the beginning of the twenty-first century, Koudelka had published *Chaos* and was working intensely on the Lhoist quarries project. Still, as the new millennium opened, he was focused on the future: "The most beautiful word — my favorite word — is 'NEXT'!"

What came next was his first large retrospective in Prague. In November 1999 Koudelka received a letter from the poet and art historian Věra Jirousová, who worked with the National Gallery: the museum was proposing a comprehensive exhibition of his work. The project was ultimately undertaken with the close collaboration of Jirousová; Marie Klimešová, the curator of the museum's collection of modern and contemporary art; the architect Emil Zavadil; and Irena Šorfová, who at that time was freelancing at the National Gallery, co-producing, coordinating, and organizing exhibitions. She worked on a range of projects with the museum, but she was particularly drawn to photography. Šorfová might propose an artist or project, as well as a designer for the exhibition, and she also worked on fundraising and promotion.

Koudelka was internationally recognized: he had had a successful show in Prague in 1990, and his *Black Triangle* project had also been exhibited in the city to much acclaim. Still, due to his twenty-year absence and the censorious policies of that period in Czechoslovakia, the breadth of his work was not widely known in his homeland. It was time to truly introduce him there. In a November 2000 letter to Koudelka, Klimešová confirmed that the exhibition had been officially approved to run from February to April 2002.[46]

Koudelka had known Jirousová, Klimešová, and Zavadil for many years, but he met Šorfová in the late 1990s, when the thirty-year-old invited him to see the museum's exhibition space and to discuss the show. He requested that Anna Fárová be invited to this initial meeting. The plan was for a retrospective of some three hundred photographs, representing his entire body of work to date.[47] Koudelka hoped that Fárová might serve as the curator — a culmination of their work together, building on the 1990 exhibition on which they had collaborated. "At this first meeting," recalls Šorfová, "Fárová agreed to be curator together with Josef, and she proposed the simple exhibition title: *Josef Koudelka: Photographer.*" But not long after, Fárová changed her mind and said she would not serve as the exhibition's curator — she never gave Koudelka an explanation for this decision. Nonetheless, she agreed to be listed as an "expert advisor." Klimešová, who had included Koudelka's theater photographs in her group show *Divadlo navzdory* (Theater in Spite Of), which she put together soon after the Velvet Revolution in 1989, promised to be personally involved in the realization of his retrospective; Jirousová and Šorfová would be responsible for all the coordination.

The Czech publisher Torst had already initiated plans for a Koudelka publication, which would include an introduction by Fárová, as part of its Fototorst series — a collection of square-format photographic monographs published bilingually in Czech and English. It was soon decided that there was no need to do a separate exhibition catalog and that instead, this Fototorst publication would accompany Koudelka's forthcoming retrospective. Along with Fárová's text, the book includes edited excerpts from ten-plus years of conversations between Koudelka and his old friend from pre-exile days, the journalist Karel Hvížďala.[48]

Hvížďala, whom I met in Prague in 2014, has conducted numerous book-length interviews in his career, including with Václav Havel. He first encountered Koudelka sometime in the mid-1960s, and still calls him by his old nickname, "Pepa." Hvížďala was at the time a journalist at the weekly magazine *Mladý svět.*

Prague, 2002. From left: Aleš Najbrt, JK, Anna Fárová, and Viktor Stoilov. Photograph by Karel Cudlín

The period before the Soviet invasion was, he says, "a merry time. We went to parties, there was wine — sometimes in Pepa's basement studio."

But when it comes to work, Hvížďala has long been struck by Koudelka's discipline. And like many others, he has appreciated how Koudelka always keeps his prints close at hand:

> *He had everything in his pockets, so carried everything everywhere — small prints of his photos . . . he was always playing with them, like playing cards.*

What he did not like, he threw into another pocket; he was always shuffling them around. That is how his books originally emerged, and still do to this day.... He would make those accordion books out of them — the edit, the ordering: it was systematic, well-thought-out work in every sense.

Hvížďala is someone whose opinion about his photographs Koudelka has often solicited. "There was no other discussion except for the photos," Hvížďala says. "Every meeting was like that." He considers Koudelka's obsessiveness in his approach to *Gypsies*:

It was not so exotic, where he was taking these photographs. What grabs you is the way he *was being grabbed. You were interested in how* he *was interested. And the aesthetics of it — how he perceived and then revealed what he was seeing ... his iconization of the situation. His very compositions — as classic as a Madonna and Child.*

Hvížďala left Prague for Bonn, Germany, in 1978. He and Koudelka exchanged the occasional postcard and met once during their respective exiles. Hvížďala returned to Czechoslovakia in 1990 and was appointed the chief reporter and chairman of the board of the Czech media group MAFRA. He then co-founded and was the co-publisher of the newsmagazine *Týden* (The Week). "I left the country when I was thirty-seven years old," he says. "I was already an adult. And I perceived this whole experience of exile as a task — everything I did was directed back toward here."

It was on Koudelka's first return trip to Czechoslovakia, when he and Fárová were planning the 1990 exhibition at the Museum of Decorative Arts, that the two men were reunited. Hvížďala recalls:

*Josef and I did an interview for the newsmagazine that I had founded [*Týden*].... Then we did another for some reason — I do not remember exactly.... When we had two or three of the interviews, we said to each other: "We should do it systematically."*

And so they did, from 1990 to 2001 in Prague. "Notes" from these discussions were published as "The Maximum, That's What Always Interested Me" in the 2002 Fototorst book *Josef Koudelka*.

Viktor Stoilov founded the Torst publishing company in 1990. A mild-mannered man with dark eyes and a wide smile, he clearly believes in his work and in the larger community it both serves and fosters. Stoilov told me that the first idea for a book with Koudelka was set in motion in the mid-1990s, before the big retrospective show or the Fototorst book were even discussed. Koudelka had seen the large-format book on Josef Sudek, edited by Fárová, that Torst published in 1995, and he had broached the subject of doing something along these lines with Stoilov. But there was a problem. Stoilov explained:

Josef wanted from Anna a new, comprehensive text about his complete works. She agreed to write a new essay but unfortunately the promised text was never delivered, and this is why the bigger book was never published.

Some years later, when the Fototorst book was in process, Stoilov continued:

> Anna was asked again to write a new text on Josef's work. She felt strongly about her existing definition of Josef's photography, so it wasn't easy to reach the final form of the text.

Koudelka says: "Anna cobbled together all these old texts she had written and I cut and pasted to eliminate repetition. Then she added something about *Exiles* and the panoramas, and the entire text was edited by Torst for publication." Koudelka and Fárová eventually agreed on her introduction, "Forty Years of Observing the Work of Josef Koudelka: Themes, Methods and Stages, 1961–2001." It includes new passages, and some aggregated passages from previous texts. Considering for the first time Koudelka's panoramas, as presented in the recently published *Chaos*, Fárová wrote especially viscerally — clearly affected by the work, but seemingly finding it lacking in redemptive virtues. She closes her essay as follows:

> Koudelka, like a mad geometrician, places his increasingly precise, ever colder, stiff order into these sad discoveries. He becomes the constructor of a perfect geometry, which suffocates life and is fraught with deadly weight. . . . The dimensions of the tragic are increasingly present, and [its] expression leaves an unforgettable impression, but there is no place to rest. We are on the stage of Antonin Artaud's "theater of cruelty." The photographer increasingly encloses himself in his own view. Are we dying or is the world? [49]

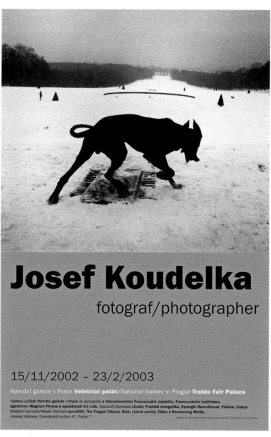

Exhibition poster for *Josef Koudelka: Photographer*, designed by Aleš Najbrt, 2002

The publication was not the only fraught aspect of the retrospective project. In 1999, a new director of the National Gallery had been appointed: Milan Knížák, who was perhaps best known as something of a rebel in the 1960s and an avant-garde artist with ties to Fluxus. Although he had to have signed off on Koudelka's exhibition, as Irena Šorfová would later write, Knížák had his own "clear-cut ideas about art. Because of the different exhibition preferences of the new management of the National Gallery and the difficulty of ensuring funding for the exhibition, the date for the opening of the exhibition was twice postponed."[50] However, Šorfová explains, the delays — and the museum's threat of cancelation attributed to funding concerns — were only some of the points of contention between Knížák and Koudelka. The details of the installation soon became the primary battleground between the two men — each willful in his own way. But because Šorfová's contract with the museum clearly delineated responsibilities, Knížák ultimately did not have

the right to intervene in the exhibition design that the National Gallery had already approved and plans for the show moved forward.

With just days to go before *Josef Koudelka: Photographer* was set to open, and sponsors and partners — including the French Embassy in Prague — onboard, the tensions only worsened. Šorfová recalls:

During preparations, it was clear that . . . the new management led by Knížák considered it [the exhibition] inferior. This manifested itself not only in postponing the opening date, but in the deliberate change of exhibition spaces within the museum.

Whatever Knížák's stance was with regard to the art of photography, and however dismissive he may have been of Koudelka's particular sensibility, nothing can fully explain the bald disdain he exhibited toward Koudelka and his work, and his apparent efforts to thwart the progress, opening, and success of the exhibition.

Because of the delays in Prague, however, the exhibition premiered to great acclaim at the Rencontres d'Arles, France, in July 2002. On November 15 *Josef Koudelka: Photographer* finally opened at Veletržní palác (the Trade Fair Palace) — Prague's first Functionalist building, a massive structure completed in 1928, today part of the National Gallery. The day before the show's public opening, the museum hosted a press conference at which Fárová presided, publicly introducing the exhibition as an "excellent achievement" and a "beautiful presentation." She went on, with growing effusiveness — "clearly touched," reflects Šorfová, by the "biographical panels dedicated to the important people in Koudelka's life, including Anna." The show included further ancillary materials: private letters, photographs from exhibition openings and other spontaneous moments, book covers, drawings and more. Fárová gushed:

Anna Fárová, JK, and Irena Šorfová at press conference for the exhibition *Josef Koudelka: Photographer* at the National Gallery in Prague, 2002. Photograph by Ondřej Hošek

I am also happy that the exhibition includes things that I hadn't expected; of course, all the various stages that are shown here are quite familiar to me, but obviously not so brilliantly executed and with such brilliant finishing touches, and culminating in a presentation. I was really fascinated by the, in quotation marks, "sentimental" panel or acknowledgments panel or memorial panel or whatever you would call it, which actually defines the whole course of his career, the places he has stopped along the way, the part about his relationships and his partnerships, his colleagues and so on. That, I think, is a splendidly beautiful thing that, as far as I know, has never before happened at any Koudelka exhibition. And it is perhaps a tribute to the fact that this exhibition is happening here in Prague. . . .

She ended her speech climactically:

Josef Koudelka is a virtuoso, methodical, and also a tester, who always tests and then perfects. His perfectionism is evident here.[51]

But shortly after the private opening of *Josef Koudelka: Photographer*, there came a shocking blow. Knížák sent out a statement that, as Koudelka puts it, "publicly denounced this exhibition, [saying] that the National Gallery was pressured by the outside into doing it." The statement, released to the public by the museum on November 15, 2002 — the day of the exhibition's public opening — said explicitly that Koudelka's show should never have been presented. Why? "In its exhibition program the National Gallery in Prague does not have photojournalism and genre photography." The press release then turns bizarrely ad hominem. The museum renounces its own exhibition and lambastes Koudelka:

> Concerning the preparations of the organized exhibition, it must be pointed out that the National Gallery was put on the defensive and could not influence the appearance of the exhibition. That is why the exhibition is lacking critical work with the material.
>
> The exhibition is overcrowded [with photographs] and has been installed without the required rhythm. The unsuitable architectural design in the lounge of the mezzanine interfered with the electronic security system. Negotiations with Mr. Koudelka were very unpleasant. Josef Koudelka considers himself to be the center of the world and has placed the National Gallery in the role of his servant.[52]

Šorfová commented on the repercussions of this statement in a 2018 essay:

> The press release led on the one hand to astonished embarrassment and on the other to a storm of opposition amongst specialists, launching a debate about whether photography, or at least a certain kind of photography, belongs in an institution like the National Gallery.
>
> The resulting situation was surely not easy for Koudelka. After all, he had, at the invitation of the National Gallery, spent four years preparing this exhibition for them.... The institution publicly showed both its disrespect for the medium of photography and for Koudelka and his exhibited works.[53]

Today, both Šorfová and Koudelka are able to joke about the ironic consequences of Knížák's attack: the crowds for the exhibition were exponentially greater than anticipated. With all the brouhaha surrounding the museum's provocative press release, "everyone," says Šorfová, "wanted to see it. 'Who is this Koudelka?!'" But she concedes: "It was very hurtful at the time." Despite these undermining assaults, the exhibition itself was a remarkable expression of Koudelka's work and sensibility. It had already been presented in France, and would subsequently travel to Mexico, Turkey, Greece, and Japan. It was consistently met with great appreciation and success.

As perturbing as Knížák's attack had been, it was Fárová's subsequent written response to the show that, like any sucker punch, utterly stunned Koudelka — especially following as it did her glowing words at the press conference. Two months after the exhibition's opening, in January 2003, she published a withering essay in the Czech magazine *Atélier* titled "Manipulátor

skutečností" (Manipulator of Reality). It seems that Fárová was infuriated by what she perceived as Koudelka's insistence that he had succeeded entirely on his own, without help or influences (this after having made the point, in her speech at the press conference, of praising his "acknowledgments panel"). She challenged the myth of Koudelka — finding him complicit in perpetuating a litany of heroizing exaggerations about his life. And, while recognizing his "strenuous hard work, prodigious talent, single-minded egocentrism," and saying that "Koudelka the person is doubtless attractive and special," she contended that he was manipulative — in the way in which he convinces others to do as he wishes. "The whole path of Koudelka's work is strewn with friends and selfless supporters," she writes (and it is reasonable to presume that she counts herself among them). "They participated in his work ingenuously and with great sympathy and gusto, fascinated by its unquestionably astonishing high quality."

As for the exhibition, she criticized it generally for being too large and incoherent; the panoramas irk her the most, apparently triggering her reconsideration of his entire œuvre:

> In this retrospective, I am perplexed mainly by the dead landscapes in which the show culminates. . . . There are, in my opinion, disproportionately many panoramic landscapes. . . . The engagé character of The Black Triangle disappears in the new whole. Koudelka the engineer drafts his landscapes and faultlessly composes, then he dries them out, and prepares and preserves them. If they contain readable things, for example, car tires or manhole covers, it is not about them, but about their roundness. . . . I sense that an absolutely cold zone dominates here, concentrated on the visual attractiveness of lifeless landscapes, with no clear meaning or mission.[54]

Years before, Fárová had seemed to appreciate the abstract aspect of his theater work, and his non-illustrative approach. But in Koudelka's panoramic landscapes and industryscapes, she seems to miss a literal relationship between the form and function of what is being depicted, and perhaps more importantly, a clear, humanist message. Conversely, writing in the late 1990s about Koudelka's work in Wales, scholar and cultural critic Derrick Price reached a very different conclusion about Koudelka's predilection for draining recognizable industrial forms of their functionality, writing:

> [Koudelka] offers us a different kind of commentary on industrial decline. He works as though he is assembling a formal alphabet of dereliction: one which maintains that objects have lost their old, familiar utility and are made strange by being dislocated, stranded, broken, sunk in mud, abandoned. . . . He seems to want to avoid inscribing any kind of critique into his pictures, which are neither sentimental nor overtly critical, but to invest the damaged landscape with the dignity of a place closely observed and brilliantly recorded.[55]

Ultimately, this was not enough for Fárová, who seemed to want Koudelka to provide his audience perhaps with absolution, or at least with something more hopeful to contemplate. She concluded her article:

> *In the last part of the exhibition, I do not sense the necessary force of renewal. . . . We know that Josef Koudelka is undoubtedly a classic, but why in his retrospective does he stop at annihilation and negation? He makes destructive moments the point and conclusion of the show. Perhaps unlimited love for his own shapes is exhausting his potential for love for everything else.*[56]

It may be that Fárová had too many preconceptions about Koudelka's sensibility, and about what constitutes meaningful photography in general, to embrace images whose composition and content are not in lockstep with each other, and in which the beauty is unconventional and not intent on redemption. At any rate, her assessment was contextualized by criteria that were of little interest to Koudelka at the time. Ultimately, however, he felt betrayed by what he viewed as her duplicity. That she had spoken so effusively about the exhibition in her earlier speech for the press left him incredulous. "Why didn't she tell me to my face what she thought about the exhibition — about the selection and installation?" he asked me. Given his own unsparing frankness, he is constantly puzzled by the prevarications of others.

At the same time, it remains incomprehensible to him that Fárová never expressed disapproval of the press release issued by the National Gallery and its director, other than calling Knížák "controversial" and "egotistical" in her "Manipulátor skutečností" article. An aggrieved Koudelka says: "Anna had been an advocate her entire life for the very kind of photography the museum was saying it did not believe in, did not want to exhibit. She'd fought for it, written about it, did exhibitions . . . and she said nothing."

On February 14, 2003, Koudelka sent Fárová a response to her critique in *Atélier* in which, rather than going on the offense or defense, he expressed his appreciation for her ideas and commentary, praised her knowledge, conceded to disagreeing with her at times, and hoped that their dialogue would continue.[57] But it did not. Although they would ask about one another through Šorfová (who continued to work with both), they never again saw each other in person. Fárová died in February 2010. Šorfová believes that they would have eventually reconciled: "This would have surely happened," she says. "Fárová died too soon." Koudelka told Šorfová in 2018: "Anna Fárová was an exceptional woman and not even this episode can change my opinion about her or about what she did for me and for Czech photography."[58]

During the process of planning and mounting this exhibition, between 1998 and 2002, Koudelka and Šorfová established an ongoing friendship and collaboration grounded in mutual respect, trust, and perfectionism. "We got to know each other to our very cores," says Šorfová. Along with her ongoing work with Koudelka, Šorfová has organized many exhibitions and was for eight years the director of programs and external relations for Prague's DOX Centre for Contemporary Art before joining the National Gallery as head of

international affairs and associate curator of photography. Šorfová has established herself as one of those individuals in Koudelka's orbit upon whom he knows he may always rely.

Mexican author and publisher Verónica Martínez Lira, who began a relationship with Koudelka during this period, refers to Šorfová as "Josef's guardian angel." She fondly recalls getting to know Šorfová — the two are now good friends — when she traveled to Prague from her home in Mexico City, only for Koudelka to unexpectedly disappear to the countryside one day to photograph. Martínez Lira and Šorfová created a sort of performative project inspired by his absence. Martínez Lira tells me: "While he worked endlessly, I would wander with Irena. We made a series of photographs titled 'Visiting Josef,' in which I appear in different tourist spots in Prague, pretending to hug an invisible man."

Verónica Martínez Lira, "Visiting Josef," Prague, 2011. Photograph by Irena Šorfová

Martínez Lira met Koudelka through Graciela Iturbide in Oaxaca in 1999. In 2001 she founded the independent publishing house Espejo de Viento, which has produced a fascinating range of books, from a volume on the medieval mystic Hildegard of Bingen to *Constelación de poetas francófonas de cinco continentes (diez siglos)* (Constellation of Francophone Women Poets from Five Continents [Ten Centuries]), an anthology of works by some 250 poets, from the eleventh century to the twenty-first. Martínez Lira and Koudelka traveled together extensively in Mexico, often visiting archaeological sites.

Koudelka has never realized any projects in Mexico, although it is a country for which he feels great affection. Martínez Lira believes this is because Mexico is simply not his land, not his history. Once he told her that "Mexico has been captured by its photographers; he spoke, above all, about Graciela Iturbide's

Graciela Iturbide and JK, 1998. Photographer unknown

work." But there is a sensibility in his photographs that Martínez Lira feels is connected to Mexico:

The images in the book Gypsies *could have been made in Mexico. There's something about the people and the landscapes that feels familiar. . . . I'm sure he has a photographic record of his time here. At the archaeological sites we visited together — Palenque, Teotihuacán, Xochicalco, Malinalco, Yagul, Monte Albán, Tula, etcetera — he asked me to leave him alone. So I never saw what he photographed.*

243

Iturbide, too, told me that she has never seen any of the photographs he has made in Mexico. Perhaps one day, when Koudelka has the time and inclination to review all his images from the country, he'll discover some he believes worthy of sharing. But when I asked him about this as recently as autumn 2020, he told me: "There's nothing."

PAUSE

Lucina was in high school in Mexico when she got the "strange and out-of-the-blue" call from her father, asking her if she wanted a video camera. "I was confused," she told me, "as I'd never asked for one." It was, she later learned, Sheila Hicks's idea. Lucina, who regularly spent summers with her father, was going to join Josef at his retrospective opening in Arles, France, in July 2002.

I asked Hicks why she suggested this gift. She responded concisely:

So she would not get bored.

So she would have the opportunity to develop an independent eye

Or regard.

Lucina shot very little of the Arles exhibition itself; neither was she seduced by the more paparazzi-like opportunities — she recalls in particular "a very fancy dinner with important people. I was fascinated by the distortions in the wine and water glasses and their shadows on the tablecloth. Josef later amusedly pointed out how much more interested I was in the glasses than in all the important people, but I had no idea who they were and felt no obligation to document them." That experience in Arles was an open-sesame for the soon-to-be sixteen-year-old. She recently told me:

> *Having a video camera and filming my father that summer gave me a new way of seeing. The things I was interested in filming, I probably would not have noticed otherwise. And if I hadn't started filming my father that summer in Arles, I wouldn't have started filming him later on. It just never would have occurred to me, nor to him.*

Unfortunately, that eye-opening experience did not translate, at least immediately, into feeling like herself around her father. Rather, says Lucina:

> *That summer when I was fifteen, I felt paralyzed around my father. I was completely unexpressive, trapped, and had no idea why. I thought it was somehow my fault. I felt guilty for not being able to be livelier and better company.*

JK and Lucina, Prague, 2018.
Photograph by Bara Lockefeer

Years later, Lucina would come to see her own discomfort as a response to what she sensed as her father's way of being around her, despite his outward gregariousness. She says: "He might have been unsure as to how to act around me." The camera ultimately served as a bridge between them. "I loved

filming," continues Lucina, "and having the camera allowed Josef and me to spend time together while both being busy doing something that we each cared about."

In the years between 2002 and 2014 Lucina picked up her camera only sporadically, as she was busy with school. But since 2014 (when she documented the first conversation for this biography), she has rarely been without her camera when around Josef. In 2018, as part of the Musée de l'Elysée in Lausanne's annual "Nuit des images" (Night of Images) event, Lucina premiered her short film *Une esquisse de Josef Koudelka* (A Sketch of Josef Koudelka). Commissioned by Tatyana Franck, the director of the museum, *Une esquisse* is visually lyrical and uniquely intimate. It is not connected to a specific Koudelka project, nor is it meant as a narrative, broad-stroke depiction of him; rather, the film unfolds as a sequence of moments with the artist. "Thanks to this commission," says Lucina, "I was forced to review and edit my footage. I had been longing to do so for years but was never able to take time off from my design work. The process was overwhelming! But through it, I gained a more practical understanding of how to assemble my film, which will help me enormously to imagine the following version." She continues filming her father to this day, with this understanding in mind.

12.

Like Fárová, Henri Cartier-Bresson was ambivalent about Koudelka's panoramas. He missed seeing people in the images. Nevertheless, Koudelka recalls: "Bresson, who didn't like the panoramas, who was repeating all the time: 'Josef, why are you doing this spaghetti?' — when I brought him *Black Triangle*, he made the exception. He said: 'Josef, this book is as important as *Gypsies*' — and he loved *Gypsies*." Koudelka continues: "Bresson always told me what he did not like. Even if I did not always agree, I listened carefully. He was always genuine with me." Along with his candor, Cartier-Bresson consistently extended himself for his "brother" from Moravia. "Right from the start," says Koudelka, "Henri was so generous with me." Their deep bond took hold soon after they met in 1971, and lasted for more than three decades, until Cartier-Bresson's death in 2004. Martine Franck died eight years later, in 2012.

It is 2014 when Josef and I discuss Henri's death. I'm wondering if it continues to resonate for him. He is quiet for a moment as he gets his bearings, and then he begins, voice cracking and dropping in pitch:

When you saw someone only from time to time, you don't necessarily feel their death all the time. When I would go to museums and see a beautiful painting, I would always think: "I have to send it to Henri." After Henri died, I would send the postcard of the painting to Martine. But now ...

When Cartier-Bresson died, Franck implored Koudelka to photograph the funeral — he was the only individual asked and permitted to do so. This was emotionally unsettling for him, but he agreed — "for Martine." Koudelka

would later drink a toast from the last remaining bottle of his father's slivovitz, carefully stored in Ivry.

Mélanie Cartier-Bresson first met Koudelka when she was only two weeks old. Her recollections of "Uncle Josef" are filled with warmth and love.

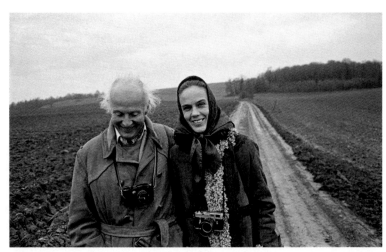

Henri Cartier-Bresson and Martine Franck, France, 1971

> *My father gave a lot to Josef — pushed him all the time to look at paintings, to go to museums . . . they had a lot of talks and arguments about paintings. . . . I think my father helped Josef to see the composition in a painting, and the rhythm. . . . Every time he got back from a trip he would come to our house first to see my father. And then, they were always working on the floor at Rue de Rivoli — the maquettes on the floor, looking at Josef's books — all the books that he did, he was showing first of all to my father, and these two "brothers" were there on the floor for hours. It was beautiful.*
>
> *He came over all the time . . . and all the dinners were so joyful and explosive!*

The French photographer's niece, Anne Cartier-Bresson, has had a distinguished career in the field of photography as well: she was for a time the director of the Atelier de Restauration et de Conservation des Photographies de la Ville de Paris (City of Paris Photographic Conservation Studio), and presently heads the photography section in the conservation department of the French Institut national du patrimoine (National Institute of Cultural Heritage). She recalls:

> *When they first met, what Henri and Josef experienced together was a true encounter. Where it changes everything . . . when there is something that leaves its mark.*

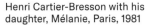

Henri Cartier-Bresson with his daughter, Mélanie, Paris, 1981

> *With Josef — my uncle didn't have this with many other photographers — there was this complicity and this deep and trusted affection. But I think that Henri always had the idea that he was, as the oldest, in control.*
>
> *I think that Josef — even at the beginning — knew at a certain moment that he had to separate himself psychologically from Henri, in order to be able to do his own work. But they stayed very, very close in a way that was often unspoken.*

Taking a deep breath, she wistfully recalls her uncle's death and Koudelka's photographs of the funeral:

Henri's death is a story that is very intimate. I find the relationship between Henri, Martine, and Josef truly touching and moving. The three of them. And this closeness and trust was made so clear when Henri died. Martine asked Josef to make a record of the burial. He was the only person to take pictures.

And so Josef went, and he took photos of Henri on his deathbed, and then the burial. We saw them afterwards, with Josef. He was there at Henri and Martine's house, and then he gave the negatives and the contact sheets to Martine. . . .

That's the end of their shared history. In images. In photographs.

But there is a grand coda. When we spoke, Mélanie mused nostalgically about "all the vacations in the South of France when Josef came." I asked her about the infamous slivovitz tree — had she unearthed her bottle when she got married, and had she and her parents drunk from it? She laughed, and divulged her plan:

Not yet. I'm waiting for Lucina to get married, and I'll drink it with her. Lucina has to come, and we need to find where Josef and my father buried the bottles, the hole. We know the tree, but it's a big tree. Then Lucina and I will dig them out and drink. It will be like we are all there together.

It was 2019 when Mélanie told me this, and Lucina Hartley Koudelka and Vincenzo Iovino had recently announced their engagement.

POUR JOSEF MELANIE

UN BIZOUXXXXX

Henri Cartier-Bresson and JK, Paris, ca. 1975. Photograph by Mélanie Cartier-Bresson. Inscribed: "For Josef, Mélanie, a kiss xxxxx."

13.

In 1990, just after the Velvet Revolution, Koudelka and Robert Delpire edited a selection of his work on the 1968 Soviet invasion in Czechoslovakia, which Delpire produced as an independent Photo Notes publication.[59] Sixteen years later, as the fortieth anniversary of the invasion was approaching, the publisher Viktor Stoilov urged Koudelka to consider making a larger book devoted to his coverage of that week in August 1968, which Torst would produce in the Czech Republic. Although the two men, along with Anna Fárová, had previously discussed this idea for the thirtieth anniversary in 1998, now the timing and the conceptual possibilities seemed optimal. But Koudelka had never before realized a significant publication of conceptual and visual heft in just one year. Could he?

Hervé Tardy discussed this project with Koudelka over dinner one evening in 2006. He remembers saying: "But Josef, that's ridiculous! You're going to

247

make this book only in a Czech edition? This is a book you could do with other publishers, in other editions."

And "Mr. No" said: "If you'd like to take care of that, go ahead."

So I say to him: "I'll deal with it. You'll see, Josef, we'll publish Invasion — we'll make a book that will be published in multiple foreign-language versions."

Koudelka further challenged Tardy to ensure that the book would have an affordable retail price. Tardy understood that for Koudelka, whom he had known for nearly forty years, making money was not a priority: "The royalties he's gotten from his books are ridiculous, they are so little. He has no interest in high royalties. What he wants is for his books to be made *just so*." Tardy concurred that the volume should be affordable to the general public.

Why the unprecedented immediate "yes" to the proposal of a major multi-edition book on the Prague invasion? Tardy and I discuss the question and conclude that Koudelka feels differently about this work. It was the first and only time he bore witness to a news event. Its continuing resonance in his homeland is incalculable. At the same time, the images read as a reminder of the immediate and pervasive threat of authoritarian governments worldwide. Koudelka's skepticism about the reliability of memory persists; this body of work is irrefutable.

As they identified the specifics of the project, Tardy carefully delineated who would be responsible for what. He recalls:

It's a book that had to be put together relatively quickly — it was prepared in Prague, with the Czech designer Aleš Najbrt, with whom Josef had worked previously. I took care of all matters of production.

I look at Invasion now, more than ten years later, and think, for me, it has all the power and all the daemon that is Josef. . . . He was young when he made these photographs, and had extremely sensitive reactions. He was engaged, he was determined. I find the book to be truly powerful, violent — which is not just about what the pictures show, but also about the way it was conceptualized.

Hervé Tardy and JK, Paris, 2011. Photograph by Lesley A. Martin

Koudelka's goal was straightforward: to present the truth of the Soviet invasion of Prague in all its complexity and to do his best, in the sequencing of images, to respect the chronology of events, while still evoking a sense of what Prague "felt like" over the course of that week in August 1968 — the intense solidarity of the Czechs in the face of Soviet aggression.

He had a perfect partner in Najbrt, whom he had met in 1992. At the suggestion of the Prague-based Slovak photographer Tono Stano, Najbrt had invited Koudelka to contribute to an issue of *Raut* (Soirée), the super-large-format, short-lived magazine co-founded by Stano, and for which Najbrt was the designer and principal editor. Describing its founding, Najbrt says: "The

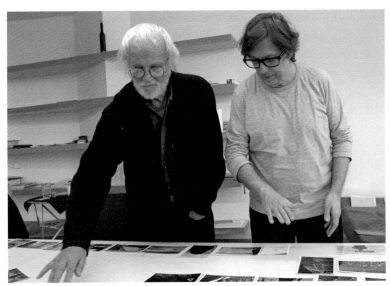

JK and Aleš Najbrt, 2013.
Photographer unknown

magazine was established quite soon after the Velvet Revolution — we wanted to present interesting people from the Czech arts scene, some famous, some unknown." Although aware of Koudelka's Roma work and the 1968 images, Najbrt knew little about the photographer when first reaching out to him. He was, however, given a thorough briefing: "Anna Fárová and other people from Prague who knew Josef were preparing me, telling me that the communication would be quite complicated, and that he might refuse to work on the project — that he has his own opinions, and he's very stubborn."

But when Koudelka saw Najbrt's design for the issue of *Raut* he was pleased: "He has an excellent eye," he says of the designer. Najbrt has a decidedly refined graphic sense. This visual intelligence, along with his generally low-key manner, collegiality, and patience, has helped him to work consistently and effectively with Koudelka to this day (including on the design of this biography). Of their nearly thirty years of collaboration on publications, exhibitions, and accompanying ephemera, Najbrt says:

> *Josef always has his very precise picture of how the things should go and makes interventions in the design. So sometimes it seems like my role is quite narrow. But I really appreciate the collaboration, which is always very intense. And I learn so much each time. . . . What I think is important and unique is that we can agree on the choice of the pictures and also on the arrangement of them on a spread.*

On January 1, 2007, Koudelka called Najbrt from Paris to ask the designer to work with him on the *Invasion* project. The plan: to look at every single image he had made during that week in 1968. "Of course," says Najbrt, "I said yes." Up until then, he continues, "I was aware of only the small group of pictures from the Photo Notes edition." There were thousands more — although Koudelka says that, of the nearly 250 photographs comprising the book, "I didn't discover one picture that I would add to the eleven I have always considered the best and selected to represent this body of work in the past."

Koudelka asked Najbrt to prepare some design treatments over the course of the following three months, and so they began brainstorming, and the designer experimented with possible layouts. Koudelka liked Najbrt's early proposal, which served to guide their work, although it took them a long time to select and position the photographs. As ever, Koudelka was clear

about his preferences, and Najbrt notes that it sometimes took several tries before the photographer would consider adding an image he'd not initially selected to the mix. Eventually they determined a logic and structure for the book — groupings of four or sixteen photographs on a spread, interspersed with driving, double-page-spread horizontals. "As we started placing the photographs in the structure we had determined," says Koudelka, "the book began to crystalize."[60]

Aleš Najbrt and JK, 2017.
Photographer unknown

Stoilov suggested that the book should include a substantive contextualizing essay and engaged three historians from Prague's Ústav pro soudobé dějiny (Institute of Contemporary History) to write the introduction: Jaroslav Cuhra, Jiří Hoppe, and Jiří Suk; in addition, they provided official documents, Czechoslovak Radio reports, and other primary materials from the period. Irena Šorfová wrote the afterword.

Tardy is a man of his word. *Invasion 68* would eventually be published in twelve international co-editions — eleven languages — beginning in 2008. Along with the Czech edition published by Torst, and Tardy's French edition,[61] there are British, Dutch, German, Greek, Italian, Japanese, Romanian, Spanish, and US co-editions. Regarding one of the co-editions, Stoilov said that, in a "certain euphoria, I promised Josef that if no Russian publisher were found, I would publish a Russian version myself."[62] He did so in December 2009.

Each of the twelve editions opens with Koudelka's dedication: "For my parents, who never saw these photographs."

As they were conceiving the book, Koudelka and Najbrt, along with Šorfová, began to prepare an accompanying exhibition. At first this was planned for the Národní muzeum (National Museum) in Prague, but ultimately, and with the help of Koudelka's friends Marta and Martin Stránský, it was held at Prague's stunning fourteenth-century Old Town Hall. The selection, sequence, and design of the show were based on the book's layout. Šorfová recalled: "There was huge interest in the exhibition. People visiting it recognized themselves, friends, and family in some of the photographs and they recalled their feelings at that time. It was very emotional."[63]

It was around this time that I entered Koudelka's orbit really for the first time (although we had met fifteen or so years earlier). Aperture was to publish the American edition of *Invasion 68: Prague*. I was then serving as editor-in-chief of the quarterly *Aperture*, and I interviewed him before the book's release for the magazine's August 2008 issue. In our conversation, he mentioned the forthcoming exhibitions in Prague, and also in Milan — there organized by Roberto Koch and Alessandra Mauro of Contrasto for their Fondazione Forma per la Fotografia exhibition space. I asked him if we might present the show at Aperture's gallery in New York. He first said no — but then acquiesced (actually, I think he was pleased).

Before we could proceed with the plan, however, it seemed we needed to check in with Koudelka's gallerist in New York, Peter MacGill. Koudelka's last show at Pace/MacGill had been more than a decade earlier, in 1993 — and

by the end of the 1990s, Koudelka had stopped allowing any gallery to sell his prints. When his printer Voja Mitrovic retired from Picto in the late 1990s, it was a turning point. As Koudelka later told curator Clément Chéroux:

> Why bother with things that don't interest me? Making prints, signing them, numbering them, selling them . . . ? I stopped all that when Voja left, and it was the best decision to make. . . . The question of vintage prints is important. But this obsession that curators have for vintage prints sometimes becomes absurd. When you do an exhibition, you do it for the public, which is much less concerned with these issues.[64]

Why would a gallery continue to represent an artist whose work it rarely gets to show, and is not permitted to sell? MacGill is succinct: "It's simple. We believe. With Josef, it's this incredibly strong, brilliant march forward." In 2019 I met with MacGill and Lauren Panzo, then a director at Pace/MacGill, who works with Koudelka. Panzo concurs, adding: "Yes, we're a gallery, but it's not about sales always."

MacGill notes, however, that working with Koudelka is not uncomplicated:

> People can get consumed working with him. He can make things so unnecessarily difficult. . . . I think the greatest thing that could ever happen would be if he could trust his team. The best is when Josef gives people the latitude to do the job they want to do for him, in order to give him a broader platform from which to operate. That's when he's the most successful. It's not that he's not in charge; he is in charge, but he needs to allow his team to help set the stage and then give the stage to him. And then it's his. Because nobody in the world is better at hanging a show, conceptualizing this and that. . . . But I believe he should not always fight the process of those around him, those who are working on his behalf.

Peter MacGill and Lauren Panzo, Grand Palais, Paris Photo, ca. 2012

What exactly has consumed MacGill and Panzo with Koudelka? First there are the usual technicalities: assisting with various aspects of exhibitions (the gallery was instrumental, for example, in facilitating Koudelka's 2014 retrospective at the Art Institute of Chicago) and reviewing contracts — usually in consultation with Sheila Hicks. But they also managed to track down one of the *Gypsies* dummies that had been lost decades earlier, and have helped to resolve any problems that have arisen with institutional acquisitions of Koudelka's work over the years.

MacGill gave his blessing for the Aperture show. And Koudelka gave his blessing for a concurrent exhibition to be held at Pace/MacGill, in which the gallery would be permitted to sell his prints. It had been almost fifteen years since Koudelka's work had been presented

in New York City. Pace/MacGill presented a selection of Koudelka's Prague work in September 2008.

The selection and sequence of the images presented in the larger *Invasion 68: Prague* exhibition at Aperture had been determined by Koudelka and Najbrt. The remaining decisions primarily concerned text panels (the typographic design would be drawn directly from the book), and the space itself: installation and production. Like the book, the show came together quickly. In keeping with his newfound "yes" approach to this work, Koudelka agreed, as he'd done with Najbrt, to let me suggest an installation concept, which he accepted. Aperture, too, agreed to let me play.[65] The installation was decidedly cinematic, with Koudelka's images (including several mural-sized prints) hung against black walls, all dramatically spotlit. There was also a selection of images from those Koudelka had made of the posters the people of Prague had plastered on the walls along their streets. These were printed using an office copy machine, on cheap paper, and taped to the outside of the walls delineating the entrance to the exhibition, as well as wheat-pasted along the

Invasion 68: Prague exhibition at LOOK3 photography festival, Charlottesville, Virginia, 2013. Photograph by Andrew Owen

boarded-up buildings and façades on Manhattan's West 27th Street, leading to Aperture's gallery.[66]

The exhibition included a short film that had been made in 2002 for Koudelka's Prague National Gallery retrospective. Moving between his images and archival news footage of the invasion, it also includes riveting found footage showing Koudelka with his cameras, confidently perched on top of one of the Soviet tanks photographing (this clip was fortuitously discovered in the archive of a Czech television station).[67]

For one of the movie's creators, Jan Horáček, the film was the start of a lasting friendship with Koudelka. In 2002 Horáček was finishing his studies at Prague's film school FAMU, when word came that Josef Koudelka was looking for someone to make a film about his 1968 photographs. Horáček jumped at the chance — "Like everyone else, I knew Koudelka's work. He was in Prague,

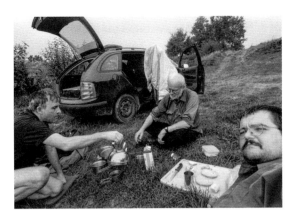

Poland, 2010. From left: Jaroslav Pulicar, JK, and Jan Horáček. Photograph by Jan Horáček

and I wanted to meet him." Koudelka visited Horáček's dorm room to discuss the project, and they proceeded from there.

Around the time he encountered Koudelka, Horáček also met the Czech photographer Jaroslav (Jarda) Pulicar, who had met Koudelka at Magnum Paris in 1989, at the suggestion of Pavel Dias. Pulicar recalls that, beginning in 1990, Koudelka began returning to Prague annually, and the two photographers would go on excursions around the country together (Pulicar driving) for a couple of weeks. Starting in March 2003, Horáček joined the pair on these jaunts, during which they might take in folk festivals. They also went on a pilgrimage to the village of Ľutina, where Markéta Luskačová had first brought Koudelka in the 1960s. ("Josef would joke that his daughter was named after this place," says Pulicar.) They also went to Grabarka in Poland. Horáček, who is trained as a director of photography, told me: "Josef offered me the chance to go with him when he traveled so I could film — he would pay for food and other expenses. I think this is because Josef was quite satisfied with the *Invasion* film."

After its presentation in New York, *Invasion 68: Prague* toured through 2013 to venues worldwide — most of them borrowed the idea of the black walls, and all of them showed the film and realized some site-specific iteration of the postering. In the United States, it was presented in Washington, DC; Charlottesville, Virginia; and Miami, among other places. Aperture also sent the show to Mexico City, Buenos Aires, São Paulo, and Tokyo.[68] It was, somewhat surprisingly, also welcome at the Pingyao International Photography Festival in China.[69]

Even more astonishing, in October 2011 *Invasion 68: Prague* opened at the Lumière Brothers Center for Photography in Moscow. "I never thought that the exhibition would take place there," Koudelka later said, "that I would succeed in taking the Russian tanks back to Moscow. Today, it would . . . no longer be possible."[70]

As miraculous as this felt — and it did — there was yet another moment

Opening of *Invasion 68: Prague* exhibition at the Lumière Brothers Center for Photography, Moscow, October 6, 2011. From left: JK, Natalia Gorbanevskaya, and Czech ambassador to Russia Petr Kolář. Photograph by Viktor Stoilov

that took our collective breath away: the arrival at the opening of Natalia Gorbanevskaya — the courageous young mother who, in August 1968, was arrested and later incarcerated in a psychiatric institute for protesting in Moscow's Red Square against the Soviet invasion. Now, more than four decades later, Gorbanevskaya and Koudelka embraced like old friends-in-arms — where so much that is unspoken is still understood — at the opening of his show. Stoilov told me that the moment "was, for me, a peak in my life — the highest point. To be there in Moscow, to have made the book exist also

in Russian! To have those photos there, and the two of them hugging. I said to myself: 'I can quit my work now. This is the greatest thing I can ever be a part of.'"

Koudelka has speculated about why these photographs from 1968 are still resonant four decades after the fact:

> *You can wonder why* Invasion *was published forty years after, in twelve editions. Why are people interested? Part of the reason, I think, is that this book, these pictures became a symbol of any act of military oppression, and of the fight for freedom.*

14.

"One Wall, two prisons." This graffiti, written in English on the Wall, spoke stridently to Koudelka of the loss of dreams, the loss of freedom. He was photographing the Israeli and Palestinian landscape as defined by this monolithic partition for his project titled *Wall*. Human Rights Watch and other such groups have referred to it as the "separation barrier." Israelis frequently refer to this structure, established in the West Bank by the State of Israel beginning in 2002 and constructed mainly from concrete and barbed wire, as the "security fence." Many Palestinians call it the "apartheid wall."

"I grew up behind the Wall," Koudelka said to filmmaker Gilad Baram:

> *All my life, till I left Czechoslovakia at thirty-two, I wanted to go on the other side of the Wall. For me it was the prison; I was in the cage. So of course I didn't like the Wall.*
>
> *But in the same time it is pretty spectacular, this Wall.*[71]

Although this is not Koudelka's *"terre,"* his history, the questions he would explore photographing for *Wall* had pulsed through him for much of his life. It immediately struck Koudelka both symbolically and physically as a familiar demoralizing tool of occupation, as well as an unconscionable assault on the landscape.

Between 2008 and 2012, Koudelka made seven trips to the region, as a participant in a group project titled *This Place*, conceived and initiated by the photographer Frédéric Brenner. The undertaking began with Brenner's hope "to create an encounter with Israel and the West Bank that truly reflected the complexity of the place, with all its rifts and paradoxes." With this plan in view, he assembled a group of twelve internationally renowned photographers who were, as he put it, "not embedded in the daily conflicts and dialectics of Israeli and Palestinian life, and who could look without complacency but with compassion." Brenner understood that this challenge was unlikely to be compellingly realized as assignments for these photographers. Instead it would be conceived as a "residency and a commission." Each individual would have the time to look, understand, process, and ultimately create a unique and in-depth project.[72]

Many who knew of Brenner's plan, whatever their politics with regard to Israel and Palestine, were initially skeptical about the project — fearing its propagandistic potential and how easily it might be co-opted and exploited. Brenner eventually managed to assuage these concerns, largely through his choice of artists. The contributors, along with Koudelka and himself, included Wendy Ewald, Martin Kollar, Jungjin Lee, Gilles Peress, Fazal Sheikh, Stephen Shore, Rosalind Fox Solomon, Thomas Struth, Jeff Wall, and Nick Waplington.[73]

Koudelka's decision to take part in *This Place* was fraught and protracted. He consulted with friends and colleagues — many of whom advised him not to touch such a loaded subject. Fellow Magnum photographer Larry Towell had completed two long-term projects on the Palestine-Israel conflict between 1993 and 2004 — bodies of work that Koudelka very much respects. From Towell's perspective, which he shared with Koudelka, and later me, Israel's engagement with Palestine "was nothing but a cruel occupation imposed by apartheid policies."

In the end, Brenner convinced Koudelka, who had never before been to Israel or Palestine, to visit Israel to determine whether or not he would participate. Koudelka insisted upon paying his own way for this 2008 scouting trip, to preclude any sense of obligation if he eventually decided against getting involved. Journalist Sean O'Hagan interviewed him shortly after that initial visit, when Koudelka was still uncertain of his plans — but it was clear he had found a subject that compelled him. "If I go," he said to O'Hagan, "it will be to photograph the wall . . . because of its devastation of the landscape. And this is monumental. I see this wall as a failure of civilization."[74] Later, Koudelka would say: "I knew if I started to do some work, I would get emotionally involved." And emotional involvement was not necessarily what he wanted.[75]

Koudelka first encountered a section of the Wall when he visited East Jerusalem. And there were other aspects of Israel and the West Bank that resonated with him:

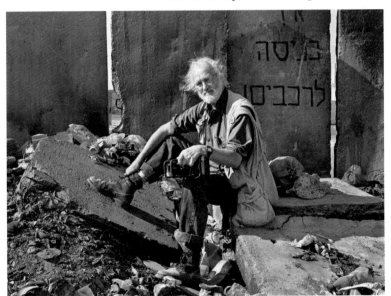

JK at Qalandiya checkpoint, Israel-Palestine, 2011. Photograph by Gilad Baram

I was interested in seeing Jerusalem, to see all of these places where, supposedly, Jesus Christ walked around. I was born as a Catholic. I know these stories from the Bible. I reread these stories when I looked at religious paintings early on. And I read many again when I started going to Israel. I'm not religious, but I know this is an important place. And then suddenly there is this Wall. You can't believe it — a wall in such a holy place!

In addition, he found this monolithic structure to be formally captivating: "It just asked to be photographed with the panoramic camera."

His usual concerns and caveats were more essential than ever. He wanted complete control over how the images would be used, and the right to do with his images what he wished — whether he published his work independently or participated in the group project. He also needed to know how the project was being funded. (It was apparently Cartier-Bresson who early on drummed it into the Magnum ethos to always inquire about the source of the money behind projects.) In this case, the sponsorship came mostly from American cultural and socially conscious foundations — none with a spurious agenda. Satisfied, Koudelka made a second trip to Israel. Brenner assured him that he would have all the creative control he wanted, to realize, publish, and exhibit his project (while acknowledging that access and mobility might at times be left to the whims of the Israeli military). Finally, on his fourth visit, Koudelka signed a contract to participate in *This Place*.

In 2009, during his second trip to Israel, Koudelka met the young Israeli photographer and filmmaker Gilad Baram, who was assigned to assist him. "They gave each photographer somebody to take them around," Koudelka says. He was dubious at first: "Of course you don't know who these people are . . . Israel is small, and the police know about everything. You know you are going to be watched. At first I thought that Gilad might be part of the Mossad." Koudelka quickly understood that Baram was not part of Israel's Central Institute for Intelligence and Special Operations, and that these suspicions were grounded more in the circumstances of his own experience in Czechoslovakia. Baram notes that, as far as he is aware, Koudelka was never the subject of surveillance in Israel.

Yes, Josef was denied a journalist card by the Israeli press office, and he was always questioned at the airport — but both can sadly happen in Israel. In fact, I was rather surprised by the freedom we had back then, to move around and get very close to what is considered highly guarded structures. We were stopped many times but never actually detained or arrested.

Baram recalls that Koudelka had seen only a small section of the Wall on his initial trip and "didn't know if what he saw . . . represented the whole thing." Understanding its visual potential is what occupied Koudelka on his second trip.

Baram was a twenty-seven-year-old photography student when they met. "All I wanted was

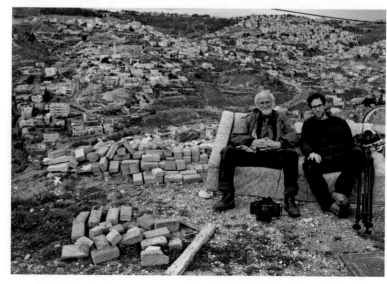

JK and Gilad Baram in Abu Dis, overlooking Southeast Jerusalem, ca. 2010. Photograph by Atta Awisat

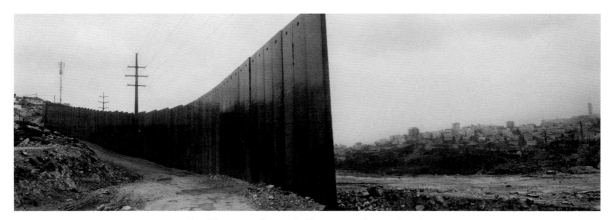

Shu'fat refugee camp, overlooking Al-Isawiya, East Jerusalem, 2009

to be like Josef Koudelka, or rather what he represented — the nomadic, freewheeling observer of the world. I felt like I was doing something special. Not just because I was with Koudelka, whose work I admired so much, but because I had the chance to see things I'd never seen before." Once the immediate dazzle had passed, he began to take stock of Koudelka's mode of seeing: "He's all the time looking — not only through the camera. Just looking. At everything. When we are driving in the car, he's looking. When we stop the car, he's looking. . . ."

It also became clear that Koudelka didn't need a photography assistant so much as a driver and "somebody to sometimes translate and sometimes deal with security issues." Baram says: "I didn't want to only do that, be a 'fixer.'" One day, toward the end of their first trip together, Baram brought his own camera and started photographing. Koudelka's response was immediate and unequivocal: he asked Baram to stop, which he did. But Baram was persistent, finding Koudelka's objections "unreasonable," and that afternoon he again began to photograph: "Josef saw me, looked at me, but this time said nothing. That's when something began to happen."

The filming came later, during the latter part of Koudelka's third visit to the region. Baram remembers what started it off: "I was paying much attention to the way Josef was looking and photographing. It was his very bizarre movement that first made me switch modes on the DSLR camera I had back then, from stills to moving image. Immediately I realized that the moving image medium was the one that corresponded to my point of interest in him." (Over the years, Koudelka has allowed some of those who have traveled with him — including Coşkun Aşar, Jan Horáček, and Cristobal Zañartu — to film him as he works, as long as they don't interfere with whatever he's doing. Lucina, as his daughter, always has special filming access — but even she knows not to get in the way of his photographing.)

After six trips together, and much follow-up time with Koudelka in Paris and Prague, Baram had enough footage and understanding to compile a visually telling and highly considered feature documentary, *Koudelka: Shooting Holy Land,* which premiered in 2015 at the Ji.hlava International Documentary Film Festival in the Czech Republic. *Shooting Holy Land* unfolds experientially in

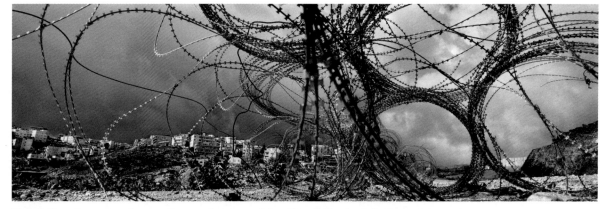

Al-Eizariya (Bethany), East Jerusalem, 2010

Koudelka-time: that is, we often end up watching Koudelka look before ulti-mately deciding from which angle and distance, for example, to take the picture. Baram also utilizes materials from Koudelka's archive, drawing clear connec-tions between this work, *Exiles*, and *Invasion 68*.

By the time of that 2015 screening, Baram, having grown increasingly disil-lusioned and skeptical that the Israeli government sincerely desired a respectful peace, had left his homeland and moved to Berlin. "I'm part of an Israeli age group marked by the murder [in 1995 of Israeli prime minister] Yitzhak Rabin," he told me. "We were fed the idea of peace and a two-state solution as the end of all wars throughout our formative teenage years. Today, this seems to be a faraway universe."

Baram says that his time with Koudelka played a part in his decision to leave his homeland:

> *The journey with Josef through Israel and Palestine, in which I saw places I'd never seen before and met people I would not have met otherwise, had a "last straw" effect on me. This opportunity to penetrate the physical and mental barrier, and see for myself, with my own eyes, the extent of my society's doings, my government's political decisions . . . left me with a feeling there's no other choice for me but to leave.*

Although many of Koudelka's colleagues had long ago shifted their allegiances to digital, Koudelka chose to shoot *Wall* entirely with film — it was the last project he would realize this way. Baram says: "I think he wanted to finish the Israel-Palestine project with film, because film for him meant real, meant material." Koudelka at first denied a connection between this work and his work on the 1968 Soviet invasion; he noted that the *Wall* images are, unlike the Prague images, mostly devoid of people. But no matter how formally disparate, their fundamental thrusts converge. Over time, Koudelka has come to acknowledge this as well. He has said: "Because of Czechoslovakia, I can feel walls, I can feel occupation, and what it means." And Baram's point is sound: the material, evidentiary nature of film matters here, just as it did with his documentation of the Soviet invasion. Although visually Koudelka prefers to rely on his own eyes — not to be influenced by what others say or by preconceptions — the

daily situation in Israel, informed by his own personal history, made this an impossible strategy for him. Baram recalls the intensity of their workdays:

> *When you go every day from seven o'clock in the morning to eight o'clock at night, and you're always next to the Wall, then the sense of being imprisoned is super palpable. This is what we were doing every day, including weekends. There was no relief. Josef created the situation like that. . . . There was no relief at all. . . .*
>
> *He was reading newspapers every day — the* Herald Tribune-Ha'aretz *newspaper in English. . . . He wakes up at around 4:30, so he had these two and a half hours before we met in which he would probably look at his photos and prepare himself for the day. But he would also read the newspaper, because he would meet me at the car with highlighted articles that interested him, and we would talk about them in the car. He's paying very close attention. He was very aware of everything political that was going on in Israel when he was there.*

The intensity of Koudelka's desire to understand aligns with his desire to be precise, to be truthful. He considers context always, even if his work does not literally address it. He wants to be fair. During the course of his project in Israel he revisited Auschwitz, which he had first photographed in the late 1980s. He traveled there three times, needing, he said, "to remember how the Jewish people had been murdered, how they had suffered." At Auschwitz he saw the same ensnaring barbed wire that now topped parts of the Wall — and he was unable to come to terms with this perverse irony. The wire, as he later told Baram, also symbolized people's fear.[76]

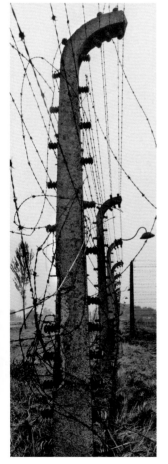

Auschwitz-Birkenau concentration camp, Poland, 1992

The trips to Israel grew increasingly unbearable for Koudelka. He found it impossible to shake the specter of oppression, so flagrantly symbolized by the Wall. Still, he had met a number of sympathetic people in Israel, including of course Baram, who had quickly earned his respect and his trust. During one of their first trips together, there was a moment of beautiful and fleeting fog, and Koudelka bolted out of the car to photograph, but he ran out of film and did not have his extra rolls on him as usual. Seeing this, Baram raced back to the car and gave Koudelka what remained of his own rolls — the younger man forsaking whatever photographs he might have made to do so. And there were many moments when Baram had to negotiate with Israeli security forces, putting himself at risk in the process. Koudelka tells me: "Without Gilad, I would never be able to come to my knowledge about Israel — which I had none — do the work there, or produce the book."

There were moments when he and Baram found themselves blocked or surrounded by Israeli military forces. One time in East Jerusalem, when they were trying to find a shady spot to eat their lunch, they had an actual altercation. Koudelka recalls:

> *Suddenly the Israeli border police holding their assault rifles came running toward us. It was the only time I was afraid there. They frisked us and kept aggressively questioning us, and one hit my camera — breaking it, but I did*

not know that until many days — and sixty rolls of film — later, when I saw I did not have one image since that moment.

Koudelka understands Baram's disillusionment with his home country: "Seeing what he saw with me had to be hard for him."

Generally, Koudelka's visits to Israel were limited to two or three weeks. Baram:

Josef photographed not only the Wall and not only in the West Bank but also in many other parts of the country . . . focused on a specific mission but at the same time, in quite an astounding way, keeping himself as curious and open as possible. We drove to and photographed in the occupied Golan Heights, in the Negev desert at the south of Israel. We also covered most (if not all) of the Roman archaeological sites in the country including Beit She'an and Cesaria. . . . We really went everywhere.

From Baram's perspective, their most difficult time together occurred when Koudelka stayed in Israel for an entire month. "Always after two weeks he'd get so agitated, he just couldn't stand being there for longer than that. Four weeks seemed interminable to him." Koudelka's flagging spirits while working on this project became particularly poignant in retrospect, when Baram, in Prague, heard Pulicar and Horáček describing how much they laughed while driving Koudelka around Europe. In Israel, Baram rarely experienced the lighthearted, joyful Koudelka:

I think the situation in Israel and Palestine touched a very deep place in him of something that is very strongly unjust. A feeling of prison, of being occupied by others . . . I think he identifies with it — with the Palestinian position — so much that it sort of becomes his own. . . . Yet I think there is a certain psychological fight in his mind, because he knows that he can get out any minute he wants to, that he can just get on a plane and leave. And every time, when he was about to leave — toward the last week of every visit — he was saying: "I'm so happy I'm going to leave this place!" As you can imagine, for me as an Israeli, sitting there and hearing this, it wasn't that easy. . . . Not in terms of nationalistic feelings . . . it's just because I know that I can't detach myself so easily . . . just like he never really detached from Czechoslovakia — even if he says he did. . . .

Josef mentioned many times the impact that the Iron Curtain had on him, as on many in Czechoslovakia and other Soviet-controlled countries. While used as a metaphor in the West, the Iron Curtain was very tangible for Josef, although he had never been anywhere near it. He knew that people had been electrocuted and shot along his country's borders with the West, trying to escape. The idea of an impassable barrier or a "cage" — as he frequently called it — was effectively engraved by the authorities in people's minds. For Josef the Iron Curtain was as real as if he had seen it with his own eyes. In the West Bank it became absolutely real — truly concrete — and he reacted very strongly.

To Koudelka, the Wall is a double violation. He speaks passionately of the crippling effects of separating people from their land, their crops — perhaps

because of his own deep nostalgia for the cherished trees he planted with his father as a child. "To cut down a tree is taking a life. . . . These trees were a part of the Palestinians," Koudelka says — trees that families planted and tended for hundreds of years, on land that was once theirs, and is now at best inaccessible, at worst destroyed by Israeli authorities because of infrastructure work supporting both the Wall and Israeli settlements.[77] Koudelka told the journalist René Backmann:

> *Just as there are crimes against humanity, there are crimes against the landscape. This land that I photographed is now a divided land. In it, both groups of people try to defend themselves. The one thing that can't defend itself is the landscape. And it is a landscape that is considered most sacred by a large part of humanity. A crime is a crime, regardless of the name or the justifications given for it.*[78]

Koudelka's book *Wall: Israeli & Palestinian Landscape, 2008–2012* was co-published in 2013 by Aperture and Xavier Barral. I worked with Koudelka editorially for Aperture; Barral worked with him on the design. It is a striking large-format horizontal book in which every image spans the gutter and pushes toward the edges of each spread. There is just enough breathing space surrounding the photographs to indicate Koudelka's framing. "Josef wanted to be able to clearly show how the Wall was a strategic thing," Barral told me. "Politically, it was something that really touched him. The new construction shocked him enormously. He looked at it as an aberration. . . . In the end, he is indignant . . . and this book, it is, in its own way, very militant." The book's texts are, as ever, starkly factual: a chronology of the Wall, informative captions for each image, and a "lexicon" of politically loaded terms related to this colossal structure. Written by the author of many reports on the Wall for the United Nations, Ray Dolphin (with assistance from Baram), these unembellished textual elements neither take sides nor push an agenda.

For the group show *This Place*, to ensure that his images would be experienced as a whole, Koudelka chose to represent *Wall* with one large print, a projection, and a handmade, accordion-fold book of thirty-five photographs.[79] When opened, this book became a twenty-two-meter-long strip, which he would position in the exhibition space to obstruct passage. Peter MacGill recalls the effect of the installation when *This Place* was exhibited at the Brooklyn Museum:

> *He put, in the middle of a room, a diagonal structure — the vitrine that contained the accordion book. . . . What was his project? Wall. And he put a wall in the room. You have this thing, however he designs it, interrupting a space — however, he wants it to be interrupted. . . . It was fucking incredible.*

In 2013, toward the end of his life, John Berger saw the book *Wall* and was inspired to write down his response and send it to Koudelka — in case, Berger said, it should ever be of use. He wrote:

> *What makes these photographs an extraordinary testimony to this crime is their largeness and quietude. They are the opposite of action pictures. They show the sky, the hills, the soil, the grass bearing witness to the pain of what*

has happened and is happening. They show, without a murmur, the skin of a place and what is being inflicted on it.

Koudelka reveals to us the epidermis of the Holy Land as it is suffering today. There is scarcely any rhetoric, there is simply the land's pain. The hills are aghast. The grass is ripped. Trees are truncated. The sky has to resort to all its patience. The light asks questions and will not stop.[80]

Along with its clear relationships to *Exiles* and to the *Invasion 68* reportage, *Wall* articulates Koudelka's persistent consideration of the human impact on the landscape, as seen in his *Black Triangle* and Beirut work. He connects *Wall* also to his *Gypsies* project, as he sees the divide between the Israelis and the Palestinians as currently unbridgeable and has compared it to the endless trials of the Romani people: "Neither situation is easily resolvable," he says. At the same time, the long history of the Palestine-Israel region — with its endlessly layered traces of humanity on one of the most sacred of historical landscapes — brushes up against his archaeological project, *Ruins*. Perhaps it is in part because *Wall* intersects with and reflects the more melancholic aspect of so many of his projects that his time in Israel left him in despair.

15.

Koudelka discovered an antidote to this anguish in the peacefulness of the quarries he continued to photograph. Beginning in 2006, he started photographing at Lhoist's sites in the southeastern and western United States — landscapes that, despite their ecological exploitation, he found mysterious and engrossing, still holding a possibility of regeneration.

Koudelka has something of a network in the United States and has traveled there regularly since the mid-1970s, most often to New York. His trips are generally project-related or timed to the annual meetings hosted by Magnum's New York headquarters in rotation with the Paris and London offices. While in New York, he sees friends and Magnum colleagues such as Bruce Davidson, Elliott Erwitt, Susan Meiselas, and Gilles Peress. He also sets up shop at the Magnum office, which he uses much as he does the Paris headquarters: making phone calls and relying on the staff to dispatch his correspondence (faxes in the old days, e-mails today) and assist him with other tasks. (Unlike the Paris office, however, New York's Magnum has only rarely served as his temporary domicile.)

Then there are Koudelka's touchstones, his "friends" at the city's museums. At the Metropolitan Museum of Art, for example, he makes regular pilgrimages to the Sardis column, the ancient Ionic marble monolith that originally stood in the Temple of Artemis at Sardis in Turkey (a site where Koudelka has photographed several times). Also at the Met are the frescoes in the reconstructed room from the Pompeian villa of Agrippa Postumus at Boscotrecase, in Campania, buried during the eruption of Vesuvius. In the museum, says Koudelka, "you are visiting the friends who don't live anymore — who have been living few centuries ago, but they are still living there by what they did. . . . This

Aaron Rose, New York, 2014

Susan Meiselas and JK, 2016. Photographer unknown

Elliott Erwitt and JK, Arles, France, 2012. Photograph by Adriana Lopez Sanfeliu

Fanny Ferrato, Donna Ferrato, and Philip Jones Griffiths, New York, 1984

Moira North and Mimi Gross, New York, 2016

Bruce and Emily Davidson, New York, 2007

Gilles Peress and JK, 2014. Photographer unknown

is nice." Looking at a painting by Rembrandt, he observes: "If you have a chance to meet him, you would like him to be your friend."[81]

There was a period when Koudelka would stay with Erwitt on Central Park West during his New York visits. At other times, both he and Lucina have stayed with Meiselas, downtown near Little Italy. Most often, however, he stayed in SoHo with his dear friend Aaron Rose, whose photographs are generally focused on the life and architecture of the city. For many years these visits with Rose invariably started off with a ritual of sorts. Koudelka's first evening in New York would always be spent with a cadre of old pals from the photography world: Rose, Thomas Roma, Sid Kaplan, and Stuart Alexander. (One objective of these soirées: to make sure Koudelka stayed awake late enough to acclimate quickly and efficiently to the time change.)

Soon after they first met — back in the 1980s — Rose (who died in 2021) essentially turned over to Koudelka an entire floor of his SoHo building, a former factory space he had lived in since 1969.[82] The loft boasts not only a wall of east-facing windows lined with plants but also a long — really long — and well-lit dream table, on which Koudelka could spread out his accordion-fold book dummies, or several rows of photographs, with room to spare. "He likes it here," the affable and imperturbable Rose told me in 2015, as we sat at the treasured table. "He likes all that light coming in, waking him up in the morning. It was the ideal place for Josef to be. . . . This table would always be clear, and he'd have the whole table for himself. And that was a joy for him."

Koudelka always looked forward to seeing Rose on his trips to the States. "He was one of my closest friends in New York. I really liked his life philosophy. And he was so different from me — growing up on the streets of New York. Still, I thought we always understood each other very well." On one visit, Rose remembered, Koudelka had a request — he asked to see a "strange place." Rose obliged, taking him to Fresh Kills on Staten Island, the 2,200-acre landfill that, until its closure in 2001, was the dumping site for New York City's residential waste. When they visited, the dump was still in operation — as Rose described it: "Piles and piles of daily garbage heaped upon hills and hills of garbage." Estimated to contain about 150 million tons of solid waste, Fresh Kills naturally attracted a lot of hungry, urban wildlife — rats and birds, especially seagulls — and they were out in great numbers that day. Rose told me:

> *Josef got into it. I thought he was mad. . . . It started drizzling, raining. Well, it's bad enough you've got the smells of everything — all that garbage! — the hills smelled like hell. But all the rain was drawing the attention of more and more birds. It had a tremendous visual effect — they crowded all over the hills, everything. And Josef started running up that hill. Those hills are not easy to go up! And it energized him so much. Whereas with me — I said: "Shit, I don't want to come up there with you!" I wanted to go back to the car. . . .*
>
> *He was completely oblivious to everything else when he was in that state of mind about taking pictures. . . . Josef doesn't care about any of the obstacles. He knows instinctively — first of all, he's not clumsy or anything*

like that. He's very clear on where he should go, how far he can go, and how he approaches things.

He's up on the hills of garbage, totally inspired, caught in the fervor of it all.

Koudelka's finely tuned reflexes have also been admired by his friend Anthony Friedkin. "He's like a matador," says Friedkin. "He knows how close you can get to the bull." Friedkin is especially amazed that Koudelka, even with his panoramas, never uses a tripod. "He shoots these panoramas handheld." The camera in Koudelka's hands becomes almost an extension of his body, both stimulating and guiding his instincts. But perhaps it was Koudelka's early handling of his negatives, when they first met around 1974, that made the biggest impression on Friedkin: "He'd have these uncut negatives — full-length rolls of film, and he'd go through them, looking at each image on the negatives, deciding which to print. He didn't have contact sheets of them yet. . . . He'd walk through the streets of Paris with these really long negatives, and they'd be rolled up in a number of *Figaro* newspapers, and Josef would hold them like he was holding a baguette."

Josef Koudelka Reviewing His Negatives, Paris, 1974. Photograph by Anthony Friedkin

Koudelka made his first trip to California in 1985, when he traveled to Los Angeles with Jill Hartley to meet her family. Three years later, he went with Cristobal Zañartu to Monument Valley, on the Arizona-Utah border, as well as to Wyoming and other points west. His subsequent US road trips were made between 1998 and 2000, when he was first photographing the Lhoist sites in America for *Lime Stone*.

A decade later, while also working on *Wall*, he returned to expand on the Lhoist project — finding a kind of solace in these quarries: in 2008 he traveled with Peter Helenius to the company's sites in Alabama, Tennessee, Missouri, and Texas. And in 2009 they made a second trip, this time through the Southwest, beginning in Salt Lake City. They covered nearly ten thousand kilometers on that drive as they wended their way through Lhoist's quarries in Utah, Nevada, Arizona, and California in Helenius's Volkswagen camper.

Helenius had started out in the 1980s as a photojournalist freelancing for various wire services and newspapers. Later he left news work behind and spent a period focusing on his personal photography — but eventually found that he missed the collegiality of the larger photographic community. So, at the age of forty-six, he applied for an internship in the (no longer extant) Magnum in Motion department, hoping to learn more about video editing and storytelling. They took him on. "I was," Helenius declares proudly, "the oldest intern in New York."

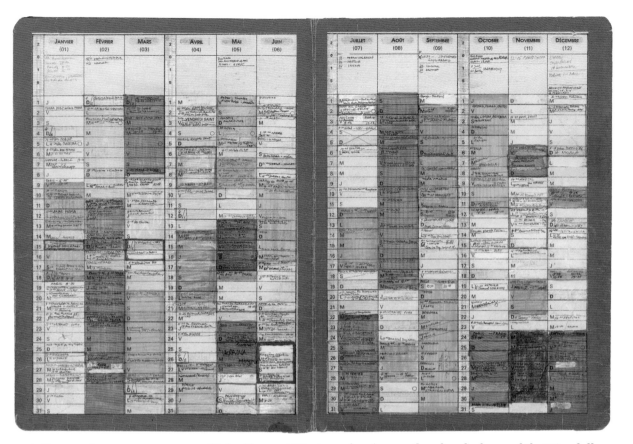

JK's 2015 agenda

JK photographing in Wyoming, 1988. Photograph by Cristobal Zañartu

He had been at Magnum for six months when he learned that Koudelka was coming into the office. He could not wait to see the man who had created the legendary *Exiles* project. Helenius's first impression did not disappoint: "[Josef] was running around with a bottle of vodka or some other spirit and exhorting people to 'Keep on dancing, keep on dancing!'" Bewitched, Helenius later made his way to where Koudelka was holding court in the office, and overheard him say that he was hoping to take a road trip in the United States. Helenius could not contain himself: "I have a van!" Soon after, it was agreed that he would be the driver on Koudelka's upcoming US journeys — and Koudelka has ever since affectionately referred to him as the "Man with a Van."

Helenius was soon disabused of certain romantic assumptions he'd harbored about Koudelka's "gypsyness."

You're thinking: "Now we're just going to roll and follow the wind!" — but it wasn't like that at all. Out came the calendar and we had to leave at this time, on this morning, and be here, and be there. . . . We were getting up at six o'clock every morning, and we were on a schedule. He would knock on the hotel door — when he said six o'clock, he meant six o'clock, not 6:05 — he would knock on the door. Or I'd knock on his door — but he'd already been up for hours.

(Koudelka confirms: "Every morning at 6 a.m. I knocked on the door and said: 'Peter, wake up! Get out of your bloody bed. Life is cruel but beautiful!

Get up!'") Koudelka likes to see the sunrise, and he prefers not to drive in the dark, as looking out the window is less engrossing, and the evenings are more productively spent reviewing his images. He also wishes to photograph in very specific light — dependent on all the variables of season and place. The sun, as always, orchestrated their days (he's been known to say: "Obey the sun!"). Helenius: "It's like he brought the sun alive for me."

Early in their journeys together, they agreed to stay clear of the interstates whenever possible, and instead explore the back roads. "Josef loves maps,"

United States (Alabama), 2000

Helenius says, "so he was always mapping things out, highlighting maps everywhere we went." As ever, finding the right place to sleep required checking out three possibilities to determine the one with the best light — along with a desk and a chair — for scrutinizing his work at night. Helenius says: "Josef didn't like the fancy places at all — it didn't matter that it was all paid for." He smiles: "Once I got over my hero-worship thing and started being myself, it was much easier for both of us."

They developed a cheery camaraderie on these trips that included an informal code of conduct (invented by Koudelka). Helenius knows that he is sometimes quite talkative while driving, and Koudelka quickly determined that there had to be a system for keeping the chattiness in check. Koudelka would signal for Helenius to stop talking by whistling: "I am glad to report," says Helenius, "that Josef only had to resort to whistling — it was a soft, two-tone whistle — two or three times over our two trips." Furthermore, no music could be played in the car — "so as to be better able to look, to see," says Helenius, paraphrasing Koudelka. (There was a single exception: on one foggy, "swampy" morning somewhere in the South, Koudelka asked his friend to pull over so he could photograph. "I broke the rules," says Helenius. "I put on this blues song. Josef really liked that.")

As they drove from quarry to quarry, Koudelka would sometimes get very meditative about the project. Helenius recalls him saying: "Before construction there will be destruction." Still, Helenius says, "he found the quarries to be incredibly beautiful. . . . He'd always say: 'Look how lucky we are to be here!'"

During their fall 2009 road trip, Helenius's friend Mike Chen caught the duo on video as they pulled out of Fresno heading to see the giant sequoias.

Chen, shooting from a car alongside the van, captured Koudelka rolling down the passenger-seat window and, with the broadest grin, giving a full-armed wave before bringing his camera to his eyes in a back-atcha farewell gesture as the van pulls ahead. The moment brings to mind the words of Sal Paradise in Jack Kerouac's *On the Road*: "What is that feeling when you're driving away from people and they recede on the plain till you see their specks dispersing? — it's the too-huge world vaulting us, and it's good-bye. But we lean forward to the next crazy venture beneath the skies."[83] (For me, those lines also poignantly evoke Koudelka's father driving him to the airport in May 1970, the night he left Prague for what would be an absence of twenty years.)

Years after his trips with Helenius, Koudelka himself would contemplate the meaning of the road, while photographing in Turkey.

The meaning of the road — there is a lot of meanings. To have a road you have to have the aim to go somewhere, but you have to realize that aim is important only because it permits you to make the trip on the road . . . that the road is much more important than the aim, than where you want to go. You have to be open to anything that will happen on the road, and if something nice happens, you should forget about the aim and just to enjoy it as much as possible. Like now the light is coming and it is very beautiful.[84]

And with the promise of beautiful light, he picks up his camera, ready for whatever comes next.

PAUSE

In February 2015, when I was working with Josef in Prague, his friends Marta and Martin Stránský invited him and Lucina, as they often do, to their home for dinner. They graciously included me, as well as Gilad Baram, who was visiting from Berlin.

France, 1973

Josef and the Stránskýs met in 1990. Mutual friends had told him that the Stránskýs might have a loft attic space to rent in their apartment at Římská ulice in Prague's residential Vinohrady neighborhood. Marta remembers hearing the doorbell ring. "I opened the door. I was still holding Marjánka [Marianna, their daughter, then four] in my arms. He said: '*Dobrý den*! I am Josef Koudelka.' . . . and he came in like the wind."

Martin, with an expression of pride and caring, and the emotion of a shared history, says: "That's how it began." He is an architect who considers Josef to be "a missionary of beauty, and a monk." Martin recalls first seeing Koudelka's photographs in fall 1984 when he and Marta stayed at their friend Jiří Horský's place. Horský had just returned from London, where he'd been thrilled by Koudelka's exhibition at the Hayward Gallery and had bought a copy of his new Photo Poche book, which had been published in conjunction with the exhibition. Horský snuck the pocket-sized book into Prague — strictures were still in place before the Velvet Revolution — and shared it with the Stránskýs. They were deeply moved by the images they saw. Martin describes his response to one 1973 photograph of three Roma men, made in France:

Lucina Hartley Koudelka (left) and Marianna Stránská, Prague, 1991

> *The image of three figures in a landscape with a horse, a shack, and a ball etched itself into my memory. . . . It contained something ancient and mystical. One felt as if one knew the picture or had seen it in a dream. A kind of déjà vu. Three figures seem to be standing in the composition of some kind of biblical story. And yet there is something about it that is essentially contemporary and free, random.*

Josef did not, in the end, rent the Stránskýs' attic space, but that meeting marked the beginning of more than thirty years of friendship, joyous celebrations, and, when Josef was not well, caretaking, in Prague and in Paris. Josef refers to the Stránskýs as his adoptive family. The closeness began with the daughters — Lucina and Marianna met when they were both five years old (the Stránskýs' son, Jan, was not yet born). When Josef brought Lucina to the Czech Republic, she often stayed with the family. They all visited Anna Fárová together at her summer home in south Bohemia near the Austrian border. The Stránskýs have stayed at Josef's place in Ivry during their visits to France.

Before the dinner party at the Stránskýs' home, I'd spent the day interviewing Josef at his sparsely furnished place in Prague, which he bought in 2003. His cousin Tonda had let Josef know about an apartment that was for sale: it is on the third floor of a lovely 1895 building that was at the time being restored.[85] After consulting with "Big Sister" Sheila Hicks, Josef decided to buy it. During this discussion, Hicks suggested additionally purchasing a second flat that was also available in the building, one flight up from the first. Although this fourth-floor space will forever be known as "Sheila's flat" — and she will always have first dibs when it comes to staying there — in recent years, it has served as a residence for Josef's children when they visit.

The principal room in Koudelka's third-floor apartment is washed in ever-changing light that, along with the tolling bells of the small church across the street, marks the passing of hours. (The composer Antonín Dvořák was employed

as organist in this church in the 1870s.) One of Koudelka's windows looks onto a tree — in the winter laced with snow, in the spring with buds — emerging between two low-scaled buildings. The view is open and bright. Close by, the Vltava River flows. Facing a different angle from his small balcony, he can see a gilded statue of the Czech Republic's patron saint, Vojtěch, adorning the façade of a building across the street. Dominating this airy room is the much-treasured long, white table, perfectly lit, on which to spread out photographs, book maquettes, exhibition plans . . . anything and everything.

On this day, Josef and I finished our conversations in the early evening, and we had some time remaining before we were to leave for dinner. I went upstairs to "Sheila's flat" where Lucina was staying. She works as an industrial designer, often collaborating with Vincenzo Iovino in their Paris-based studio, Paralleloa, which brings together architecture, design, art, and craft. I asked Lucina if I might have a look at some of the projects that she and Vincenzo have realized, and we spent the following half hour looking at their work, as well as her own inventive lighting projects — a refined melding of craft, attention to materials, and clean lines — on her computer screen.

Eventually, Josef came upstairs to fetch us. I asked if he had seen Lucina's recent projects. He had not. Over the next ten minutes or so, Lucina quickly showed him some of her designs, and he seemed both genuinely surprised and impressed.

At dinner that evening, Josef announced to those assembled around the table that today Lucina had finally been willing to show him her work! Lucina turned red, clearly agitated, and protested that he had never before asked to see it.

New Year's dinner at JK's apartment in Prague, 2020. From left: Marta Stránská, Lucina Hartley Koudelka, JK, and Martin Stránský. Photograph by Vincenzo Iovino

This scenario echoes an incident Lucina had brought up in an earlier conversation. Josef, despite his life-loving, ever-hopeful effervescence, often presumes the worst. "He makes assumptions," she told me, "and believes they are true." Lucina described a dinner in Ivry with her father, Hervé Tardy, and Verónica Martínez Lira — Josef's girlfriend. At one point, Josef declaimed: "Lucina does not show much interest in my work!" Martínez Lira pressed Josef on this: "How do you know that Lucina does not show much interest in your work?" Lucina remembers his response: "He pulled out a series of arguments that he was completely convinced proved his point, yet to me didn't make any sense." One that particularly flummoxed her was his saying that when she comes to his exhibitions, "she usually looks around quickly, doesn't make any comment, and then walks away without saying if she likes it or not." Finally, Verónica suggested that Josef address the question to Lucina directly. He turned to her: "Lucina, are you interested in my work?"

"Yes," replied Lucina, "I am."

Then he asked me: "Why?" I said: "Because I am. And because I care about you and therefore care about what you do." And at that moment something

was released . . . it was so simple. I felt like a heavy and very unnecessary weight had been lifted. Unfortunately, this feeling didn't last. For reasons that escape my understanding, he keeps holding onto his assumption that I am not interested in his work.

It seems that, just as Josef assumed Lucina had no interest in his work, he assumed that she did not wish to share her work with him. He maintained that he never asked her about it because he didn't want to seem intrusive. I suggested that if Lucina was unwilling to share something with him, she would simply say so. But how is she supposed to know that he is even willing to look at what she's doing if he never shows any curiosity?

Lucina does not need me or anyone else to speak on her behalf in such situations; she can take care of herself. But, just as Verónica Martínez Lira did at that dinner in Ivry, sometimes it helps if someone paying attention from the outside navigates long-established habits and subsequent expectations and sensitivities, parsing the difference between what is said, what is meant, and what is understood. And although there are moments that may resonate as indifference, my sense is, rather, that at times Josef is simply obtuse.

It is certain that Josef wants all his children to live freely and meaningfully. It is equally certain that they appreciate it when he demonstrates authentic interest in their lives, just as their curiosity about his projects pleases Josef. But, says Josef, "While I'm happy if my children are interested in my work and like what I'm doing, I will be most happy if they find, independently of me, what is important to them in life and what they can do best, and that they will be doing it."

16.

The year 2012 signaled a change in Koudelka's approach that would prove to be very liberating. He had completed the photographs for *Wall* using film, and now was contemplating converting to digital photography.

From left: Claude Picasso, Jonathan Roquemore, and JK, Lausanne, Switzerland, ca. 2019. Photographer unknown

This leap was prompted by a conversation with Jonathan Roquemore, who in 2008 had overseen the production at Magnum of most of the digital prints in Aperture's traveling exhibition of Koudelka's *Invasion 68: Prague*. Koudelka, who was seventy-four in 2012, told Roquemore that he had concerns about working with film. Roquemore understood: "The decline in general availability of film and processing of medium-format roll film presented multiple questions as to how Josef would be able to continue with his projects — to just keep working as he has always done." Roquemore strategically suggested to Koudelka that they pose these questions to colleagues at Leica, and soon he and Koudelka found themselves at the Leica factory, which at the time was located in Solms, Germany.

Koudelka always traveled light — not bringing a tripod, lighting, or assistants, and taking only the most minimal clothing and toiletries — but also heavy: he carried kilos of film, along with small prints from whatever projects he was working on. The right digital approach could address all this, but, as Roquemore notes: "No manufacturer had a product on the market which met Josef's requirements in terms of format, resolution, and ruggedness."

Leica took on the challenge. Stefan Daniel (at the time Leica's director of photo-product management) and his team got to work, ultimately creating a custom digital panoramic camera for Koudelka at the company's expense. The goal, says Roquemore, was "to support Josef so that he could keep taking photographs when roll film became more and more difficult to process — in the long run giving him more freedom to just pick up the camera, some batteries and memory cards, and hit the road." In 2012 Koudelka tried out the prototype for this bespoke, high-definition digital camera — a unique iteration of Leica's new S2 medium-format digital camera, which had recently been released. Leica had customized everything, from the software to the camera's formatting capabilities, in order to correspond to the 6-by-17-cm panoramic format Koudelka had been using. Christophe Batifoulier at Picto in Paris remembers that Koudelka first tested Leica's S2 photographing the Roman city Timgad in Algeria. "Then Josef sent me files that I tested to see if his values and the general quality were sufficient for the realization of large prints. After various tests we agreed that the whole was satisfactory. . . . Then the Leica engineers cropped the sensor in order for Josef to have his panoramic format."

Enrico Mochi and JK editing, Ivry studio, 2022. Photograph by Jonathan Roquemore

That was the equipment. Then the challenge was how to integrate the technology into Koudelka's usual process of working. For this, Roquemore and the Leica team joined forces with Enrico Mochi, at the time manager of all things digital at Magnum Paris, and Koudelka's longtime ally in the digital preparation of all his projects. Mochi, who repeatedly went beyond the call of duty for Koudelka, began working in the darkroom of Magnum Paris in 1993, where he would make his press prints: "Because of Josef's needs, . . . today I can say that it was at this moment when I really learned to print." Mochi's collaboration was critical. Roquemore says: "With Enrico on board, we set out to build a physical and digital-processing seamless workflow, which allowed Josef to continue photographing, editing, and proof printing upon returning from his travels. Once Josef made his selections, the files were given to Batifoulier, who made the scans and produced the prints of Josef's panoramic photographs for exhibition." (Some years later, in 2018, Roquemore orchestrated the digitization of Koudelka's 35mm contact sheets, which would prove invaluable to the photographer.)[86]

The most immediate and tangible advantages of this new camera for Koudelka were, as anticipated, pragmatic. Along with carrying significantly

less weight on his wanderings, working digitally has allowed him a great deal more financial independence. He says:

> I don't need to think about finding the money to pay to develop the film and make the contact sheets and other printing. What is fantastic now is that I buy the ticket myself, I pick up this digital camera, and I go. . . . And I go to the same place, as I have always done, over and over again, but everything is on my camera — I don't have to carry the images I've made before to refer to, and I don't have to think about buying film, or running out of film when I'm not somewhere I can easily get more film. With digital, I can continue to shoot and shoot, and then eventually, when I know I have something good, I can eliminate what is not good.

As for the images themselves, he concludes:

> So finally, Leica sends you the new camera, and you take it on the trip, you take your usual camera, and you test everything. You make four trips. You go around, and you try with this new camera, and you think that it might work. And suddenly, the last two trips, you realize you are taking more pictures with this new digital panoramic camera than with your panoramic film camera, and when you see the prints, you see that you can achieve the same high visual quality with the digital as you did with the film.

Stuart Alexander filmed Koudelka trying out his custom panoramic digital Leica; the footage reveals him testing multiple poses and angles as he attempts to get the feel of it. It is clearly a visceral process. A photographer's relationship to his camera is not unlike a musician's to his or her instrument. Koudelka had found his new Stradivarius.

17.

"Joseph [*sic*] is in an excellent and expansive mood," wrote Aperture editor Mark Holborn to Michael Hoffman, executive director of Aperture, in October 1986. Holborn had recently been in Paris meeting with various photographers, Koudelka among them. They had discussed *Gypsies* — first published in 1975.

Holborn was exhilarated. He wrote that Koudelka "is keen for [*Gypsies*] to go out of print" so that he might embark on an entirely new version of the book:

> He showed me the original dummy for [Gypsies] that he produced in Czechoslovakia. It is totally different, and for me even greater and more intense as a book, than Delpire's version. . . . You completely enter the work. It is profoundly moving. Joseph wants to publish it in contrast to Delpire's version. I believe it is one of the best photo books of all time. Hence Joseph's concern about the position with the existing book.[87]

It would take another twenty-five years, but in 2011 Koudelka would finally realize an iteration of *Gypsies* based on his and Milan Kopřiva's original 1968 concept. The designer had died in 1997. The new book, adapted from the Kopřiva

maquette by Aleš Najbrt with Koudelka, is vertically oriented and has the original double-page spreads, gatefolds, and juxtapositions of images — in contrast to Delpire's 1975 horizontal volume, which has a single image per spread, each opposite a blank page. And the image selection in the 2011 edition is much expanded: while the 1975 *Gypsies* comprises sixty images, mostly made in East Slovakia in 1962–68, the 2011 *Gypsies* contains 109 images made between 1962 and 1971, including several made outside Central Europe.

Perhaps predictably, Koudelka's rethinking of *Gypsies* was a thorny issue for Delpire. From Koudelka's perspective:

> *Delpire was irritated, and he was doing everything to stop me from doing it. . . . He thought that the first book was so good — anything else I would do would be less good. He wanted his 1975 book and its reprints to be the only* Gypsies *book.*
>
> *So there is the sense of possession, which is very logical. Most people behave this way. But . . . I would have been sorry all my life if I didn't publish this book the way I first wanted to. . . . It's not a question of which book is better. . . . The books are completely different.*

Delpire ultimately published the French version (Aperture would initiate the English-language edition) of what would be casually termed "*Gitans* II" (or "*Gypsies* II"), appending a "posteriori" text (for the French edition only) to make his position with regard to "*Gitans* II" very clear. While unconventional, given the history of the intense relationship between Delpire and Koudelka,

JK and Robert Delpire, 2003.
Photographer unknown

especially when creating the original *Gitans*, this meta-reflection feels understandable and touchingly honest. The thrill for those of us who publish, edit, and curate the arts comes on those rare occasions when we encounter astounding talent, originality, an inspiring sensibility and perspective, soul-stirring advocacy. We can't imagine not throwing ourselves behind it full force. When this successfully launches that artist into the privileged freedom of pursuing anything they may wish to do, we feel part of that, have a stake in it. The feeling evoked is not necessarily possessiveness (although sometimes it is that), but a kind of pride — pride in our own instincts, perhaps, pride in helping to manifest the artist's talents, and naturally, pride in the artist. In the long run, our goal is to support the work in keeping with his or her vision. As Delpire wrote in the book's "posteriori":

> *Since this edition has come into being, the relationship between author and publisher has often been delicate, even contentious. . . .*
>
> *Josef was already speaking often about a sequel to* Gitans, *which he wanted to supplement with photos from Romania, from Hungary. Then he told me, to my astonishment, that he wanted to do this* "Gitans *II" his own way, without me. Strong in his convictions and his desires, as he had always been.*

And so here is Gitans, *on which I did not collaborate. I decided to publish the French version, although I wasn't accustomed to publishing a work in which I had not participated in the choice of images, or the layout, or the production.*

But I accept Gitans *in the form that Josef wanted. Aware of being faithful to our old friendship and to a principle I had held throughout my career as a publisher, careful to allow the author the free will of his expression and his intentions.*[88]

Will Guy, too, contributed to this new edition, updating his original 1975 text. Here, he criticizes post-Communist practices toward the Roma, which have left many worse off than before. The Communists, Guy pointed out to me, had needed the Roma mainly as unskilled laborers. But the ideology of assimilation also provided some Roma with opportunities to join the army and police force and to take part in the mainstream education system. (He points out, though, that among the many hardships suffered by the Roma under Communism, many in the community were "illegitimately segregated into so-called special schools for those with learning difficulties.")

The designer Najbrt's challenge was grappling with the multiple existing visions for the book — Kopřiva's, Koudelka's, and of course Delpire's original *Gitans*, by now a classic — as he considered his own approach. Najbrt has great respect for Kopřiva's unique style: "He had this kind of signature," he told me; "you could always tell when a book was designed by him."[89]

About Koudelka, Najbrt says:

Josef is always involved, he always has his own opinion on the typography. And sometimes it's not very easy to make him see my point of view, my opinion. I must be strong in my argument. He sees the typography as almost part of the pictures, the whole presentation — he doesn't underestimate it at all. He thinks it's very important. Eventually, we got there.

The book's printing was another major consideration. Like many of his Magnum compatriots, Koudelka has often favored printing his work with rich blacks and high contrast. He had seen *Corpus*, by his friend the Mexican photographer Alejandra Figueroa. It was printed by Gerhard Steidl and the photographs have a gravure feel. "When I saw her book, I wanted to see if I could use this kind of printing." After a few test runs with various other printers, he ultimately chose to work with this idiosyncratic master printer, whose publishing house is based in Göttingen, Germany. Peter MacGill, who has a good relationship with Steidl (and knows how to dance with the printer's infamous reluctance to commit to a production schedule), helped to set it up, and Hervé Tardy made it happen. Tardy reflects on the process:

Delpire was a formidable picture editor. And, he understood the best of Josef, and that is something Josef accepted from Delpire. Gypsies *has all the mind, all the spine, all the smell of the perfect book.*

But "Gypsies II" is also differently, insanely perfect. . . . You couldn't take a black-and-white book any further than "Gypsies II". . . . There was

Steidl, who is never easy, but then neither is Josef. And I was in the middle of it. So . . . there was a first version that was made as five bound samples. They printed the pages, bound them . . . and then threw them in the garbage can.

Koudelka reflects on the process: "We thought we could make it better: more contrasty and more black. But the corrections were wrong — it became softer, with less contrast."

They went back to the drawing board. Says Tardy:

So again they took the plates, they took the pages — and again they threw it all in the garbage can. There were about a hundred copies of that version. So that was two times the book had gone through the machine, which brought it to the third trip through the machine — which was the last. . . .

So at some point, I think that Steidl was starting to count his pennies. . . . It's because they tossed out paper, plates, and then they decided. . . . There are some passes that have a black varnish. . . . They tried and did everything necessary. And "Gypsies II" came out exactly how Josef wanted it.

Gerhard Steidl and JK at work on *Gypsies* II, Göttingen, Germany, 2011. Photograph by Hervé Tardy

There was no backlash to "*Gypsies* II." It was in sync with the zeitgeist of the moment. By this time, people were accustomed to remixes and mash-ups of favorite songs, directors' cuts of beloved films: revisiting the familiar in a new way. And this publication was not only reconceived but expanded, with more photographs. Koudelka's choice to rethink *Gypsies* was also in keeping with his own lifelong past/forward process.

And then he did it again. No sooner had "*Gypsies* II" been published than Koudelka was making plans for yet another version. He had in mind a "pocket-sized" (for large pockets) edition of *Gypsies* — referred to informally as "little *Gypsies*," to distinguish it in communication from the original 1975 Delpire and then the 2011 Steidl editions. Stuart Alexander wrote the accompanying essay.[90]

Published in 2016, "little *Gypsies*" features, for the first time, a gatefold near the end of the book that indicates how Koudelka's *Gypsies* prints might be ideally sequenced in future exhibitions when he is not around to supervise — with the understanding that this layout would be adapted to various exhibition spaces and their unique and respective floor plans. Alexander writes that Koudelka "has arrived at the ideal relationships on a wall which can be radically different from the ideal placement in a book's more rigid configuration."[91] It is a reminder of a formulation Ferdinando Scianna shared with me: "Everything you say in life is

a message in a bottle, and each person who opens the bottle reads the message and may make a different interpretation. Still, Josef wishes to control as much as he can about not just his work, of course, but the experience of the work — now, and from beyond the grave."

In 2017 Koudelka's process was further revealed in the exhibition *La fabrique d'Exils* (*The Making of Exiles*), curated by Clément Chéroux at the Centre Pompidou, Paris. After several visits to the photographer's Ivry studio, Chéroux proposed a project grounded in Koudelka's *katalogues* — "the big notebooks with small photographs glued on the cardboard . . . he was organizing his photographs through subjects — like shadows, silhouettes, and things like that, but also through forms." These notebooks had instantly captivated Chéroux, and he suggested to Koudelka that they begin the exhibition with pages from them to show — rather than tell — visitors how the photographer sees. Chéroux said that they could "group the photographs not as they are in the book, *Exiles*, but as they appear in the *katalogues*." But it wasn't only these pages that had attracted Chéroux. When we spoke in 2019, he told me:

> *I perfectly remember the moment when Josef put on the table a small box with all these small-sized prints that he made at the time — his "self-portraits" of the places where he was sleeping when he was traveling. . . . That was an incredible surprise, to see that he was acting also like a conceptual photographer, taking the photographs of the place where he was sleeping — this autobiographical approach. But at the same time, it perfectly makes sense:* Exiles *is all about him, all about his own history, his own story. And so for me, it totally makes sense to add these unexpected paths to the understanding of* Exiles, *and I wanted to include these. . . . Of course, he at first said no — doubting my motives, I think.*

In both the exhibition and the related publication — created by Xavier Barral, Koudelka, and Chéroux and featuring a comprehensive essay by Michel Frizot[92] — Koudelka ultimately agreed to include photographs that suggest the interplay between art and life in his process of realizing *Exiles*. These more personal images — documenting where he slept and where he ate, for example — while not part of the *Exiles* series per se, reveal its backstory and resonate with its elemental sense of solitude, possibility, and the wonder and melancholy of everyday life. Still, says Chéroux, "I think that, until the opening, he was not totally convinced that it would add something important. But then he realized everybody was fascinated with that . . . everybody was saying that it was a revelation."

Is there any separation, any distinction between Koudelka the photographer and Koudelka the man? Personally, I think there is very little, except that the photographer is never sentimental, unlike the man. I wondered aloud about this with Dominique Eddé, who agreed: "They are very close to each other. Zero artifice, true, merciless, mute, elegant, harsh and human, rooted in earth and nature."

For Barral, the process of working on *The Making of Exiles* was very different from his previous projects with Koudelka. Rather than focusing on a subject, it was about exploring the photographer's process from the genesis. Barral found this inspiring: "I would love to continue to go through all his documents." Barral told me that what he finds uniquely electrifying about his friend's way of working — revealed in the *katalogues* as well as his exhibition installations — is "this way he has of taking images and saying *voilà*! — putting an image like that, here, and then this other one, there — how he makes the pages. It's beautiful. I love the way he has of reflecting on the relationships that exist among his images."[93]

As he did with the 2016 edition of "little *Gypsies*," Koudelka closes *The Making of Exiles* with a gatefold — this time as the volume's endpapers — demonstrating how all the photographs constituting *Exiles* might be sequenced in a future exhibition, when he is not present to supervise.

Robert Delpire and JK, Arles, France, 2004. Photograph by Sarah Moon

The Making of Exiles is a generous gesture by Koudelka. It offers a nuanced and intimate understanding of his unique weave of art and life, chance and intention — his vision. And this book, unlike "*Gypsies* II," was never intended as a reimagining of the original Delpire-conceived book. While at times contentious and exasperating, their forty-plus years of collaboration and friendship, as well as mutual respect and ultimately trust and understanding, mattered deeply to both men.

In his late years, Delpire suffered from debilitating back pain. Traveling became terribly difficult, and he worked primarily out of the Paris home that he shared with his wife, Sarah Moon (and their cat, Haiku). There he could often be found in his downstairs studio, making collages of plants and other natural elements — his *herbières*. Delpire died on September 26, 2017, at ninety-one. Koudelka was installing an exhibition in Bologna when he received the news. He was crushed. Lucina, who had known Delpire all her life, was with her father. "That night, we drank some grappa to remember him," Koudelka told me. "When I got home, like with Bresson, I drank some of the last bottle I have of my father's slivovitz."

18.

It was in 1991 in Delphi that Koudelka made the first image that would, almost twenty years later, be included in *Ruins* — a project that had not yet been conceived as such. The attraction to these ancient landscapes was subconscious at

first. But as he discovered over the decades how many archaeological sites he had photographed in his wanderings, and the pleasure these environments provided, this random image became the springboard to obsessive hunter-gathering throughout the Greco-Roman Mediterranean world — especially after 2012, traveling lighter than ever with his new custom-made panoramic Leica.

Along with these journeys and the variously revised or otherwise newly considered older projects, over the course of four years beginning in 2014 he would have two distinct retrospectives, as well as his first comprehensive exhibition focusing on the panoramas.

Josef Koudelka: Nationality Doubtful was curated by Matthew Witkovsky of the Art Institute of Chicago, where it opened in 2014. It traveled to the J. Paul Getty Museum in Los Angeles, where it was organized and further shaped by curator Amanda Maddox. It concluded its tour at Madrid's Fundación MAPFRE in 2015, overseen by curator Carlos Gollonet.[94]

Koudelka and Witkovsky are both intelligent and strong-willed; it took a while to establish a rhythm for their collaboration and, not surprisingly, there were missteps along the way. After knowing Koudelka for some three years, and a year into working together on the exhibition, Witkovsky had read virtually everything that had ever been written about the photographer. "I believed I had learned all that could be learned from the writings on Josef," he told me. He was in for a surprise. At one point in the early stages of planning the exhibition,

Matthew Witkovsky and JK, Paris, 2013. Photographer unknown

> *I'm there asking Josef questions, and I ask one question and he stops and he glares at me. And he says: "Matthew, you may be the worst-informed curator who has ever talked about my work." I fell off my chair! I was so embarrassed and shocked. I mean, I knew there was stuff I didn't know, but it didn't seem like I was completely ignorant. But for him, I hadn't yet scratched the surface....*
>
> *It turned out that for Josef and me to really have a dialogue meant for both of us to ... walk a bridge across to another area of how photographs get presented to a museum public.*

This became specifically apparent as they discussed which of the *Gypsies* prints to include — not which images, but which actual physical prints. Koudelka has no interest in using vintage prints simply because they are vintage. He thinks only about what is the best print, the best presentation for the space and context in which they will be exhibited. Many curators, on the other hand, very much want to show a photographer's prints from the period in which the images were originally made. But in this case, the discussion of vintage prints was particularly complicated. Witkovsky:

> *What do you do with a print that was made for one context — like the 1967 exhibition of* Gypsies *which was in a theater lobby in Prague, and you bring it into a totally different context — in this case the Art Institute of Chicago?*

Their solution was to exhibit more than one set. It was a strategy that speaks to the nature and history of the medium itself, Koudelka's exhibition history, and the provenance of different iterations of the same image. A distinguishing aspect of the *Nationality Doubtful* retrospective was its Koudelka-like repetitiveness — of series, of specific images — but with different prints in different formats. The presentation insisted that the viewer consider not just the image, but the physical print in the specific context. This approach also allowed the museum to display how an audience may have first viewed the work, offering an experiential approach to understanding Koudelka's site-specificness.

Witkovsky explained that they did this

to meet Josef's stated interest in making certain the show was conceived for a specific place. But to suggest also that the same image can be made differently, depending on different contexts. To say "vintage" doesn't necessarily mean better, so it breaks with the usual museum habit of implying that the thing you're looking at is the one and only thing.

Whatever momentary hurdles arose during the process of putting together the exhibition were for the most part mitigated by "Josef's endless curiosity," which clearly made an impression on Witkovsky. He says with some reverence:

You could have the impression that he's a man who knows exactly what he wants in every instance. . . . On the other hand, he takes note of new things that he comes into contact with. Within a known circle or universe there are all these unknowns that he's very happy to listen to, and see if they somehow change the shape of his universe in a way that interests him.

Witkovsky confides about their six years of work together, after trying very hard to "win Josef's trust":

It really became a challenge for me to see if I could be as open-minded and as willing to learn as Josef Koudelka, which was not a simple question, actually. . . . And I would say it took a good two and a half years until the complexity and seriousness of it really sunk into me.

Josef told me he learned a lot from the process as well, including what not to do again! But that's part of the reason he keeps revisiting projects, including the idea of a retrospective — to keep learning.

JK and Amanda Maddox, New York, 2017. Photograph by Edward Grazda

Amanda Maddox worked with Koudelka on the show's presentation at the Getty, and had an especially significant and hard-won role with the exhibition catalog. When she first told Koudelka that she wanted to focus her text on the period he spent in England at the beginning of his exile, he responded dismissively: "It's not important. Nothing happened!" Maddox knew that couldn't be true, and she figured out early on that the best strategy for making her case was to propose a trial run. "Let me try — if you don't like it, we don't have to use it and I'll write something else." He had nothing to lose but, as it turns out, much to gain from her persistence. It was the

first time that this period of Koudelka's life had been rigorously chronicled and considered. Factual discrepancies were clarified and Koudelka's early life in his new world was made vivid.[95]

Maddox and I discussed Koudelka's notion of "home." She suggested that, during the period when he was based in the UK, "to all intents and purposes, Josef did have a home — whether or not he wanted to see it as such — with David Hurn. David said: 'You can come and go as you want.'" The same was true in Paris with Franck and Cartier-Bresson, as well as with Delpire. If not a home in a conventional sense, he certainly did have reliable base camps to which he could always return and from which he could always leave, with minimal attachment but plenty of heart.

It was for *Nationality Doubtful* that Stuart Alexander, who by then had known and worked with Koudelka for around thirty years, wrote his first essay about him and his work — in this case, focusing on *Exiles*. Alexander observes that the eternal nomad could also call Magnum's Paris and New York offices "home."[96] Koudelka, though, has his own idea of what "home" means: "For me, home is anywhere I am, and yet nowhere as well." In this way, the concept of exile is less about not being in one's homeland and more, says Josef — quoting a headline about himself that he taped into one of his thematic notebooks more than thirty years ago — about being "a man who made exile his home."

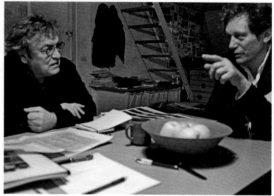

Xavier Barral and François Hébel, 2016

Gilles Tiberghien has focused on the panoramas since Koudelka began making them in the 1980s. In the *Nationality Doubtful* catalog, he continued his exploration of Koudelka's images of "the wounds and scars of a land devastated by an intensive exploitation of the soil and subsoil to feed the enormous demand for raw materials of an ever-accelerating economic development."[97]

Koudelka's poetically stark consideration of human impact on the land — for better or for worse — was never more powerfully presented than in a 2017 exhibition of his industrial landscapes at the Foto/Industria show in Bologna. Exploring themes related to industry and work, this biennial event is produced by the Fondazione MAST (Manifattura di Arti, Sperimentazione, e Tecnologia — Manufacture of Arts, Experimentation, and Technology). The artistic director of the 2017 iteration — and founder of the event itself in 2013 — was Koudelka's old friend François Hébel, with whom he had worked for many years at Magnum. For this third edition of Foto/Industria, Hébel invited Koudelka, as well as Joan Fontcuberta, Lee Friedlander, Mimmo Jodice, and Thomas Ruff, among others, each to present a solo exhibition.[98]

The survey featured Koudelka's expansively scaled panoramas on multiple subjects engaging the industrial landscape over some thirty years. The immensity of the exhibition venue, the Museo Civico Archeologico in

Bologna, along with the sheer quantity of images, intensified the power of the photographs. Although I had viewed his panoramas previously in various exhibitions, and at a smaller scale in a range of publications, for me this presentation was an epiphany. The land seemed to be reciting its own saga — of greed, of wars, as well as of victories and hope for renewal, and even the photographer's own journey. Although the images were in dialogue with one another, there were enough discrete rooms and walls of varying sizes to be able to experience each print on its own. This was Koudelka's larger vision made manifest. As Peter MacGill put it: "It was a ridiculously, off-the-charts powerful show. . . . It's the force of Koudelka showing us the tragedy of what has happened to the earth. This may be his most important work."

On January 10, 2018, Josef Koudelka turned eighty. In Prague, Marta and Martin Stránský hosted a wonderful party, overflowing with family and friends, affection and enthusiasm, and a seemingly endless array of food and drink (Marta is a masterful cook). There was also a surprise that brought tears to Koudelka's eyes: a performance by the Petr Mička cimbalom band, a folk group from the Horňácko region of Moravia, playing traditional music — the same melodies that had so resonated with Koudelka in his youth, forever bonding him to his *terre*.

Celebrating JK's eightieth birthday, Prague, 2018. Photograph by Fabio Ponzio

Two months later, on March 21 — commemorating the date he'd first returned to Prague in 1990 — *Koudelka: Návraty* (Koudelka: Returning) premiered at Prague's Museum of Decorative Arts. Conceptualized by Koudelka and curated by Irena Šorfová in collaboration with him, the show was accompanied by a publication designed by Aleš Najbrt.[99] Simultaneously, a reconstruction of Koudelka's *Decreazione*, the exhibition that had premiered at the Holy See Pavilion of the Venice Biennale five years earlier, was presented at the National Gallery in Prague. The National Gallery also hosted an iteration of Koudelka's *Invasion* exhibition to mark the fiftieth anniversary of the incursion. This included a remarkable new video installation by Zdeněk Jiráský comprising projections of Koudelka's images on nine screens, with a soundtrack of Czechoslovak Radio broadcasts from that

fateful week in August 1968, and archival footage documenting the Soviet invasion by film director Jan Němec.

Koudelka: Returning was the retrospective of all retrospectives. The Museum of Decorative Arts had just finished a major renovation, and a large portion of its holdings had been moved into storage. The building's second floor, now largely empty, was turned over to the show. The exploration of each of his bodies of work was expansive: as conceived by Koudelka, each display was unique and built on what he had learned from previous exhibitions. His early work on the theater was prominently featured, some unframed and mounted (as they had originally been displayed), others printed at a larger size and framed. The relationship between this work and the *Gypsies* images was pronounced: the evocative faces, gestures, and sense of intimacy.

The large-scale panoramas were, for the most part, displayed one per wall. Clusters of his miniature working maquettes for panoramic projects as early as Sollac, and including *Reconnaissance: Wales, Piemonte, Camargue, Lime Stone*, and *Ruins*, were stacked on individual Plexiglas shelves — allowing his evolution, his process, and the dynamism between images to become evident.

As a title, *Koudelka: Returning* functioned as perfectly as had *Nationality Doubtful*: both addressed critical moments in the arc of Koudelka's life. Building on the biographical panel concept from his 2002 retrospective, *Returning* dedicated a space to a more intimate exposition of Koudelka, with an illustrated timeline, as well as a larger-than-life portrait of him by Gilad Baram (a gift to the selfie set). The title suggests both his return home as well as his obsessive return to projects and sites over time and, more generally, the cyclical nature of time.

Witkovsky considers the theme of return to be an integral aspect of "the epic," and finds a link here to Koudelka at his most primary:

> *Josef has always loved Greek stories, and Greek stories are nothing but the same stories returned to and repeated over and over — this is a quality of epic. And that's how these stories get passed down through generations.*
>
> *He is utterly rigorous and he has an appreciation of time, both as it cycles around and as it slowly advances. . . . I mean lived time, as both cyclical — which relates to his love of myth but also of ritual and tradition — and also geologic time, in the sense of something that changes. . . . He is also aware of the conundrum of approaching these questions, both cyclical time and geologic time, with camera equipment and within the institutional structures of our time.*

This love of Greek mythology, of ritual and tradition, coupled with a sense of durational time, would permeate Koudelka's next monumental project, *Ruins*.

19.

Ruins encompasses Koudelka's work of three decades in more than two hundred archaeological sites throughout the Mediterranean world, including in Albania, Algeria, Bulgaria, Croatia, Cyprus, Egypt, France, Greece, Israel, Italy, Jordan, Lebanon, Libya, Morocco, Portugal, Slovenia, Spain, Syria, Tunisia, and Turkey. Coşkun Aşar's personal and impressionistic 2021 film *Crossing the Same River* reveals Koudelka's deeply felt connection to these environments, chronicling moments of this project-in-the-making in Turkey, where Aşar traveled by car with Koudelka. Here the photographer says that he strives to "come up with something that is not obvious — what all these . . . people who have been through were not able to see." He says that one problem with photographing these ruins (in Aşar's documentary Koudelka calls them "beautiful" so many times that he surprises himself) is that the overwhelming emotion he experiences while in these extraordinary places can easily get lost in translation. Rather, he must evoke the essence of ruins, and that, for him, is in the stone itself. In the film we see him patting the columns fondly: "Nice stone." At another point in Aşar's film, we see Koudelka looking out on a breathtaking Aegean seascape near Assos, where he was photographing the Temple of Athena. He speaks about the refugees from Syria going to Greece

Coşkun Aşar, Turkey, 2016

in recent years, saying we must remember that contemporary tragedy — even while experiencing all this ancient splendor. Elsewhere, such as with the Temple of Apollo at Didyma, Koudelka solemnly recalls the slave labor that built many of the magnificent structures he is photographing. Despite their formal grandeur, these sites, and Koudelka's interpretations of them, breathe their histories: the temporal, the anthropological, and the divine are forever intertwined.

His old acquaintance and collaborator Bernard Latarjet, who has observed the evolution of Koudelka's panoramic work since the mid-1980s, considers *Ruins* to have a metaphorical relationship to the present. He stresses that these Mediterranean sites share a sea, and thus, despite their disparate cultures, have a fundamental commonality. Perhaps for this reason, Koudelka first wanted to organize the publication *Ruines* (*Ruins*) — conceived with Xavier Barral and the French archaeologist and historian Alain Schnapp — not by site or even by country, but purely formally, through juxtapositions and relationships between the 171 images. Schnapp and Barral disagreed. They believed, and ultimately persuaded Koudelka, that it would be more effective to structure the book by geographic location. Schnapp also had the idea of selecting quotes to accompany many of the photographs, which Koudelka appreciated. The voices of Homer, Virgil, Camus, and the ancient traveler and geographer Pausanias, among many others excerpted, do not explain the images, but rather offer possible, often lyrical, entry points. In keeping with Koudelka's consistent desire for precise information, each image

has a detailed caption, and there is also a list of sites depicted by location, as well as a map and a glossary of architectural and archaeological terms.

In their respective contributions to the book, Schnapp, Latarjet, and Héloïse Conésa, curator of contemporary photography at the Bibliothèque nationale de France (BnF) — where this exhibition would open — consider the meaning of the word "ruins," the enduring fascination we have with them, photography, and the notion that everything ultimately ends in ruin. Schnapp views our attraction to ruins as part of an atavistic desire to connect with the past, thus also engaging our imagination. He writes:

> A ruin is only a true ruin if we recognize it as a much eroded human creation that is quite distinct from the stones and vegetation that cover it. A ruin exists only if the eye of the classical scholar, the poet or the archaeologist recognizes it as such: it has to be identified, dated and given a function, and we must be able to imagine the process of its construction and deconstruction. . . . It is the way we perceive it that gives the ruin back its form, restores what is lost and takes us back to its original structure. Ruins remain to some extent material objects, but they call for an immaterial perception of what they once were.[100]

Conésa discusses the profound interest in ruins among the earliest photographers, noting how "the first wide-angle photographers of ancient ruins, like Gustave Le Gray and Édouard Baldus for the *Missions Héliographiques*, wanted to create faithful documentary images."[101] By contrast, Schnapp invokes the Venetian artist, archaeologist, and architect Giovanni Battista Piranesi, who "championed the creativity of the draughtsman and believed he was entirely free to choose the framing and perspective of the monuments he was depicting . . . an aesthetic approach that allowed the ruins to speak." He finds an affinity with Koudelka's non-documentary approach, writing: "The archaeology of Koudelka's images is very much an *arkhe*, a beginning, which allows the stones to speak, as Piranesi wanted."[102]

Stills from Coşkun Aşar's film *Crossing the Same River* (2021), showing JK working at the archaeological site in Sagalassos, Turkey, in 2016

Christophe Batifoulier of Picto made the scans for *Ruins*, as well as the prints for the exhibition. Making the prints proved to be a profoundly difficult challenge for all concerned, testing the skills and determination of Batifoulier, who by the time of the show had worked with Koudelka on projects over the course of almost sixteen years.[103] The most difficult task was

Sagalassos-2016_001

Sagalassos-2016_002

Sagalassos-2016_003

Sagalassos-2016_004

Christophe Batifoulier of Picto, JK, and Clarisse Bourgeois of Magnum Photos, at Picto, Paris, 2022. Photograph by Enrico Mochi

to respond to Koudelka's desires and direction for each individual image (regarding light, contrast, and tonal balance), while always considering the photographer's larger vision for the project and its 171 pictures as a totality. Batifoulier also acknowledges that Koudelka's expectations have increased considerably over time, as he has realized what is now possible with the digital tools and technologies currently available:

Josef has always exhibited perfectly realized images and prints. In that, nothing has changed — simply the cursor of a certain idea of perfection has moved upward because the techniques allow us to do so.

The job of the printer has not changed. The tools have evolved and demand even more investment, but it is always a question of sensitivity in the service of another.

Joining forces with Koudelka and Batifoulier was Clarisse Bourgeois of Magnum Photos in Paris. Having worked at the agency's lab for many years and seen its transformation from an analog to entirely digital lab by 2005, she is now Magnum's *"chef de fab"* (chief of production) in Paris. Among a host of responsibilities, Bourgeois helps to produce many Magnum exhibitions; she worked closely with Koudelka on the 2013 exhibition *Vestiges* (presented in Marseille), a precursor of what would eventually constitute the *Ruins* project.[104] The exhibition, *Ruines*, was organized by Magnum Photos (Andréa Holzherr is the agency's global cultural director) and the Bibliothèque nationale de France. As he had so many times before, Koudelka collaborated closely with Xavier Barral on the publication's design.

About his approach to working with Koudelka, Barral told me:

The relationship I have with Josef is one where my position . . . has always been to try to understand why he chose this image, and why I have chosen the same or another image. I then feel obliged to say why I have chosen an image. Our relationship, it is created on the fact that I explain to him why I have taken this image and not others. . . . And, of course, he does not always agree.

What are Koudelka's criteria for editing down his images, after having already identified those he believes might work? Barral said:

I find that he is always looking for where the image is still becoming something. If it is already revealed, he takes it out.

He went on to describe the "different Josefs" he had come to know over the years: the "whirlwind, the cyclone," but also the person he found more "restrained, calmer." Part of Koudelka, Barral observed, takes a childlike joy in life. This is the Josef who showed Barral around Prague — the "Czech Josef in his city." There is also the man whom Barral (like Anthony Friedkin) has described as "a matador, with a matador's tricks." At still other times, "I find

that he is more mindful — very attentive." Summing up his experiences with the multiple Josefs who often coexist, he observed: "His aesthetic rigor is what is constant. . . . I believe he always puts it first."

Library of Celsus, Ephesus, Turkey, 2013

This last truth especially excited Barral with regard to Koudelka's *Ruins* project, which they were in the process of conceiving when I met with Barral. He avowed it was "undoubtedly one of the greatest projects he has done":

> *Perhaps not in terms of the graphic revolution of the image, but for its intellectual quality. It is something where Josef approaches history, time — and it is astonishing. I am not sure that he perceives this. I think for him there is a necessity to do the landscapes — they are a function of necessity, not, I don't believe, a strategy. But he has a need to understand, to see, to perceive culture. The idea of culture. . . .*
>
> *He is a curious person. He is an intellectual in the sense that he truly reads what he sees. I think he reflects tremendously on what he sees.*

The books Barral designed and published over the course of nearly three decades attest to his own conceptual and intellectual expansiveness. Seeing himself as a "conductor" (his word), he collaborated with a remarkably diverse group of artists working in a range of media, including Antoine d'Agata, Daniel Buren, Sophie Calle, Martine Franck, William Kentridge, and Annette Messager, as well as curators and other culturally engaged people, such as Agnès Sire and Diane Dufour.[105] Éditions Xavier Barral has also created thematic books on subjects ranging from evolution to birds to Mars.

JK considering variations of his photographs of the Library of Celsus, Ephesus, Turkey, in 2015, during the shooting of Aşar's film *Crossing the Same River* (2021). Photograph by Coşkun Aşar

Koudelka's *Ruins* would be the last book Barral would complete. He died suddenly at his home in Paris in February 2019, at the age of sixty-three.[106] Like so many who knew and had collaborated with Barral, Koudelka was devastated by the news. He and Lucina had seen him just the day before. He commemorated Xavier's memory, toasting him with his father's slivovitz.

Ruins was published in 2020 (Aperture published the English-language co-edition). In it, Koudelka pays tribute to Barral, "an incomparable colleague and a great friend."

"In the end," Barral once observed to me of *Ruins*, "I think that this work . . . is autobiographical." And yet, unlike the *Gypsies*, *Exiles*, or *Black Triangle* projects, with *Ruins* there is no obvious umbilical connection between Koudelka and these vestiges of the Mediterranean world. What Barral intuited about his friend is resonant with the larger concepts and processes that Koudelka has consistently and instinctively embraced. In a sense, ruins — "tools of our collective memory,"[107] as Schnapp characterizes them — are the material equivalent to oral history, an evolving story, losing and gaining details and nuance over time. Koudelka has been considering what Schnapp describes as the "tension between the remembered and the forgotten"[108] ever since he was in school during the Communist era, when he first grasped that what he was being taught there was different from what he was learning at home — that "fact" and "truth" could be misrepresented, relative, even falsified, and histories could be revised and rewritten. This became more pronounced for Koudelka when he understood the evidentiary weight of his coverage of the 1968 Soviet invasion — the value of bearing witness. As he constantly reminds us, he does not put faith in memory, including his own, and yet he is obsessed with what was and how that is tethered to what is and what will be.

When Koudelka's subject was people, he often focused on communities that were slowly disappearing, as well as on transient, nomadic figures, not attached to a specific landscape — exiles, the peripatetic Roma. When his emphasis shifted to the landscape, he sought the visible traces of human influence — the landscape's layers of "memory," altered by people or reclaimed by nature, or both. The work, like its author, is ultimately hopeful — less about what has vanished, and more about what remains, and what comes next.

In the early months of 2020, soon after Batifoulier had finished printing Koudelka's photographs for the *Ruins* project, it became clear that the exhibition, scheduled to open April 20, would have to be postponed. The deadly coronavirus had descended upon France and most of the rest of the world, and the people of Paris, including one of its most nomadic sometime residents, were in lockdown. On March 16, President Emmanuel Macron declared that his country was "at war" with the virus, and the following day began a period of

Marmaria, Sanctuary of Athena Pronaia, Delphi (Phocida), Greece, 1991

enforced confinement for all French citizens. Koudelka repeatedly expressed how lucky he felt that all the prints for his exhibition had been made before non-essential businesses (including printers) were forced to temporarily shut their doors.

PAUSE

This biography finds itself unfolding in real time as I write in New York City during the spring and summer months of 2020 (and while editing the text some months later).

During the first lockdown conversation I had with Josef — socially distanced by the breadth of the Atlantic Ocean — he confided: "This is very difficult for someone like me." If his freedom is at stake, clearly there had better be a compelling reason. It was not the practical mandates of the moment that perturbed him especially (stay home, wear a mask . . .), but the skepticism about what was happening. It took some convincing by his son, Nicola, and by Fabio Ponzio — both based in Italy, which was hit early and especially lethally by the coronavirus — for Josef to accept that the virus was not a manipulative government hoax. His experiences living in German-occupied Czechoslovakia, and then under a Communist regime and "normalization," predisposed him to contemptuous distrust of any authority that dares dictate what he can and cannot do, where he can and cannot go.

As the virus hit Paris, but before the lockdown, Jonathan Roquemore received a phone call from colleagues at Magnum Paris enlisting his help to convince Koudelka to stop taking the metro to Magnum and to stay at home in Ivry. At eighty-two, with a respiratory condition that began some years ago, the photographer was at great risk of becoming ill.

Finally, when Magnum closed its offices, as ordered, Josef had no choice. Although he had moved much of his archive to Prague, a number of his materials remained in Ivry. So he adapted, following a lifelong photographic metaphor for every situation: making a positive from a negative. Confined to his Ivry studio, having finished all his printing for both the *Ruins* book and the exhibition — and with the show now postponed for almost five months — Koudelka, undaunted, committed his time as he'd always intended to do when no longer able to photograph for whatever reason: he spent the subsequent months scrutinizing his life's work, first in the form of prints, all stored in Ivry. He also began taking walks around the gardens within the cluster of converted old factories where he has lived since 1990: "Can you believe I never did this before? And it's beautiful!"

In the spring of 2020, the dynamic undergirding Koudelka's conceptual consideration of ruins — whether focusing on industrial landscapes or the vestiges of the Greco-Roman world — seemed to be playing out globally. His faith in the possibility of nature's renewal, despite the destructive forces of human intervention, was affirmed. Within weeks of humans sheltering in place and all forms of transportation coming to a relative standstill everywhere, nature

rebounded: animals, from baby sea turtles to mountain lions, benefited and thrived in the strange and undisturbed peace. At the same time, the planet experienced an unprecedented drop in carbon emissions from the burning of fossil fuels, and inhabitants of some of the most polluted environments experienced remarkably cleaner air, skies, and water.[109]

Equally affecting in this period was the shift in our experience of both time and space. Space insinuated itself tangibly and relatively — in direct, socially distanced proportion to another human being. Time seemed simultaneously to expand and contract, tidelike in its assertion, flowing and ebbing unquantifiably. In spring 2020, days seemed to meld into each other, with sunrise and sunset the only reliable contours. For many working remotely from home, there were no more "Tuesdays," as such. Goals were set in terms of duration and statistics, and then just as quickly reset, when any part of the mysterious equation realigned.

VI Next

1.

By the summer of 2020 the first onslaught of Covid-19 seemed to be subsiding. France, like many other countries, began a phased reopening. Grounded in the nation's own scientific criteria, temporary quarantines and other safety controls were established, while many of the lockdown regulations were cautiously removed. July saw the partial reopening of many cultural institutions that had been closed for months. Koudelka's *Ruines* opened at the Bibliothèque nationale on September 14, 2020. The show comprised 120 prints. The "top forty" — those images that Koudelka deems the best — were printed large, and framed at nearly three meters wide; the eighty others were framed at 120 centimeters in width. Koudelka was adamant that every country in which he photographed be represented in the forty large prints, the notion being that these could eventually constitute an independent exhibition. There was no vernissage, and the number of viewers permitted into the museum at any one time was limited.

Koudelka was very pleased with the show — in large part because of the installation designed by Jasmin Oezcebi, with whom he had hoped to collaborate since seeing *FOTO/GRÁFICA* in 2012 at Le Bal in Paris, an exhibition she had designed featuring Latin American photobooks.

By all accounts, *Ruines* was spectacular. The large panoramas, individually framed in black, with white mattes, were hung back-to-back on twenty metal armatures — designed and constructed for this purpose — suspended by cables from the ceiling. The prints appeared to be floating, positioned so that the viewer could focus on one image at a time and still experience the larger context. Viewers were immersed in these hovering pictures, while smaller prints defined the exhibition's perimeter.[1]

"With this exhibition, I did the maximum I could do with these pictures," Koudelka told me. His only disappointment was that much of his family and so many friends and colleagues (including myself) were unable to come to Paris to see it at the Bibliothèque. At the time of the opening, travel to France, indeed to much of Europe, was greatly restricted. On September 25, as the pandemic again gripped the country, Paris Photo canceled its annual fair, which had been scheduled to run November 12–15, as the French government mandated limited

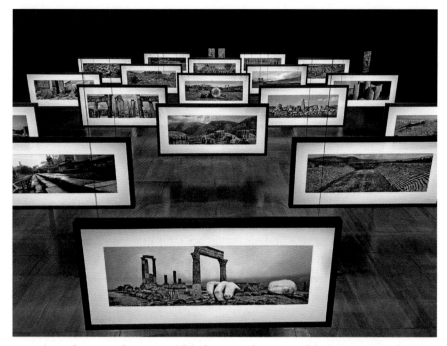

Installation of JK's exhibition *Ruines* at the Bibliothèque nationale de France, Paris, 2020. Photograph by Clarisse Bourgeois

capacity at large-scale events. This decreased any possible international attendance for *Ruines*. On October 29 Josef lamented to me: "Can you imagine, my exhibition closes tomorrow!" Originally scheduled to end in mid-December, it closed early due to the alarming rise in Covid numbers. The French government once again announced itself at war with the virus. The hope was that these temporary closures would be successful in decreasing the spread, and that cultural institutions would be permitted to reopen in December. If that had happened, *Ruines*, almost thirty years in the making, would have had a final two weeks in Paris. Unfortunately, the exhibition never officially reopened to the public. From February to September 2021, however, it was presented at the Museo dell'Ara Pacis in Rome, under the auspices of Contrasto.[2]

2.

Koudelka loyally visits his "friends" at museums as part of any journey he makes. With these encounters in mind, when he was in his sixties he began considering his own legacy, especially with regard to the venues in which he wanted his work to live in perpetuity. Sheila Hicks has been a key force in encouraging him to make gifts of his photographs to museums that matter to him, and Koudelka has also considered expanding on existing collections of his work (several of which have been highlighted in this telling of his life). "I would like my work to be in museum collections in different countries," he says. "Luckily enough, I was not selling pictures for a long time, and have a collection of pictures that could be placed in important institutions." In particular, he is committed to giving back to cities and countries that have embraced and offered so much to him, such as London, Paris, and Prague. He has also made a selection of photographs for his children.

Some of the first Koudelka images to become part of a major collection in Paris were those commissioned by Bernard Latarjet in the mid-1980s for the Mission Photographique de la DATAR. The prints that are part of the DATAR project are archived at the Bibliothèque nationale de France. In 2020 Koudelka made a significant donation of 171 (50-by-60-cm) prints from the *Ruins* series to the BnF as well. He made another major donation of his work to Paris when, in conjunction with his *La fabrique d'Exils* exhibition at the Centre Pompidou in 2017, he gave the museum seventy-five photographs from the *Exiles* series. Clément Chéroux says: "Koudelka made a very generous gift. It was vintage *Exiles* prints. . . . There were no conditions from Josef at all."

The United Kingdom gave Koudelka asylum when he first left Czechoslovakia in 1970, supported him with photographic grants, and gave him his first major exhibition in 1984. In November 2022, says Jonathan Roquemore: "The photographic acquisitions committee of the Tate, in London, unanimously voted to establish the Josef Koudelka legacy collection — an in-depth collection representing Josef's lifework. The collection — part gift, part acquisition — will ultimately comprise around eighty photographs."

In conjunction with Koudelka's 2014 *Nationality Doubtful* retrospective, the Art Institute of Chicago acquired a selection of his photographs — half of them purchased by the museum, and the others gifts or promised gifts from the artist. Jan Mlčoch, the photography curator at the Museum of Decorative Arts in Prague, notes that the trove destined for Chicago is truly unique. It includes the original prints adhered to boards from Koudelka's 1967 *Gypsies* exhibition, presented in the foyer of the Divadlo za branou: photographs made between 1961 and 1966. "For twenty years they were here, in the museum, wrapped up," says Mlčoch. "No one knew what it was. One day I said: 'Josef, I'd like to show you something.' . . . Josef didn't even know that they were there!" This acquisition is especially resonant because the Art Institute of Chicago was, in 1976, the first museum in the world to devote an exhibition to the *Gypsies* photographs alone.

Bernard Latarjet and JK at the *Ruines* exhibition, Paris, 2020. Photograph by Enrico Mochi

By far the largest gift will go to Prague, capital of Koudelka's homeland, and the city in which he plans to spend much of his time in the coming years. "I am getting older," he mused during one of our transatlantic lockdown conversations, in late May 2020. "I will not be able to keep taking the metro in Paris, as I always have." Koudelka's Ivry studio is a walkup, with several flights of steep and dimly lit stairs to navigate. His centrally situated, luminous studio-home in Prague, which he may access either by an elegant, wide stairway or by elevator, is in all ways easier for living and working. (There's even a tram — free to ride for citizens over sixty-five — a stone's throw from his door.) Although he will surely miss the proximity of Lucina and his friends and colleagues in Paris, he has many friends in Prague.

Koudelka made a gift of four hundred works to the photography collection of the Museum of Decorative Arts in Prague in 2013 — after six years of negotiations facilitated by Irena Šorfová, and with the support of the museum's director,

Helena Koenigsmarková. Tomáš Pospěch, who became a photography curator at the museum in 2019, will oversee the Josef Koudelka collection and the conservation and cataloging of the gift (ultimately some 1,800 photographs) as well as any research of the collection. As with all his donations to institutions in the Czech Republic — about two thousand photographs in all — Koudelka did not demand that the museum purchase any of the photographs. His requirements were and continue to be only about the work itself: that the conditions for storing it be secure and excellent, that it is made available to researchers, and that works may be loaned out for exhibitions worldwide. Most important to him is that

> there is one place in this world, if somebody wants to see my pictures, they can come and see my pictures. More important, in this one place in the world, I want to have one example of each of my pictures that I consider good. The other rule is that they are kept properly and safely, archivally.
>
> When I considered where this place should be, I thought it must be the country where I was born, and decided on the Museum of Decorative Arts in Prague for the largest gift. It is a state institution. There is a repository where my work will be safe. This is also the place which has the principal photography collections in the Czech Republic.[3]

In his text for Koudelka's *Returning* book, Mlčoch contextualizes the photographer's gift in terms of other humanist work in the museum's collection, by Magnum photographers as well as by what he calls "the Czech classics." These include František Drtikol, Josef Sudek, and Jaromír Funke, along with those closer to Koudelka's own generation — in many cases his friends — such as Pavel Dias, Dagmar Hochová, Markéta Luskačová, and Miloň Novotný.[4]

Koudelka has also made substantial donations to the National Museum and the National Gallery in Prague,[5] many of which were formalized in September 2021; he is planning others (as ever, with the help of Šorfová).

Josef Koudelka Foundation board: Jonathan Roquemore, JK, Irena Šorfová, and Stuart Alexander after first meeting, Paris, 2019. Photograph by Jaroslav Fišer

This is the where. Also crucial for Koudelka is the what. On this matter he is clear:

> I have selected the images that I like and that I was precisely selecting over many years. I do not want any images other than those I have deemed good pictures ever to be used for anything in any way.

It is for this reason that he is systematically going through every image he has ever made, indicating which photographs he approves and within which category or theme they belong. To protect the integrity of his work and safeguard his wishes, Koudelka established a not-for-profit foundation in the Czech Republic in November 2019, headquartered in Prague, to exist in perpetuity. Koudelka is the foundation's chair and founder, and he has entrusted Stuart Alexander, Roquemore, and Irena Šorfová to serve as its founding supervisory board (with the possibility of additional board members in the future): "It is my wish and

At the Ministry of Culture in Prague, signing documents to officialize JK's gifts to four major museums in the Czech Republic, 2021. Czech minister of culture Lubomír Zaorálek (second from left), JK, and Helena Koenigsmarková, director of the Museum of Decorative Arts in Prague. Photograph by Ondřej Kocourek

decision that the foundation has the independence to do the necessary work in the correct way and free from any outside influence." He adds: "I want the foundation to complete the things that I didn't succeed in finishing — but the selection must always be mine."[6]

3.

With much of his archive to be housed in Prague, and his own eventual move to the city, Koudelka says that his relationship with Magnum is changing. Over the years, the cooperative agency has struggled, financially and otherwise — largely as a consequence of enormous shifts in the print magazine industry and in the nature of imaging itself. This has resulted in fewer and shorter editorial assignments, even for photographers of the agency's caliber. Still, for many of its members, the concept of a cooperative aligns with their values, and much of its talented staff shares this belief in a less-money-driven, more-mission-driven ideal for Magnum.

For Koudelka, the agency has always been an important ally and facilitator — especially for his exhibitions in recent years. He feels profoundly indebted and loyal to Magnum and remains sympathetic to the cooperative's economic challenges and vulnerabilities. He has always believed Magnum's independence is indispensable to its identity — that it must never be owned or otherwise controlled in any way that might compromise the cooperative's core social, ethical, and journalistic integrity. On June 23, 2016, he hand-wrote a letter, in English, addressed to all those present at the Magnum annual meeting, which took place that year in London. Fearful that the agency might forsake its independence by allowing itself to be purchased or otherwise bailed out, he said:

> I am sorry that I can't be with you at this year annual meeting, but I am with you in my mind
>
> I would like to all member know, that if the discussion about future of Magnum will go direction against keeping our control and independence in order to pay Magnum debt to photographers,
>
> I DON'T WANT MY MONEY BACK
>
> Magnum gave me so much and I feel that by doing that, I could pay back my debt to Magnum.
>
> Salute amigos
>
> Josef

At the bottom of this page, he scrawled:

Good luck with choosing good new photographers.

In a 2017 note to Magnum, Koudelka wrote: "You don't need to pay me anything that you owe me,"[7] releasing Magnum forever from its substantial financial obligation to him.

Even as the cooperative's role in Koudelka's life winds down, Magnum is still synonymous with family for him, and the bond will always be strong.

4.

When Paris first reopened in 2020 Koudelka began journeying once again from Ivry to the Magnum offices. There, with Enrico Mochi by his side to guide him, he began to navigate the computer and peruse the digital archive of his work. Still, it would have been impossible for Koudelka to review all his contact sheets, working so sporadically with Mochi. Even before the cases had again risen exponentially, exposure to Covid was a threat, as was the possibility of another lockdown. Koudelka had already finished going through his archive of prints in Ivry. What to do?

In early October 2020 Mochi brought Koudelka his very first computer — an old iMac that Mochi had at home. He recalls:

Josef had been asking me for some time if I could help him learn to use a computer and, during breaks while working together at Magnum, he would play with the computer next to mine. Then, with the pandemic, I thought of him locked up at home. Since he had all the thirty thousand contact sheets of his 35mm negatives scanned, I was looking for a way to allow him to consult the contact sheets so he could continue to go through his archive.

After the first lessons from Mochi came follow-ups and rescues from Hervé Tardy, Lucina, and Vincenzo. The result? Koudelka is now independent, free to roam as he wishes — now time-traveling in his own archive. Tardy described a "very touching experience with our pupil":

The goal — simple: he wants to see his contact sheets, nothing more. But it can't be so simple when you know that there are more than thirty thousand of them.

Turning it on, turning it off, how to open a file? Everything must be written down. "Write down everything for me." . . . Patiently, in order, I write down the lesson for him. . . . After numerous repetitions, the first contacts arrive — old ones from 1960, images for the most part unknown. Some images of the family, of his military service . . . but already the photographs.

After a few days of this, Josef called to tell me he was learning, but he did not yet have the instincts. More days passed. Tardy told me that the controls "have been mastered. The contacts dance on the screen." And he observed wryly: "The engineer is always there, but the planes have changed a lot."

Along with the possibility of discovering a previously overlooked image that Koudelka deems worth revisiting, there are aspects of his oeuvre that he wants to contextualize and review by subject, many of which he first considered in his *katalogues*. For instance, he pulled together all his images on festivities in southern Europe, "just to see what I did." He has done the same with his images of the asylum in Palermo. There are theater images that he'd never fully explored; he gathered these into one place and collaborated with Aleš Najbrt to bring together this body of work as *Koudelka: Theatre*, published in 2021 by delpire & co (In 2020, Delpire Éditeur became delpire & co). Also in 2021 Koudelka worked with Tomáš Pospěch to compile a selection of his diary entries over the years that were then published by Torst as *Deníky* (Diaries). And he has begun to revisit his

more autobiographical images — where he ate, where he slept — as well as thousands of photographs made over the years of friends and colleagues: a massive undertaking. (A handful of these images are included in this biography.) "And now Josef is very happy," Mochi concludes, "because as soon as he gets up in the morning, he turns on the computer and consults the screen and edits. And then re-edits and re-edits and re-edits." In the summer of 2021, Mochi left Magnum, although he continued to work independently with certain photographers, including Koudelka. He will also serve on a project basis for the Josef Koudelka Foundation.

By Josef's eighty-third birthday, on January 10, 2021, his computer interactions included "Zooming" — at least with me, regarding this biography. With the pandemic raging again, and vaccinations not yet available on a mass scale, this was the only way to proceed with our work. Josef was game, albeit somewhat skeptical initially. Our first Zoom meeting was intended to be a five-minute trial run. Lucina set everything up on his end, and five minutes into the conversation I suggested that he seemed comfortable enough with the technology for us to come up with a plan for future conversations. "Why?" he said. "It works. Let's keep going." So we did — for the next five hours. On January 25 he was vaccinated; later that day he called to tell me, "I am so happy. I am free!"

PAUSE

"So, what it is?" Josef booms exuberantly into his phone in July 2021. Lucina, in Ivry, is pregnant; her baby is due in November. Jonathan Roquemore is with Josef — they've just hauled most of his belongings from Ivry to Prague — and Roquemore happens to be filming the conversation. Boy or girl? Josef's voice crescendos: "*Bambina!* Ah, fantastic! Incredible!" Lucina later tells me: "I wonder why I never imagined what it would feel like to be pregnant. Having a baby used to seem like a normal thing some people do. Now that I have a new person growing inside my own body, I am in awe, I find it infinitely astounding. I feel like I have stepped onto a parallel plane."

Vincenzo Iovino and Lucina Hartley Koudelka with their baby, Ume Iovino Koudelka (three months old), February 24, 2022. Photograph by Vincenzo Iovino. (Camera on self-timer)

Ume Iovino Koudelka was born November 24, 2021. Lucina and Vincenzo's announcement reads: "Ume (pronounced Oomay) is the name in Japanese for a certain type of plum tree and its plums. Ume flowers bloom at the end of winter, announcing the arrival of spring." (One thinks of slivovitz and Josef Sr.'s plum brandy.) When I call to congratulate Josef the day after the baby's birth, the new grandfather is ecstatic. "She did it! Lucina did it!"

5.

In the fall of 2021 Covid seemed to be on the wane — a reprieve that turned out to be only temporary, with the

virus constantly mutating. I was able finally to travel to Prague to work with Josef. Our last in-person work session had been nearly two years earlier, in January 2020. Over the course of ten days in October 2021, he and I reviewed all that had evolved from our Zoom meetings, addressed questions, clarified factual details. We also looked at a draft design for this book, revising it together with Aleš Najbrt. I left Prague feeling relieved that we had spent the time with each other and resolved so much. Two months later, Josef was back in Ivry, where it was determined that he urgently needed a pacemaker. His stay in the hospital would be far longer than anticipated, however, as he was hit by a breakthrough case of Covid (at this point hospitals were buckling under the burden of the highly contagious Omicron variant). The pacemaker operation had to be delayed until he was no longer ill and feverish.

Just before Christmas 2021, with pacemaker in place but still quite weak, Josef was released from the hospital and went to stay with Lucina and Vincenzo and one-month-old Ume. Lucina told me that this was the most intense and overwhelming period of her life — especially making sure that her father ate and drank, despite his reluctance. She felt that his life was in her hands.

The grueling bouts of illness had taken a toll on Josef: he had lost strength, weight, and clearheadedness. His doctor, André Fontaine, visited him regularly during his time with Lucina and Vincenzo, and then sent him to the Hôpital Charles-Foix in Ivry for physical therapy, as Josef needed to regain mobility. But it soon became evident that a potentially deadly staph infection had taken hold of his body, and he was moved yet again, to the Hôpital universitaire la Pitié-Salpêtrière in Paris. There, Hervé Tardy was with him constantly, and Marta and Martin Stránský came from Prague (as Tardy texted me in early January) to "bring their strength to Josef's recovery war front." Their concerns were as pragmatic as they were loving. Josef had no appetite and was utterly depleted; they took it upon themselves to make sure he ate regularly. On January 17 Lucina wrote to let me know that his infection had responded to the antibiotics (and no doubt also to Josef's unflagging force of will), and that he would be transferred back to the hospital in Ivry to truly begin his rehabilitation. "He came back to life. For a moment I wasn't sure he would," she later confided. "Though he has always been especially talented at taking a positive outlook on his life, I was impressed by his ability — amidst this seemingly unfortunate avalanche of events. He told me he was looking at himself from an exterior viewpoint, and that everything is an experience one can learn from."

Josef remained in the Ivry hospital through May 2022, gaining strength each day, talking on the phone, seeing people, and working (often with Enrico Mochi) seemingly nonstop from his room — now Command Central — on future projects, specifically refining edits of his work on festivities and the asylum in Palermo. He returned to his studio in June and looked forward to returning to Prague later in the summer.

He was, as ever, both candid and hopeful about his own situation. But this did not mitigate his profound despair at the news of Vladimir Putin's Russian

Pages from one of JK's notebooks, with quotations he has been compiling by theme since 1988

forces invading Ukraine in February 2022 — news that did not, however, surprise him. "From time to time I listen to Czech Radio," Josef said to Dominique Eddé. "I prefer not to talk." These words, Eddé told me, were followed by a silence: "Those who know him know that his words were inspired by his deep humility toward the mystery of horror in humankind."

In his early public addresses after the start of the invasion, Volodymyr Zelensky, the president of Ukraine, spoke not just of the catastrophic physical destruction to his country, but also of the psychological and spiritual attack against the Ukrainians' right to live freely in their own country, as individuals and as a nation — words both aspirational and especially resonant for anyone whose liberties have ever been threatened or violated.

The right to live freely: Josef has said that his images of the Czechoslovaks' peaceful resistance to the Soviet invasion invoke "the dream about being free that we all have." After August 1968 he perceived what was happening in Czechoslovakia as the end of the dream — and yet today, more than five decades after the pictures were made, that dream is precisely what resounds throughout this work. His photographs convey the inner strength and bravery of his fellow citizens coming together in solidarity against oppression, and with the hope — so cherished and embodied by Josef — of being free.

Epilogue

Josef and I have spent days working in Prague with Aleš Najbrt on the visual concept and design template for this biography. After years of making himself available and enduring my questions, Josef is at last cheerfully challenged by the process as we consider how, visually, to interweave his life story and his work. Other than telling me when something is factually incorrect, he has not intervened in the textual account — but with the visual storytelling he is all in. After one meeting, during which we've focused on images from the 1950s and 1960s, he says: "What is beautiful about photography is that it will stay. Most of those airplanes I was taking care of when I was an engineer are by now destroyed. There is no proof of my existence."

Josef's perpetual hopefulness, his willful faith in the very act of being, feels more bound than ever to photography (and the everlastingness of books): proof of life! "The existence of thousands of negatives that you exposed," he says, "this is proof that you were alive. That it was not just a dream." We are quiet for a moment. I'm thinking of Josef's remarkable aliveness and laughing to myself at the notion that he craves proof. We return to contemplating the day's progress. I ask him if we might make a kind of "overture" of images to open the book; he has more ideas regarding the photographs for us to consider tomorrow.

The sun set hours ago, but brilliant moonlight has taken hold of the space where we work, flooding it with silver. When we stop for the day, I gather my computer and other materials from the long table, and prepare to leave. Lucina does the same. Josef accompanies me to the door, and once more we review our plans for tomorrow. I put on my boots: there is a dusting of fresh snow on the ground from the night before, and I'm happily anticipating the luminous walk along the Vltava River, back to where I'm staying. We say our thanks and *ahoj*'s, and then, lest we wrap up the day too serenely, Josef smiles hugely, and lets loose his primal call: "NEXT!"

Spain, 1975

Notes

Throughout this book, quotations that are not annotated were drawn from interviews conducted by the author in person, by phone, or by e-mail, between 2014 and 2022. In the quoted material, idiosyncratic line breaks, punctuation, and spacing (especially in correspondence), as well as negligible errors in grammar and spelling, have sometimes been adjusted for readability.

Unless otherwise indicated, all quotes, passages, and text excerpts that were originally in Czech (with the exception of certain Anna Fárová materials from about 1990 and before) and all conversations occurring in Czech were translated to English by Derek Paton and Marzia Paton, who also often served as onsite interpreters; the author expresses deep thanks to them both for their invaluable collaboration. With this blanket acknowledgment, the Patons are credited as translators in the following notes only for previously published texts. Koudelka's diary and *katalogue* entries were written predominantly in Czech; translations of those passages to English here are generally by Koudelka (often extemporizing as translator during our interviews) and are not annotated. Marguerite Shore translated various texts, correspondence, and interviews from the original Italian. She, along with Diana C. Stoll, translated various texts, correspondence, and interviews from the original French. Unless otherwise specified, Paula Kupfer translated various texts, correspondence, and interviews from the original Spanish.

Much of Anna Fárová's writing, including correspondence and texts from books, articles, interviews, speeches, and exhibition catalogs, has been gathered and/or published by Viktor Stoilov of the Torst publishing house. Readers are alerted that Fárová often repurposed passages from her own writings, with slight alterations, in multiple publications, so original sources may not be given in the following notes. Her words are translated here principally by Derek and Marzia Paton.

The correspondence, diaries, *katalogues*, agendas, and other materials designated "JK archive" are housed in Prague. Materials derived from the archive of the Torst publishing house in Prague are noted as "Torst Archive." The Aperture Archive is located in New York City.

Full publishing data for Koudelka's books in multiple editions and multiple languages are cited in the bibliography and/or on first mention in the notes that follow; quotes from those volumes are cited from English editions when applicable. When no English edition exists, passages have been translated and the page number of the original-language quote is given.

Readers are reminded that Czechoslovakia was established in late 1918, when a small group of politicians declared independence from Austria-Hungary shortly before it was defeated in World War I and the Austro-Hungarian empire was dissolved. In 1938 (the year Koudelka was born) the division of Czechoslovakia began: border areas were annexed by Nazi Germany and, to a lesser extent, by Hungary and Poland. On March 14, 1939, Slovakia became a nominally independent state and the next day Bohemia and Moravia (where Koudelka and his family lived) were made a German Protectorate. After World War II the country was reconstituted as Czechoslovakia, but its easternmost part would soon be annexed by the Soviet Union. Less than three years after the war, the Communist Party took control of the country, and held power until the Velvet Revolution in late 1989. (The relative political liberalization of the late 1960s known as the Prague Spring was brought to an end with the invasion of Soviet Warsaw Pact troops in August 1968.) At the beginning of 1993 the country split, mostly amicably, into two sovereign states, the Slovak Republic and the Czech Republic (also known as Czechia). Throughout this volume, therefore, the place of Koudelka's birth is referred to by a variety of names, depending on the time in history under discussion.

PROLOGUE (pages 9–11)

1. The international photography cooperative Magnum Photos was founded in 1947 by Robert Capa, Henri Cartier-Bresson, George Rodger, and David "Chim" Seymour. It has long represented the humanist potential of photography — in the words of Cartier-Bresson, Magnum is "a community of thought, a shared human quality, a curiosity about what is going on in the world, a respect for what is going on and a desire to transcribe it visually." Susan Meiselas has been a member of Magnum Photos since 1976; she has been the president of the Magnum Foundation since it was founded by the members of Magnum Photos in 2007. She reached out to me, and then Koudelka, in 2012 about my possibly writing his biography as part of a series the foundation had initiated, of which Andrew Lewin is the managing editor.

I P.P. — PRAGUE PHOTOGRAPHER (pages 13–93)

1. The term "Gypsy," although long widely used, is considered by many to be pejorative; its usage was banned at the First World Roma Congress in London in 1971. In this biography, I will be discussing Koudelka's project titled *Gypsies*, made at a time when these communities were still often referred to thus. Except in direct quotations or referring to the project itself, the preferred designations "Roma" or "Romani" are used throughout this volume.

2. Will Guy, e-mail to the author, February 23, 2017. Guy, who contributed the postface to Koudelka's 1975 *Gypsies* (as "Willy Guy"), is a scholar of Central European history and a research fellow at the University of Bristol, UK; he has published several books and numerous articles on the Roma people.

3. Guy, e-mail to the author, June 9, 2021.

4. Czesław Miłosz, 1981 preface to *The Captive Mind*, trans. Jane Zielonko (New York: Vintage International, 1990), p. x. (Originally published in 1953 by Knopf, New York.)

5. Robert Delpire, Alain Finkielkraut, and Danièle Sallenave, "Conversation à trois à propos des photographies de Josef Koudelka," in Josef Koudelka, *Exils*, Photo Copies 11 (Paris: Centre national de la photographie, 1988); trans. for this biography by Diana C. Stoll.

6. Søren Aabye Kierkegaard, *The Journals of Søren Kierkegaard* IV A 164 (1843), ed. and trans. Alexander Dru (London; New York; Toronto: Oxford University Press, 1938).

7. Robert Delpire, "Regarding Josef," in *Koudelka*, trans. Molly Stevens (New York: Aperture, under license by Delpire Éditeur, Paris, 2006), p. 7. (Originally published in 2006 by Delpire Éditeur, Paris.) Hereafter referenced as *Koudelka* (Delpire, 2006).

8. Josef Koudelka, *Animal*, text by Ludvík Vaculík, Collection Porte-folio no. 4 (Amiens, France: Trois Cailloux, Maison de la Culture d'Amiens, 1990).

9. Koudelka asserts this in an interview with journalist Karel Hvížďala (who has intermittently conducted interviews with the photographer since 1990). See excerpts published in Czech and English in "The Maximum, That's What Always Interested Me," notes from discussions between Koudelka and Hvížďala in Prague, 1990–2001, in *Josef Koudelka*, trans. Derek Paton, Fototorst 10 (Prague: Torst, 2002), p. 128. Hereafter referenced as *Josef Koudelka* (Torst, 2002).

10. Milan Kundera, *The Joke (Definitive Version)*, fully revised by Kundera (1982; New York: HarperCollins, 1992; repr. Harper Perennial, 2001), pp. 131–32. (Originally published in 1967 under the title *Žert* by Československý spisovatel, Prague.)

11. See Vladimír Birgus and Jan Mlčoch, *Czech Photography of the 20th Century*, trans. Derek Paton, Marzia Paton, and William McEnchroe (Prague: Kant, 2010), p. 149.

12. Ibid., pp. 151, 152–53.

13. Antonín Dufek, in Josef Chuchma, "The Individualist Josef K. in the Czech Context," in *Returning*, ed. Josef Koudelka and Irena Šorfová, trans. Derek Paton and Marzia Paton (Prague: Uměleckoprůmyslové museum v Praze and Karel Kerlický–Kant, 2018), p. 36.

14. Eva Zapletalová, adapted from her diary entries, provided by Alena Bártová, Zapletalová's daughter, September 2014.

15. Koudelka, in Romeo Martinez, "Photography as Destiny," in *Josef Koudelka: Retrospecktif/Retrospective*, trans. John Tittensor and Derek Paton (Istanbul: Pera Museum, 2008), p. 15. (Originally published in Italian in 1983 in *I grandi fotografi* by Gruppo Editoriale Fabbri, Milan.)

16. Ibid.

17. Koudelka with Hvížďala, "The Maximum," p. 123.

18. Koudelka, in Vicki Goldberg, "A Vagabond Who Sees the World Starkly," *New York Times*, August 18, 2002; nytimes.com/2002/08/18/arts/art-architecture-a-vagabond-who-sees-the-world-starkly.html.

19. Jiří Jeníček, "K výstavě fotografií Josefa Koudelky" (Concerning the Exhibition of Koudelka's Photographs), opening speech delivered at Divadlo Semafor, Prague, January 26, 1961; quoted in Josef Moucha, "For Humanity," in *Returning*, p. 18. Typescript in the JK Archive.

20. Anna Fárová, in *Josef Koudelka: Z fotografického díla 1958–1990* (Prague: Uměleckoprůmyslové museum v Praze, 1990), n.p.; repr. in *Anna Fárová: Dvě tváře*, ed. Viktor Stoilov (Prague: Torst, 2009), p. 222; trans. Derek Paton.

21. Fárová, "In the Beginning: From the Semafor Theater to *Divadlo* Magazine," in *Koudelka* (Delpire, 2006), p. 10.

22. Ibid., p. 11.

23. Fárová, in Josef Chuchma, "True to Herself: Anna Fárová and Fifty Years of Work for Photography," in *Anna Fárová & fotografie: Práce od roku 1956/ Anna Fárová & Photography: From 1956 to [the] Present*, trans. Derek Paton and Marzia Paton (Prague: Langhans Galerie, 2006), p. 39. (Originally published under the title "Je to druh poznání" in *Revolver Revue*, no. 31 [May 31, 1996]: 111.)

24. I am grateful to Aleš Najbrt for bringing these designers to my attention.

25. Anna Fárová, "Forty Years of Observing the Work of Josef Koudelka: Themes, Methods, and Stages, 1961–2001," in *Josef Koudelka* (Torst, 2002), pp. 6–7. (Sections originally published in *Divadlo* 15, no. 6 [June 1964]: 34–41.)

26. Ibid., p. 7.

27. Fárová, in *Anna Fárová: Dvě tváře*, p. 238.

28. Ibid., p. 223.

29. Pierre Soulages, "Experiments: Choosing the Essential," in *Koudelka* (Delpire, 2006), p. 27.

30. Matthew S. Witkovsky, "Schooled in the Sixties," in *Josef Koudelka: Nationality Doubtful* (Chicago: Art Institute of Chicago, 2014), p. 52.

31. Alfred Jarry, preface to *Ubu Roi* (1896), trans. Beverly Keith and Gershon Legman (Dover Thrift Editions, n.d.), pp. 1–2.

32. Kenneth Tynan, "Withdrawing with Style from the Chaos," *New Yorker*, December 19, 1977; newyorker.com/magazine/1977/12/19/withdrawing-with-style-from-the-chaos.

33. Fárová, in *Anna Fárová: Dvě tváře*, p. 225.

34. Koudelka, in Amanda Maddox, "The Walls and the Books of Josef Koudelka/Zdi a knihy Josefa Koudelky," in *Czech and Slovak Photo Publications, 1918–1989/Česká a slovenské fotografické publikace 1918–1989*, trans. (from English to Czech) Marzia Paton, concept and design by Manfred Heiting, with essays by Vojtěch Lahoda, Amanda Maddox, Petr Roubal, James Steerman, and Thomas Wiegand (Göttingen, Germany: Steidl, 2018), pp. 433–34. Maddox expands on the process of the book's development and Koudelka's frustration with it: "Koudelka [constructed] his own book dummy: a vertically oriented maquette that respected the original proportions of his photographs and required trimming or cropping of very few images. However, Fára [the book's designer] rejected the layout proposed by Koudelka in favor of his own, and Koudelka's photographs were published without his permission" (p. 434).

35. Fárová, in *Josef Koudelka: Fotografie; Divadlo za branou, 1965–1970*, ed. Anna Fárová and Otomar Krejča (Prague: Divadlo za branou II, 1993), p. 16.

36. Otomar Krejča, in ibid., p. 7.

37. Krejča, "The Experience of Theater," in *Koudelka* (Delpire, 2006), p. 41.

38. Koudelka, with Hvížďala, "The Maximum," pp. 124–25.

39. Koudelka, in Fárová, *Anna Fárová: Dvě tváře*, p. 226.

40. Krejča, in *Josef Koudelka: Fotografie; Divadlo za branou*, p. 7.

41. Koudelka, with Hvížďala, "The Maximum," p. 126.

42. Krejča, "The Experience of Theater," p. 41.

43. Georges Banu, in ibid., pp. 42–43.

44. Koudelka, with Hvížďala, "The Maximum," p. 125.

45. Markéta Luskačová, in Dean Brierly, "Markéta Luskačová," *Black & White* 12, no. 73 (March 2010): p. 54.

46. Dagmar Hochová, in Irena Šorfová, "Returning Home," in *Returning*, p. 45. See also Tomáš Pospěch, "Rozhovor s Dagmar Hochovou: Akrobat na glóbu života," *DIGIarena.cz*, February 24, 2012; digiarena.e15.cz/rozhovor-s-dagmar-hochovou-akrobat-na-globu-zivota.

47. Witkovsky, "Schooled in the Sixties," p. 50. See also Koudelka, with Hvížďala, "The Maximum," p. 127.

48. Koudelka, with Hvížďala, "The Maximum," p. 126.

49. Ibid.

50. Ibid.

51. See Stuart Alexander, "Josef Koudelka: *Gypsies*," in *Josef Koudelka: Gypsies*, texts by Song Youngsook and Alexander, trans. ERITS (Seoul: Museum of Photography, Seoul, 2016), n.p. While Koudelka does not recall the precise publication in which he first saw Farm Security Administration work, Alexander hypothesizes in this essay that Fárová had the exhibition catalog for the show *The Bitter Years, 1935–1941: Rural America as Seen by the Photographers of the Farm Security Administration*, curated by Edward Steichen and presented in 1962 at the Museum of Modern Art in New York. It is almost certain that she had the catalog for John Szarkowski's 1966 Dorothea Lange retrospective, since in their correspondence Szarkowski promised to send it to her.

52. Alexander, "Josef Koudelka: *Gypsies*," n.p.

53. Fárová, *Anna Fárová: Dvě tváře*, p. 213.

54. Allan Porter, "Josef Koudelka — A Monograph," *Camera* 58, no. 8 (August 1979): 4.

55. Anna Fárová, "Koudelka: Some Remarks on the Young Czechoslovakian Photographers," *Camera* 46, no. 11 (November 1967): 26–35.

56. In the magazine's introductory editorial, Porter contextualized the theme, referring to projects focused on place and/or distinct peoples, such as W. Eugene Smith's 1950s work in Pittsburgh, Paul Strand's *Living Egypt* (1969), and Alexander Gardner's *Photographic Sketchbook of the War* (1865–66). The issue's portfolio section includes Jens S. Jensen's pictures of working-class people in Sweden, as well as John Walmsley's work on the progressive Summerhill School in England. Koudelka's work on the Roma opens the portfolio section.

57. Anna Fárová, letter to John Szarkowski, April 13, 1967. Artist's correspondence file, Museum Collection Files, Anna Fárová. Department of Photography, Museum of Modern Art, New York (trans. from French).

58. Szarkowski, letter to Fárová, October 6, 1967. Artist's correspondence file, Museum Collection Files, Anna Fárová. Department of Photography, Museum of Modern Art, New York.

59. Peter C. Bunnell, letter to Anna Fárová, May 24, 1968. Artist's correspondence file, Museum Collection Files, Anna Fárová. Department of Photography, Museum of Modern Art, New York.

60. Michel Frizot, *The Making of Exiles*, ed. Josef Koudelka and Clément Chéroux, trans. Jeremy Harrison (Paris: Éditions Xavier Barral; Éditions du Centre Pompidou, 2017), p. 134.

61. Fárová, *Anna Fárová: Dvě tváře*, p. 227.

62. See Erika Zlamalová, "IV Congress of Czechoslovak Writers," *Prague Writers' Festival*, April 30, 2008; pwf.cz/en/prague-spring/898.html.

63. See Robert Littell, ed., *The Czech Black Book*, prepared by the Institute of History of the Czechoslovak Academy of Sciences (New York; Washington, DC; London: Frederick A. Praeger, 1969), p. 6. This book is an account of the Soviet invasion of Czechoslovakia, including eyewitness testimony, official documents and bulletins, speeches, leaflets, broadcasts, articles, and announcements, among other materials.

64. Broadcast by Czechoslovak Radio, August 21, 1968, transcribed in Josef Koudelka, *Invasion 68: Prague*, trans. Derek Paton and Marzia Paton (New York: Aperture, 2008), p. 20. (Published in Czech under the title *Invaze 68* by Torst, Prague, 2008.)

65. Koudelka, interview with Mario Calabresi, *A occhi aperti* (Roma: Contrasto, [2013]), pp. 32–55; trans. for this biography by Marguerite Shore.

66. Ludvík Svoboda, report of August 25, 1968, quoted in *The Czech Black Book*, p. 144.

67. *Rudé právo* (Red Rights), August 25, 1968, quoted in *Invasion 68: Prague*, p. 262.

68. Svoboda, quoted in *The Czech Black Book*, p. 144.

69. Koudelka, with Hvížďala, "The Maximum," p. 130.

70. Koudelka, "Josef Koudelka: Srpen 1968," p. 2; repr. in *Anna Fárová: Dvě tváře*, p. 234.

71. Koudelka, interview with the author, "Invasion 68: Prague," *Aperture* 192 (Fall 2008): 29.

72. Koudelka, "Josef Koudelka: Srpen 1968," p. 2; repr. in *Anna Fárová: Dvě tváře*, p. 234.

73. Koudelka, interviewed by Sean O'Hagan, "40 Years On: The Exile Comes Home to Prague," *Guardian*, August 23, 2008; theguardian.com/artanddesign/2008/aug/24/photography.

74. Ian Berry, in Russell Miller, *Magnum: Fifty Years at the Front Line of History* (New York: Grove, 1997), pp. 233–34. (Originally published in 1997 by

Secker & Warburg, London.) Other Czechoslovak photographers who covered the invasion include Pavel Dias, Bohumil Dobrovolský, Markéta Luskačová, Miroslav Martinovský, Miloň Novotný, and Miroslav Zajíc. Irena Šorfová, e-mail to the author, September 13, 2021, and per Koudelka.

75. Moucha, "For Humanity," in *Returning*, p. 22. Moucha is quoting a folk musician who appeared in Rudolf Adler's made-for-television documentary film *Poutník — Fotograf Josef Koudelka* (Prague: Československá televize, 1991).

76. Natalia (also Natalya) Gorbanevskaya, *Red Square at Noon*, trans. Alexander Lieven (New York; Chicago; San Francisco: Holt, Rinehart and Winston, 1972), pp. 54–56. (Originally published in 1970 under the title *Midi, Place Rouge* by Éditions Robert Laffont, Paris.)

77. Gorbanevskaya, "A Few Minutes of Freedom: An Interview with Natalya Gorbanevskaya, a Soviet Dissident," in *The Soviet Invasion of Czechoslovakia in 1968: The Russian Perspective*, ed. Josef Pazderka, trans. Judith Wermuth-Atkinson, Derek Paton, and Marzia Paton (Lanham, MD: Lexington Books, 2019), pp. 254–55. Also Pazderka, e-mail correspondence with the author, July 27, 2021.

78. *Rudé právo* (Red Rights), August 24, 1968, quoted in *Invasion 68: Prague*, pp. 173, 219.

79. Koudelka, "Josef Koudelka: Srpen 1968," p. 31; repr. in *Anna Fárová: Dvě tváře*, p. 237.

80. Krejča, in *Koudelka* (Delpire, 2006), p. 43.

81. On April 17, 1969, Cartier-Bresson had written to Fárová, with whom he had collaborated on a book in 1958. Correspondence in JK Archive.

82. Historians at Leica corroborate that there was indeed a Joseph Cooper who died in 1975, whose Leica pocket companion was first published in 1962. (Cooper also published various writings on medical matters.)

83. Matthew S. Witkovsky, curator of Koudelka's 2014 *Nationality Doubtful* exhibition at the Art Institute of Chicago, offers information on these prints: "Ahead of the AIC exhibition, in 2013, we bought 10 photographs of the Prague invasion that Koudelka had printed and sold directly to [Allan] Stone in January 1969, along with 10 prints from *Gypsies*. Through my intervention, 9 of the 10 *Gypsies* prints were sold to the Getty; the tenth had been inadvertently ruined by Stone through poor mounting. Josef was told at the time of the offer of sale, which came from Stone's widow and children. . . . Most of the *Invasion* prints were included in the AIC venue of the show." Witkovsky, e-mails to the author, March 29, 2018, and August 30, 2021.

84. See Amanda Maddox, "A Stranger in No Place: Josef Koudelka in Great Britain, 1969–1984," in *Josef Koudelka: Nationality Doubtful*, pp. 139–40.

85. Koudelka, with Hvížďala, "The Maximum," p. 131.

86. "Czechoslovakia/Invasion" clip, *CBS Evening News*, August 20, 1969, reported by Walter Cronkite and narrated by Charles Collingwood, 4 min. 30 sec. (Nashville: Vanderbilt Television News Archive).

87. *L'aveu* (*The Confession*), 1970, dir. Costa-Gavras for Paramount Pictures (139 min.). Based on the account *L'aveu* by Lise London and Artur London (Paris: Éditions Gallimard, 1968).

88. Artur London and Lise London, *The Confession*, trans. Alastair Hamilton (New York: William Morrow, 1970), pp. 439–44.

89. Koudelka, "Josef Koudelka: Srpen 1968," pp. 2–32; repr. in *Anna Fárová: Dvě tváře*, p. 237.

90. According to the "Schedule of Miscellaneous Income for the Fiscal Year Ended April 30, 1970," from Magnum's Annual Financial Report. Magnum Foundation archive manager Ryan Buckley, e-mail to the author, March 8, 2018.

91. Koudelka, letter to Nathan Lyons, March 5, 1968. JK Archive.

92. John Szarkowski, letter to Allan Porter, September 16, 1969. JK Archive. Szarkowski noted that, while he was impressed with Koudelka's work, he would have "absolutely no idea where to begin to look" for a working grant.

93. Peter Keen (writing for Koudelka), letter to Elliott Erwitt, 1969. JK Archive.

94. Erwitt, letter to Koudelka, October 23, 1969. JK Archive. See also Maddox, "A Stranger in No Place," p. 139.

95. See Stuart Alexander, "Exile, 1970–1990," in *Returning*, p. 24.

96. Koudelka, interview with Calabresi, *A occhi aperti*, pp. 32–55; trans. for this biography by Marguerite Shore.

97. Marc Riboud, letter to Koudelka, December 15, 1970. JK Archive.

98. Charles Harbutt, letter to Russ Melcher, n.d. JK Archive.

1. Koudelka, postcard to Anna Fárová, May 29, 1970. Torst Archive.

2. See Maddox, "A Stranger in No Place," p. 141.

3. Marc Riboud, letter to Miroslav Brůžek, July 10, 1970. JK Archive; trans. for this biography by Marguerite Shore.

4. Koudelka, with Hvížďala, "The Maximum," p. 132.

5. See Maddox, "A Stranger in No Place," pp. 138, 140–41.

6. Ibid., p. 141

7. Marguerite Yourcenar, "Tellus Stabilita," in *Memoirs of Hadrian*, trans. Grace Frick (1963; New York: Farrar, Straus and Giroux, 2005), pp. 122–23. (Originally published in 1951 under the title *Mémoires d'Hadrien* by Librairie Plon, Paris.)

8. See Grattan Puxon, "London, 1971: The First World Roma Congress," blog entry for FXB Center for Health & Human Rights at Harvard University, April 25, 2019; fxb.harvard.edu/2019/04/25/london-1971-the-first-world-roma-congress/.

9. Trans. from Czech; style and emphasis follow the original note. JK Archive.

10. Koudelka, with Hvížďala, "The Maximum," p. 125.

11. See Maddox, "A Stranger in No Place," pp. 138–40.

12. Copy negatives are made from photographing original prints and thus creating duplicate or "copy" negatives, from which copy prints may be made — in this way protecting the original negatives and prints.

13. See Witkovsky, "Schooled in the Sixties," pp. 104 and n4, pp. 110–11.

14. Koudelka, with Hvížďala, "The Maximum," p. 143, n2. The first *Cikáni* book maquette had an unusually itinerant life. By the time Koudelka's contract with Mladá fronta was canceled, that original dummy had been returned to the designer Kopřiva, who, sometime in the mid-1970s, gave it to the Czech photography critic Vladimír Remeš. More than a decade later, it was included in the 1989 exhibition *Co je fotografie — 150 let fotografie* (What Is Photography? 150 Years of Photography), organized by Remeš's wife, Daniela Mrázková, at Prague's Mánes Exhibition Hall. Kopřiva later asked Remeš to send back the dummy in order for him to return it to Koudelka. Remeš told him that he had returned the original to Mladá fronta, where it allegedly went missing.

15. Koudelka, in Miller, *Magnum: Fifty Years at the Front Line of History*, p. 237.

16. Erwitt, letter to Koudelka, November 24, 1970. JK Archive. This second maquette had been assembled for Koudelka shortly before he left Prague in May 1970. At that time Mladá fronta retained the original dummy, as it still intended to publish the book, and Koudelka needed a maquette to take with him. Koudelka enlisted Markéta Luskačová's help, and she made a complete set of sized prints for it — but the prints shrank during the drying process, and Koudelka insisted that the images all be reprinted so that an accurate dummy could be constructed. According to Luskačová, the photographer Jan Reich was asked to print the second set of images, but Luskačová ultimately stepped in to help speed the process, "otherwise the dummy would not be ready for Josef to take it with him."

17. Szarkowski, letter to Koudelka, January 11, 1971. JK Archive.

18. Szarkowski, letter to Koudelka, postmarked May 3, 1971. JK Archive. The exhibition, titled *Extension to the Museum Collection*, was presented at the Museum of Modern Art, New York, April 22–July 1971.

19. In 1976 Anne Wilkes Tucker would be the founding curator of the photography department at the Museum of Fine Arts Houston, where she stayed until her retirement in 2015.

20. Anne Wilkes Tucker, letter to Koudelka, September 8, 1971. JK Archive.

21. Museum of Modern Art press release, September 22, 1971; moma.org/calendar/exhibitions/2658?locale=en.

22. John Szarkowski, *Looking at Photographs: 100 Pictures from the Collection of the Museum of Modern Art* (New York: Museum of Modern Art, 1973), p. 202.

23. Marc Riboud, letter to Koudelka, December 15, 1970. JK Archive.

24. Koudelka, letter to Fárová, July 1971. Torst Archive.

25. Koudelka, letter to Fárová, n.d. Torst Archive.

26. Koudelka, letter to Fárová, n.d. Torst Archive.

27. In 1974 Cornell Capa would found New York's International Center of Photography, grounded

in this exhibition's premise of the "concerned photographer."

28. Miller, *Magnum: Fifty Years at the Front Line of History*, p. 237.

29. Koudelka, with Hvížďala, "The Maximum," pp. 132–33.

30. Ibid., p. 132.

31. Miłosz, 1981 preface to *The Captive Mind*, p. xiii.

32. Koudelka, with Hvížďala, "The Maximum," pp. 134–35.

III BUILDING (pages 119–163)

1. Henri Cartier-Bresson, *The Mind's Eye: Writings on Photography and Photographers*, trans. Diana C. Stoll (New York: Aperture, 1999), p. 85.

2. Koudelka, letter to Fárová, July 1971. Torst Archive.

3. Koudelka, with Hvížďala, "The Maximum," pp. 139–40.

4. Koudelka, letter to Sergio Larraín, January 1975. JK Archive.

5. Cecil Beaton and Gail Buckland, *The Magic Image: The Genius of Photography* (London: Pavilion, 1989), p. 186. (Originally published in 1975 by George Weidenfeld & Nicolson, London.)

6. Ibid., p. 267.

7. Henri Cartier-Bresson, "Martin Munkácsi," *Aperture* 128 (Summer 1992): n.p.

8. Henri Cartier-Bresson, interview with Yves Bourde, "Un entretien avec Henri Cartier-Bresson: 'Nul ne peut entrer ici s'il n'est géomètre,'" *Le monde*, no. 1,350 (September 5, 1974): 13. Published in English as "Only Geometricians May Enter," in *Henri Cartier-Bresson: Interviews and Conversations, 1951–1998*, ed. Clément Chéroux and Julie Jones, trans. Carole Naggar (New York: Aperture, 2017), p. 68.

9. Koudelka, in *Crossing the Same River*, 2021, dir. Coşkun Aşar (81 min.); working transcript.

10. Koudelka, with Hvížďala, "The Maximum," p. 140.

11. While no years are specified in this or the following communications between Koudelka and Lee Jones, the letters quoted here and on the following page are undoubtedly from 1971. They could not have been from 1970, as Koudelka was then still on his exit visa. He did not become an associate member of Magnum until 1971 — and his status as such likely prompted Jones's notes. By June 1972 Koudelka was already working with Robert Delpire on a refined concept of the *Gypsies* book. These letters are in the JK Archive.

12. Koudelka, letter to Fárová, February 3, 1972. Torst Archive.

13. The Paris-based quarterly *Verve*, known for featuring works by cutting-edge modernist visual artists and writers, ran from 1937 to 1960.

14. See Robert Delpire, interview with the author conducted via correspondence over the course of a year, "The Intuitionist: Robert Delpire," *Aperture* 207 (Summer 2012): 62–79. I am grateful to Stuart Alexander for his input via correspondence with me, January–February 2021 and June 2021. Delpire Éditeur became delpire & co in 2020.

15. Henri Cartier-Bresson, *D'une Chine à l'autre*, preface by Jean-Paul Sartre, "Neuf" 14 (Paris: R. Delpire, 1954); and *Les danses à Bali*, observations by Beryl de Zoete, Collection "Huit" 2 (Paris: R. Delpire, 1954).

16. Delpire, "Robert Delpire and Josef Koudelka on *Exiles*," in Josef Koudelka, *Exiles*, 3rd English-language ed. (New York: Aperture, 2014), n.p.

17. Delpire, "The Rage to See," in Josef Koudelka, *Gypsies* (Millerton, NY: Aperture, 1975), front jacket flap.

18. Delpire, memo to Koudelka, February 23, 1973 (underlining in original). JK Archive.

19. Koudelka, letter to Delpire, March 8, 1973. JK Archive.

20. Delpire, interview with the author, "The Intuitionist," p. 68.

21. Koudelka told me that, in the course of working through these myriad layouts, "Delpire made these propositions which I didn't like — for example, wanting to have the photographs printed on brown paper, or with brown surrounding the photographs. I have one dummy where one plate should have white and one plate should have brown paper. He also wanted to have a special binding using screws or something so pages could be taken out. He first sequenced the pictures by categories. I refused it — it was too much like a catalog . . . too much of an art-directed book." Koudelka insisted that the book remain simple: "I wanted for people to turn the pages and be able to see the photographs, see something about the life." Delpire, for his part, was not interested in publishing a book he felt was "becoming quite conventional." Fundamentally, says Koudelka, "I didn't want it

to only be a collection of the photographs, which Delpire probably didn't either — but he started that way, more or less." Additionally, some of Koudelka's friends and colleagues weighed in on the process. David Hurn wrote to Koudelka: "When you showed me your first Dummy you brought that you had done yourself — I had had a feeling of great excitement as I have seldom had on seeing a book." Of the maquettes that Delpire was producing, Hurn wrote: "That simplicity and Power have been lost." Hurn, letter to Koudelka, [1973]. JK Archive.

22. Delpire, memo to Koudelka, May 1973. JK Archive.

23. Robert Delpire, interview with Diana C. Stoll, "Photography in Its Childhood," *Aperture* 142, "France: New Visions" (Winter 1996): 69.

24. Stuart Alexander, "Under the Stars, 1970–1990," in *Josef Koudelka: Nationality Doubtful*, p. 170.

25. Sheila Hicks and Josef Koudelka, "Overheard: A Conversation between Sheila Hicks and Josef Koudelka," interview recorded by Rebecca Clark in Paris, April/May 1992, in *Sheila Hicks* (Prague: Uměleckoprůmyslové museum v Praze and Oswald, 1992), n.p.

26. From "Magnum Photos: Chronology of Bureau Addresses," compiled by Stuart Alexander in 2004, and then regularly updated by him. Courtesy Stuart Alexander.

27. Koudelka, letter to Fárová, n.d. [November or December 1971]. Torst Archive.

28. "Overheard: A Conversation between Sheila Hicks and Josef Koudelka," n.p.

29. Fárová, letter to Koudelka, January 16, 1972. JK Archive.

30. Hicks, postcard to Fárová, January 31, 1972. Torst Archive.

31. "Overheard: A Conversation between Sheila Hicks and Josef Koudelka," n.p. From 1980 to 1983 Hicks was the publisher and editor of the New York–based *American Fabrics and Fashions* magazine (*AFF*), a dynamic, large-format publication for the textile industry to which she had contributed since the 1960s. Through this platform, Hicks embraced and explored the breadth of her interests — from architecture to anthropology to painting and photography and the very concept of a print magazine. *AFF*'s Spring 1981 issue includes two full-page reproductions of Koudelka's photographs of interiors of Roma dwellings from the mid-1960s, displaying layered fabrics and carpets. On the issue's contents page the piece is listed as

"Josef Koudelka: Textile as seen by the brilliant and homeless Czech Photographer" (*AFF*, no. 122 [Spring 1981]: 72–73.) In the same issue were actual fabric samples by Jack Lenor Larsen and Knoll, as well as swatches by "creative knitters," a linen sock by Agache, and an homage to Hicks's mentor Josef Albers, with color reproductions of one of his *Homage to the Square* works.

32. "Overheard: A Conversation between Sheila Hicks and Josef Koudelka," n.p.

33. Ibid.

34. See Maddox, "A Stranger in No Place," p. 142.

35. Koudelka, diary entry, August 27, 1972, quoted in Maddox, "A Stranger in No Place," p. 142.

36. "Josef Koudelka: Gypsies in the British Isles," in *British Image 2* (London: Arts Council of Great Britain, 1976), p. 23. Koudelka's portfolio is introduced here by an excerpt from Szarkowski's wall text for Koudelka's 1975 Museum of Modern Art exhibition (including a passage on *Gypsies*: "Koudelka's pictures seem to concern themselves with prototypical rituals, and a theater of ancient and unchangeable fables").

37. Koudelka, letter to Fárová, n.d. [sometime after Koudelka met Delpire in May 1972, and before December 11 of that year]. Torst Archive.

38. Koudelka, letter to Fárová, n.d. [April 1973?]. Torst Archive. The approximate date is from Viktor Stoilov of Torst Publishing House, who originally sorted through and annotated the letters.

39. Irena Šorfová, interview with Koudelka, November 2016, quoted in her text "Returning Home," in *Returning*, p. 44.

40. Delpire, memo to Koudelka, 1974. JK Archive.

41. For a discussion of Michael E. Hoffman's work with Aperture, see R. H. Cravens, "Visions & Voices: A Celebration of Genius in Photography," in *Photography Past/Forward: Aperture at 50*, ed. Melissa Harris (New York: Aperture, 2002).

42. Delpire published Frank's book as *Les Américains* in 1958. The original hardcover English-language edition was published with Grove Press in 1959; a special paperback edition was published by Aperture with New York's Museum of Modern Art in 1968.

43. *Aperture* magazine was launched in 1952. Its founders included Ansel Adams, Dorothea Lange, Barbara Morgan, Beaumont Newhall, Nancy Newhall, and Minor White; White edited the publication during its first decades. Aperture's

book-publishing program was initiated by Hoffman in 1965. See Cravens, "Visions & Voices."

44. The financial arrangement between Aperture and Delpire was somewhat unusual. According to Koudelka, Delpire was struggling financially at the time, which led Aperture to make a more substantial financial commitment than it might generally offer as a co-publisher. (This is reflected in the book's colophon, which specifies: "*Gypsies* was prepared and designed by Robert Delpire Editeur, and produced by Aperture.") Regarding the question of format: recall that Koudelka and Delpire had spent the better part of two years conceiving the book, in the process rejecting the vertical format initially proposed by Kopřiva, given the entirely different picture treatment proposed by Delpire. According to a letter of November 1974, however, Hoffman thought that *Gypsies* should be a vertical book. Koudelka, Delpire, and Cartier-Bresson met to discuss the proposal. Per Koudelka's notes from that meeting, Cartier-Bresson felt it was worth making the change if it was a question of the life and death of the book; Delpire left the decision to Koudelka, who told me: "For me, it was not a question of the life and death of the book — it was the question of the life and death of me. If I accept his suggestion, I'm going to have a book, but a bad book. . . . Should I be looking all my life at something that I made, but that I didn't believe in?" In the end, Hoffman agreed to the horizontal format that Koudelka and Delpire had chosen.

45. The French edition was to be called *Gitans: La fin du voyage* (Gypsies: The End of the Voyage), and the cover of the book had been designed to accommodate that title. But Hoffman felt that the US edition, which would be introducing Koudelka and his work to a North American audience, needed to have a very clear title — he wrote to Delpire on January 24, 1975, specifying that, for one thing, the title must be in English. And he was uncertain of the subtitle, "The End of the Voyage," which he felt required some explanation that was not in the book. Hoffman wrote again to Delpire on March 13: "I have been attempting to conjure up a new title for the book and all thoughts to date have been, like 'Nomads of Destiny,' ridiculously romantic and not in keeping with Josef's point of view as I understand it. If neither you nor Josef have a new title by next week, I hope you will provide a new jacket layout with the title: *KOUDELKA Gypsies Aperture*." And, apparently after some further interchange, a month later, on April 10: "Title: Honestly, I am not trying to be inflexible but 'Gypsies Last Pictures' doesn't

mean anything to me and the public and reviewers will be dumbfounded. Koudelka can't have it both ways: a literary title and no . . . suggestion of his way of working, no stated point of view, no explanatory captions. The photographs are of gypsies. That's what he wants. So let's call it what it is." The letters from Hoffman to Delpire are in the Aperture Archive.

46. In the US edition of the book, a translation of Delpire's introduction, titled "The Rage to See," appears on the book's front jacket flap.

47. See Josef Chuchma, "Anna Fárová and Fifty Years of Work for Photography," in *Anna Fárová & fotografie: Práce od roku 1956*, pp. 47–48.

48. Koudelka, postcard to Fárová, July 15, 1972. Torst Archive.

49. Stuart Alexander, "Exile, 1970–1990," in *Returning*, p. 25. According to Alexander, fourteen of the photographs in the MoMA show were of non-Roma subjects.

50. Alexander, "Under the Stars," pp. 172–73.

51. No explanation has been found in the PMA's files for why the show never happened. The museum eventually purchased ten of those sixty prints (in addition to the initial twenty), keeping the remaining fifty on extended loan before returning them to Magnum Photos in late 1980. Samuel Ewing (Philadelphia Museum of Art), e-mail to the author, November 11, 2019. All the prints were accessioned in 1977: the first twenty prints purchased are numbered 1977-144-1–20; the following ten are 1977-231-1–10.

52. "Josef Koudelka," *Aperture* 77 (1976): cover and 5–33.

53. Gene Thornton, "Documentary Photos Without Captions Leave Us in the Dark," *New York Times*, April 6, 1975; nytimes.com/1975/04/06/archives/photography-view-documentary-photos-without-captions-leave-us-in.html. It should be said that Koudelka considers the role of text and captions in relation to his images — both placement and content — in terms of each publication and exhibition he realizes. There is no general rule, except the need for absolute accuracy.

54. Delpire, "The Rage to See."

55. Sidney Rapoport, in Thomas Dugan, *Photography Between Covers: Interviews with Photo-Bookmakers* (Rochester, NY: Light Impressions, 1979), p. 215. Daniel Frank of Meridian Printing further explained in e-mails to the author, October 6, 2019,

and September 29, 2020, that *Exiles* was printed by Genoud in Switzerland, also offset in duotone with high-density black and dark gray as the duotone color.

56. Jill Hartley, note to Koudelka, December 1975. JK Archive.

57. Koudelka, in Allan Porter, "Josef Koudelka: A Monograph," *Camera* 58, no. 8 (August 1979): pp. 5, 42.

58. Koudelka, letter to Fárová, July 9, 1979. Torst Archive.

59. Fárová, letter to Koudelka, December 10, 1979. Torst Archive.

60. Cartier-Bresson, letter to Koudelka, August 1979. JK Archive.

61. Bruce Chatwin, *The Songlines* (1987; New York: Penguin, 1988), p. 56.

IV FORCES OF NATURE (pages 165–201)

1. Kundera's 1967 novel *The Joke* is about this very threat. The protagonist of the book, Ludvík Jahn, writes a "joke" on a postcard when he is a young man in the late 1940s or early 1950s — "Optimism is the opium of the people!" — seven words that end up ruining his life. Jahn is ultimately expelled from the Communist Party and thrown into the section of the Czechoslovak military reserved for traitors. Kundera's note to the "definitive" English-language edition reads: "Between December 1965 and early 1967 the original Czech manuscript was kept from publication in Prague by Communist censorship; I had rejected all the changes they wanted to impose on me, and the novel was finally allowed to appear in April 1967 exactly as I had written it." Milan Kundera, *The Joke (Definitive Version)*, fully revised by Kundera (1982; New York: HarperCollins, 1992; repr. Harper Perennial, 2001), pp. 319, 322–23.

2. Franco Zecchin, *Continente Sicilia* (Roma: Postcart, 2019), p. 8. (French edition published as *Continent Sicile* by Contrejour, Biarritz.)

3. Magnum and Olympus had a partnership at the time, giving Magnum photographers access to cameras and other photo supplies. Hervé Hughes, e-mail to the author, February 2021. Hughes met Koudelka in 1982 at Olympus Scope in Paris, when Hughes was working for Olympus repairing photographic equipment.

4. Zecchin, *Continente Sicilia*, pp. 8–9.

5. Zecchin, e-mail to the author, August 2020.

6. Zapletalová, adapted from her diary entries.

7. Taylor Hackford, introduction to *Portrait of a Film: White Nights* (New York: Abrams, 1985), p. 7.

8. Ibid., p. 9.

9. Ibid., p. 132.

10. Toledo's widow, Danish weaver Trine Ellitsgaard, told me that her husband (who died in September 2019) purchased some of Koudelka's prints in Paris early on, "long before Koudelka was famous." He later bought additional photographs, ultimately amassing a group of seventeen prints, among them many signature images from the *Gypsies* and *Exiles* series. Today these photographs are part of the collection that Ellitsgaard and Toledo donated to the Instituto de Artes Gráficas de Oaxaca, which was founded in 1988 by Toledo. Ellitsgaard, e-mail to the author, May 2019.

11. Robert Delpire, in Delpire, Finkielkraut, and Sallenave, "Conversation à trois," n.p.

12. Delpire, letter to Koudelka, January 2, 1983, quoted in Alexander, "Under the Stars," p. 174.

13. Bernard Cuau, "A Book of Questions," in *Josef Koudelka*, Photo Poche (Paris: Centre national de la photographie, 1984), n.p.

14. Delpire, Finkielkraut, and Sallenave, "Conversation à trois," n.p.

15. Nan Richardson, memo to Werner [Mark Linz], June 29, 1987. Aperture Archive. Also Carole Kismaric, letter to Robert Delpire, September 30, 1983. Aperture Archive.

16. Czesław Miłosz, "On Exile," in Josef Koudelka, *Exiles* (New York: Aperture, 1988), n.p. Delpire did not include Miłosz's essay in his first edition of *Exils*. When he published a revised French edition in 1997, however, the three-way conversation among Delpire, Finkielkraut, and Sallenave would be replaced by Miłosz's text. Koudelka, pleased with Miłosz's contribution, was eager for it to be included in the French revised edition and discreetly covered the cost himself for the French rights to the text. For that 1997 French edition, Delpire also penned a postface titled "L'œil existe à l'état sauvage" (The Eye Exists in the Wild State) — a phrase borrowed from André Breton. Both the French and the English editions of the 1997 revised *Exiles* included four additional photographs, and

the books were printed at a larger trim size, to match the format of *Gypsies*.

17. Gilles A. Tiberghien, "'Where Are the People?': Landscape in the Photography of Josef Koudelka," in *Josef Koudelka: Nationality Doubtful*, p. 218.

18. Fárová, in *Anna Fárová: Dvě tváře*, pp. 232–33.

19. Bernard Latarjet, "How We Met," in Josef Koudelka, *Ruins*, trans. Lorna Dale and Francisca Garvie (New York: Aperture, 2020), p. 11. (Originally published in 2020 under the title *Ruines* by Éditions Xavier Barral and Bibliothèque nationale de France, Paris.)

20. Ibid. See also Alexander, "Exile 1970–1990," in *Returning*, p. 25.

21. Bernard Latarjet, introduction to *Josef Koudelka*, trans. Jennifer Abrioux and Yves Abrioux, Mission Photographique Transmanche, Cahier 6 ([Calais]: Centre Régional de la Photographie Nord-Pas-de-Calais, with the Centre de Développement Culturel de Calais; [Paris]: Éditions de la Différence, 1989), n.p. Text in French and English.

22. This commission was arranged by Magnum for Koudelka, Sebastião Salgado, and Harry Gruyaert; the resulting publication is *Regards d'acier* (Dunkirk, France: Sollac Dunkerque, 1988).

23. Koudelka, 1990 interview, quoted in Fárová, *Anna Fárová: Dvě tváře*, p. 233.

24. François Hébel, "Paysages industriels/Industrial Landscapes," in *Koudelka Industries*, texts by François Barré and Hébel in French and English, trans. Valérie Grundy (Paris: Éditions Xavier Barral, 2017), n.p.

25. Koudelka, letter to Fárová, February 3, 1987. Torst Archive.

26. Koudelka, letter to Fárová, September 7, 1987. Torst Archive.

27. The two exhibitions, which were nearly identical, would subsequently travel in their respective continents.

28. Irving Penn, *Passage* (New York: Knopf, 1991), p. 270.

29. Koudelka, postcard to Fárová, May 2, 1989. Torst Archive.

30. Koudelka, postcard to Hervé Hughes, 1989. Courtesy Hughes.

V RETURNING (pages 203–289)

1. Anna Fárová, speaking at a press conference for the exhibition *Josef Koudelka, Photographer* at the Veletržní palác (Trade Fair Palace), National Gallery, Prague, November 14, 2002. Transcript of audiorecording. Irena Šorfová Archive, Prague.

2. Fárová, speech delivered at the opening of *Josef Koudelka: Z fotografického díla, 1958–1990* at Uměleckoprůmyslové museum v Praze (Museum of Decorative Arts), Prague, December 20, 1990. In Fárová, *Anna Fárová: Dvě tváře*, pp. 219–20.

3. Tomáš Pospěch, "One Landscape after Another," in *Returning*, p. 29.

4. Josef Koudelka, *Černý trojúhelník — Podkrušnohoří: Fotografie 1990–1994*; *Le triangle noir — La région située au pied des monts Métallifères*; *The Black Triangle — The Foothills of the Ore Mountains*, essay by Josef Vavroušek; texts by Zdeněk Stáhlík, Igor Michal, and Petr Pakosta; and an excerpt from Václav Havel's 1991 "Environment for Europe" speech (Prague: Vesmír and Správa Pražského hradu, 1994). All texts in Czech, French, and English.

5. Havel, in ibid., n.p.

6. Vavroušek, in ibid, n.p.

7. Robert Delpire, "Notes," in Josef Koudelka, *Chaos*, 2nd ed., trans. Liz Heron (London: Phaidon, 2005), p. 6. (Originally published in 1999 by Nathan/Delpire, Paris.)

8. Ibid., p. 9.

9. Dominique Eddé, preface to *Beirut: City Center*, photographs by Gabriele Basilico, Raymond Depardon, Fouad Elkoury, René Burri, Josef Koudelka, and Robert Frank, excerpts from French trans. and adapted by Eric Tabet (Paris: Éditions du Cyprès, 1992), n.p. (Originally published in French under the title *Beyrouth: Centre ville*.)

10. Ibid., n.p.

11. The *Beyrouth* project was supported by the Hariri Foundation.

12. Eddé, in *Beirut*, n.p.

13. See André Green, interviewed by Dominique Eddé, *La lettre et la mort* (Paris: Denoël, 2004); *Kite* (London: Seagull, 2012; originally published in 2003 by Éditions Gallimard, Paris); *The Crime of Jean Genet* (London: Seagull, 2016); and *Edward Said: His Thought as a Novel* (London: Verso, 2019).

14. Dominique Eddé, "Koudelka's Beirut: The Vision of What Cannot Be Seen," *Magnum Photos Newsroom*, September 12, 2018; magnumphotos.com/newsroom/conflict/josef-koudelka-beirut/.

15. Zañartu's film *Voyage with Josef Koudelka* (20 min., standard-definition video, PAL) was shot in 1991 and edited in 2002. It was shown in conjunction with the presentation of Koudelka's 2002 retrospective in Arles.

16. Josef Koudelka, *Reconnaissance: Wales*, preface by Christopher Coppock, text by Derrick Price (Cardiff: Ffotogallery, in association with Cardiff Bay Arts Trust, National Museums and Galleries of Wales, and Magnum Photos, 1998).

17. As he and Delpire had done with *Chaos*, Koudelka would continue to recontextualize, in various projects, panoramas that had originally been made as part of commissions, including: *Teatro del tempo/Théâtre du temps: Rome, 1999–2003*, texts by Erri De Luca and Diego Mormorio (Rome: Peliti Associati; [Arles, France]: Actes Sud, 2003); *Koudelka: Camargue*, text by Jean Giono (Arles, France: Actes Sud/Conservatoire du Littoral, 2006); and *Piemonte*, text by Giuseppe Culicchia (Rome: Contrasto, 2009).

18. The accompanying catalog is *Koudelka: Decreazione* (Rome: Contrasto, 2013).

19. The 2013 Holy See Pavilion also engaged Genesis's themes of "creation" (with interactive videos by the Milanese collective Studio Azzurro) and "re-creation" (with paintings by American artist Lawrence Carroll). See Charlotte Higgins, "Vatican Goes Back to the Beginning for First Entry at Venice Biennale," *Guardian*, May 31, 2013; theguardian.com/artanddesign/2013/may/31/vatican-first-entry-venice-biennale.

20. See ibid.

21. In November 2013 Lucina provided similar help for Koudelka's retrospective at Tokyo's National Museum of Modern Art, his first solo show in Asia. She told me: "Josef asked me to make a proposal for a very graphic wall. He made his proposal. So did the curator. Much to my surprise, his favorite was mine. He knew I was fascinated with Japan and offered to take me with him as his assistant. My trip would be paid for, and I could stay a while longer to travel and explore Japan. I supervised the hanging of his *Beginnings* and *Theater* work, and when I was not working on the show, I was filming."

22. Increasingly in recent years, Koudelka has arranged to make gifts of photographs to museums whose permanent collections he feels it would be interesting to join — often these are to institutions or cities that have supported him in the past. The donations are generally orchestrated in such a way that the institutions are expected to purchase some prints as well — in a sense, to demonstrate their commitment to his work. The Musei Vaticani had expressed interest in such a plan, but ultimately the arrangement did not work out, and Koudelka instead donated the photographs to Prague's National Gallery.

23. Koudelka, in Aşar's *Crossing the Same River*, 2021; working transcript.

24. Koudelka, "Interview with Bernard Latarjet and Josef Koudelka," English-language insert accompanying *Josef Koudelka: Sledi/Vestiges, 1991–2012* ([Ljubljana, Slovenia]: Muzej in galerije mesta Ljubljane, [2014]).

25. Bernard Latarjet, e-mail to the author, 2016.

26. Tiberghien, "Where Are the People?," p. 219.

27. See *Josef Koudelka: Periplanissis, Following "Ulysses' Gaze,"* introduction by Alain Bergala and text by Margarita Mandas (Thessaloniki, Greece: Organization for the Cultural Capital of Europe, 1997, 1995), n.p.

28. Hiromi Nakamura, quoting Koudelka in "Dialogue," *Following "Ulysses' Gaze"* (Tokyo: Tokyo Metropolitan Museum of Photography, 1997), n.p. This museum was one of the venues that presented Koudelka's photographs of the project.

29. Ibid.

30. Koudelka, interview with Christian Caujolle, "J'ai toujours photographié des choses en train de disparaître," *Art Newspaper: Édition française*, November 10, 2020; artnewspaper.fr/interview/josef-koudelka-j-ai-toujours-photographie-des-choses-en-train-de-disparaitre; trans. for this biography by Marguerite Shore. (Originally published in *Art Newspaper France–Mensuel*, no. 22 [September 2020].)

31. Milan Kundera, *Immortality*, trans. Peter Kussi (New York: Harper Perennial, 1992), p. 314. Written in Czech in 1988 but originally published in French, as *Immortalité* (by Gallimard, Paris), in 1990. First published in Czech as *Nesmrtelnost* in 1993.

32. Koudelka recalls that he also selected a book about cowboys and Indians from Valchov's one-room "library." "There were a lot of guns," he says, "and so my father made me return it. No guns, ever, not even as toys."

33. John Berger, "Appearances," in Berger and Jean Mohr, *Another Way of Telling* (1982; New York: Vintage International, 1995), p. 89.

34. Josef Koudelka, *Piemonte*, text by Giuseppe Culicchia (Milan: Contrasto, 2009). (French edition published by Éditions Xavier Barral, Paris.)

35. Her mother kept their Ivry flat, which she has rented out over the years.

36. See Jacqueline de Ponton d'Amécourt, "Nature and Man: Josef Koudelka, the Freedom to Observe," in Josef Koudelka, *Lime* (Paris: Éditions Xavier Barral, 2012), n.p.

37. Geoff Dyer, "In the Thick of It," *Guardian*, November 17, 2006; theguardian.com/artanddesign/2006/nov/18/photography.

38. Dominique Eddé, "The Dusk of the World," in *Koudelka* (Delpire, 2006), p. 153.

39. D'Amécourt, "Nature and Man," in *Lime*, n.p.

40. Gilles A. Tiberghien, "L'envers du paysage/The Underside of the Landscape/Die andere Seite der Landschaft," in Josef Koudelka, *Lime Stone*, text in French, English, and German (Paris: Atalante-éditions in association with Groupe Lhoist, 2001), n.p. At the time Atalante-éditions was the name of the publishing arm of Xavier Barral and Annette Lucas's Agence de Création Visuelle.

41. Hébel, "Paysages industriels/Industrial Landscapes," in *Koudelka Industries*, n.p.

42. D'Amécourt, "Nature and Man," in *Lime*, n.p.

43. The book's scans were made by Christophe Batifoulier of Picto, and the separations were handled by Daniel Regard of the photogravure workshop Les Artisans du Regard in Paris. Like the *Piemonte* publication, *Lime* must be turned in order to view the horizontal panoramas; some are paired, others are opposite a blank white page.

44. D'Amécourt, "Nature and Man," in *Lime*, n.p.

45. Delpire, "Notes," in *Chaos*, p. 6.

46. Marie Klimešová was the curator of the National Gallery's collection of modern and contemporary art from January 1998 through January 2002. Katarína Rusnáková was the director of the collection from September 1999 to the beginning of September 2000. When Rusnáková left, Klimešová stepped in as the acting director of the collection through the end of 2000, and in January 2001 Tomáš Vlček took over the position of director of the collection of modern and contemporary art. Milan Knížák became the director of the National Gallery on July 1, 1999; the exhibition programs for the museum's collection of modern and contemporary art had to be submitted to him for approval. E-mails between the author and Marie Klimešová, October 2022.

In a letter to Koudelka dated November 18, 1999, Věra Jirousová wrote that she was "anxiously waiting for the situation in the National Gallery, and therefore also in the Trade Fair Palace, to stabilize, so that I could officially ask for the honor of making the first important exhibition in the collection of modern art of the National Gallery in Prague to be of your absolutely irreplaceable photographs. I hope that this is good news for you too." In the same letter, she wrote that "Anetta" (Anna Fárová) would work out the exhibition concept, and that the National Gallery would provide two coordinators to the team (Jirousová noted that she hoped to be one of them).

Rusnáková wrote to Koudelka on April 10, 2000, confirming "the National Gallery in Prague's interest in organizing your exhibition in the collection of modern and contemporary art from February to April 2002." She specified the precise locations where the exhibition would be presented, and that the "coordination of the exhibition has been entrusted to Věra Jirousová and Irena Šorfová."

Klimešová wrote to Koudelka on November 29, 2000, in her capacity as acting director of the National Gallery's collection of modern and contemporary art: "I am delighted to inform you that the project of your exhibition at the National Gallery in Prague has been confirmed in the exhibitions program of the collection of modern and contemporary art for 2002." She again confirmed the dates and exact locations of the exhibition, and continued: "I shall personally take part, and as an expert advisor, Anna Fárová will do so externally." Klimešová closed her note: "We are happy that, in collaboration with you, with your concept as the author, together we shall succeed in mounting a large, successful retrospective, which will for the first time present to the Czech public a large range of your photographic works." All letters in JK Archive.

47. Šorfová, "Returning Home," pp. 42–43.

48. *Josef Koudelka* (Torst, 2002) includes an introduction by Anna Fárová and an interview with Koudelka by Karel Hvížďala, "The Maximum."

49. Fárová, "Forty Years of Observing the Work of Josef Koudelka," p. 16.

50. Šorfová, "Returning Home," p. 42. Diane Auberger, the director of Magnum Photos in Paris, wrote to National Gallery director Knížák: "We have been very surprised to hear that, 3 months previous to the opening, you may consider not doing the exhibition for financial reasons." Auberger noted that "Irena Šorfová has been in touch with the French Institute which has agreed to pay . . . 50,000 FF to cover the transportation and insurance costs of this exhibition." Auberger, letter to Milan Knížák, October 12, 2001. JK Archive.

51. Fárová, speaking at the press conference for the *Josef Koudelka: Photographer* exhibition, November 14, 2002. Transcript courtesy Irena Šorfová Archive, Prague.

52. For the full National Gallery statement, see Jan H. Vitvar, "Nespokojený Knížák: Teď s Koudelkou" (Unhappy Knížák: Now with Koudelka), *iDnes*, November 23, 2002; idnes.cz/kultura/vytvarne-umeni/nespokojeny-knizak-ted-s-koudelkou. A021122_183908_vytvarneum_brt. (Trans. from Czech.)

53. Šorfová, "Returning Home," in *Returning*, p. 43.

54. Fárová, "Manipulátor skutečností," *Atélier*, no. 2 (January 23, 2003): p. 7; repr. in Fárová, *Anna Fárová: Dvě tváře*, p. 251.

55. Derrick Price, "Picturing Wales," in *Reconnaissance: Wales*, n.p.

56. Fárová, "Manipulátor skutečností," p. 7; repr. in *Anna Fárová: Dvě tváře*, pp. 252–53.

57. Koudelka, letter to Fárová, February 14, 2003. JK Archive.

58. Koudelka, in Šorfová, "Returning Home," p. 43.

59. Josef Koudelka, *Prague, 1968*, text by Petr Král; Photo Notes 3 (Paris: Centre national de la photographie, 1990).

60. Koudelka, interview with the author, "Invasion 68: Prague," p. 26.

61. The French edition was produced under Tardy's Tana imprint. Tardy founded the publishing house Copyright in 1982 — which he envisioned as "a large, creative studio designed to publish all kinds of illustrated books." He sold Copyright and Tana in 2013 to devote himself to his own photography and other personal work, as well as to the occasional project with Koudelka: "In the middle of all that," Tardy told me in a conversation, "there is my friendship with Josef. A friendship made to see beautiful pictures, to stay alive, and sometimes to suffer."

62. Viktor Stoilov, in Šorfová, "Returning Home," p. 46.

63. Šorfová, ibid.

64. Koudelka, conversation with Clément Chéroux, "Josef Koudelka: Je suis de passage" ("I Am Passing Through"), May 21, 2015, Fondation Henri Cartier-Bresson, Paris; trans. for this biography by Marguerite Shore.

65. There were many collaborators on the exhibition project at Aperture. An agreement was made with Mark Lubell, then director of Magnum in the United States, for the co-production of the exhibition prints. Danielle Jackson, who at the time coordinated Magnum's exhibitions and cultural projects, oversaw the show on Magnum's end. Jonathan Roquemore, whose Zurich-based firm the Index Ltd represented Magnum internationally at the time, handled the printing of the images at Magnum (Koudelka came to New York to oversee the printing). On the installation concept I worked with Annette Booth, then manager of Aperture's gallery, along with art director Yolanda Cuomo.

66. It was a dramatic installation: seventy-four black-and-white archival pigment prints, made from high-resolution scans of Koudelka's original photographs, were mounted to a thin and transparent substrate and installed on the gallery's walls, which were painted a rich black. The space was dimly lit, except for lighting directed on the works.

67. The film *Invasion 68* (2002) is a collaboration by Karel Čtveráček, Jan Horáček, Šárka Sklenárová, Ivan Acher, and Vladimír Žán. It includes footage by the cameraman František Procházka, a score by Acher, and sound by Jan Čeňek.

68. Aperture and Magnum co-produced two identical sets of exhibition prints. Magnum traveled its show to Belgium, the Czech Republic, Italy, Poland, Romania, and Slovakia.

69. When the exhibition prints and text panels entered China in late summer 2012, there was a moment when it was uncertain whether the show would be released from customs. Ultimately, however, the exhibition was liberated and went on to be shown in Pingyao.

70. Koudelka, in Šorfová, "Returning Home," p. 46.

71. Gilad Baram's film *Koudelka: Shooting Holy Land* (Germany/Czech Republic, 72 min.) is the first full-length documentary on the photographer. Baram directed, produced, and wrote the film and served as its cinematographer, working

with Elisa Purfürst (co-writer and editor) and Radim Procházka (co-producer). The film premiered in 2015 at the Ji.hlava International Documentary Film Festival (Czech Republic); it was later screened in festivals, including the Trieste International Film Festival (Italy), DOK.fest Munich International Documentary Film Festival (Germany), and Docaviv International Documentary Film Festival (Israel). It has been featured at photography festivals and other cultural events, and at major museums, often in conjunction with Koudelka's exhibitions. In 2018 the film was purchased for broadcast by, among others, Arte/ZDF in France and Germany and Sky Arte in Italy; it has since been distributed to cinemas in the Czech Republic, Israel, and Germany. In 2014 a 27-minute cut of the film was presented at the J. Paul Getty Museum in Los Angeles, accompanying the exhibition *Nationality Doubtful*; this short version of the film has since been included in other Koudelka exhibitions. In 2019 a version was released on DVD, Blu-ray, and via VOD streaming by Baram's Berlin-based production company Nowhere Films. The additional material in this expanded film includes footage of interviews Baram conducted with Koudelka, in the field and in the studio, and a dialogue between Koudelka and Baram in front of a live audience in Prague.

72. Frédéric Brenner, afterword to *This Place* (London: MACK, 2014), p. 189.

73. The exhibition *This Place* opened at the DOX Centre for Contemporary Art in Prague in October 2014; the project curator was Charlotte Cotton. The show then traveled to the Tel Aviv Museum of Art; the Norton Museum of Art in West Palm Beach, Florida; the Brooklyn Museum, New York; and the Jüdisches Museum, Berlin.

74. Koudelka, interview with Sean O'Hagan, "40 Years On," *Guardian*, August 23, 2008.

75. Koudelka, in Baram's *Koudelka: Shooting Holy Land* (2019 disc edition).

76. See ibid.

77. Aspects of Gilad Baram's informal conversations with Koudelka, as recounted to the author.

78. Koudelka, transcript of interview with René Backmann, "A Crime Against the Landscape" (2013), trans. Diana C. Stoll, n.p. Backmann has spent more than twenty-five years covering the Middle East and is the author of *A Wall in Palestine* (New York: Picador, 2010). An edited version of this interview (in French) appeared as "Israel/ Palestine: Le mur de séparation, un 'dommage irreparable,'" in *L'Obs*, December 18, 2013; nouvelobs.com/photo/20131218.OBS9970/israel-palestine-le-mur-de-separation-un-dommage-irreparable.html#reagir.

79. Koudelka originally titled this accordion-style book *Zone*.

80. John Berger, "The Land's Pain," note to Koudelka, 2013. Aperture Archive.

81. Koudelka, in Aşar's *Crossing the Same River*, 2021; working transcript.

82. See Sarah Goodyear, "The Self-Described 'Hermit' Who Took Some of History's Most Unforgettable Pictures of Coney Island: Photographer Aaron Rose Spent a Lifetime Hiding in Plain Sight," *Bloomberg CityLab*, May 15, 2014; bloomberg.com/news/articles/2014-05-15/the-self-described-hermit-who-took-some-of-history-s-most-unforgettable-pictures-of-coney-island.

83. Jack Kerouac, *On the Road* (New York: Penguin, 1982), p. 148.

84. Koudelka, in Aşar's *Crossing the Same River*, 2021; working transcript.

85. I am grateful to Viktor Stoilov for providing historical information about Koudelka's Prague home and neighborhood. Stoilov, e-mail to the author, October 7, 2021.

86. Roquemore organized the digitization of all thirty thousand of Koudelka's 35mm contact sheets in 2018, in partnership with the Dutch firm Picturae, which specializes in high-tech digitization of everything from photographs to glass slides to herbarium specimens. Although Magnum was not directly involved with the digitization, Mochi's work was central to the organization of the files and other logistical needs.

87. Mark Holborn, letter to Michael E. Hoffman and Carole [Kismaric], October 22, 1986. Aperture Archive.

88. Robert Delpire, "Posteriori," in Josef Koudelka, *Gitans* (Paris: Delpire, 2011); trans. for this biography by Marguerite Shore.

89. Kopřiva's inclusive, eclectic, humorous, and clearly researched concept of ornament — as it has evolved and emerged through the history of art and its relationship to typography and graphic design — is prodigiously demonstrated in his 1981 book *Typoornamenty*, which Aleš Najbrt describes as "a kind of printed collection or database

which he drew on massively." Milan Kopřiva, *Typoornamenty*, 3rd ed. (1981; Prague: Pluto, 1991).

90. In 2012 Delpire Éditeur became part of the photography program of the Libella publishing group; Stuart Alexander was named editor-in-chief of Delpire Éditeur in 2018. "Little *Gypsies*" was realized in 2016, to accompany an exhibition at the Museum of Photography in Seoul, South Korea. In "little *Gypsies*," there is just one image per spread, each opposite a blank page — all photographs reproduced at the same size. The book's vertical format requires that it be turned on its side to view the horizontal images correctly (as had previously been done with both *Lime* and *Piemonte*). Three years later, in 2019, it was revised with an updated design by Najbrt and published more broadly by Delpire Éditeur. The two editions are very similar: both are beautifully printed in offset (the first in South Korea, the second in Belgium); each features an essay by Alexander (with minor modifications for the 2019 edition, including losing the gatefold that showed a suggested sequence for a future *Gypsies* exhibition that had been included in the 2016 edition). *Gypsies* was not the only Koudelka classic to be revisited. *Exiles* was revised for a third time in 2014, co-published in association with Delpire. Aperture's US edition has a cover newly designed by Xavier Barral (at Koudelka's request), and an additional text compiled from excerpts selected from various publications and conversations between Koudelka and Delpire regarding the origins of *Exiles*.

91. See Alexander, "Josef Koudelka: *Gypsies*," in *Josef Koudelka: Gypsies*, (Museum of Photography, Seoul, 2016), n.p.

92. *Josef Koudelka: La fabrique d'Exils*, texts by Clément Chéroux and Michel Frizot (Paris: Éditions du Centre Pompidou/Éditions Xavier Barral, 2017). (Also published in English, as *The Making of Exiles*, trans. Jeremy Harrison.)

93. Directly after the title page in *The Making of Exiles* is a signature Koudelka picture made in 1968 during the Soviet invasion: the arm with the watch. This has been the first image — *preceding* section 1 — in every edition of *Exiles* since 1988: it is placed opposite his dedication to all who have helped him since he left Czechoslovakia. In *The Making of Exiles*, Koudelka also includes his photograph of his *own* arm with his watch — an image made in 1976 in Spain (not included in the original 1988 edition of *Exiles*). Perhaps by riffing on his iconic 1968 image, Koudelka is acknowledging that the original picture was posed,

but for a specific purpose: to indicate a precise point in time and space. Chéroux writes of the 1976 photograph: "Eight years later, in a field bordered with trees in Spain, it was his own watch that he placed in front of the camera. It was 7:53 a.m. with nothing in sight. The hands of the watch do not pinpoint a historical moment, they indicate a personal temporality. Koudelka understood that a photograph was not a transparent instrument for representing the world. By incorporating himself in the image, he was showing that there was a conscious being behind the camera. He was keen that people looking at his photo should understand that it was not simply the transposition of a piece of reality, but actually the expression of somebody's subjective view." Chéroux, "The Open Sky," in *The Making of Exiles*, p. 29.

94. *Josef Koudelka: Nationality Doubtful*, Art Institute of Chicago, June 7–September 14, 2014. The show traveled to the J. Paul Getty Museum, Los Angeles, November 11, 2014–March 22, 2015; and Fundación MAPFRE, Madrid, September 15–November 29, 2015.

95. In addition to the valuable information provided by Amanda Maddox in her "A Stranger in No Place" and "The Walls and the Books" essays, the author wishes to thank Maddox for so generously and collaboratively making herself, her notes, and her contacts available throughout the writing of this biography.

96. Alexander, "Under the Stars," p. 171.

97. Tiberghien, "Where Are the People?," p. 219.

98. See François Barré, "L'industrie faisant paysage/Industry Making Landscape," in *Koudelka Industries*, n.p. Koudelka's exhibition was accompanied by a large-format, spiral-bound catalog conceived by Koudelka and Xavier Barral (who also was its publisher). The volume includes texts by Hébel and by Barré.

99. The publication *Returning* includes contributions by Irena Šorfová and Stuart Alexander, a 1967 text by Anna Fárová, and essays by Museum of Decorative Arts curator Jan Mlčoch; photographer, curator, and writer Josef Moucha; art historian Tomáš Pospěch; and critic Josef Chuchma. I have invoked their insightful perspectives throughout this biography.

100. Alain Schnapp, "Looking at Ruins, Then and Now," in *Ruins*, p. 14.

101. Héloïse Conésa, "A Panoramic Odyssey," in *Ruins*, p. 7.

102. Schnapp, "Looking at Ruins," p. 17.

103. Batifoulier made the scans from Koudelka's original files for both the exhibition and publication. There were 120 prints in the show, and an additional 51 — 171 images total — in the book. He told me: "Making prints of the *Ruins* work was especially complicated due to the quantity, the need to give homogeneity to the entire group . . . and Josef's extremely demanding nature. Nothing was left to chance and the group of images had to be tested a multitude of times before achieving the desired results."

104. The *Vestiges* exhibition was produced with the additional assistance of Karen Jonsson, then development manager at Magnum Photos.

105. Diane Dufour was the European director of Magnum Photos from 2000 through 2007. In 2010, with Raymond Depardon, she co-founded Le Bal arts center in Paris, an independent platform for exhibitions, publications, and education, devoted to "the contemporary image in all its forms — photography, video, film and the new media"; le-bal.fr/en.

106. Éditions Xavier Barral, founded in 2002, has continued after Barral's death as Atelier EXB, a collective project under the direction of Jordan Alves, Nathalie Chapuis, Yseult Chehata, Charlotte Debiolles, and Perrine Somma. Their recent list includes publications on Sophie Calle, Jon Cazenave, Raymond Depardon, Harry Gruyaert, and Sergio Larraín. See Christine Coste, "La maison d'édition Xavier Barral rachetée par ses employés," *Le journal des arts*, March 17, 2020; lejournaldesarts.fr/medias/la-maison-dedition-xavier-barral-rachetee-par-ses-employes-148761.

107. Schnapp, "Looking at Ruins," in *Ruins*, p. 14.

108. Ibid.

109. See Jillian Ambrose, "Carbon Emissions from Fossil Fuels Could Fall by 2.5bn Tonnes in 2020," *Guardian*, April 12, 2020; theguardian.com/environment/2020/apr/12/global-carbon-emisions-could-fall-by-record-25bn-tonnes-in-2020.

VI NEXT (pages 291–299)

1. The smaller images were framed to their edges in fine black metal, without mattes, and lay face-up, recessed on low pedestals. The few vertical panoramas in the exhibition were hung on the walls, flush-mounted to board with no frames — also seeming to float. Additionally, the walls were hung with maps and texts.

2. *Josef Koudelka: Ruines* was presented at Bibliothèque nationale de France, François Mitterrand Site, Gallery 2, September 14–October 30, 2020; *Josef Koudelka: Radici* was shown at the Museo dell'Ara Pacis in Rome, February 1–September 26, 2021; see arapacis.it/en/node/1006995. Contrasto published the Italian co-edition of the book, titled *Radici*. Contrasto's Roberto Koch explains, "*Radici* means roots — but in many senses, including cultural meanings, and also the fact that looking at our roots would be probably more important now than ever, if you want to imagine for the future."

3. In January 2020 I was in Prague to meet with Koudelka. Irena Šorfová kindly took me on a tour of the Museum of Decorative Arts' newly built repository, located a half-hour's drive outside the city center. It is a round structure with windows on the exterior, its light-filled offices and meeting spaces defined by its circumference. The interior of the building is square, windowless, with a climate-controlled environment designed to be archivally safe for art in all media. Koudelka and Lucina were with us, as were Helena Koenigsmarková, Jan Mlčoch, and Jonathan Roquemore (who was visiting from Switzerland). Construction on this central repository began in September 2013 and was completed in May 2015; in part this was timed so that the building could house the Museum of Decorative Arts holdings while the museum's main building (erected in 1897–99) underwent a major renovation, from January 2015 through November 2017. Along with this gift to the Museum of Decorative Arts, as well as those to the National Museum and the National Gallery in Prague, Koudelka is planning additional gifts to his homeland as well: "I was born in Moravia," he says proudly, "and I will give certain photographs from *The Black Triangle*, *Invasion 68*, and *Gypsies* to the Moravian Gallery in Brno" (that gallery also has a substantial collection of Josef Sudek's photographs). "The Slovak National Gallery [in Bratislava] should also get some *Gypsies* pictures, as so many of them are from Slovakia." Along these lines, Koudelka is very conscious as to how much he owes the Roma, and is planning a future

gift of sixty photographs that he has selected from *Gypsies* to go to a cultural institution to be determined that represents and advocates on behalf of European Roma.

4. Jan Mlčoch, "Of Gifts and Giving," in *Returning*, p. 17.

5. Along with the eighteen panoramas from his *Decreazione* exhibition, Koudelka will eventually give the National Gallery in Prague twenty large vintage prints from *Gypsies* (some of which were exhibited in Anna Fárová's *7+7* show there in 1967). He has donated the *Invasion 68* exhibition (produced and toured by Aperture) to Prague's National Museum. Magnum's duplicate exhibition that toured Europe was given to the city's Museum of Decorative Arts, to which he has also donated the complete *Ruins* exhibition, as well as 50-by-60-cm prints of the 171 images comprising the book.

6. See the Josef Koudelka Foundation website: josefkoudelka.org. The foundation will address all conceptual, physical, and digital aspects of his work and assure that it is never misrepresented. It will also oversee his library and archive — including his contact sheets, *katalogues*, agendas, diaries, ephemera, book dummies, and so on (all currently retained by Koudelka). Most of these materials will eventually reside at the Museum of Decorative Arts, and will, together with the photographs (and his negatives, currently stored at Magnum Paris), comprise the Josef Koudelka collection and archive, under the foundation's auspices. Along with the foundation's supervisory board, Koudelka has gathered an international advisory board (his three children are honorary members of the latter, although he says: "I always wanted my children to live their own lives and not spend their time on my legacy"). The foundation's principal mission is to preserve and protect Koudelka's work both physically and intellectually — maintaining the integrity of his bodies of work so that they are never broken up — and to care for his archive. The other mandate is to advance the appreciation of Koudelka's artistic legacy, and to make sure that significant groups of work are placed in important institutions.

7. These 2016 and 2017 notes are housed in the JK Archive.

Selected Bibliography
BOOKS BY JOSEF KOUDELKA

Compiled by Stuart Alexander
Publications are listed in chronological order

Gitans: La fin du voyage. Introduction by Robert Delpire; postface by Willy Guy. Paris: Delpire, 1975. (Printed in 1975 but not published until 1977. 60 photos.)

Gypsies. Texts by John Szarkowski and Anna Fárová; postface by Willy Guy. Millerton, NY: Aperture, 1975. (60 photos.) A special edition of this volume was published by Aperture for the Museum of Modern Art, New York.
 British edition: London: Gordon Fraser Gallery, 1975.
 British edition: London: Robert Hale, 1992.

Josef Koudelka. Text by Romeo Martinez. Collection I Grandi Fotografi. Milan: Gruppo Editoriale Fabbri, 1982. (42 photos.)

Josef Koudelka. Introduction by Bernard Cuau. Collection Photo Poche. Paris: Centre national de la photographie, 1984. (66 photos.)
 British edition: London: Thames & Hudson, 1984.
 Exists in several different language editions.

Exils. Texts by Robert Delpire, Alain Finkielkraut, and Danièle Sallenave. Collection Photo Copies. Paris: Centre national de la photographie, 1988. (61 photos.)
 British edition: *Exiles.* Text by Czesław Miłosz. London: Thames & Hudson, 1988.
 US edition: *Exiles.* Text by Czesław Miłosz. New York: Aperture, 1988.

Josef Koudelka. Texts by Bernard Latarjet and Michel Guillot. Translated by Jennifer Abrioux and Yves Abrioux. Mission Photographique Transmanche, cahier no. 6. Douchy-les-Mines, France: Éditions de la Différence, Centre de Développement Culturel de Calais, Centre Régional de la Photographie Nord-Pas-de-Calais, 1989. (15 panoramic photos. Accordion binding.)

Prague, 1968. Text by Petr Král. Collection Photo Notes. Paris: Centre national de la photographie, 1990. (50 photos.)

Animal. Text by Ludvík Vaculík. Collection Porte-folio, no. 4. Amiens, France: Trois Cailloux, Maison de la Culture d'Amiens, 1990. (18 photos.)

Josef Koudelka: Fotografie, Divadlo za branou, 1965–1970. Edited and with texts by Anna Fárová and Otomar Krejča. Prague: Divadlo za branou II, 1993. (42 photos.)

Černý trojúhelník — Podkrušnohoří: Fotografie 1990–1994 (Le triangle noir — La région située au pied des monts Métallifères; The Black Triangle — The Foothills of the Ore Mountains). Essay by Josef Vavroušek; texts by Zdeněk Stáhlík, Igor Michal, and Petr Pakosta; excerpt from a speech by Václav Havel (texts in Czech, French, and English). Prague: Vesmír and Správa Pražského hradu, 1994. (34 panoramic photos. Accordion binding.)

Josef Koudelka: Periplanissis, Following "Ulysses' Gaze." Introduction by Alain Bergala; text by Margarita Mandas. Thessaloniki, Greece: Organization for Cultural Capital of Europe, 1995, 1997. (43 photos.)

Exils. Essay by Czesław Miłosz; postface by Robert Delpire. Revised edition. Paris: Delpire, 1997. (65 photos.)
 British edition: *Exiles.* London: Thames & Hudson, 1997. (The text by Miłosz is not included.)
 Italian edition: *Exils.* Rome: Fratelli Alinari, 1997. (The text by Miłosz is not included.)
 US edition: *Exiles.* New York: Aperture, 1997. (The text by Delpire is not included.)

Reconnaissance: Wales. Preface by Christopher Coppock; text by Derrick Price. Cardiff, UK: Ffotogallery, in association with Cardiff Bay Arts Trust, National Museums and Galleries of Wales, and Magnum Photos, 1998. (16 panoramic photos.)

Chaos. Text by Bernard Noël; postface by Robert Delpire. Paris: Nathan/Delpire, 1999. (108 panoramic photos.)
 British and US editions: *Chaos.* London: Phaidon, 1999. (The text by Noël is not included.)
 Italian edition: *Caos.* Rome: Motta, 1999.

Lime Stone. Text by Gilles A. Tiberghien, in French, English, and German. Paris: Atalante-éditions, in association with Groupe Lhoist, 2001. (36 panoramic photos.)
> **French trade edition:** *Lime Stone.* Paris: Éditions de la Martinière, 2001.

Josef Koudelka. Introduction by Anna Fárová; interview with Koudelka by Karel Hvížďala. Collection Fototorst 10. Prague: Torst, 2002. (82 photos. In Czech with English translation by Derek Paton and Marzia Paton.)

En chantier. Paris: Textuel, 2002. (10 panoramic photos.)

Teatro del tempo: Rome, 1999–2003. Texts by Erri De Luca and Diego Mormorio. Rome: Peliti Associati, 2003. (24 panoramic photos.)
> **Greek edition:** *Theatro del Tempo.* Athens: Apeiron, 2003.
> **French edition:** *Théâtre du temps.* Arles, France: Actes Sud, 2003.

Josef Koudelka: L'épreuve totalitaire. Essay by Jean-Pierre Montier. Paris: Delpire, 2004. (97 photos.)

Josef Koudelka. Text by Alessandra Mauro. Collection I Grandi Fotografi, Magnum Photos. Milan: Hachette, 2005. (36 photos.)
> **French edition:** Paris: Hachette, 2005.
> **Spanish edition:** Paris: Hachette, 2005.

Koudelka. Texts by Robert Delpire, Dominique Eddé, Anna Fárová, Michel Frizot, Petr Král, Otomar Krejča, Gilles A. Tiberghien, and Pierre Soulages. Paris: Delpire, 2006. (115 photos plus 51 panoramic photos.)
> **British edition:** London: Thames & Hudson, 2006.
> **Czech edition:** Prague: Torst, 2006.
> **German edition:** Berlin: Braus, 2006.
> **Greek edition:** Athens: Apeiron, 2006.
> **Italian edition:** Rome: Contrasto, 2006.
> **Spanish edition:** Barcelona: Lunwerg, 2006.
> **US edition:** New York: Aperture, 2006.

Koudelka: Camargue. Text by Jean Giono. Arles, France: Actes Sud/Conservatoire du Littoral, 2006. (22 panoramic photos.)

Invasion 68: Prague. Texts by Jaroslav Cuhra, Jiří Hoppe, and Jiří Suk; afterword by Irena Šorfová. Paris: Tana, 2008. (248 photos.)
> **British edition:** London: Thames & Hudson, 2008.

Czech edition: *Invaze 68: Anonymní český fotograf.* Prague: Torst, 2008.
Dutch edition: *Invasie 68: Praag.* Amsterdam: Mets & Schilt, 2008.
German edition: *Invasion 68: Prag.* Munich: Schirmer/Mosel, 2008.
Greek edition: *Invazie 68: Praga.* Athens: Apeiron, 2008.
Italian edition: *Invasione 68: Praga.* Rome: Contrasto, 2008.
Japanese edition: Tokyo: Heibonsha, 2011.
Romanian edition: *Invazie 68: Praga.* Prague: Torst, 2008.
Russian edition: *Invaze 68: Praga.* Prague: Torst, 2008.
Spanish edition: *Invasión 68: Praga.* Barcelona: Lunwerg, 2008.
US edition: New York: Aperture, 2008. English translation by Derek Paton and Marzia Paton.

Piemonte. Text by Giuseppe Culicchia. Rome: Contrasto, 2009. (76 panoramic photos.)
> **British edition:** *Piedmont.* London: Thames & Hudson, 2009.
> **French edition:** *Piemonte.* Paris: Éditions Xavier Barral, 2009.
> **US edition:** *Piedmont.* Rome: Contrasto, 2009.

Gypsies. Text by Will Guy. New York: Aperture, 2011. (109 photos.)
> **British edition:** *Gypsies.* London: Thames & Hudson, 2011.
> **Czech edition:** *Cikáni.* Prague: Torst, 2011.
> **French edition:** *Gitans.* Paris: Delpire, 2011. (Includes an additional text by Robert Delpire.)
> **German edition:** *Roma.* Göttingen: Steidl, 2011.
> **Italian edition:** *Zingari.* Rome: Contrasto, 2011.
> **Spanish edition:** *Gitanos.* Barcelona: Lunwerg, 2011.

Lime. Text by Jacqueline de Ponton d'Amécourt. Paris: Éditions Xavier Barral, 2012. (173 photos.)

Wall: Israeli & Palestinian Landscape, 2008–2012. Texts by Gilad Baram and Ray Dolphin. Paris: Éditions Xavier Barral, 2013. (54 panoramic photos.)
> **German edition:** Munich: Prestel, 2013.
> **Italian edition:** Rome: Contrasto, 2013.
> **US edition:** New York: Aperture, 2013.

Exils. Introduction by Robert Delpire; essay by Czesław Miłosz. 3rd edition (revised). Paris: Delpire, 2014. (75 photos.)

> **British edition**: *Exiles*. London: Thames & Hudson, 2014.
> **US edition**: *Exiles*. New York: Aperture, 2014.

Josef Koudelka: Gypsies. Texts by Song Youngsook and Stuart Alexander, in Korean and English. Translated by ERITS. Seoul: Museum of Photography, 2016. (109 photos.)

Koudelka: Gitans. Texts by Stuart Alexander and Will Guy. Paris: Delpire, 2019. (109 photos.)

> **British edition**: *Gypsies*. London: Thames & Hudson, 2019.
> **Italian edition**: *Zingari*. Rome: Contrasto, 2019.
> **US edition**: *Gypsies*. New York: Aperture, 2019.

Ruines. Texts by Héloïse Conésa, Bernard Latarjet, and Alain Schnapp. Paris: Éditions Xavier Barral/ Bibliothèque nationale de France, 2020. (170 panoramic photos.)

> **British edition**: *Ruins*. London: Thames & Hudson, 2020.
> **Italian edition**: *Radici*. Rome: Contrasto, 2020.
> **US edition**: *Ruins*. New York: Aperture, 2020.

Koudelka: Theatre. Text by Tomáš Pospěch, in English and French. Paris: delpire & co, 2021. (58 photos.)

Deníky. Edited by Tomáš Pospěch. Excerpts from Koudelka's diaries, 1969–2019, in Czech. Prague: Torst, 2021. (53 photos, 36 illus.)

Chronology

by Stuart Alexander

1938
Josef Dobroslav Koudelka is born January 10 in Bosko-vice, Moravia, Czechoslovakia. His parents are Josef and Marie (Nečasová) Koudelka, and he has an older sister, Marie (called Zuzana). The family lives in the Moravian village of Valchov.

ca. 1952
Introduced to photography by a friend of his father, he begins to take pictures of family and friends using a Bakelite camera.

1956–61
Studies engineering at the České vysoké učení technické v Praze (Czech Technical University in Prague).
Acquires an old Rolleiflex.
Meets the photographer and critic Jiří Jeníček, who encourages him to exhibit his work at the Divadlo Semafor (Semafor Theater) in Prague.

1961
At the opening of the Semafor exhibition, he meets art critic Anna Fárová, a major figure in Czechoslovak photography, with whom he will collaborate until he leaves the country in 1970.
Travels abroad for the first time, to Italy, as a musician in a folk music and dance group.
Begins to photograph the Roma of Czechoslovakia.

1961–67
Works as an aeronautical engineer in Prague and Bratislava.
Begins working with an SLR camera.
Contributes to the magazine *Divadlo* (Theater) as a freelance photographer.

1963
Befriends Markéta Luskačová, a cultural sociology student, who is beginning to photograph religious festivals in Slovakia.

1964
Begins to photograph performances at the Divadlo Na zábradlí (Theater on the Balustrade).

1965
At the invitation of Otomar Krejča, director of Prague's Divadlo za branou (Theater Behind the Gate), he begins to photograph performances at the theater.

Becomes a member of the Svaz československých výtvarných umělců (Union of Czechoslovak Artists).

1967
Leaves his engineering job to devote himself full-time to photography.
Receives the Union of Czechoslovak Artists' annual award for his innovative theatrical photographs.
His photographs of the Roma are shown for the first time in the exhibition *Koudelka: Cikáni 1961–66* (Gypsies 1961–66), at Divadlo za branou, Prague.

1968
Travels to Romania with sociologist Milena Hübschmannová to photograph the Roma.
Returns to Prague the day before Warsaw Pact troops invade the city, ending the short-lived political freedom in Czechoslovakia that would come to be known as the Prague Spring. Throughout this tumultuous period, he photographs confrontations between Czechoslovaks and Soviets, as well as daily life in the streets.

1969
Makes his first visit to England in April when the Divadlo za branou theater group invites him to accompany them to London and exhibit his theater photographs in the foyer of the Aldwych Theatre.
In mid-July, he embarks on his second visit to the United Kingdom, where he remains for three months.
His photographs of the Soviet-led invasion of Prague the previous year are secreted out of Czechoslovakia and sent to the United States. The photographers' cooperative Magnum Photos distributes the photographs while Koudelka is still in the United Kingdom, attributing them to "P.P." (Prague Photographer) to avoid reprisals against Koudelka and his family; a photo-essay "by an anonymous Czech photographer" is published in major international magazines. The images win him the Robert Capa Gold Medal from the Overseas Press Club. Elliott Erwitt, then president of Magnum Photos, makes a short film of animated stills with these images for *CBS Evening News*, maintaining Koudelka's anonymity.

1970
Leaves Czechoslovakia on a three-month exit visa to photograph the Roma in the West. At the expiration of the visa, however, he does not return home; he becomes stateless. The United Kingdom grants him asylum; he will continue to live there through 1979.

Begins traveling and photographing the Roma, religious and popular festivals, and daily life in various European countries.

1971
Elliott Erwitt proposes that Koudelka join Magnum Photos; he becomes an associate member.
Meets Henri Cartier-Bresson, who will become a close friend.

1972
Meets publisher Robert Delpire, with whom he will work closely for many years.
Befriends Romeo Martinez.

1974
Becomes a full member of Magnum Photos.

1975
Josef Koudelka, a solo exhibition organized by John Szarkowski, opens at the Museum of Modern Art, New York.
In Paris, Robert Delpire prepares Koudelka's photographs of the Roma as *Gitans: La fin du voyage* to be printed in New York (although this iteration of the book will not be published until 1977); Aperture publishes the US edition under the title *Gypsies*.

1978
Awarded the Prix Nadar by the Gens d'Images, Paris, for *Gitans: La fin du voyage*.

1980–87
Leaves the United Kingdom for France in 1980. Still stateless, he continues to travel throughout Europe.

1984
Josef Koudelka, his first major exhibition, conceived by Robert Delpire and organized by the Arts Council of Great Britain, is held at Hayward Gallery, London. To accompany the exhibition, *Josef Koudelka* (Collection Photo Poche) is published, in both English and French, by the Centre national de la photographie, Paris.
After the death of his father and sixteen years of anonymity, Koudelka's photographs of the invasion of Prague are published for the first time under his own name. (Before this date he had chosen to remain anonymous, seeking to protect his family still living in Czechoslovakia from possible reprisals.)

1986
At the invitation of the French governmental agency Mission Photographique de la DATAR, he takes part in a project to document the urban and rural landscape of France. It is for this project that he begins to work with a panoramic camera.

1987
Becomes a naturalized citizen of France.
Awarded the Grand Prix National de la Photographie from the Ministère de la Culture et de la Communication, France.

1988
Two major exhibitions of Koudelka's work, organized by Robert Delpire, are presented at the Centre national de la photographie, Palais de Tokyo, Paris, and at the International Center of Photography, New York. The exhibitions travel throughout the United States and Europe.
Exils is published by the Centre national de la photographie, Paris (published as *Exiles* by Aperture, New York, and Thames & Hudson, London).
Begins photographing with a panoramic camera in the north of France for the Mission Photographique Transmanche, a project to record changes in the region caused by construction of the tunnel underneath the Channel.

1989
Receives the Hugo Erfurth Prize from the city of Leverkusen, Germany, and the Agfa-Gevaert AG company.
Although he is still unable to return to Czechoslovakia, as a holder of a French passport he is invited to visit the Soviet Union along with seven other photographers. He photographs in Moscow.
His work for the Mission Photographique Transmanche leads to the publication of his first book of panoramic photographs, *Josef Koudelka*.
Awarded the Prix Romanès from the Roma author Matéo Maximoff.
Exiles (1988) receives the International Center of Photography Publication Award for Outstanding Photographic Book.

1990
With the collapse of the Communist regime, returns to visit Prague for the first time since going into exile in 1970. Photographs in Eastern Europe.
Anna Fárová curates an exhibition in Prague, in which Koudelka's photographs of the 1968 invasion as it unfolded in the city are featured, with an accompanying publication. This is the first time these photographs have been exhibited and published in Czechoslovakia.
Begins to photograph one of the most devastated landscapes in Europe: the foothills of the Ore Mountains in northern Bohemia, which have been destroyed by strip mining. They make up the western portion of

the vast region known as the "Black Triangle," which includes southern Germany and Poland.

1991
Receives the Henri Cartier-Bresson Award from the Centre national de la photographie and American Express, Paris.
Photographs the war-devastated city center of Beirut with a panoramic camera.

1992
Receives the Erna and Victor Hasselblad Foundation International Award in Photography.
Named Chevalier de l'Ordre des Arts et des Lettres, by the Ministère de la Culture et de la Communication, France.

1994
After four years of work in the Black Triangle region, conceives and organizes the exhibition and book of panoramic photographs *Černý trojúhelník — Podkrušnohoří: Fotografie 1990–1994* (*The Black Triangle — The Foothills of the Ore Mountains*), published by Vesmír and Správa Pražského hradu in Prague.
Invited by the producers of the film *Ulysses' Gaze*, directed by Theo Angelopoulos, Koudelka accompanies the film crew to record his personal vision of the Balkan countries where the film is shot. These photographs are exhibited and published under the title *Josef Koudelka: Periplanissis, Following "Ulysses' Gaze."*

1996–97
Invited by the Kulturstiftung des Freistaates Sachsen (Cultural Foundation of the Free State of Saxony) and the Siemens Culture Program to participate in the project *Aufriß: Künstlerische Positionen zur Industrielandschaft in der Mitte Europas* (Outline: Artistic Positions and Industrial Landscape in Central Europe), Koudelka and eight other artists are asked to react to the region in Saxony, Poland, and the Czech Republic where the landscape has been ruined by industrial exploitation and strip mining.

1997–98
Receives a commission from Ffotogallery, Cardiff, Wales, on behalf of Cardiff Bay Arts Trust, to make a series of panoramic images in South Wales. The culmination of this project is the book and exhibition *Reconnaissance: Wales*, accompanied by Welsh exhibitions of other groups of Koudelka's work.

1998
Awarded the Centenary Medal by the Royal Photographic Society, Bath, England, for his "sustained significant contribution to the art of photography."

2001
Completes a series of panoramic photographs for the Lhoist Group, producers of lime and dolomite. The photographs present Koudelka's view of changes to the landscape as a result of the mining of limestone; this work is published in the book *Lime Stone*.

2002
Named Officier de l'Ordre des Arts et des Lettres, awarded by the French Ministère de la Culture et de la Communication.
A major retrospective exhibition conceived and designed by Koudelka is presented at the Národní galerie (National Gallery) in Prague.
Awarded the Medal of Merit of the Czech Republic by President Václav Havel.

2003
Completes a project in Rome; the resulting exhibition, *Teatro del tempo* (*Theater of Time*), is accompanied by a book of the same title.
Photographs archaeological sites in Greece for an exhibition to coincide with the 2004 Summer Olympic Games in Athens.

2004
Receives the Cornell Capa Infinity Award for "distinguished achievement in photography" from the International Center of Photography, New York.

2006
Koudelka, the first retrospective book to cover the photographer's entire career up to this point, is published in France and several other countries.
The volume is the culmination of thirty-five years of collaboration with Robert Delpire.

2008
Forty years after the Soviet Union and its Warsaw Pact allies invaded Prague, Koudelka's book *Invasion 68: Prague* is published. By the following year, it has been published in eleven languages. The volume includes hundreds of previously unpublished photographs. The related exhibition is produced in three sets: the first by Art Link is shown in Prague, Slovakia, and Italy; the second and third sets are co-produced by Aperture and Magnum. The Aperture show is presented in China, Japan, Latin America, Poland, Russia, and the United States; Magnum's show is presented in Belgium, the Czech Republic, Italy, Romania, and Slovakia.

2011

The book *Gypsies* is published in seven editions. It is a revised and enlarged version of a maquette prepared in Prague forty-three years earlier by Koudelka and graphic designer Milan Kopřiva.

2012

Koudelka's book *Lime* is published in France: photographs of fifty-one quarries in eleven countries, made for the Lhoist Group from 1999 to 2010. Named Commandeur de l'Ordre des Arts et des Lettres by the French Ministère de la Culture et de la Communication.

2013

Vestiges 1991–2012/Josef Koudelka opens at Centre de la Vieille Charité in Marseille. It is his first retrospective exhibition on the subject of major ancient Greek and Roman archaeological sites in twenty Mediterranean countries.
The book *Wall: Israeli & Palestinian Landscape, 2008–2012* is published, completing a project Koudelka began in 2008 as one of twelve photographers invited to participate in the project *This Place*, initiated by photographer Frédéric Brenner. *Wall* comprises photographs related to the Israeli-constructed barrier that runs through the Palestinian West Bank and Israel.

2014

The retrospective exhibition *Josef Koudelka: Nationality Doubtful* opens in June at the Art Institute of Chicago and in November at the J. Paul Getty Museum, Los Angeles; in 2015 it is presented at Fundación MAPFRE in Madrid.
The newly revised and expanded edition of *Exiles* is published by Aperture, New York; Thames & Hudson, London; and Delpire, Paris.
The group exhibition *This Place*, including Koudelka's *Wall* photographs, opens at the DOX Centre for Contemporary Art in Prague, before touring to the Tel Aviv Museum of Art; the Norton Museum of Art in West Palm Beach, Florida; the Brooklyn Museum in New York; and finally the Jüdisches Museum in Berlin.

2015

Josef Koudelka: Twelve Panoramas, 1987–2012 opens at Pace/MacGill Gallery, New York.
Premiere of the documentary film *Koudelka: Shooting Holy Land* by photographer and filmmaker Gilad Baram.

2016

Exiles/Wall opens at the Nederlands Fotomuseum, Rotterdam.
Gypsies opens at the Museum of Photography, Seoul.

2017

Josef Koudelka: La fabrique d'Exils opens at the Centre Georges Pompidou, Paris.
Josef Koudelka: Industrial Landscapes opens at the Museo Civico Archeologico, Bologna, as part of the Foto/Industria biennial.

2018

Prague's Uměleckoprůmyslové museum (Museum of Decorative Arts) and National Gallery host the exhibitions *Koudelka: Návraty* and *Koudelka Decreazione*, drawn from Koudelka's gifts to those institutions.

2019

The Josef Koudelka Foundation is established in Prague.

2020

Ruines opens at the Bibliothèque nationale de France in Paris, the culmination of twenty-five years of photographing archaeological sites in the Mediterranean.

2021

Donation of more than two thousand photographs representative of his life's work to four museums in the Czech Republic.
Photographer and filmmaker Coşkun Aşar completes the documentary film *Koudelka: Crossing the Same River* (the film premieres in 2022).

2022

The exhibition *Josef Koudelka IKONAR: Constellation d'archives*, based on an examination of more than thirty thousand 35mm contact sheets, opens at Photo Elysée in Lausanne, Switzerland.

Index

Acknowledgments

Josef Koudelka: Next would not have happened without Susan Meiselas and Andrew Lewin. It was Susan, president of Magnum Foundation, who first approached me in 2013 with the idea of a Josef Koudelka biography, conceived as part of the foundation's Legacy Series of books. Andy, the managing editor of the series, contributed throughout the process: meeting with Josef and with me early on to discuss the book, and offering extremely helpful suggestions on the manuscript.

Researching the story of Josef's layered and peripatetic life required input from many corners; this book includes the words and observations of scores of his friends, family members, and colleagues around the globe — in the United States, Mexico, the United Kingdom, France, Italy, and of course the Czech Republic, as well as a few other spots on the map of Josef's lifelong journeys. I have been fortunate and honored in these interchanges: everyone graciously made themselves available to me and spoke with the candor and thoughtfulness demanded by the subject. I extend my profound thanks to Antoine d'Agata, Pedro Diego Alvarado, Bruno Barbey, Caroline Thiénot-Barbey, Xavier Barral, Alena Bártová, Christophe Batifoulier, Letizia Battaglia, Clarisse Bourgeois, Anne Cartier-Bresson, Mélanie Cartier-Bresson, Yseult Chehata, Clément Chéroux, Sergio Dahò, Raymond Depardon, Pavel Dias, Antonín Dufek, Trine Ellitsgaard, Elliott Erwitt, Samuel Ewing, Gabina Fárová, James Fox, Eric Franck, Anthony Friedkin, Harry Gruyaert, Will Guy, François Hébel, Peter Helenius, Jan Horáček, Hervé Hughes, David Hurn, Karel Hvížďala, Graciela Iturbide, Vítězslav Jelen, Mojmir Ježek, Marie Klimešová, Robert Koch, Roberto Koch, Helena Koenigsmarkova, Bernard Latarjet, Peter MacGill, Amanda Maddox, Cristina Marinelli, Verónica Martínez Lira, Alessandra Mauro, Russ Melcher, Voja Mitrovic, Jan Mlčoch, Sarah Moon, Josef Moucha, Moira North, Lauren Panzo, Tod Papageorge, Jacqueline de Ponton d'Amécourt, Allan Porter, Tomáš Pospěch, Zdeněk Přikryl, Jaroslav Pulicar, Grattan Puxon, Pavel Rohan, Aaron Rose, Marialba Russo, Karel Šálek, Alain Schnapp, Ferdinando Scianna, Mariana (Marie) Šejnová, Agnès Sire, Elizabeth Skelton, Dominique Souse, Zdeněk Stáhlík, Chris Steele-Perkins, Marta Stránská, Martin Stránský, Gilles A. Tiberghien, Francisco Toledo, Maria Tomášová, Larry Towell, Paul Trevor, Jan Tříska, Lindsay Ward, Matthew S. Witkovsky, Cristobal Zañartu, Franco Zecchin, and Irena Zítková. Without the recollections, anecdotes, ideas, and perspectives of these people, and others with whom I spoke or corresponded over the past nine years, this volume would not have been possible.

I am particularly thankful to a group of Josef's close friends and associates who patiently answered wave after wave of my queries; many of them also reviewed passages of the book-in-process to ensure that facts and details were correct. My deep appreciation goes to Coşkun Aşar, Robert Delpire, Jill Hartley, Sheila Hicks, Markéta Luskačová, Fabio Ponzio, Jonathan Roquemore, and Irena Šorfová. I am also very grateful to Viktor Stoilov, who granted me indispensable access to Anna Fárová's writings and correspondence with Josef.

This book has benefited from the attentions of an exceptional group of readers, who generously offered their time, intelligence, and insights. Each of these readers knows Josef extremely well, and each was committed to helping me render as accurate a portrait of him as possible. For this, and for their willingness to field a barrage of questions, I am especially indebted to Stuart Alexander, Gilad Baram, Dominique Eddé, and Hervé Tardy.

The extraordinary Diana Stoll has been a colleague, an incisive reader, and an honest editor of my writing for more than three decades. She is unsentimental, exacting, and pulls no punches. Her diplomatic insistence when letting me know that a word, a sentence, a phrase, or a chapter is not quite working is deeply appreciated, as is her guidance in getting everything to fall into place in the end. I am grateful for our long collaboration and friendship, and for her work on this book.

In this volume that juggles several languages, I have been fortunate to have the help and friendship of brilliant translators. Czech translator Derek Paton has been a wonder to work with. He and his wife, Marzia — also a superb translator — built bridges of understanding for me regarding Josef's life, culture, friends, and colleagues, and translated much of Anna Fárová's correspondence, Josef's early correspondence, and other texts and documents throughout the process, generously making themselves endlessly available to me; they also interpreted all the interviews that were conducted in Czech. Derek kindly agreed to be a reader of the book as it took shape. It is clear why Josef has nicknamed him "Professor": not only was Derek an astute, assiduous, fact-checking reader, he often offered historical and other insights, and helped me to understand nuances in the Czech language and culture. Both he and Marzia also translated my correspondence into Czech when needed, and went above and beyond, reaching out to colleagues and friends who they thought might provide relevant

information or anecdotes. I am so lucky to have the Patons as collaborators — and now, good friends.

I have had the joy of Marguerite Shore's friendship and collaboration for many years. I am, as ever, grateful for her talents as a translator of both French and Italian; Meg helped enormously by translating correspondence, interviews, and texts for this volume.

A good part of my heart and soul will always be with Aperture: an organization that takes risks, pushes boundaries, and makes outstanding things happen. I am proud to have had a very long association with this remarkable institution.

I am grateful to Chris Boot, Aperture's executive director when this book was initiated, for his enthusiastic advocacy of the project, and to Sarah Meister, Aperture's current executive director, for her continued interest.

Aperture's creative director, Lesley A. Martin, and I have worked together for so many years now that I've lost count. Lesley went far beyond the call of duty for *Josef Koudelka: Next*. I am forever thankful for her passion, her intelligence, and her collaboration; I am so fortunate to have her on my team. Also at Aperture is the excellent Susan Ciccotti, senior text editor, who brought her careful eye to this book, and who valiantly helped to compile its index and other aspects of the project. I also extend my thanks to: Andrea Chlad, production manager, for her painstaking work on the proofing and printing of *Next*; Richard Gregg, sales director of books; Kellie McLaughlin, chief sales and marketing officer; and Isla Ng and Claire Voon, proofreaders. I am especially grateful to Aperture designer Karina Eckmeier, and to Taia Kwinter, Aperture's publishing manager through 2022, who brought attentiveness, precision, and kindness to the preparation of this book's final galleys; they jumped in at my first SOS and remained present and collaborative thereafter. It is a truly great team, with whom any artist or writer is very fortunate to work.

This book has benefited from the care and attentions of several former Aperturians, who are all now on new paths but, fortunately for me, were able to bring their time and talents to this project. Sarah Dansberger helped to locate materials in Aperture's archive, meticulously compiled the book's endnotes, and checked all previously published quotes against their sources. Sally Knapp gave the final galleys scrupulous last reads — her impeccable eye is superhuman. Paula Kupfer translated Spanish correspondence and interviews. Amelia Lang took on the daunting tasks of tracking down high-resolution image files for the many images by photographers other than Koudelka, and compiling the captions and the permissions necessary to help bring the book to completion. I am endlessly appreciative for her diligence, care, and unflagging good spirits. I am deeply indebted to all these women for their patience, fastidiousness, and calm under pressure. Wow!

I extend my appreciation to Theodore Panken for his transcriptions and to intern Samantha Jin Soon. My thanks go to publisher Michelle Dunn Marsh and printer Daniel Frank for answering questions about Sidney Rapoport's printing techniques. Paul Wilson, former singer with the Czech underground band Plastic People of the Universe, kindly shed light on the rock-and-roll scene in Prague in the late 1960s through the early 1970s. Erica Harrison of the Trace Project generously provided information about BBC wartime broadcasts in Czechoslovakia. I am grateful to Czech journalist Josef Pazderka for his ongoing willingness to respond to my queries, especially with regard to the Soviet dissidents who in 1968 protested the Soviet invasion of Prague by peacefully demonstrating in Moscow's Red Square.

A great number of interlocutors in this book kindly allowed Aperture to reproduce their photographs in *Josef Koudelka: Next*; to them and the other photographers whose work is included in these pages, I extend my profound thanks.

Picture research has of course been a central part of this book's formulation. Along with the large body of Josef's work that is handled by Magnum, I had access to the bonanza of materials in his personal archives, diaries, and contact sheets.

I am beyond thankful to the amazing Enrico Mochi for his invaluable help with all things photo: Enrico pored through Magnum's archives searching for likenesses of Josef and other relevant photographs, and alongside Josef in the Koudelka photo archives, assembled, organized, and made most of the high-resolution scans of Josef's images for this publication, while also reviewing all other scans in the biography.

I am extremely grateful to the Josef Koudelka Foundation (again, thank you Irena, Jonathan, and Stuart); to Magnum Foundation — especially executive director Kristen Lubben and archive manager Ryan Buckley (and again, thank you Susan); and to Magnum Photos for their support, every step of the way. Along with those affiliated with Magnum already mentioned, I appreciate the help of Andréa Holzherr, Karen Jonsson, and Marion Schneider.

Yolanda Cuomo is a stellar designer of photobooks — but she did not design this volume: it is the work of the wonderful Aleš Najbrt, Josef's longtime collaborator, based in Prague. However, as was the case with many projects created in this strange era, advancing this book to its next stages was complicated (to say the least) by the advent of the Covid-19 pandemic. During the pivotal period in 2020–21 when images and text were ready to be integrated in draft layouts for the book, overseas travel was not an option, and crucial in-person working sessions with Josef and Aleš could not take place. With extraordinary grace and generosity, Yo offered to work with me in New York to implement Aleš's design in early drafts of the layout. For this, and for her friendship, I am deeply grateful. Yo's associate, the amazing Bobbie Richardson, is likewise lovely to work with: I am so thankful for Bobbie's patience, her attention to detail, and her many other talents.

Profound thanks go to Aleš Najbrt for this book's beautiful and dynamic design, and for his flexibility in allowing the team in New York to bring his vision for *Josef Koudelka: Next* to light in the early stages. Once the book was back in his hands, Aleš remained patient and game through round after round of revisions, each tweak, swap, and finesse bringing us closer to Josef's concept of the "maximum." For his generosity of spirit, close collaboration, and visual eloquence, I am forever indebted to Aleš. Thanks also go to his colleagues at Studio Najbrt, especially Pavlína Nebáznivá, Adéla Pěchočová, Jiří Veselka, and Jakub Spurný.

Trustee emeritus of Aperture Mark Levine has been a consistent champion over the years both of Koudelka's work and of mine at Aperture. His interest and advocacy mean so much to both of us. The book was made possible through the generous support of Mark and Elizabeth Levine, ET Harmax Foundation; Marina and Andrew E. Lewin; and Dr. Stephen W. Nicholas and Ellen Sargent. I am so very grateful to them all. Andy and Steve currently serve on Aperture's Board of Trustees. I am, as ever, thankful to the entire Aperture Board.

I am thrilled that two of the publishers featured in this biography will produce co-editions of *Next* in their respective languages. I extend my heartfelt thanks to Torst in the Czech Republic and delpire & co. in France.

For their encouragement, friendship, inspiration, and intelligence, I extend loving thanks to the following individuals — some of whom are now with us only in spirit: Linda Azarian; Launa Beuhler; Charles Bowden; Suzanne Burger; Wendy Byrne; Pieranna Cavalchini; Germano Celant; Mary-Charlotte Domandi; Thomas Eisen; Deborah Freedman; Karen Frome; Ella, Gemma, Renee, and Stanley Harris; Jessica Helfand; Michael E. Hoffman; Karen Hust; Elizabeth Ann Jonas; Ben Ledbetter; Carole Naggar; Marianne R. Petit; Fred Ritchin; Barbara Sest; Wendy Setzer; Robert Farris Thompson; Anne Wilkes Tucker; Ivan Vartanian; and Deborah Willis.

My gratitude to Mark Singer is immense — for his tenderheartedness, and for his thorough and tough reads of this manuscript.

Everyone in Josef's family has been so generous with their recollections and understanding, doing everything possible to facilitate the writing and compiling of this biography. I am especially grateful to Josef's sister, Zuzana Berndorff; her husband, Henry Berndorff; and their children, Dagmar and David Berndorff, as well as to Josef's cousins Miroslav (Mirek) Koudelka, Antonín (Tonda) Koudelka, and Josef (Martin) Martinů.

I extend my deep and affectionate thanks to Josef's children, Rebecca Johnson, Lucina Hartley Koudelka and her husband, Vincenzo Iovino, and Nicola Koudelka, who have been exceptionally generous, frank, and open with their memories and insights. Lucina filmed most of my conversations with her father, and I am grateful for the gift of her presence. She was, among other things, a conduit for stories to which otherwise I might never have been privy, often offering a counterperspective to Josef's, adding texture to my understanding of him. Lucina also helped to expedite endless arrangements — especially during what we have come to term the "Zoom period" of this book's evolution. I am so very happy, appreciative, and thankful for her help and friendship.

Finally, Josef. I know you didn't quite realize what you signed up for with this project, and I am so grateful to you for allowing me into your life and for the nine years of conversations, as well as for your intense and all-in collaboration on the book's photo research and design. Thank you also for never attempting to censor or impose your formidable will on the storytelling. Your openness and trust permitted me to write honestly, freely, and with integrity. I know how supremely fortunate I have been to have had the time with you that this project demanded. I hope with all my heart to have done your life and your work justice with this book. I've had so much fun! Endless thanks and appreciation.

NEXT!

—M.H.

Text and Image Credits

Unless otherwise indicated, quotes, passages, correspondence, and text excerpts originally in Czech (with the exception of some Anna Fárová materials, ca. 1990 and earlier) and conversations that occurred in Czech were translated to English by Derek Paton and Marzia Paton, who also often served as onsite interpreters. Marguerite Shore translated various texts, correspondence, and interviews from the original Italian. She, along with Diana C. Stoll, translated various texts, correspondence, and interviews from the original French. Unless otherwise specified, Paula Kupfer translated various texts, correspondence, and interviews from the original Spanish. Much of Anna Fárová's writing, including correspondence and texts from books, articles, interviews, speeches, and exhibition *katalogues*, has been gathered and/or published by Viktor Stoilov of the Torst publishing house. Materials derived from the archive of the Torst publishing house in Prague are noted as "Torst Archive." The correspondence, diaries, *katalogues*, agendas, and other materials designated "JK Archive" are housed in Prague. The Aperture Archive is located in New York City.

Photographs by Josef Koudelka are © Josef Koudelka/ Magnum Photos and courtesy the Josef Koudelka Foundation. Historical photographs of Koudelka's family and friends as well as photographs of ephemera, including postcards, notebooks, clippings, identification cards, travel documents, etc., are courtesy the Josef Koudelka Archive. Nothing by or from Josef Koudelka and/or the Josef Koudelka Archive may be reproduced without the written permission of Josef Koudelka or the Josef Koudelka Foundation.

Front cover: © The Irving Penn Foundation; frontispiece (page 2): © Fondation Henri Cartier-Bresson/Magnum Photos; page 8: © Antoine d'Agata/Magnum Photos; page 21: © Tomáš Pospěch; page 24: © Sarah Moon; page 28 (top): © Lucina Hartley Koudelka; page 33 (bottom): © Jill Hartley; page 58: wedding album courtesy Jan Tříska and Karla Chadimová; page 62 (top): © Karel Cudlín; page 62 (bottom): © Markéta Luskačová; page 63: © Bohumil Puskailer; page 76: © Oldřich Škácha; page 99: © Keith Arnatt; page 106: © Fernando Herráez; page 109: © Jill Hartley; page 113: © Martine Franck/Magnum Photos; page 117: © Guy Le Querrec/Magnum Photos; page 121: © Fondation Henri Cartier-Bresson/Magnum Photos; page 123: © Paulo Nozolino; page 129: © Marc Riboud/Fonds Marc Riboud au MNAAG/Magnum Photos; page 136 (bottom): © Chris Killip Photography Trust/Magnum Photos; page 137: © Martine Franck/Magnum Photos;

page 138: © Markéta Luskačová; page 142 (top): © Hervé Tardy; page 143: © Coşkun Aşar; page 144: © Cristobal Zañartu; page 148: © Raymond Depardon/Magnum Photos; page 149: © Tristan Cassiet; page 152: © Elliott Erwitt/Magnum Photos; page 154: © Alécio de Andrade, ADAGP Paris, 2022; page 155 (bottom): © Sarah Moon; page 162: © Paul Trevor 2023; page 166: © Fabio Ponzio/ Courtesy the artist; page 169: © Sylvia Plachy; page 172: Courtesy Marialba Russo; pages 175, 176: © Jill Hartley; page 177: © Pavel Dias; page 179: Courtesy Graciela Iturbide; page 181: © Fondation Henri Cartier-Bresson/ Magnum Photos; page 186: © René Burri/Magnum Photos; page 187: © Harry Gruyaert/Magnum Photos; page 192: Courtesy Graciela Iturbide; page 193: © Harry Gruyaert/Magnum Photos; page 197: © Marthe Cartier-Bresson; page 200 (top): © Hervé Hughes; page 201: © Anthony Friedkin; page 208: © Stanislav Vaněk; page 212 (bottom): © Nazarian; page 214: © Dominique Eddé; page 215: © Cristobal Zañartu; page 223: © Cristina Marinelli; page 233: © Vincenzo Iovino; page 236: © Karel Cudlín; page 239: © Ondřej Hošek; page 243 (top): © Irena Šorfová; page 244: © Bara Lockefeer; page 247: © Mélanie Cartier-Bresson; page 248: © Lesley A. Martin; page 252: © Andrew Owen; page 253 (top): Courtesy Jan Horáček; page 253 (bottom): © Viktor Stoilov; page 255: © Gilad Baram/Nowhere Films, Berlin; page 256: © Atta Awisat; page 262 (bottom): © Adriana Lopez Sanfeliu; page 264: © Anthony Friedkin; page 265 (bottom): © Cristobal Zañartu; page 269: © Vincenzo Iovino; page 271: © Jonathan Roquemore; page 275: © Hervé Tardy; page 277: © Sarah Moon; page 279: © Edward Grazda 2022; page 281: © Fabio Ponzio; page 284 (all): © Coşkun Aşar; page 285: © Enrico Mochi; page 286 (bottom): © Coşkun Aşar; page 292: © Clarisse Bourgeois; page 293: © Enrico Mochi; page 294: © Jaroslav Fišer; page 295: © Ondřej Kocourek, Museum of Decorative Arts, Prague; page 297: © Vincenzo Iovino

Every effort has been made to trace and properly acknowledge copyright holders. Should inaccuracies or omissions have occurred, Aperture requests that the parties in question contact the publisher with corrections.

JOSEF KOUDELKA: NEXT

A Visual Biography by Melissa Harris

Editor: Diana C. Stoll
Creative Director: Lesley A. Martin
Design: Aleš Najbrt (Studio Najbrt) and Josef Koudelka
Typesetting and Image Placement: Jiří Veselka
and Jakub Spurný (Studio Najbrt)
Covid-Period Typesetting and Image Placement:
Yolanda Cuomo and Bobbie Richardson (Yolanda
Cuomo Design) with Melissa Harris
Additional Typesetting: Karina Eckmeier
**High-Resolution Scans, Photo Research, and
Caption Research:** Enrico Mochi
**Photo and Caption Coordination and Caption
Research:** Amelia Lang
Publishing Manager: Taia Kwinter
**Aperture Archive Research and Editorial
Assistance:** Sarah Dansberger
Production Manager (Aperture): Andrea Chlad
Production Managers (Studio Najbrt): Adéla
Pěchočová and Pavlína Nebáznivá
Editorial Assistant: Noa Lin
Senior Text Editor: Susan Ciccotti
Proofreaders: Sally Knapp, Isla Ng, and Claire Voon
Work Scholar: Iesha Coppin-Forde
Indexer: Pilar Wyman

Additional staff of the Aperture book program includes:
Sarah Meister, Executive Director; Emily Patten,
Managing Editor, Books; Caroline Foulke, Assistant to
Managing Editor; Minjee Cho, Production Director;
Thomas Bollier, Production Consultant; Kellie
McLaughlin, Chief Sales and Marketing Officer; Richard
Gregg, Sales Director, Books

Special thanks:
Josef Koudelka: Next was made possible, in part, with
generous support from Marina and Andrew E. Lewin,
and Mark and Elizabeth Levine, ET Harmax Foundation.
Additional thanks to Dr. Stephen W. Nicholas and
Ellen Sargent.

Library of Congress Cataloging-in-Publication Data
Names: Harris, Melissa, author.
Title: Josef Koudelka : next : a visual biography / by
 Melissa Harris.
Other titles: Next : a visual biography
Description: First edition. | New York, NY : Aperture,
 2023. | Includes bibliographical references and
 index. | Summary: "Josef Koudelka: Next presents
 an intimate portrait of the life and work of one of
 photography's most renowned and celebrated artists.
 Based on hundreds of hours of interviews conducted
 over the course of six years with Koudelka-as well
 as ongoing conversations with his friends, family,
 colleagues, and collaborators worldwide-writer,
 editor, and curator Melissa Harris independently
 reports and crafts a unique, in-depth, and revelatory
 biography. Josef Koudelka: Next is richly illustrated
 with hundreds of photographs, including many
 biographical and behind-the-scenes images from
 Koudelka's life, as well as iconic images from his work,
 from the 1950s to the present. The visual presentation
 is conceived in collaboration with Koudelka himself,
 as well as his longtime collaborator, Czech designer
 Aleš Najbrt" — Provided by publisher.
Identifiers: LCCN 2023002277 | ISBN 9781597114653
 (paperback)
Subjects: LCSH: Koudelka, Josef, 1938- |
 Photographers — Czechoslovakia — Biography. |
 Photography, Artistic.
Classification: LCC TR140.K685 H37 2023 | DDC 770.92
 [B]--dc23/eng/20230314
LC record available at https://lccn.loc.
 gov/2023002277

First edition, 2023
Printed in China
10 9 8 7 6 5 4 3 2 1

To order Aperture books, or inquire about gift or group
orders, contact:
orders@aperture.org

For information about Aperture trade distribution
worldwide, visit:
aperture.org/distribution

aperture

548 West 28th Street, 4th Floor
New York, NY 10001
aperture.org

Aperture, a not-for-profit foundation, connects the
photo community and its audiences with the most
inspiring work, the sharpest ideas, and with each other
— in print, in person, and online.

Co-published by Aperture and Magnum Foundation